MASTERS
OF
COLOR
AND
LIGHT

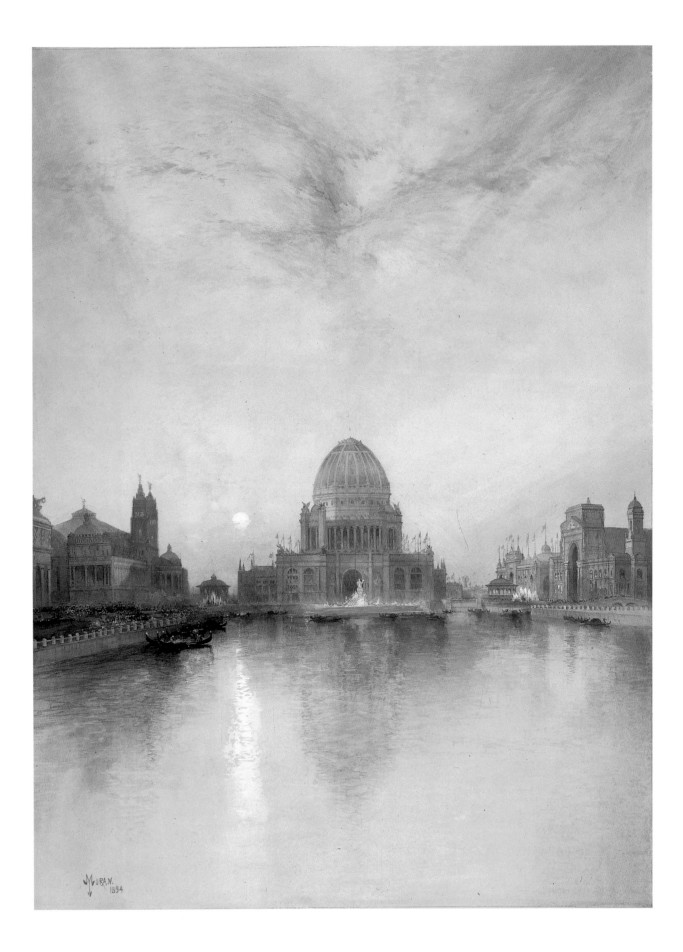

MASTERS
OF
COLOR
AND
LIGHT

HOMER, SARGENT, AND THE AMERICAN WATERCOLOR MOVEMENT

LINDA S. FERBER
AND
BARBARA DAYER GALLATI

THE BROOKLYN MUSEUM OF ART
in association with
SMITHSONIAN INSTITUTION PRESS · Washington and London

Masters of Color and Light: Homer, Sargent, and the American Watercolor Movement is made possible with the generous support of Aetna.

Critical support has also been provided by the Overbrook Foundation, the Gilbert and Ildiko Butler Foundation, the Ronald H. Cordover Family Foundation, Mr. and Mrs. Leonard L. Milberg. Additional funds were provided by Mr. and Mrs. John S. Tamagni, Mr. and Mrs. James H. Ottaway, Jr., Mrs. Hugh Tatlock, and Françoise and Harvey Rambach.

Support for the catalogue were also provided through the generosity of Furthermore, the Publication Program of the J.M. Kaplan Fund, as well as a publications endowment created by the Iris and B. Gerald Cantor Foundation and The Andrew W. Mellon Foundation.

PRODUCTION EDITOR: Jack Kirshbaum
DESIGNER: Janice Wheeler

Library of Congress Cataloging-in-Publication Data
Ferber, Linda S.
 Masters of color and light : Homer, Sargent, and the American watercolor movement / Linda S. Ferber and Barbara Dayer Gallati.
 Includes bibliographical references and index.
 ISBN 1-56098-572-0 (cloth : alk. paper)
 1. Watercolor painting, American—Exhibitions. 2. Watercolor painting—19th century—United States—Exhibitions. 3. Homer, Winslow, 1836–1910—Exhibitions. 4. Sargent, John Singer, 1856–1925—Exhibitions. 5. Watercolor painting—New York (State)—New York—Exhibitions. 6. Brooklyn Museum of Art—Exhibitions.
 I. Gallati, Barbara Dayer. II. Brooklyn Museum of Art. III. Title.
 ND1807.F47 1998
 751.42'2'097307474723—dc21 98-10924

British Library Cataloging-in-Publication data available
04 03 02 01 00 99 98 5 4 3 2 1

Manufactured in Italy not at government expense

The paper used in this publication meets the minimum requirements of the American National Standard for Permanence of Paper for Printed Library Materials Z39.48-1984.

For permission to reproduce any of the illustrations, correspond directly with the sources. Smithsonian Institution Press does not retain reproduction rights for these illustrations individually or maintain a file of addresses for photo sources.

Frontispiece: Thomas Moran, *Chicago World's Fair,* 1894 (cat. no. 42)

CONTENTS

FOREWORD

Masters of Color and Light: Homer, Sargent, and the American Watercolor Movement is drawn entirely from the Brooklyn Museum of Art's permanent collection and, as such, is an especially fitting commemoration of the 175th anniversary of the founding of the Museum. Two landmark purchases of watercolors by John Singer Sargent (1909) and Winslow Homer (1912) established the foundation of a great collection. In this important volume, Linda S. Ferber, Andrew W. Mellon Curator of American Art, and Barbara Dayer Gallati, Associate Curator of American Painting and Sculpture, investigate the nineteenth-century American watercolor movement that preceded Brooklyn's pioneering acquisitions as well as the Museum's considerable role, through acquisitions and exhibitions, in the evolution of the watercolor in the United States during the first six decades of this century.

I want to thank the curators and the staff for their considerable efforts in bringing both exhibition and publication to a successful realization. My sincere thanks are due as well to generations of generous donors for their continuing and devoted support during nine decades of collecting which has established the Brooklyn Museum of Art's collection among the finest public holdings of American watercolors in our nation.

As in every endeavor, we have had the support of the Museum's Trustees, and it is a pleasure to express our gratitude to Robert S. Rubin, Chairman, and to every member of the Board for their confidence in and support of the Museum's staff.

We are very grateful to Aetna for its sponsorship of the exhibition and for the generous support of the Overbrook Foundation, the Gilbert and Ildiko Butler Foundation, the Ronald H. Cordover Family Foundation, Mr. and Mrs. Leonard L. Milberg, and Furthermore, the Publication Program of the J. M. Kaplan Fund. Additional support was provided by Mr. and Mrs. John S. Tamagni, Mr. and Mrs. James H. Ottaway, Jr., Mrs. Hugh Tatlock, and Françoise and Harvey Rambach.

Funds for the research and development of the catalogue were also provided by the Iris and B. Gerald Cantor Foundation and the Andrew W. Mellon Foundation.

Arnold L. Lehman
Director
Brooklyn Museum of Art

PREFACE

The Brooklyn Museum of Art has long been associated with American watercolors. In the early years of this century, soon after the Museum's building on Eastern Parkway opened, a set of landmark acquisitions was made that permanently ensured the institution's reputation as a leader in collecting American works in the medium. The first was the much-heralded 1909 purchase of eighty-three watercolors by John Singer Sargent and the second was the 1912 addition of a dozen watercolors from the estate of the recently deceased Winslow Homer. These seminal acquisitions were soon joined by more American watercolors, which, for many years, were more or less permanently installed in the Museum's galleries until concern about their preservation compelled their retirement to storage. Today, despite the rarity of its public display, the Museum's watercolor collection is one of the most popular aspects of its holdings and inspires a steady flow of visitors—artists, scholars, collectors, and general public—who now come to study these works by appointment.

In 1915, with the organization of the first complete survey of Homer's work in watercolor, the Museum inaugurated what would become a tradition of noteworthy special exhibitions devoted to American watercolor. The enormous critical success of the 1921 *Exhibition of Water Color Paintings by American Artists* (a survey of contemporary production) led to the Museum's groundbreaking series of watercolor biennials that went uninterrupted from 1923 to 1963. These shows, which were frequently international in scope, not only generated critical and public interest in the medium but also stimulated the growth of the collection itself, as witnessed by the Museum's purchase of significant works out of the biennials by such artists as Charles Burchfield, Edward Hopper, and Mark Rothko. In turn, Brooklyn's growing reputation as a center for watercolor display and study encouraged generous donors to amplify the collection over the years with additional works by Homer and Sargent as well as pieces by John William and John Henry Hill, William Trost Richards, Edwin Austin Abbey, Charles Demuth, Georgia O'Keeffe, and Stuart Davis, among others.

Other notable exhibitions have kept the Museum in the watercolor mainstream: Lloyd Goodrich's 1945 *American Watercolor and Winslow Homer,* which was co-organized by the Walker Art Center and the Brooklyn Museum, and the more recent *The New Path: Ruskin and The American Pre-Raphaelites,* which in 1985 refocused attention on a group of mid-nineteenth-century watercolor specialists whose works had been nearly forgotten. Not to be ignored are the Museum's *Curator's Choice* exhibitions, which highlighted portions of Brooklyn's

watercolor collection throughout the 1980s and early 1990s. A major step in documenting the collection was taken with the 1984 publication of the illustrated checklist of the Museum's American watercolors, pastels, and collages, the availability of which has greatly increased the use of the collection within the scholarly community in terms of its inclusion in loan exhibitions and published materials.

The present volume stands midway between the checklist of 1984 and a complete catalogue of the American watercolor collection—a work currently in progress but not to be expected for some years. Our intentions are twofold. The first is to provide an overview of the collection (which now numbers nearly 800 watercolors) by highlighting 150 carefully chosen works whose dates span a period of more than two centuries. The second is to document the origins and development of the collection against the backdrop of nineteenth-century Brooklyn culture (which had its own wide array of artists' associations, exhibition opportunities, collectors, and press) and to address broader issues provoked by the investigation of such "local" history. We arrived at a checklist that naturally includes works by such masters as Homer and Sargent, but one that also reveals less well known aspects of the collection, many of which have come to light through the curatorial process that entailed a fascinating excursion into the depths of the collection. This exploration stimulated questions about the patterns of the collection's formation as they relate to the larger history of the watercolor in America, the institution's growth, and, of course, the vicissitudes of taste in the determination of artistic reputations.

Thus, while we set out to define the relatively narrow, albeit noteworthy, history of the Museum's activity in collecting and exhibiting American watercolors, we found ourselves faced with questions, the investigation of which intersected with the broader history of watercolor production in this country. Our research methods were straightforward—accomplished mainly by mining the rich archival materials unique to the institution and interpreting them in the light of the copious newspaper and magazine coverage devoted to Museum acquisitions and events. The collection itself and the information gleaned from these previously untapped resources have inspired the seven essays that follow. Chapter 1 traces for the first time Brooklyn's part in the final phases of the American Watercolor Movement, which flourished from about 1870 to about 1885 and which was centered in the then separate city of New York. During this period the medium received focused critical attention and active patronage largely through the agency of the American Watercolor Society, founded in 1867, and, more locally, via the efforts of the Brooklyn Art Association, which sponsored watercolor vigorously during its own heyday between 1872 and 1885. Linking the hitherto separate histories—Brooklyn and New York—is John Mackie Falconer, a forgotten but intriguing figure who was active in the promotion of watercolor in both cities.

Consideration of the first important American watercolor to enter Brooklyn's collection (Albert Fitch Bellows' *Coaching in New England*) prompted chapter 2, an exploration of the phenomenon of "exhibition watercolor" in America and the

media-driven debates about the respective merits of transparent and opaque watercolor that accompanied it. Chapters 3, 4, and 5 are based on the most notable strengths of the collection—large groups of paintings by Richards, Homer, and Sargent. But, rather than rehearsing the well-documented histories of these artists with respect to their watercolor output, the authors have taken this opportunity to investigate previously unexplored areas of patronage, the art market, and critical reception as they contributed to each of these artists' reputations as specialists in the medium.

An intensely local focus such as the one undertaken here, while limiting in some respects, can be liberating in others. In surveying the reviews of the Brooklyn watercolor biennials, the persistent conviction emerged that watercolor was the "American medium." In that connection, chapter 6 offers an introductory treatment of such critical attitudes, which are seen to have originated in the strong shift toward cultural nationalism that arose in the early twentieth century and were transmitted by a framework of language that developed in the 1870s. Finally, chapter 7 focuses on a number of once admired and now ignored artists whose art suggests that, while our current surveys of American watercolor are useful, they are perhaps unduly abbreviated narratives of a livelier history.

With *Masters of Color and Light: Homer, Sargent, and the American Watercolor Movement,* the Brooklyn Museum of Art adds its name to the impressive list of museums that have recently devoted publications to celebrating American watercolors. These institutions include the Museum of Art, Carnegie Institute, the Worcester Museum of Art, the Metropolitan Museum of Art, and the Museum of Fine Arts, Boston—the very institutions that, with Brooklyn, participated in the early flurry of Homer and Sargent acquisitions that formed the foundations of our country's finest public collections of works in the medium. Our task would have been impossible without the scholarly efforts of the authors of the above catalogues, and we acknowledge their contribution to the field.

On a more immediate level, we take this opportunity to thank the many people who generously and directly aided in bringing this project to fruition: Laila Abdel-Malek, Museum of Fine Arts, Boston; Warren Adelson, Adelson Galleries, Inc.; Kevin Avery, The Metropolitan Museum of Art; Edith Caldwell, Caldwell Gallery, San Francisco; Nan Cohen, University of Seattle, Washington; Helen Cooper, Yale University Art Gallery; Melissa de Medeiros, M. Knoedler and Company; Ann DiFonzo, Yale University Art Gallery; Carol Donovan, Garrison Library, Garrison, New York; Simon Fenwick, Royal Watercolour Society, London; Richard Finnegan, Adelson Galleries, Inc.; Carter Foster, The Cleveland Museum of Art; Kathleen A. Foster, Indiana University Art Museum; Robin Frank, Yale University Art Gallery; Abigail Booth Gerdts of the Lloyd Goodrich and Edith Havens Goodrich, Whitney Museum of American Art, Record of Works by Winslow Homer, Graduate Center of the City University of New York; Louise Greene, University of Maryland; Jonathan Harding, The Century Associ-

ation; Joy Holland, Brooklyn Public Library; Wrenn Hardy, Museum of Fine Arts, Boston; Jeanie James, The Metropolitan Museum of Art; Vance Jordan, Vance Jordan Fine Art Inc.; Karl S. Kabelac, Rush Rhees Library, University of Rochester; Cheryl Leibold, Pennsylvania Academy of the Fine Arts; Barbara Buhler Lynes, Georgia O'Keeffe Catalogue Raisonné Project; Kenneth Maddox, Newington-Cropsey Foundation; Clark S. Marlor, Brooklyn; Susan Mason, Adelson Galleries, Inc.; Julie Moffatt, Brooklyn Public Library; M. P. Naud, Hirschl & Adler Gallery; Kenneth Newman, The Old Print Shop; Elizabeth Oustinoff, Adelson Galleries, Inc.; Elaine S. Pike, Vassar College Library; Karen Quinn, Museum of Fine Arts, Boston; Ganine St. Germain, Prospect Park Alliance; Chantal Serhan, British Museum; Kim Sloan, British Museum; Judy Sourakli, Henry Art Gallery, University of Seattle; Reagan Upshaw, Gerald Peters Gallery; Virginia Valpy, Courtauld Institute of Art; Judith Walsh, Brooklyn Public Library; Meredith Ward, Richard York Gallery; Timothy M. Warren; H. Barbara Weinberg, The Metropolitan Museum of Art; Patricia J. Whitesides, The Toledo Museum of Art; Jim Zwadlo, Liberty Library, Liberty, New York.

Once again we at the Museum have had the pleasure of joining with the Smithsonian Institution Press in a copublishing venture. We take this opportunity to extend our special appreciation and gratitude to Amy Pastan, a former member of the press staff, who started this project with us and left it in the capable hands of Jack Kirshbaum, who brought it to completion.

As always, the talented staff of the Museum deserves our highest praise and gratitude. We especially thank Roy R. Eddey, then Acting President and Deputy Director, for his early support of this project. Among our curatorial colleagues at the Museum, we owe particular debts to Teresa A. Carbone, Associate Curator, American Painting and Sculpture; Diana Fane, Curator of the Arts of Africa, Pacific, and the Americas; Charlotta Kotik, Curator of Contemporary Painting and Sculpture; Marilyn S. Kushner, Curator of Prints, Drawings, and Photographs; Brooke Kamin Rapaport, Associate Curator of Contemporary Painting and Sculpture; and Kevin Stayton, Curator of Decorative Arts, for their sharing of good advice and information. To Deirdre E. Lawrence, Principal Librarian/ Coordinator of Research Services, Deborah Wythe, Archivist, and the entire staff of the Museum's Art Reference Library go our continuing appreciation for their skill and constant cooperation in connection with this and every other research project we undertake here. We also acknowledge and thank Kenneth Moser, Vice Director for Collections, on whose superior talents as a conservator and administrator we consistently depend. The parameters of this project have occasioned our close working relationship with the paper conservators Antoinette Owen, Conservator of Paper, and Rachel Danzing, Assistant Conservator of Paper, whose knowledge and advice were invaluable. We are also grateful to another member of the conservation department, Carolyn Tomkiewicz (although in this case it was for her skill as a translator that she was needed). Other members of the staff were instrumental in facilitating the completion of this volume: in Collections

Management, Cathryn Anders, Jeanne Mischo, and the Museum's fine team of art handlers; in Exhibitions Management, Cheryl Sobas and Michelle Tolini; in Photography, Dean Brown and Faith Goodin; in the Registrar's Office, Terri O'Hara; in the Editorial Division, James Spero, Joanna Ekman, and David Randall; and Jennifer Noonan in the Department of Prints, Drawings, and Photographs.

We are particularly grateful for the office and administrative support of Usha Kutty, Kevin Cooper, and Joseph Pergola (in the Director's Office) and that of Hadar Yerushalmi (in American Painting and Sculpture). While we concentrated on this project, they kept things running smoothly and stepped into action on this manuscript as our deadlines loomed.

It is safe to say that no deadlines would have been met without the dedicated and sophisticated research assistance of Sarah Elizabeth Kelly and Thomas B. Parker. They accomplished their work with a high level of professionalism and great spirit. We also thank Sarah Snook, who was occasionally called away from her research on another project to help us in the inevitable "pinch," and our departmental volunteer, Joan Blume.

Finally, we acknowledge the extraordinary editorial skills of Fronia W. Simpson, who always makes things better.

It is our hope that this volume will be welcome not only for the new information that it provides but also for its potential in opening new avenues of inquiry in the continuing investigation of watercolor in America.

MASTERS
OF
COLOR
AND
LIGHT

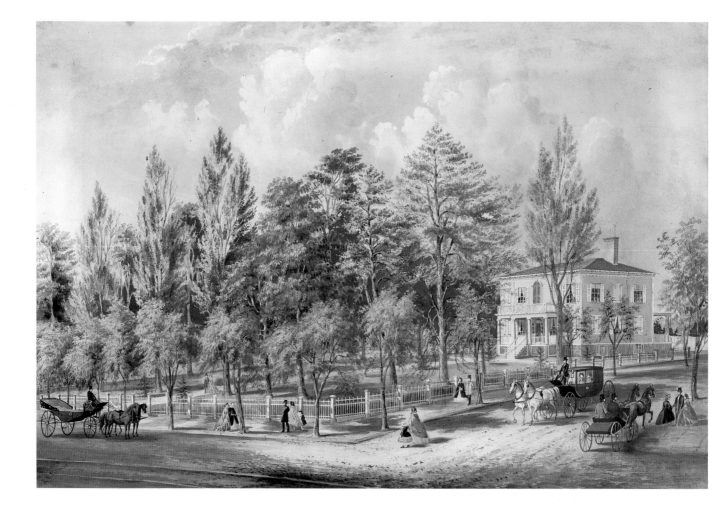

I

"A TASTE AWAKENED": THE AMERICAN WATERCOLOR MOVEMENT IN BROOKLYN

LINDA S. FERBER

I

Frances Flora Palmer (1812–76). *The Samuel Fleet Homestead, Brooklyn,* c. 1850s. Transparent and opaque watercolor over graphite on cream, moderately thick, slightly textured wove paper mounted to Japanese paper. Partial watermark: J WHAT . . . / 184. 18⅜ × 27¼ in. (46.7 × 69.2 cm). Signed lower left: *F. F. Palmer.* 43.171, Bequest of Clara H. Baxter

"Brooklyn! Brooklyn! In fifty years, as a New Yorker, I had been in Brooklyn but twice. It seemed an eternity away. San Francisco was not as distant as the City across the Bridge. The Brooklyn Museum I had frequently heard of, but had never been there. It had bought a block of Sargent's water colors. It had bought the Tissot biblical drawings. It had bought many Winslow Homer water colors. It contained quite a few paintings by Davies. Such was my visualization whenever I heard the name Brooklyn Museum." So Alfred Stieglitz began a letter to the Brooklyn Museum director William Henry Fox (1858–1952) in June 1921.[1] His remarks establish that from early in this century the Brooklyn Museum of Art has been associated with three important watercolor acquisitions: the purchase by public subscription in 1900 of some 345 meticulously detailed gouaches illustrating the New Testament by the Frenchman James Jacques Joseph Tissot; in 1909, eighty-three watercolors by John Singer Sargent, and in 1912, a dozen watercolors by Winslow Homer. We have evoked two of these still-powerful associations in our title—*Masters of Color and Light: Homer, Sargent, and the American Watercolor Movement*—which also offers a useful premise from which to introduce both the exhibition and this publication. *Masters* suggests the qualitative frame of reference with which we have selected some of the finest representative works from Brooklyn's collection. *Color and Light* refers to the primary visual characteristics and attractions of this versatile medium. Homer and Sargent were the two American masters whose work epitomizes the medium's technical and expressive possibilities.

The American Watercolor Movement—an interval of sustained popularity of the medium from about 1870 to about 1885—speaks to the larger historical context in which both Brooklyn's collection and the work of

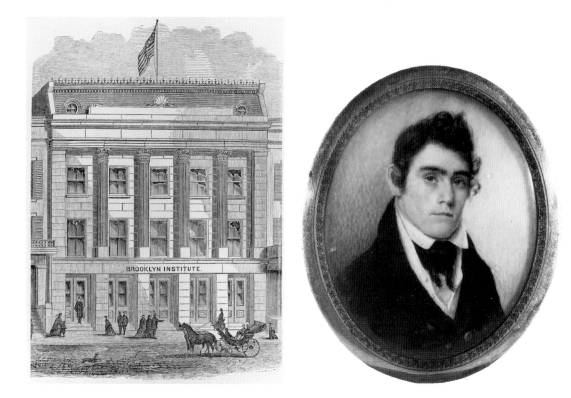

Fig. 1. *(far left)*
The Brooklyn Institute
building, 182 and 184
Washington Street
From an engraving in
Brooklyn Institute Yearbook
(1888–89)
Brooklyn Museum of Art
Archives

Fig. 2. *(left)*
Eliab Metcalf (1785–1834)
*Portrait of John Haslett,
M.D.,* c. 1823
Watercolor on ivory
Brooklyn Museum of Art,
20.962, Bequest of Samuel
E. Haslett

Homer and Sargent must be understood.[2] The American Society of Painters in Water Colors, founded in 1866, was based in New York City, holding their celebrated annual exhibitions at the National Academy of Design. Brooklyn also enjoyed a surge of watercolor enthusiasm between 1875 and 1885. A series of exhibitions was held at the Brooklyn Art Association in a little-known collaboration with the American Watercolor Society. Brooklyn's watercolor movement was largely due to the efforts of John Mackie Falconer, a forgotten but fascinating figure who was active in both organizations and in both cities.

WATERCOLOR IN BROOKLYN

Stieglitz's letter is revealing in its playful but pointed reference to the otherness of Brooklyn. More than two decades after the Consolidation of 1898, when the cities of Brooklyn and New York were joined, the locus still had a distinct and separate culture born of some two centuries of autonomy as a Dutch settlement and, after 1855, as the third-largest city in the United States. Consideration of the watercolor movement in somewhat local terms—the subject of this brief essay—begins in the early decades of the nineteenth century when the art collection of the then-named Brooklyn Institute (today the Brooklyn Museum of Art) was in its infancy. It was housed in an imposing granite neoclassical building on Washington Street near what is today the approach to the Brooklyn Bridge (fig. 1). Founded

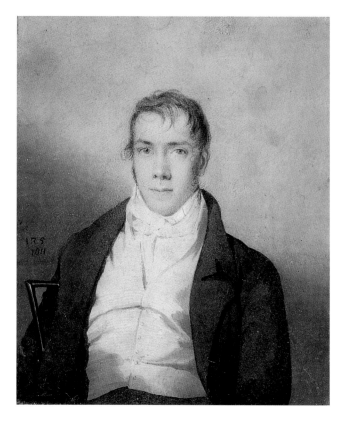

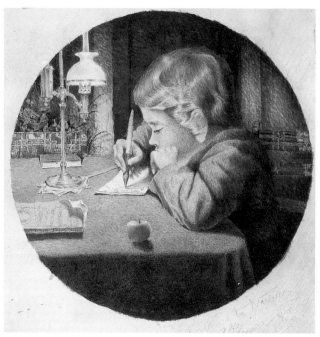

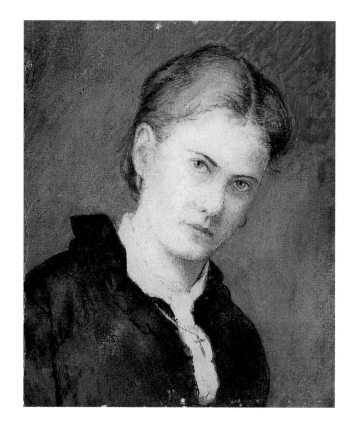

2 *(above)*

John Rubens Smith (1775–1849). *Portrait of an Unknown Gentleman*, 1811. Watercolor over graphite on beige, moderately thick, slightly textured wove paper. 7¼ × 5⅛ in. (18.4 × 13 cm). 21.467, Bequest of Samuel E. Haslett, by exchange

3 *(above, right)*

Robert Brandegee (1848–1922). *Writing to Mother*, 1869. Watercolor over graphite on cream, moderately thick, slightly textured wove paper. 10 × 9¹¹⁄₁₆ in. (25.4 × 24.6 cm). Dated and inscribed lower right: *Writing to Mother / Farmington / Jan 10, 1869.* 82.134.2, Charles Stewart Smith Memorial Fund

4 *(right)*

Ralph Albert Blakelock (1847–1919). *Portrait of the Artist's Wife*, c. 1876. Watercolor over graphite on brown, moderately thick, slightly textured wove paper. 6¼ × 5⅜ in. (15.9 × 13.7 cm). Inscribed on verso: *This picture was painted / by my father Ralph A. Blakelock and given to me / by my mother. / Louis R. Blakelock / Sept 20 1913.* 30.58, Museum Collection Fund

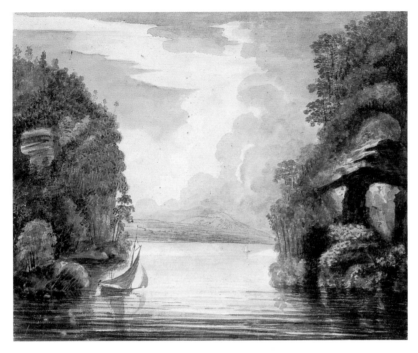

5 *(left)*

Captain William Pierie (18th century). *Narrows at Lake George,* 1777. Watercolor on cream, thick, rough-textured laid paperboard. 8⁷⁄₁₆ × 10³⁄₁₆ in. (21.4 × 25.9 cm). Signed lower right: *P.* Inscribed lower left border: *View of America by Capt. Pierie, Artillery.* Inscribed lower left: *Narrows at Lake George.* 50.66.1, Dick S. Ramsay Fund

6 *(opposite, above)*

William Strickland (1753–1834) and Joseph Halfpenny (1748–1811). *View down the Potomack, from the Junction of the Cohongoronta and the Shenandoah in Virginia,* 1795–96. Watercolor over graphite on cream, medium-weight, slightly textured laid paper mounted to paperboard. 18⅛ × 25 in. (46 × 63.5 cm). Signed, dated, and inscribed lower left: *Sketched June 1795 by William Strickland Esq.* Signed, dated, and inscribed lower right: *Finished by Joseph Halfpenny 1796.* 1991.43, Dick S. Ramsay Fund

7 *(opposite, below)*

George Beck (1748?–1812). *Stone Bridge over the Wissahickon,* c. 1800. Opaque watercolor on paper mounted to canvas attached to Masonite and a wooden strainer. Primary support: 19⅜ × 24⅛ in. (49.2 × 61.3 cm). Secondary support (including strainer): 21½ × 27½ in. (54.6 × 69.9 cm). 1991.10.1, Purchased with funds given by Mr. and Mrs. Leonard L. Milberg

as an Apprentices' Library in 1823 and renamed in 1843, the institute was a fixture of local cultural life.³

Although there were no watercolors in the institute's fine art collection, the medium was in use as an applied art in ways typical of the period. For example, in 1823 Robert Haslett, a young physician stationed at the Brooklyn Navy Yard, sat for a miniature watercolor portrait executed by New York painter Eliab Metcalf (fig. 2). Although largely replaced by photographic portraits (see fig. 7), the tradition of small-scale watercolor likenesses persisted (cat. nos. 2, 3, 4).⁴ Brooklyn and the other towns at the western end of Long Island were visited by nineteenth-century topographical watercolor specialists. Today we appreciate such watercolor views for themselves and recognize their contribution to the development of American landscape painting (cat. nos. 5, 6, 7). However, most were prepared primarily for documentary purposes and as points of departure for the printmaker and the publisher (cat. nos. 8–12).⁵ In 1823 William Guy Wall painted his large watercolor, *New York from Heights near Brooklyn* (fig. 3) while also at work with printmaker John Hill (1770–1850) on the famous *Hudson River Portfolio.*⁶ Looking north and including a view of Brooklyn's Gowanus Bay, Wall's prospect scans the distant skyline of neighboring New York on Manhattan Island. About 1840 George Harvey looked south from Greenwood at dawn toward the town of Flatbush for a subject in his ambitious watercolor series *Atmospheric*

8 *(above, left)*

William Guy Wall (1792–after 1864). *Falls of the Passaic,*
c. 1820. Transparent watercolor with small touches of opaque
watercolor on cream, moderately thick, moderately textured
wove paper mounted to Japanese paper. 17⅜ × 24 in. (44.1 × 61
cm). 42.108, Presented in memory of Dick S. Ramsay

9 *(below, left)*

William James Bennett (1784–1844). *View on the Potomac,*
Looking toward Harper's Ferry, c. 1834. Watercolor over graphite
on beige, medium-weight, slightly textured wove paper. 16 ×
22½ in. (40.6 × 57.2 cm). 46.196, Dick S. Ramsay Fund

10 *(right)*

George Harvey (c. 1801–78). *A Cedar Swamp,* c. 1839.
Transparent watercolor with small touches of opaque
watercolor and gum varnish over graphite on cream,
moderately thick, slightly textured wove paper. Watermark:
J WHATMAN. 13¹³⁄₁₆ × 10¼ in. (35.1 × 26 cm). 46.51,
Dick S. Ramsay Fund

Fig. 3.
William Guy Wall
(1792–after 1864)
New York from Heights near
Brooklyn, 1823
Watercolor on paper
The Metropolitan Museum
of Art, Arnold, 1954. The
Edward W. C. Arnold
Collection of New York
Prints, Maps and Pictures.
(54.90.168)

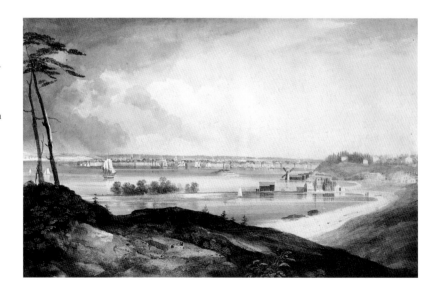

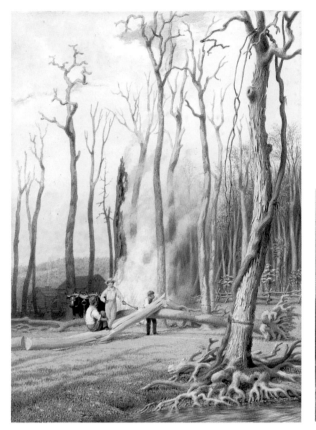

Landscapes (fig. 4; cat. nos. 11, 12).[7] Frances Flora Palmer, who lived in Brooklyn, rendered *The Samuel Fleet Homestead*, then located at the intersection of Fulton and Gold Streets, in a watercolor of about 1850 (see cat. no. 1).[8] William Rickarby Miller traveled to New Utrecht, today Bay Ridge, to document a

11 *(above, left)*
George Harvey (c. 1801–78). *Spring—Burning Fallen Trees, in a Girdled Clearing, Western Scene*, c. 1840. Illustration intended for *Atmospheric Landscapes of North America* (unpublished). Illustration for *Harvey's Scenes of the Primitive Forest of America*, 1841. Watercolor over graphite on cream, medium-weight, slightly textured wove paper. 13¹³⁄₁₆ × 10⁵⁄₁₆ in. (35.1 × 26.2 cm). 46.49, Dick S. Ramsay Fund

Fig. 4.
George Harvey (1801–78)
Sunrise—Flatbush and the Ocean from the Greenwood Cemetery, Long Island N.Y., c. 1840
Watercolor on paper
© Collection of the New-York Historical Society

12 *(opposite, right)*

George Harvey (c. 1801–78). *Rain Clouds Gathering—Scene amongst the Allegheny Mountains*, c. 1840. Illustration intended for *Atmospheric Landscapes of North America* (unpublished). Watercolor over graphite on cream, moderately thick, slightly textured wove paper. 8⅜ × 13⅝ in. (21.3 × 34.6 cm). 46.50, Dick S. Ramsay Fund

13 *(above)*

William Rickarby Miller (1818–93). *A Deserted Homestead on Fifth Avenue, Brooklyn*, 1869. Transparent watercolor and graphite with touches of opaque watercolor on light beige, moderately thick, slightly textured wove paper mounted to Japanese paper. 13⁹⁄₁₆ × 16⁹⁄₁₆ in. (34.4 × 42.1 cm). Signed and dated lower right: *W. R. Miller Del. / Oct. 12. 1869.* Inscribed lower left: *Old Homestead 78th St, 5th Ave.*. 85.82.1, Purchased with funds given by Mr. and Mrs. Leonard L. Milberg

fast-disappearing indigenous architecture in his watercolor of 1869, probably the one exhibited at the Brooklyn Art Association in 1874 as *A Deserted Homestead on Fifth Avenue, Brooklyn* (cat. no. 13).[9]

Watercolor was also a favorite medium for the amateur. A local watercolor enthusiast and a descendant of Brooklyn's earliest settlers, James Ryder Van Brunt devoted decades to recording neat and colorful views of Dutch homesteads and historic landmarks such as *Johnson Residence and Remsen House* (1867; fig. 5).[10] Another antiquarian and a highly skilled amateur was the newcomer John Mackie Falconer, who relocated about 1858, after two decades of living in New York, to spend nearly fifty busy years as a Brooklynite. His 1864 watercolor of the soon-to-be-demolished Philadelphia house once occupied by William Penn (cat. no. 14) mined the same vein of picturesque nostalgia as Miller's *Deserted Homestead.*

Drawing and watercolor painting (the terms were almost always synonymous) were also important accessories of genteel culture in the nineteenth century. Young ladies of Brooklyn could study drawing and watercolor as polite accomplishments at the Packer Collegiate Institute (founded as the Brooklyn Female Academy in 1846). Drawing lessons were available at the Apprentices' Library from 1841, as was instruction at the Adelphi Academy, which opened in 1863. Falconer reported in 1854 that watercolor painting was being taught at the Brooklyn Atheneum. Frances Flora Palmer and Fidelia Bridges (cat. no. 15), local women

14 (below)

John Mackie Falconer (1820–1903). *William Penn's Mansion, South Second Street, Philadelphia, 1864*, 1864. Transparent watercolor with small touches of opaque watercolor on cream, medium-weight, slightly textured wove paper mounted to particleboard. 17½ × 23½ in. (44.5 × 59.7 cm). Signed lower right: *J. M. Falconer*. Inscribed lower left: *William Penn's House, Philadelphia May 24 1864*. 1997.76, Gift of the American Art Council and Bernard & S. Dean Levy, Inc.

Fig. 5. (above)
James Ryder Van Brunt
(1820–1916)
Johnson Residence and Remsen House, 1867
Watercolor on paper
The Brooklyn Historical Society

watercolor professionals active at midcentury, had also been trained as instructors. The latter's sisters opened a school in Brooklyn in 1854.[11] For other enterprising students of all ages, a vast literature of drawing manuals was available for self-instruction. We know that the institute library contained a copy of John

15

Fidelia Bridges (1834–1923). *Wisteria on a Wall,* 1870s. Transparent and opaque watercolor over graphite on off-white, moderately thick, moderately textured wove paper. 10¹/₁₆ × 14 in. (25.6 × 35.6 cm). 85.225, Gift of Mr. and Mrs. O. Kelley Anderson, Jr.

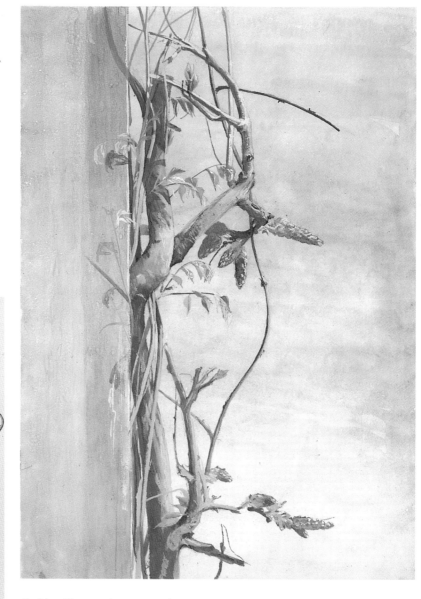

THE

AMERICAN DRAWING-BOOK:

A

MANUAL FOR THE AMATEUR,

AND

BASIS OF STUDY FOR THE PROFESSIONAL ARTIST:

ESPECIALLY ADAPTED

TO THE USE OF PUBLIC AND PRIVATE SCHOOLS, AS WELL AS HOME INSTRUCTION.

BY

J. G. CHAPMAN, N. A.

"Any one who can learn to write, can learn to draw."

NEW YORK:
W. J. WIDDLETON, PUBLISHER.
M.DCCC.LXIV.

Fig. 6.
John Gadsby Chapman (1808–89)
Title page of *The American Drawing Book* (1864) with stamps from "Brooklyn Institute Free Library" and "Youth's Free Library: Brooklyn Institute"
Brooklyn Museum of Art Library Collection

Gadsby Chapman's very popular *American Drawing Book* (1864), which included a chapter on painting in watercolor (fig. 6). This survivor is representative of many others then in circulation. The drawing academy and, especially, the drawing manual were critical elements in cultivating a popular taste for watercolors.[12] Falconer, for example, had dozens of drawing books in his own library and was reported to have written his own contribution to the genre.[13]

JOHN MACKIE FALCONER—WATERCOLOR CRUSADER

Although little known today, in his lifetime Falconer was regularly acknowledged for his devotion to the medium and to the watercolor movement. "Mr. Falconer has always been an enthusiastic admirer of the aquarellist's art," commented the *Brooklyn Daily Eagle* in 1873, "and the success of the American Society of Painters

in water colors is, perhaps, more due to his support than to that of any other artist."[14] It was in New York City that the American watercolor movement would be formally organized, and it was largely through the agency of Falconer that it would come to Brooklyn. In fact, a survey of the watercolor movement's institutional history places Falconer center stage in all three acts: a prelude in the 1850s; the formal initiation of the movement in the 1860s; and its advent in Brooklyn in the 1870s.[15] A recently discovered carte-de-visite photograph of Falconer, made about 1863, provides visual testimony of his long-standing devotion to the medium (fig. 7). It shows a dapper gentlemen in his forties posed for a carefully staged photographic portrait d'apparat recorded—brush in hand—in the act of watercolor painting.

Born in Edinburgh and educated at the high school there, Falconer immigrated to the United States as a youth in 1836.[16] Settling first in New York, he spent his working life in the hardware and houseware business manufacturing, importing, and marketing a range of merchandise from bathtubs to silverplate. Employed at Windle & Company in downtown New York for several decades, Falconer would assume ownership of the firm in 1874. In 1858 he relocated from his residence at 167 Hudson Street to 82 Willoughby Street in Brooklyn. A highly proficient painter in watercolor and oil (see cat. no. 14; fig. 8) and a printmaker as well, Falconer was thoroughly immersed for six decades in the professional art worlds of New York and Brooklyn. His friends and correspondents form a who's who of the midcentury art establishment: collectors, critics, dealers, and especially artists—among them Thomas Cole, Asher B. Durand, Jasper Cropsey, William Sidney Mount, William Hart, and John F. Kensett. With Kensett, Falconer conducted the business of the New York Artist's Fund Society for years.[17] A bachelor, his energies beyond business seem to have been completely devoted to such art organizations: a compensation, perhaps, for his mercantile livelihood. Kathleen A. Foster, in her invaluable dissertation, "Makers of the American Watercolor Movement, 1860–1890," has noted the "general clubbiness" of the people involved. She writes of the "multimemberships" and "overlapping circles" of the New York art community.[18] Falconer's business experience supplied entrepreneurial and organizational skills enabling him to play at various times the roles of art historian, curator, pedagogue, organizer, and artist. For most of his long life he would play out his artist-impulses by collecting and through his work for the institutions that nurtured and promoted the production of art.

Although he told Mount that his interest in "Fine Art" was "tabooed" at Windle & Company, financial success in business enabled him to collect art steadily beginning in the 1840s. He confessed to Mount in 1856: "Half the interest I have in my pictures, are in the knowing of their authors. . . . I have no ambition to form a large collection but I wish a representation of the best of my friends."[19] In fact, Falconer formed an enormous collection of paintings, watercolors, drawings, prints, manuscripts, books, and photographs. A glimpse of his domestic environ-

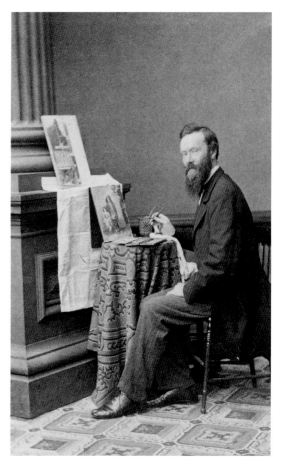

Fig. 7.
John Mackie Falconer,
c. 1863
Photographer unknown
Courtesy, Susan Herzig &
Paul Hertzmann,
Paul M. Hertzmann, Inc.,
San Francisco

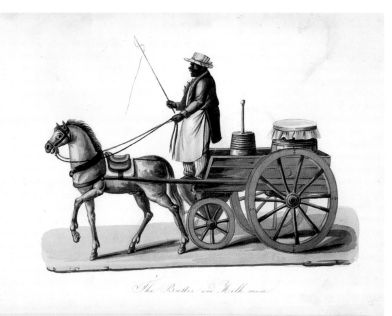

16

Nicolino V. Calyo (1799–1884). *The Butter and Milk Man*,
1840s. Watercolor over graphite on off-white, moderately thick,
smooth-textured wove paper. 10½ × 14¾ in. (26.7 × 37.5 cm).
Inscribed lower center: *The Butter and Milk Man.* 1990.16,
Purchased with funds given by Mr. and Mrs. Leonard L. Milberg

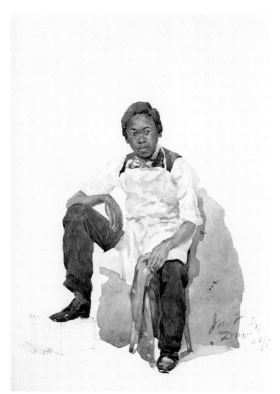

Fig. 8.
John Mackie Falconer
(1820–1903)
Young Man in White Apron,
1851
Watercolor on paper
M. & M. Karolik
Collection, Courtesy,
Museum of Fine Arts,
Boston

ment is recorded in a charming oil painting commissioned by Falconer from fel-
low Brooklyn artist Seymour Joseph Guy. *Evening* records the interior at 12 St.
Felix Street in Brooklyn, as it appeared in 1867 (see fig. 9). His mother, Cather-
ine Stewart Falconer, reads in the foreground, and the collection is seen on the
walls behind. Falconer's large holdings included several hundred watercolors.
Among the European artists represented in the medium were Birket Foster,
Samuel Prout, and J. G. Vibert. American watercolors included works by Cole,
Cropsey, Guy, Hart, Samuel Colman, John William Hill, and John Henry Hill.
Falconer's art collection and library were dispersed after his death in 1903 in two
estate sales.[20]

The sales also included many of Falconer's own oil paintings, watercolors, and
etchings. His watercolor painting style was an English-based blend of the docu-
mentary and the picturesque, carefully drawn in graphite and painted in trans-
parent tints, somewhat in the manner of the early-nineteenth-century English
master Samuel Prout. The antiquarian tastes reflected in *William Penn's Mansion,
South Second Street, Philadelphia, 1864* (see cat. no. 14) were established early and
persisted throughout his work in all media: watercolor, oil, etching, and even the
watercolor and enamel painting on china (a byway of the watercolor movement)
for which he was also known in the late 1870s.[21] "If there is anything which Mr.
Falconer loves," noted the *Daily Eagle,* "it is an old house, even if it be in ruins."[22]
Falconer's watercolor vignettes of figure types (fig. 8) relate to the eighteenth-cen-
tury English tradition of the *Cries of London* recording the street characters and
vendors of the city, as does Nicolino Calyo's image of the 1840s, *The Butter and
Milk Man* (cat. no. 16). Falconer's studies are from a series painted in the studio
from life as exercises as well as for local color in urban subjects.

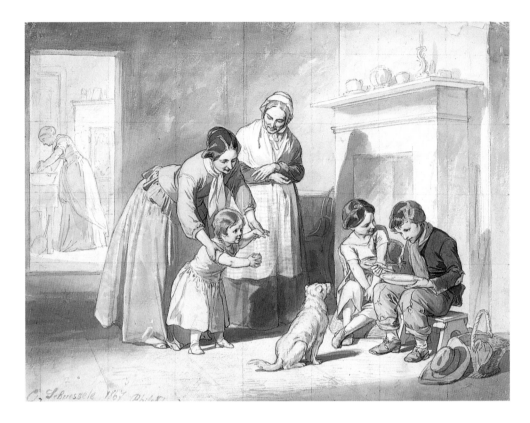

THE PRELUDE: THE NEW YORK SOCIETY OF PAINTERS IN
WATER COLORS

Some of these watercolors may have been the products of attendance at the Water Color School "for the study of local life character" conducted by the New York Society for the Promotion of Painting in Water Colors, organized in December 1850.[23] Falconer was a founder; fellow members included Cropsey, Hart, Charles Parsons, and John William Hill. A review of the minutes, many in Falconer's hand, reveals that the society held many meetings in his "rooms" at 167 Hudson Street. He held office during almost the entire five-year life span of the organization. The model for the New York Society was the Society of Painters in Watercolours (in London) founded in 1804. However, watercolor "wars" long won in England were still to be fought in the United States. At midcentury the medium was accorded only a marginal status. In the hierarchy of mediums, oil painting stood first as the prime exhibition medium for the professionally trained artist. Within this professional sphere, watercolor was associated with the preparatory sketch or study, private documents that were held in the studio (cat. nos. 17–20). Supposed occupational hazards associated with watercolors included a concern that "that working in water-colors injures the eye for working in oil" and questions persisted about the durability of the medium.[24] Contemporary exhibition practice also weighed against the "lighter and daintier art." Watercolor was at a disadvantage when displayed at the National Academy of Design, for example, in competition with larger darker heavily framed oil paintings.

17 *(above)*

Christian Schussele (1824–79). *Study for Lesson in Charity,* 1857. Watercolor and graphite on off-white, moderately thick, moderately textured wove paper. 13¾ × 18¼ in. (34.9 × 46.4 cm). Signed and dated lower left: *C. Schussele 1857.* 1992.14.1, A. Augustus Healy Fund and Carll H. de Silver Fund

18 *(right)*

Theodore Robinson (1852–96). *Bergère,* 1889. Formerly known as *Decorative Head.* Transparent and opaque watercolor over graphite (recto) and watercolor over graphite (verso) on off-white, thick, rough-textured wove paper. 15¼ × 11¼ in. (38.7 × 28.6 cm). Signed and dated lower center: *Th. Robinson–89.* Signed and inscribed verso, right margin: *Bergère / Th Robinson.* 39.60, Dick S. Ramsay Fund

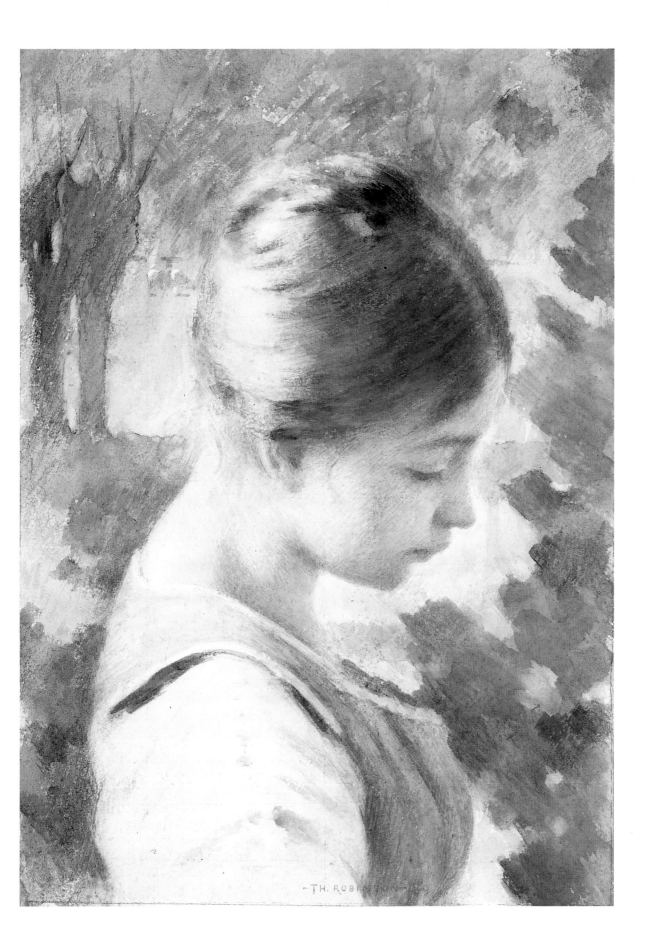

19 *(left)*

John La Farge (1835–1910). *St. Paul Preaching,* c. 1900–1905. (design for stained glass). Watercolor over graphite on slightly textured wove paper mounted to cream, moderately thick, moderately textured wove paper. Watermark: J WHATMAN 1891. Primary support: 13⅛ × 4⁵⁄₁₆ in. (33.3 × 11 cm). Secondary support: 18⁷⁄₁₆ × 11 in. (46.8 × 27.9 cm). Signed lower right: *John La Farge.* Inscribed lower right: *Return to John La Farge 51 West 10th Street.* 22.53, Gift of John Hill Morgan

20 *(below)*

James Brooks (1906–92). *Studies for the Flight Mural at Marine Air Terminal,* 1938. Transparent and opaque watercolor, graphite, and collage elements on cardboard. 3 panels, 3 × 21⅞ in. (7.6 × 55.6 cm) each. 1996.42.3, Gift of Charlotte Park Brooks in memory of her husband, James David Brooks

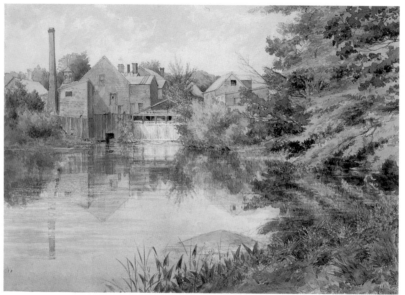

21 *(left)*

Francis Hopkinson Smith (1838–1915). *In the Woods*, 1877. Transparent and opaque watercolor and black chalk on beige, thick, rough-textured woodpulp board. 26 ⁷⁄₁₆ × 16 ¹⁄₁₆ in. (67.2 × 40.8 cm). Signed lower right (initials in monogram): *FHS / 77*. 1994.65, Gift of the American Art Council

22 *(above, right)*

George Tribe (active 1895). *Old Felt Mill on the Negunticook River, Camden, Maine*, 1895. Watercolor over graphite on cream, moderately thick, moderately textured wove paper. 9¾ × 13¹³⁄₁₆ in. (24.8 × 35.1 cm). Signed and dated lower right: *GTT / 1895*. Signed and dated on original mat: *George T. Tribe / July 1895*. Inscribed on original mat: *Old Felt Mill / Negunticook River / Camden M[aine]*. 1993.121, Purchased in memory of former Museum staff member Jane Carpenter Poliquin. (1955–92) with funds given by her friends and colleagues

23 *(below, right)*

August Kollner (1813–1907). *Rockdale, near Manayunk, Pa.*, 1865. Watercolor, graphite, and ink on cream, moderately thick, smooth-textured wove paper. 10½ × 13 in. (26.7 × 33 cm). Signed and dated lower right: *A.K. fec. May 14, 1865*. Inscribed lower left: *Rockdale / Manayunk*. Inscribed lower left: *Rockdale, near Manayunk, Pa*. Signed and dated lower right: *AK fec. May 14, 1865*. 82.193.2, Gift of Mr. and Mrs. Leonard L. Milberg

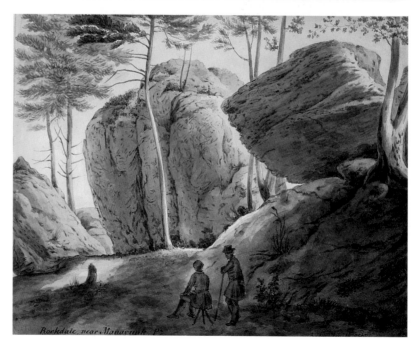

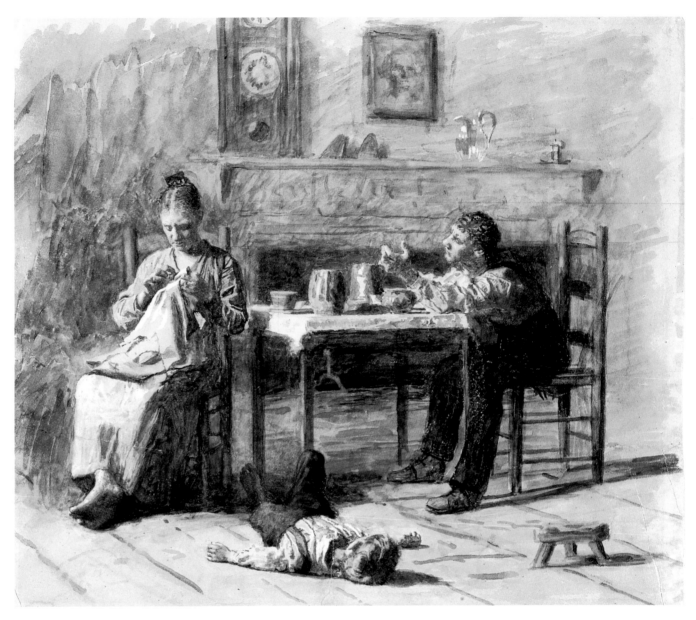

24

Thomas Eakins (1844–1916). *Thar's Such a Thing as Calls in This World,* 1879. Illustration for "Mr. Neelus Peeler's Conditions," *Scribner's Monthly,* June 1879. Watercolor with opaque white highlights over graphite on cream, moderately thick, smooth-textured wove paper. 10½ × 12¼ in. (26.7 × 31.1 cm). 30.1452, Brooklyn Museum of Art Collection

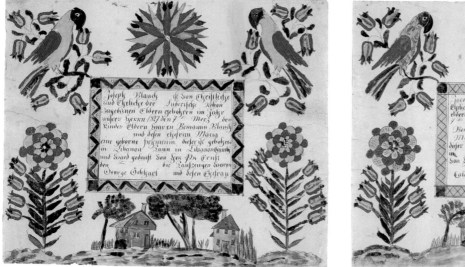

25 *(above, left)*
Anonymous Artist. *Fractur Drawing, Birth Certificate of Joseph Blauch, March 7, 1827,* 1827. Iron gall ink, transparent and opaque watercolor modified by gum varnish on beige, medium-weight, slightly textured wove paper. 12¹³⁄₁₆ × 16 in. (32.5 × 40.6 cm). 39.553a, Dick S. Ramsay Fund

26 *(above, right)*
Anonymous Artist. *Fractur Drawing, Birth Certificate of Jacob Blauch, March 7, 1827,* 1827. Iron gall ink, transparent and opaque watercolor modified by gum varnish on beige, medium-weight, slightly textured wove paper. 12¹³⁄₁₆ × 16 in. (32.5 × 40.6 cm). 39.553b, Dick S. Ramsay Fund

27 *(right)*
H. Lynde (active 1859–96). *Bird's Nest,* 1862. Transparent and opaque watercolor over graphite on beige, moderately thick, slightly textured wove paper. irregular, 8⅞ × 11½ in. (22.5 × 29.2 cm). Signed and dated lower center: *H. Lynde 1862.* 85.178.4, Purchased with funds given by Mr. and Mrs. Leonard L. Milberg

The professional status of watercolor was further diminished by widespread amateur practice. "Amateurs" might be as skilled as Falconer and Francis Hopkinson Smith (cat. no. 21) or as competent as the unknown but talented George Tribe (cat. no. 22). Nevertheless, an association with amateurs diminished watercolor's standing, as did gender-based assumptions about the medium as merely "an accomplishment, or a husband-catcher."[25] The perception of watercolor as a medium primarily in service to the ideas of others was just as compromising. Watercolor had long been associated with topographical printmaking (cat. no. 23; see also cat. nos. 11 and 12), book and magazine illustration (cat. no. 24; see also cat. nos. 121, 139, 140), and other utilitarian and decorative practices (cat. nos. 25, 26, 27). These applications compromised artistic autonomy by removing the medium from the realm of originality.

The society attempted to address these issues, raised again and again during the nineteenth century (some still are today), with a formal organization of professional artists and committed amateurs who would work to "to promote . . . the practice, and to cultivate in the public, a taste for the art of painting in Water Colors and the establishment of an Annual Public Exhibition." The single public exhibition of the society took place at the international exposition held in 1853 at the New York Crystal Palace. This prelude was recalled in the 1870s as a critical early step: "A few pictures upon a small screen in the Art Department at the exhibition in the Crystal Palace, New York, . . . may be considered the beginning of the water-color movement in America." Falconer showed two views of a New Jersey landscape at different times of the day, suggesting that he, like George Harvey, was interested in watercolor's capacity to capture nuances of outdoor light and atmosphere.[26]

Sometime in 1855 the society disbanded, but there were other signs of vitality in the watercolor camp. Of particular importance was the supportive posture of the recently launched New York periodical the *Crayon*, which quickly became the most influential American art journal of its day.[27] Falconer was friendly with the coeditors, John Durand and William J. Stillman. He had invited them to meetings of the society. Ever practical, he also gave them financial counsel and persuaded his employer to buy advertising space in several early issues. He bought a subscription for Mrs. Thomas Cole, promoted the magazine on his own business travels, and also served as the correspondent on "Western art" in newsy letters from midwestern cities published in several issues.[28]

In an unpublished letter written to John Durand when the first issues were being planned in late December 1854, Falconer summarized watercolor's hopeful prospects in the United States. He lamented the lack of time that kept him from providing "a complete article on the art" for the *Crayon*. He suggested, however, the major points that should be covered:

Your judgements will probably lead you to preface the matter with the renown the Art has achieved in England and how much field is open here for cultivation in the way of acquiring specimens for framing or portfolio—With the latter in England, many a rational and agreeable Evening is spent and there families vie with each other in their acquisition of recent works—In our city where so many of the parlour walls are white, the Picture in Water Colour, is especially fitted and facilities now enable us to get mounts on drawings, quite equal to the English or French—Thus protected the work in water colour will preserve its freshness for ages.[29]

By 1854, despite the decline of the society, Falconer believed that the United States was as fertile a ground as England for the success of the medium. His lively description of the family gathered around the portfolio suggests that he understood the appreciation of watercolors as both a social and a domestic activity—as an exercise in communal connoisseurship serving a wider agenda of culture and refinement. Whereas museum exhibition techniques present framed works dis-

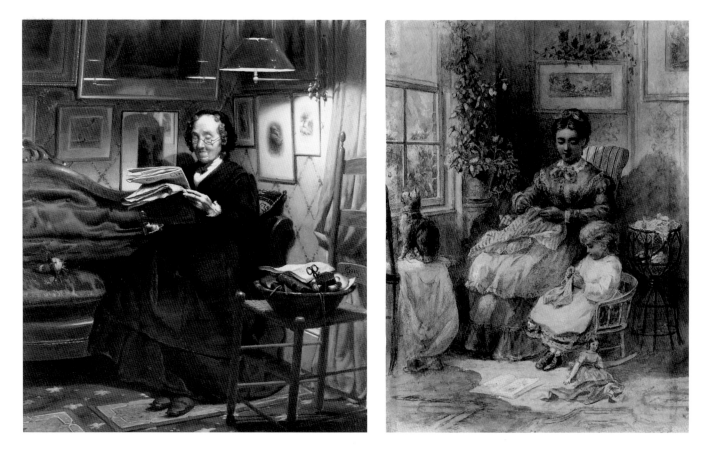

Fig. 9. *(above, left)*
Seymour Joseph Guy
(1824–1910)
Evening, 1867
Oil on panel
Worcester Art Museum,
Worcester, Massachusetts.
Stoddard Acquisition Fund

Fig. 10. *(above, right)*
Lyman W. Atwater (1835–91)
Watercolor on paper
Sewing, c. 1870
Private Collection

played on the wall, domestic collections in the nineteenth century were enjoyed in a number of formats. Falconer refers in his letter to "framing or portfolio" as the two usual fashions of watercolor presentation. A view of his own "parlour walls" in Guy's *Evening* (fig. 9) shows drawings and watercolors matted, framed, and densely concentrated on a wallpapered surface in an attempt to accommodate a portion of his enormous collection. Lyman W. Atwater, another Brooklyn watercolor specialist, portrayed a contemporary interior (possibly his own) in *Sewing*, about 1870 (fig. 10).[30] This glimpse of a cozy window corner includes a framed landscape watercolor on the wall embellished by a spray of dried leaves, demonstrating the easy association of watercolor with home decoration. This would frequently be pointed out as one advantage of the medium over oil for the modest domestic dwelling. In 1875 the *Nation* observed: "Aquarelle is a method of art which goes to the adornment of homes, and it partakes largely of the spirit of a decoration or object of furniture." "Water color drawings are bright and cheerful," editorialized the *Brooklyn Daily Eagle*, "adding materially to the attractiveness of a home, and, if they be good, educating their owners in art as rapidly as works in oil."[31]

The portfolio was used to house unframed works; a set of sheets—usually unbound—was held within a hinged cover or flexible case for carrying and storage. Falconer's collection also included another common mode of storage and display:

an album of sixty drawings and watercolors by his contemporaries bound in brown morocco leather (Museum of Fine Arts, Boston). Addressing one of the most persistent reservations about the medium, Falconer assured Durand that all of these methods "will preserve [watercolor's] freshness for ages." He closed his letter with evidence of the growing interest in watercolor elsewhere, reporting on collections formed in other American cities and announcing "a school on plan of the N.Y.W.C.S.'s has been started in the Athenaeum at Brooklyn, and is prosperous."[32]

Perhaps Falconer also read "Brooklyn," an article published in the December 1855 issue of the *Crayon*, that extolled that nearby metropolis as "one of the pleasantest cities in the world." Early in 1857 he wrote to William Sidney Mount of the possibility of relocating: "I am half possessed with the idea of moving to Brooklyn with a view to getting out of the gradually enhancing cost of living here. The winter fogs and detention from ice are somewhat of a bar however and I am quite undecided though in looking about I have gained some knowledge of Brooklyn and of the value of brick and frame buildings."[33] By May 1858 Falconer had evidently become one of Brooklyn's commuters for his mother was listed in the Brooklyn city directory at 82 Willoughby Street. (He, like many of his neighbors, commuted daily via the ferry to business in New York.)

At midcentury the Brooklyn Institute had been joined by a number of other organizations devoted to the teaching and exhibition of art. In 1853 the farsighted bequest to the institute by the Apprentices' Library founder, Augustus Graham (1775–1851), established a School of Design. Graham's generosity also supported a Gallery of Fine Arts, enabling the institute to begin to build a public collection of oil paintings by American artists, an event of national significance whose importance was duly noted by the *Crayon*.[34] A short-lived Brooklyn Art Union attempted to stimulate local patronage by instituting a lottery modeled on the successful American Art-Union in New York City. A Brooklyn Sketch Club was founded in 1857 as a forum for both professional and amateur artists. The Graham Art School (not a part of the institute) was founded in 1858 to provide additional art education for the city's youth. The Brooklyn Art Social, established in 1859, was the prototype for the highly successful Brooklyn Art Association, a major exhibition venue founded in 1861, which also conducted classes. A Brooklyn Academy of Design joined the constellation of local art organizations supporting the visual arts in 1866.[35] While maintaining his New York affiliations, Falconer immediately became deeply involved in many of these Brooklyn organizations. In addition to being active in the Brooklyn Sketch Club, he attended the Brooklyn Academy of Design as well as the Graham Art School, then conducting classes in a room of the Brooklyn Institute. Falconer was also present when the Brooklyn Art Social was reorganized into the Brooklyn Art Association on January 5, 1861.[36] This affiliation would be an important one for Falconer and for the watercolor movement in Brooklyn.

28

John William Hill (1812–79). *Mountain Stream (Catskill Creek),*
1863. Watercolor over black chalk on cream, medium-weight,
smooth-textured wove paper. Watermark: J WHATMAN TURKEY
MILL. 13³⁄₁₆ × 17¹⁄₁₆ in. (33.5 × 43.3 cm). Signed and dated lower
right: *J. W. Hill 1863.* 1991.44.1, Gift of Mrs. Mary Stewart
Bierstadt, by exchange

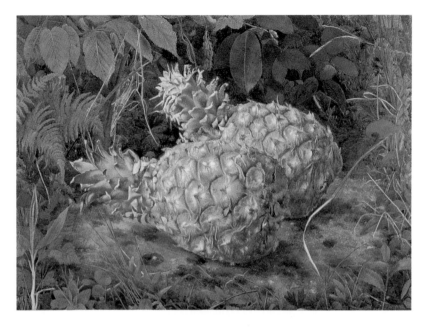

29 *(left)*

John William Hill (1812–79). *Pineapples,* c. 1864. Watercolor on cream, moderately thick, moderately textured wove paper. 10¹³⁄₁₆ × 15⅜ in. (27.5 × 39.1 cm). Signed lower right: *J. W. Hill.* 84.149, Purchased with funds given by Mr. and Mrs. Leonard L. Milberg

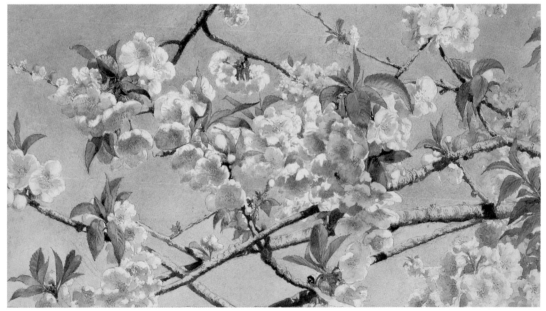

The New York Water Color Society was dissolved in 1855. Interest in watercolor percolated for the following decade largely through the agency of the *Crayon* and the influence of the English critic John Ruskin, an eloquent champion of the medium. Ruskin's American followers founded their own short-lived organization in the early 1860s: the Association for the Advancement of Truth in Art. Calling themselves American Pre-Raphaelites, the painters among them applied themselves to detailed study from nature in both oil and watercolor.[37] Falconer knew the members, who included John William Hill, from the old Water Color Society. Early in 1863, just before the association was established, Falconer corre-

30 *(above)*

John William Hill (1812–79). *Apple Blossoms,* c. 1874. Watercolor over graphite on cream, moderately thick, slightly textured wove paper mounted to a cream wove paper. 8¹³⁄₁₆ × 15½ in. (22.4 × 39.4 cm). 74.170, Museum Collection Fund

31 *(above, left)*

John Henry Hill (1839–1922). *Fringed Gentians,* c. 1867.
Watercolor over graphite on light beige, moderately thick,
slightly textured wove paper. 10³⁄₁₆ × 7¼ in. (25.9 × 18.4 cm).
Signed lower right: *J. H. Hill.* 1996.90.1, Purchased with funds
given by Mr. and Mrs. Leonard L. Milberg

32 *(above, right)*

John Henry Hill (1839–1922). *Lake George,* 1875. Watercolor
over graphite on white, medium-weight, slightly textured wove
paper. 10⁷⁄₁₆ × 14 in. (26.5 × 35.6 cm). Signed and dated lower
left: *J. Henry Hill 75.* 1991.44.2, Gift of Mrs. Mary Stewart
Bierstadt, by exchange

sponded with the founder, Thomas Charles Farrer (c. 1840–91), inviting his par-
ticipation in a project to raise funds for Brooklyn's Graham Art School. It is likely
that Falconer was also one of the unnamed "guests" recorded at the meetings of
the association, some of which were held in Brooklyn at the Clinton Avenue res-
idence of engraver and art dealer Samuel P. Avery.[38] Avery, in turn, had attended
meetings of the old Water Color Society. In the 1860s and 1870s Brooklyn had its
share of Ruskinians, including the watercolor specialist Fidelia Bridges (cat. no.
15), Avery, and Gordon L. Ford, an important American Pre-Raphaelite collector
who was also a force in the Brooklyn Art Association. The circle of artists, most
of them watercolor specialists— including the Hills (cat. nos. 28–33), Henry Far-
rer (cat. nos. 34, 35), Henry Roderick Newman (see cat. nos. 51–54), William
Trost Richards (see cat. nos. 58, 60–64, 67–71), and Bridges— would exhibit reg-
ularly at the association. Many of them would also respond to the summons late
in 1866 to revive the idea of a watercolor society.

THE AMERICAN SOCIETY OF PAINTERS IN WATER COLORS

That November, Falconer, Charles Parsons, and Alfred Jones, all members of the
old society, borrowed a large number of American and foreign watercolors as a
special feature of the annual benefit exhibition of the Artist's Fund Society. The
exhibition was widely acknowledged both as "the largest collection of the kind
ever gathered together in America" and as "the first step towards a long wished for
reform" of watercolor's neglect. The excitement generated led to a December
meeting of artists at which the American Society of Painters in Water Colors was
founded.[39] Both optimism and ambition were reflected in the choice of a name
reflecting national rather than local aspirations. A decade later the name was

33 *(opposite)*

John Henry Hill (1839–1922). *Natural Bridge, Virginia,* 1876. Watercolor over graphite on cream, very thick, slightly textured wove paper mounted to a secondary paper. 21¼ × 14⅛ in. (54 × 35.9 cm). Signed and dated lower right: *J. Henry Hill 1876.* Signed and inscribed verso lower right: *The Natural Bridge Va Painted May 1876. J. H. Hill.* 82.85.2, Gift of Mr. and Mrs. Leonard L. Milberg

34 *(above, right)*

Henry Farrer (1843–1903). *Carnations,* 1864. Watercolor over graphite on cream, moderately thick, moderately textured wove paper. 5⅜ × 8⅞ in. (13.7 × 22.5 cm). Signed and dated lower left: *H. Farrer. 1864.* 84.150.2, Purchased with funds given by Mr. and Mrs. Leonard L. Milberg

35 *(below, right)*

Henry Farrer (1843–1903). *Pink Rose,* 1871. Transparent watercolor with small touches of opaque watercolor highlights over graphite on cream, moderately thick, moderately textured wove paper. 5⅜ × 8⅞ in. (13.7 × 22.5 cm). Signed and dated lower left: *H. Farrer. 1871.* 84.150.1, Purchased with funds given by Mr. and Mrs. Leonard L. Milberg

shortened to its present form, the American Watercolor Society. Samuel Colman was elected the first president. Falconer was prominent among the "amateurs" present. He was appointed to the board of control and was a member of the editorial committee that quickly produced a brochure, *Water-Color Painting: Some Facts and Authorities in Relation to Its Durability* (1868), an eighteen-page document of positive testimony on the question from English authorities. The committee concluded that the United States even offered certain unique advantages for watercolors: "We believe our dry American climate to be particularly favorable to durability of tints and colors."

The "American climate" for appreciation of the medium seemed to be favorable as well. The second half of the nineteenth century would witness a weakening in the critical distinction between the sketch and the exhibition work. The waning of this private-public discrimination, along with Ruskin's endorsement of the medium, served to stimulate an appetite for watercolor. "The most striking Art feature of the Fall and Winter," reported *Putnam's Magazine* on the first

annual watercolor exhibition held at the National Academy of Design late in 1867, "is the great interest suddenly manifested by the New York public in water-colors."[40] The Brooklyn public was interested too, and the fortunes of the new watercolor society were followed closely. "This somewhat neglected branch of art is quickly becoming popular," reported the *Brooklyn Daily Eagle* in 1867. "Our artists seem to excel in this branch of the art," another article observed, singling out the work of Hart, Colman, and Albert F. Bellows for particular notice.[41] Fal-coner was represented with five submissions. Like many of his cofounders and early members, he would exhibit regularly through the 1880s.

The opportunity to show watercolors in an exclusive setting drew the enthusi-astic support of artists. Critical attention was steady and the tone generally con-gratulatory. Each year's reviews reprised the organization's short history and com-mended the society on progress to date in creating an American watercolor school. Visitors to these exhibitions represented new sources of patronage which, in turn, stimulated production. Foster discusses in detail the complex dynamics of the heyday of the movement. We will simply point here to a few instances of artist response. Winslow Homer left illustration in 1875 after successfully exhibit-ing at the Watercolor Society annuals, confident in the expectation of steady in-come from watercolor sales. By 1876, according to the *Art Journal*, Samuel Col-man had virtually given up oils to focus exclusively on watercolors. A decade after the first annual exhibition, *Harper's Weekly* would declare: "It pays to paint in wa-ter-colors, and that, it must be allowed, is a powerful incentive even to the most idealistic of artists."[42] By the mid-1880s, the *Brooklyn Daily Eagle* noted that every major American painter in oils was also working in watercolors. "It is interesting to study the variations of style and tone which are exhibited in the work of our best known familiars—so different from their characteristics in oil as to be scarcely recognizable. . . . William T. Richards maintains his proud pre-eminence, whether he dissolves his genius in water or in oil." The latter's decade of extraor-dinary production from 1870 to 1880 demonstrates the powerful incentive offered by the dynamics of the movement.[43]

WATERCOLOR AT THE BROOKLYN ART ASSOCIATION

Watercolors were among the works shown at the Brooklyn Art Association's reg-ular exhibitions organized twice a year beginning in 1859.[44] For more than a decade, these large surveys of contemporary work, most for sale by artists and some on loan from collectors, were installed in the Assembly Room of the Brook-lyn Academy of Music. Designed by Leopold Eidlitz (1823–1908), the hall stood on Montague Street in the fashionable residential district of Brooklyn Heights. A review of the spring Art Association exhibition in 1867 complained that a meager group of three pictures (out of about 275) representing the "water color school" had been rendered even more insignificant by being skied: "The Hanging Com-mittee has put them too high up to allow a close study of their merits, which lie

Fig. 11.
The Brooklyn Art
Association building
172 and 174 Montague Street
Photograph from *Brooklyn
Institute Yearbook* (1898–99)
Brooklyn Museum of Art
Archives

in the delicacy of their drawing and coloring. These pictures are from the collection of Mr. Chas. H. Williamson . . . who proposes to essay the development of a taste for water-color paintings here."[45] Williamson, a watercolor amateur himself, and Falconer, who served for many years on the hanging committee, were no doubt pleased with the plans already under way to put the Art Association, which had no headquarters, on the map.

Early in 1868 *Putnam's Magazine* reported: "We understand that this flourishing Society intend the erection of a handsome Academy of Design, to contain a free picture-gallery, where the artists of Brooklyn and other cities can exhibit their works on sale, free of all expense."[46] The completion in 1872 of a splendid building for the Brooklyn Art Association (fig. 11), designed by J. Cleveland Cady (1837–1919) in the modern Gothic style, signaled a new era for the organization and for art exhibitions in Brooklyn. The association's permanent quarters housed a series of spacious galleries, including a "Water color gallery 18 × 24 feet."[47] Located on Montague Street next door to the Academy of Music, the association's galleries were regularly extended to accommodate large exhibitions by use of the academy's Assembly Room reached via a passageway connecting the buildings.

To commemorate the building's completion, Falconer organized the *First Chronological Exhibition of American Art*.[48] He enlisted the aid and endorsement of a distinguished "Consulting Committee" that included art historian Henry T. Tuckerman as well as artists Daniel Huntington, John Durand, Worthington Whittredge, Kensett, and the dealer Avery. The exhibition drew national attention, large crowds, and was cited afterward as having "proved that there was in the United States a wealth of native art which few people believed to have existed."[49] This ambitious program signaled that the association, like the American Watercolor Society, intended to play more than a local role. For the next decade the Art Association would eclipse the quiescent Brooklyn Institute with regular exhibitions that became landmark events of culture and fashion in both cities. Early on, there were plans afoot to form a permanent collection for the association. In January 1873 the *Eagle*, reporting on the proposed sale of the recently deceased Kensett's "last Summer's work," appealed to local civic pride: "In view of Mr. Kensett's popularity in Brooklyn we have no doubt that with a proper effort this collection might be secured as a nucleus for the free gallery of the Art Association."[50]

Interest also quickly developed in showing watercolors in the new Montague Street galleries. The *Daily Eagle*'s review of the 1873 annual of the society in New York admonished the Art Association to move quickly: "As this exhibition closes some weeks before the opening of the Spring exhibition of the Association, with a proper effort on the part of the hanging committee, a creditable display might be organized in Brooklyn, and we trust that it will be done." A measure of that "trust" lay in the recognition in the same article of "Mr. Falconer of this city" and his role as an "original member" in "the success of the American Society of Painters in water colors."[51] Falconer was a founding member of the Art Association as well, active in its affairs, and anxious to join forces with the Watercolor

Society. Also helpful was the fact that William Hart, who served as second president from 1871 to 1872, was from Brooklyn. By the fall the association circulated to members an announcement of winter plans (not to be realized) "for an interesting and extensive . . . Exhibition of American and Foreign Water Colors."[52] The enthusiasm for a joint venture was shared in New York. Early in 1874 minutes of the seventh annual meeting of the American Watercolor Society recorded the following: "Resolved that the Society is in favor of transferring our next annual Exhibition to the Galleries of the Brooklyn Art Association after it has remained open the usual length of time here." (At that meeting, Falconer also proposed fellow Brooklynite Fidelia Bridges for "Active Membership.")[53] Once again, lack of time prevented implementation of the plan.

Finally, in March 1875, an extension of the society's eighth annual exhibition opened for three weeks in the galleries of the Art Association and the Watercolor Movement was launched in Brooklyn. The importance attached to the event is evident in the coverage. The *Art Journal* reported:

A supplementary exhibition of the American Society of Painters in Water-Colours was opened in the galleries of the Brooklyn Art Association in that city, March 8th, and was continued for three weeks. The collection was composed of about five hundred and fifty drawings, in black-and-white and in colour, one half of which appeared in the recent Water-Colour Exhibition in New York, while the remainder was made up of new pictures contributed from the studios and private galleries. The success which attended the exhibition in New York was very great, and a similar flattering result was achieved in Brooklyn, where over one hundred drawings were sold, and a taste was awakened for this beautiful art, which was very gratifying, not only to the society under whose auspices the display was organized, but also to all who are interested in the general art-culture of the country.[54]

Among the artists who contributed new paintings to refresh the Brooklyn display were Falconer, Alfred F. Bellows, Francis Hopkinson Smith, James D. Smillie, and Winslow Homer. The *Aldine* lauded the Brooklyn venue as well: "The recent largest exhibition ever presented to the public, by this growing society, is on many accounts the most remarkable art-event of the day. . . . As they lately hung on the walls of the Brooklyn Art Association grand gallery, the general effect of the whole collection was very beautiful—much more striking than when divided between the four galleries and the corridor of the National Academy of Design in New York City."[55]

Both parties were eager to maintain momentum. Association directors enthused about the "new feature in our work": "With the experience obtained from this first watercolor exhibition, and considering the rapidly growing interest in this art, we believe it advisable to arrange for a similar exhibition the coming season."[56] At the quarterly meeting of the Watercolor Society that fall, Falconer proposed and received approval for a Brooklyn venue for the 1876 watercolor annual.[57] That year, however, Brooklyn lost to Philadelphia, and the Watercolor

Society instead went to the Centennial Exposition. So did the *Brooklyn Daily Eagle*, whose correspondent reported, "The Water Color Society of New York have filled one gallery with choice drawings, many of which were executed especially for this display, and others have been selected from private collections. . . . The exhibition is one of the best ever organized by the Society, and yet it attracts very little attention. The pictures in oil are decidedly the most popular with the visitors; they appear to prefer the crudest efforts in the latter medium in preference to the charming watercolors." Nevertheless, this outpost of the movement received a special citation of merit from the exposition's Jury of Awards, a signal, as Foster writes, that the Watercolor Society had been recognized as a "power" in American art.[58]

Back in Brooklyn, the 1875 watercolor venture convinced the Art Association directors to exploit the popularity of the medium by incorporating the display of watercolors as a prominent feature of every exhibition. In 1877 the association again essayed a cooperative venture with members of the New York society, on a smaller scale but choice in selection and exclusive in site of display: "The Water Color Room will contain about one hundred drawings and will form the finest display ever made in connection with a regular Spring or Autumn exhibition. Mr. John M. Falconer . . . has made special exertions to organize this part of the exhibition, and by personal solicitation has obtained contributions from all of the principal New York aquarellists."[59] These included the stalwarts of the Watercolor Society: Samuel Colman, Louis Comfort Tiffany, Robert Swain Gifford, James D. Smillie, F. Hopkinson Smith, Falconer and Albert F. Bellows whose *Coaching in New England* (1876; see cat. no. 36), lent by the local collector Henry D. Polhemus, was included. The 1878 and 1879 spring exhibitions also included special installations of watercolors. Discussions were under way as well to adjust the association's annual schedule to offer a watercolor exhibition every spring and one of oil paintings each fall. The *Daily Eagle* applauded the decision to feature watercolors: "[It] would add novelty to the season . . . and it would tend to popularize this beautiful department of art in Brooklyn."[60] The new program began in 1881, reflecting Foster's general observation that watercolor reached a zenith of critical favor and popular enthusiasm in the early 1880s. A description of the March 1881 reception of the Brooklyn Art Association held in the association's galleries and the adjoining assembly rooms of the Academy of Music captures the excitement of that moment: "About 2,000 persons spent considerable time in endeavoring to see 607 water-colors. Those who were wise relinquished the struggle at an early hour and seated themselves in the assembly room to listen to the music of the orchestra. Others persisted, at the expense of considerable physical discomfort, caught occasional glimpses, over rows of heads, of pictures on the line, and were enabled by the aid of opera glasses to study from a distance the paintings which were 'skied.'"[61]

The Brooklyn venue was acknowledged repeatedly as a welcome market for watercolors. The *Eagle* served notice to readers in 1881 that some of the best

works left unsold after the New York exhibition "are now offered to Brooklyn purchasers."[62] The reviewer of 1882, after praising the exhibition, used the opportunity to consider the general state of patronage in the city. Beginning on an optimistic note, he observed the "excellent" attendance, going on to admonish his fellow citizens: "Brooklyn has never had a better opportunity of showing its appreciation of good art than is now held out to her through the water color collection in the association galleries. . . . Brooklyn with her six hundred and odd thousand inhabitants, should surely be able to support and maintain at least two art exhibitions a year on a par with the best in the country. . . .[A]ll over the United States, from San Francisco to Maine, art is becoming a prime factor in our national life." Brooklyn, in the opinion of the *Daily Eagle*, received low marks in such a national comparison and a revealing editorial followed:

She is behind about every large city in the Union in her support of the fine arts as represented by American pictures. The sales at her exhibitions are absurdly small when we compare them with the sales made at exhibitions in St. Louis, Philadelphia, Boston, Chicago and other large places, but at the same time the collections brought together at the Art Association are fully as important as any exhibited in the country. So poor is the patronage bestowed upon our local exhibitions that the artists of the country are getting to look upon Brooklyn as a most undesirable place in which to exhibit their works. . . . These are pretty severe truths, but it is high time their full significance was appreciated by those taking even the smallest interest in the esthetic growth of our city.

There followed an appeal to local civic pride expressed as an exhortation not only to visit the exhibition but also to purchase watercolors:

If you cannot depend upon your own judgment take some friend with you to the Art Association, who can act as an interpreter of the good works. . . . But do not stop here. Take home at least one or two of the best pictures coming within your means. Place them in your parlor, in your dining room, your sleeping apartment, wherever you can live in the atmosphere they create. . . . There is an embarrassment of riches to select from at the association exhibition, and you are not obliged to be an Astor or a Vanderbilt to pick out some of the best works in the collection.[63]

The bold, even urgent, nature of this appeal for public support for the Art Association's programs reflected the fact that, despite the success of the new watercolor program, long-standing tensions between the artists and the lay managers of the organization were mounting quickly in the early 1880s. These behind-the-scenes battles, played out in the reviews of the watercolor exhibitions, were familiar ones over the operation of schools and control of hanging committees.[64] Another issue debated was whether the association's emphasis should be upon the support of local talent or subscribe to the wider social and cultural ambitions of the directors, some of whom were important collectors. This contentious matter also raised the larger question of whether the association's mandate was to serve a

popular audience or one of connoisseurs. The semiannual exhibitions had long offered opportunities to the large community of Brooklyn's professional, amateur, and fledgling artists. Many of the Watercolor Society regulars lived in Brooklyn and exhibited at both venues. Other more local talents were shown as well. For example, Henrietta Benson Homer, a gifted amateur flower painter, was lauded as "a constant exhibitor."[65] Student efforts of the Brooklyn and Packer Institutes as well as Adelphi Academy were also regularly included in association exhibitions. A certain degree of critical tolerance granted to the watercolor medium may, in fact, have been one key to its genuine popularity: "A water color exhibition, even though it contains a number of ordinary or inferior works, always presents a cheerful appearance to the eye, owing to the great amount of luminous color displayed, and the first impression on entering the gallery of the Art Association is one of light and animation."[66]

Nevertheless, the reviewer of the 1884 watercolor exhibition welcomed a move toward more professional standards, applauding the "conservative spirit" that had reformed picture selection to be ruled by "quality not quantity." He noted that in past years, "amateur and professional artists often found their works hung side by side much to the injury of both," and also decried "wall space for the often very amateurish efforts" from Packer, Adelphi, and Brooklyn Institute students.[67] In fact, after 1882 Falconer and the other Brooklyn artists who had long served on the hanging committee were swept away in this reform, replaced for a few years by the lay directors. The long presidency of the Brooklyn artist Richard W. Hubbard also come to an end in 1881. His successor, Frederic Cromwell, a banker, was the first in a succession of lay presidents during the last decades of operation.

In 1883 the policy of a free gallery was altered. "It has been decided by the directors of the association to charge a small admission fee to the present exhibition," wrote the reviewer of the watercolor exhibition. Financial exigency was cited as the immediate cause: "The money taken in admissions would, of course, go toward the support of the association. . . . A comparatively few gentlemen in the Art Association have, almost unaided, kept up the institution during the past five or six years, giving it their personal attention and often paying good round sums out of their own pockets toward its maintenance that should have been paid by the members generally. These gentlemen are willing to continue in their good work, but it is no more than just that the public should second their efforts. This can be done in no better way than by paying cheerfully an admission fee to all the exhibitions given by the association." Although the decision was reversed the following year, the reasons for imposing the fee reflected the persistent trend to audience exclusivity: "All who really take an interest in pictures will not object to paying a quarter for the privilege of inspecting a large, well selected collection of water colors, and this small fee . . . will free the gallery from the little army of boys and girls who cannot possibly appreciate the pictures and who crowd in front of them, obstructing the view of older people."[68]

The reviewer of the 1885 watercolor exhibition, the association's fiftieth and the last of the collaborations with the Watercolor Society, could announce that the organization was debt-free and prosperous. However, he also pointedly noted "the scarcity of works by Brooklyn artists," inferring an artist boycott by such poor local participation. He suggested a "healthy" solution lay in the replacement of "New York artists" by locals on the hanging committee.[69] Another 1885 review addressed the embattled state of affairs directly: "[Brooklyn] has not been esteemed for its patronage of art, and for this the management of the Art Association is somewhat to blame. This has been in the hands of laymen, and from the standpoint of the artists has lacked the intelligent direction that has been displayed in the New York Association [a reference to the National Academy of Design] which has been in the hands of professionals. The artists, too, are censurable, for having sent to the Brooklyn exhibitions their two years old pictures."[70] The watercolor exhibitions, however, seem to have been excepted from this indictment and were hailed in 1884 as having been a sustained success: "These exhibitions have been well attended from the first. There are a large number of people who cannot afford to purchase first class works in oil, but at the same time have a desire to decorate their homes with good art. Having passed through the chromo and lithograph stages of their art education, they look about for something original and at the same time within reach of their modest incomes. They naturally turn to water colors, and the water color exhibitions at the association have already been the means of brightening many a Brooklyn home."[71]

By that time, however, both the American watercolor movement and the Brooklyn Art Association were winding down. The latter would be increasingly overshadowed by the Brooklyn Institute of Arts and Sciences during the following decade. By the mid-1880s the watercolor medium, no longer neglected, had joined the mainstream of American art production. "The art of water color painting has taken immense strides in this country within comparatively a few years. . . . To-day there is hardly an artist of any reputation in oil in the United States who is not devoting a certain portion of his time to water color painting. The present exhibition at the Art Association is an excellent demonstration of this fact."[72]

Falconer's hopes, expressed in his 1854 letter to John Durand had, in essence, been realized. Twenty years later, American watercolors received the prestige accorded the medium in England and American artists enjoyed the economic benefits of that respect. The American public, in turn, had embraced watercolors as an attractive commodity: domestic, decorative, and inexpensive. The Art Association had joined the American Society of Painters in Water Colors in a campaign to popularize "this beautiful department of art in Brooklyn" with a decade of satellite exhibitions in which more than three thousand watercolors had been shown. Watercolors by Falconer, Miller, Bellows, and Robert F. Blum, now in the Museum collection, were once displayed in the galleries on Montague Street (see

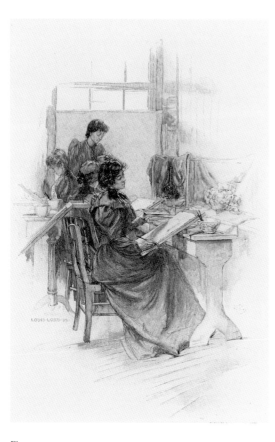

Fig. 12.
Louis Loeb (1866–1909)
*Still-Life Class—The
Aquarellistes,* 1893
Illustration from James R.
Campbell, "The Pratt
Institute," *Century* (1893)
Brooklyn Public Library

cat. nos. 13, 14, 36, 47). Perhaps the most telling testimony is the fact that among the thirty-three artists in this exhibition active during the heyday of the movement, some twenty-two of them exhibited watercolors at the Brooklyn Art Association.

CONCLUSION

While the Art Association and the American Watercolor Movement were on the wane, the city of Brooklyn was on the move. The years between 1850 and 1880 had seen the establishment of many art organizations, all of which testified to the lively cultural life of a proud and ambitious city. The Great East River Bridge, under construction since 1869, was nearing completion. Optimism ran high about Brooklyn's future. Prospect Park designed on 526 acres of former farmland by Frederic Law Olmsted and Calvert Vaux had been opened in 1866. A competitive spirit galvanized supporters of the nearly defunct institute to daring plans. In 1888 a Citizen's Committee on Museums of Art and Science outlined plans for a Brooklyn Institute of Arts and Sciences, whose mission would combine those of the Metropolitan Museum of Art (founded in 1870) and the American Museum of Natural History (founded in 1869). The old Brooklyn Institute, the germ of this grand scheme, was expanded into sixteen departments (which by 1897 had grown to twenty-five). Some of these departments were independent organizations that joined the institute, like the Brooklyn Academy of Music and the Brooklyn Art Association. The latter's galleries were used regularly for institute programs from the 1890s; the Tissot watercolors were exhibited there in 1899 and 1900. The Art Association's teaching program would be largely supplanted in the 1890s by classes in drawing and watercolor offered by the Brooklyn Institute of Arts and Sciences and by the newly founded Pratt Institute, which opened in 1887 (fig. 12). The association itself would finally be incorporated into the institute in 1923.[73]

The institute's permanent collection, fine arts and natural history, was still mostly housed in the inadequate facilities in the old institute building on Washington Street, which had been badly damaged by fire in 1890. By 1891 the institute directors had made plans to build a large museum, a complex that would

Fig. 13.
Francis L. V. Hoppin
(1867–1941)
*Architect's Rendering of the
Central Museum of the
Brooklyn Institute of Arts and
Sciences,* 1893
Watercolor on paper
Brooklyn Museum of Art,
X737

house nearly all departments of the newly incorporated Brooklyn Institute of Arts and Sciences in a single structure. The City of Brooklyn created Institute Park, a site on Prospect Heights just east of Prospect Park, and appropriated funds for the construction of a building designed by the firm of McKim, Mead & White. Francis L.V. Hoppin's 1893 watercolor of the façade of the Central Museum of the Brooklyn Institute of Arts and Sciences rendered an enormous Beaux-Arts building complex on Eastern Parkway, only one-sixth of which was to be completed (fig. 13).[74]

To come full circle, we should also note that in 1893 the *Daily Eagle* paid a call on the elderly John Mackie Falconer. He had retired from business in 1880 and relinquished his amateur status when he listed himself in the city directory for the first time in 1887 as "Artist." He exhibited regularly at the Watercolor Society until 1892 and at the Art Association until 1886. That year he had sold a portion of his huge library and moved to 123 Madison Street in the city suburb of Bedford Stuyvesant. There the *Eagle* found and paid tribute to him as "a fit representative of the company of artists who planted the seed of art in Brooklyn and who have watched over its growth with most heartfelt interest."[75] Falconer must have been gratified when the west wing of the museum was opened to the public in 1897. The opening art exhibition was composed primarily of loans from private collections; several of his American paintings were among them. Only a few European watercolors were among some 583 works of art on view.[76] Within little more than a decade, however, the Museum would be famous for the landmark watercolor acquisitions noted at the beginning of this brief history.

William Henry Goodyear (1846–1923), a Yale-educated art historian, was appointed curator of fine arts in 1899. He would oversee a quarter century of rapid collection growth. Brooklyn was "typical" of other wealthy and ambitious urban entities like New York, Boston, Worcester, and Pittsburgh by participating in a turn-of-the-century finale to the American watercolor movement in establishing public collections anchored by important holdings of Homer and Sargent watercolors. This impulse at Brooklyn paralleled the growth of the institute itself into an enormous museum of arts and sciences, where great American watercolors would join a constellation of collections formed to educate the public. The role of Brooklyn's watercolor collection and exhibitions in twentieth-century collecting patterns and trends in art history is discussed elsewhere. We will conclude here by pointing out that the nineteenth-century collection has been formed in the twentieth. The balance of this volume is devoted to recording highlights of that collection and to a series of topics investigating the currents that produced an environment in which this versatile medium flourished in the United States. In that historic environment of local and national enthusiasm lies the foundation of the Brooklyn Museum of Art's American watercolor collection.

NOTES

1. Alfred Stieglitz, "Regarding the Modern French Masters Exhibition; A Letter," *Brooklyn Museum Quarterly* 8 (July 1921), 107 (hereafter Stieglitz 1921).

2. Recent surveys of the history of watercolor in the United States and the American Watercolor Movement include Ralph Fabri, *History of the American Watercolor Society: The First Hundred Years* (New York: American Watercolor Society, 1969) (hereafter Fabri 1969); Theodore E. Stebbins Jr., *American Master Drawings and Watercolors: A History of Works on Paper from Colonial Times to the Present* (New York: Harper & Row, in association with the Drawing Society, 1976) (hereafter, Stebbins 1976); Donelson Hoopes, *American Watercolor Painting* (New York: Watson-Guptil Publications, 1977) (hereafter Hoopes 1977); Kathleen A. Foster, "Makers of the American Watercolor Movement, 1860–1890," (Ph.D.diss., Yale University, 1982) (hereafter Foster 1982); *American Drawings and Watercolors in the Museum of Art, Carnegie Institute* (Pittsburgh: Museum of Art, Carnegie Institute, 1985) (hereafter Carnegie 1985); Christopher Finch, *American Watercolors* (New York: Abbeville Press, 1986) (hereafter Finch 1986); *American Traditions in Watercolor: The Worcester Art Museum Collection*, Susan E. Strickler, ed. (New York: Worcester Art Museum, Abbeville Press, Publishers, 1987) (hereafter Worcester 1987); *American Watercolors from the Metropolitan Museum of Art* (New York: American Federation of Arts, in association with Harry N. Abrams, 1991) (hereafter MMA 1991); Sue Welsh Reed and Carol Troyen, *Awash in Color: Homer, Sargent, and the Great American Watercolor* (Boston: Museum of Fine Arts, Boston, in association with Bulfinch Press, Little, Brown, 1993) (hereafter Reed and Troyen 1993).

3. Recent institutional histories can be found in Thomas S. Buechner, "Historical Introduction," in *The Brooklyn Museum Handbook* (Brooklyn: Brooklyn Museum, 1967), 1–36; Linda S. Ferber, "A Brief History of the Collection: The First Hundred Years," in *Masterpieces of American Painting from The Brooklyn Museum*, exh. cat. (New York: Davis & Long, 1976), 2–8 (hereafter Ferber 1976); Linda S. Ferber, "History of the Collections," in *Masterpieces in The Brooklyn Museum* (New York: Brooklyn Museum in association with Harry N. Abrams, 1988), 8–23 (hereafter Ferber 1988); Leland M. Roth, "McKim, Mead & White and the Brooklyn Museum, 1893–1934" (hereafter Roth 1988) and Joan Darragh, "The Brooklyn Museum: Institution as Architecture, 1934–1986," in *A New Brooklyn Museum: The Master Plan Competition* (New York: Brooklyn Museum and Rizzoli, 1988), 26–51 and 52–72; Teresa A. Carbone, "Historic American Paintings in The Brooklyn Museum: A Brief History of the Collection," in *Masterpieces of American Painting from The Brooklyn Museum*, exh. cat. (New York: The Jordan-Volpe Gallery, 1996) (hereafter Carbone 1996); Linda S. Ferber, "A Brief History," in *Brooklyn Museum of Art* (New York: Brooklyn Museum of Art, in association with Scala Books, 1997), 9–16.

4. John Hill Morgan, "Miniature by Eliab Metcalf of John Haslett, M.D.," *Brooklyn Museum Quarterly* 8 (January 1921), 29–32.

5. The best survey of early landscape is found in Edward Nygren et al., *Views and Visions: American Landscape before 1830,* exh. cat. (Washington, D.C.: Corcoran Gallery of Art, 1986) (hereafter Nygren 1986).

6. Nygren 1986, 298–302; MMA 1991, 61.

7. On Harvey and the Atmospheric Landscape series, see Museum of Fine Arts, Boston, *M. & M. Karolik Collection of American Water Colors and Drawings, 1800–1875* (Boston: Museum of Fine Arts, Boston, 1962), 176–77 (hereafter Karolik 1962), and Richard J. Koke et al., *American Landscape and Genre Paintings in the New-York Historical Society* (Boston: New-York Historical Society, in association with G. K. Hall, 1982), 94–113 (hereafter Koke 1982).

8. For Palmer, see: Karolik 1962, 253–57; Charlotte Streifer Rubinstein, "The Early Career of Frances Flora Bond Palmer (1812–1876)," *American Art Journal* 17 (autumn 1985), 71–88 (hereafter Rubinstein 1985).

9. For Miller, see Koke 1982, 342–77.

10. For Van Brunt, see Karolik 1962, 290–91; *Brooklyn before the Bridge: American Paintings from the Long Island Historical Society*, exh. cat. (Brooklyn: Brooklyn Museum, 1982), 98–111, 135 (hereafter Brooklyn 1982).

11. Marjorie L. Nickerson, *A Long Way Forward: The First Hundred Years of the Packer Collegiate Institute* (Brooklyn: P.C.I., 1945), 20–21; Ferber 1976, 1; Charlotte Morrill, comp., *History of Adelphi Academy* ([Brooklyn?]: Associate Alumnae of Adelphi Academy, 1916), 83; John M. Falconer to John Durand, Manuscript and Archives Division, The New York Public Library, Astor, Lenox and Tilden Foundations, December 18, 1854, John Durand Papers, roll 22, frames 0123–0125, New York Public Library, Archives of American Art, Smithsonian Institution (hereafter Durand Papers AAA); Rubinstein 1985, 73, 78; May Brawley Hill, *Fidelia Bridges: American Pre-Raphaelite*, exh. cat. (New Britain, Conn.: New Britain Museum of American Art, 1981), 8–9 (hereafter Hill 1981).

12. For the drawing manuals, see Peter C. Marzio, *The Art Crusade: An Analysis of American Drawing Manuals, 1820–1860* (Washington D.C.: Smithsonian Institution Press, 1976).

13. Stebbins 1976, 147; Brooklyn 1982, 18, 23 n. 19.

14. *Brooklyn Daily Eagle,* February 14, 1873, 3. For Falconer, see S. R. Koehler, "The Works of American Etchers—6: J. M. Falconer," *American Art Review* 1 (1880), 190–91; Henry R. Stiles, *The Civil, Political, Professional and Ecclesiastical History and Commercial and Industrial Record of the County of Kings and the City of Brooklyn, N.Y. from 1683 to 1884* (New York: W. W. Munsell, 1884) 2: 1142 (hereafter Stiles 1884); *Appleton's Cyclopaedia of American Biography* (New York: D. Appleton, 1887–88), 404 (hereafter Appleton 1888); "Local Studios: A Fine Variety of Pictures enjoyed at the abode of J. M. Falconer," *Brooklyn Daily Eagle*, March 14, 1893 (hereafter Falconer 1903); Karolik 1962, 154–55; Stebbins 1976, 148–50; Koke 1982, 16–20; Linda S. Ferber, "Our Mr. John M. Falconer," in Brooklyn 1982, 16–23 (hereafter Falconer 1982).

15. Stebbins 1976, 148–150; Hoopes 1977, 59; Foster 1982, 22–26; Brooklyn 1982, 18–21.

16. For the most recent biography, see Brooklyn 1982, 16–23.

17. For Falconer and Cole, see Edward C. Parry III, *The Art of Thomas Cole: Ambition and Imagination* (Newark: University of Delaware Press, 1988), 364, 366, and "'Thomas Cole Is No More': A Letter from John Falconer to Jasper Cropsey, February 24, 1848," *American Art Journal* 15 (autumn 1983), 74–76; For Cropsey, see Brooklyn 1982, 16–17: I wish to thank Kenneth W. Maddox, Newington-Cropsey Foundation, for first bringing the Falconer-Cropsey correspondence to my attention; a series of letters between Mount and Falconer is published in Alfred Frankenstein, *William Sidney Mount* (New York: Abrams, 1975), 317–21 (hereafter Frankenstein 1975); John K. Howat, "Kensett's World," in *John Frederick Kensett: An American Master,* exh. cat. (Worcester, Mass.: Worcester Art Museum, in association with W. W. Norton, 1985), 40.

18. Foster 1982, 17.

19. Falconer to Mount, December 20, 1856; Falconer to Mount, September 21, 1857, quoted in Frankenstein 1975, 318, 319.

20. The Anderson Auction Company, New York, "Library of the Late John M. Falconer . . . Relating to the History and Practice of the Fine Arts," December 28, 1903; The Anderson Auction Company, New York, "Collection of oil paintings, water-colors and engravings formed by the late John M. Falconer," April 28–29, 1904, 669 lots (hereafter Falconer 1904). An earlier sale had already reduced the scale of his library and print collection: George A. Leavitt & Co., New York, "Catalogue of the Valuable Library and Choice Prints collected by . . . John M. Falconer, Esq.," June 2–4, 1886, 1205 lots (hereafter Falconer 1886).

21. See "The Water-Color Exhibition," *Harper's Weekly* 21 (February 24, 1877), 150; Jennie J. Young, *The Ceramic Art: The History and Manufactures of Pottery and Porcelain* (New York: Harper & Brothers, 1879), 482, 484–86; the Museum has several plates painted by Falconer in the collection (66.27.1–3; 1992.263.2). I want to thank Kevin L. Stayton for bringing these to my attention.

22. Falconer 1893.

23. Stebbins 1976, 148–52; Hoopes 1977, 59; Foster 1982, 22–23; Finch 1986, 86; Worcester 1987, 25–27.

24. "Fine Arts," *Putnam's Magazine* (January 1868), 132.

25. "Drawing Teachers," *Crayon* 3 (February 1856), 60.

26. Clara Erskine Clement and Laurence Hutton, *Artists of the Nineteenth Century and Their Works* (Boston: Houghton Mifflin, 1879), xxx (hereafter Clement and Hutton 1884); Stebbins 1976, 148, notes the parallel of Falconer's subjects to those of George Harvey.

27. For *Crayon,* see John Simoni, "William James Stillman and *The Crayon,*" in "Art Critics and Criticism in Nineteenth-Century America" (Ph.D. diss., Ohio State University, 1952), 57–119; Richard D. Bullock, "Editing *The Crayon,*" in "William James Stillman: The Early Years" (Ph.D. diss., University of Minnesota, 1976), 125–224; Janice Simon, "*The Crayon.* 1855–1861: The Voice of Nature in Criticism, Poetry, and the Fine Arts" (Ph.D. diss., University of Michigan, 1990); Marion Grzesiak, "*The Crayon*" *and the American Landscape,* exh. cat. (Montclair, N. J.: Montclair Art Museum, 1993).

28. Windle & Company advertised in the 1855 issues of December 12, 19, and 26; Falconer issued invitations in letters to Stillman and Durand on April 21 and October 29, 1855, John Durand Papers, roll 22, frames 0137 and 0139, New York Public Library, AAA, Mrs. Cole's subscription was ordered in Falconer to Stillman and Durand, December 21, 1855, John Durand Papers, roll 22, frame 140, New York Public Library, AAA. News from the Midwest was delivered in three letters: Falconer to "My Friends" of January 24, February 24 and 25, 1855, John Durand Papers, roll 22, frames 126–36, New York Public Library, AAA, excerpts were published in the *Crayon* in 1855, issues of January 31, 76; February 7, 92.

29. Falconer to Dear Sir, December 18, 1854, John Durand Papers, roll 22, frames 0123–0125, New York Public Library, AAA (hereafter Falconer 1854).

30. For Atwater, see Brooklyn 1982, 26–39, 126.

31. "Fine Arts: The Water-Color Exhibition," *Nation* (February 4, 1875), 84; "More of the Pictures to Be Seen at the Spring Exhibition," *Brooklyn Daily Eagle,* March 26, 1885, 1.

32. Falconer 1854 cited private collections in Washington, New Orleans, Philadelphia, and New York.

33. Falconer to Mount, February 28, 1857, quoted in Frankenstein 1975, 319.

34. Ferber 1976, 3–4; Carbone 1996, 7–8.

35. Brief surveys of Brooklyn's art organizations are found in Stiles 1884, 1136–45; Clark S. Marlor, *A History of the Brooklyn Art Association with an Index of Exhibitions* (New York: James F. Carr, 1970), 3–8, 85–86 (hereafter Marlor 1970); Ferber 1976, 4; Brooklyn 1982, 19; Ferber 1988, 10.

36. Marlor 1970, 7.

37. On the watercolors of American Pre-Raphaelites, see William H. Gerdts, "The Influence of Ruskin and Pre-Raphaelitism on American Still-Life Painting," *American Art Journal* 1 (fall 1969), 80–97; Stebbins 1976, 154–61; Foster 1982, 101–60; Foster, "The Pre-Raphaelite Medium: Ruskin, Turner and American Watercolor," in Linda S. Ferber and William H. Gerdts, *The New Path: Ruskin and the American Pre-Raphaelites,* exh. cat. (New York: Brooklyn Museum and Schocken Books, 1985), 79–108; Finch 1986, 89–97.

38. Falconer to Thomas C. Farrer, January 9, 1863, Gordon L. Ford Papers, Manuscripts and Archives Division, The New York Public Library. Astor, Lenox and Tilden Foundations; on Avery in Brooklyn, see Madeleine Fidell Beaufort, "Brooklyn Art Gatherings in the 1850s," *Confrontation* 25–26 (1983), 90–95.

39. Stillman S. Conant, "The Exhibition of Water Colors," *Galaxy* 3 (January 1, 1867), 54; "Art Matters," *American Art Journal* 5 (November 15, 1866), 55; Francis A. Silva names Falconer as having the inspi-

ration for the AFS watercolor exhibition and as a key figure in orga-
nizing the AWS in "Our Art Clubs. II. The American Water Color
Society," *Art Union* (July–September 1885) 51; *Appleton* 1888 also cites
Falconer as the prime mover in organizing the AFS watercolor exhi-
bition; Foster 1982, 24.

40. "Fine Arts," *Putnam's Magazine* (January 1868), 131.

41. "Art Gossip, " *Brooklyn Daily Eagle,* January 30, 1868, 2; "Art Gossip,"
Brooklyn Daily Eagle, January 2, 1868, 3.

42. Helen A. Cooper, *Winslow Homer Watercolors,* exh. cat. (Washington:
National Gallery of Art, 1986), 34 (hereafter Cooper 1986); G. W.
Sheldon, "American Painters: Samuel Colman, N.A.," *Art Journal*
(1876), 265; "The Water-Color Exhibition," *Harper's Weekly* 21
(February 24, 1877), 150.

43. For Richards' participation in the watercolor movement, see Ferber
1980, 259–98; Ferber 1982; and this volume.

44. Marlor 1970 is the major reference on the Brooklyn Art Association.

45. "The Brooklyn Art Association: Reception and Exhibition," *Brooklyn
Daily Eagle,* March 27, 1867, 2.

46. "Fine Arts: The Brooklyn Art Association," *Putnam's Magazine* (Jan-
uary 1868), 133.

47. Brooklyn Art Association, "Minutes," April 24, 1871, 129, Brooklyn
Museum of Art Archives (hereafter BAA Minutes).

48. Marlor 1970, 36–40, 407–14; Brooklyn 1982, 19–20; Kate Nearpass,
"The First Chronological Exhibition of American Art," *Archives of
American Art Journal* 23 (1983), 21–30.

49. Clement and Hutton 1879, xxxviii.

50. "Fine Arts," *Brooklyn Daily Eagle,* January 16, 1873, 4.

51. "American Society of Painters in Water Colors," *Brooklyn Daily Eagle,*
February 14, 1873, 3.

52. BAA Minutes, September 15, 1873, 164.

53. American Watercolor Society, "Minutes," February 17, 1874, 66, roll
N68-8, frames 466–467, American Watercolor Society Records
owned by the American Watercolor Society, Microfilmed by the
Archives of American Art, Smithsonian Institution AAA (hereafter
AWS Minutes).

54. "American Society of Painters in Water-Colours," *Art Journal,* n.s., 1
(1875), 126.

55. "The American Society of Painters in Water Colors," *Aldine* 7 (May
1875), 339.

56. BAA Minutes, April 26, 1875, 197–98.

57. AWS Minutes, November 23, 1875, 87, roll 68-8, frame 481.

58. "Pictures: Brooklyn Artists in the Exposition," *Brooklyn Daily Eagle,*
July 11, 1876, 2; Foster 1982, 32; Falconer sent a number of works,
among them cat. no. 14.

59. "The Art Exhibition: The Water Color Room," *Brooklyn Daily Eagle,*
April 22, 1877, 4.

60. "Pictures: The Eighteenth Season of the Art Association," *Brooklyn
Daily Eagle,* May 27, 1877, 3.

61. Foster 1982, 36; "Art Reception in Brooklyn," *Brooklyn Daily Eagle,*
March 8, 1881, 4.

62. Ibid.

63. "Water Colors at the Art Association," *Brooklyn Daily Eagle,* March
16, 1882.

64. Marlor 1970, 53–57.

65. "Local Art: Brooklyn Painters in the Exhibition," *Brooklyn Daily
Eagle,* December 12, 1874, 2.

66. "Fine Arts. The Spring Exhibition of Water Colors at the Art
Association Galleries," *Brooklyn Daily Eagle,* March 15, 1884, 1.

67. "The Spring Water Color Exhibition," *Brooklyn Daily Eagle,* March
19, 1884.

68. "Fine Arts," *Brooklyn Daily Eagle,* March 18, 1883; BAA Minutes,
February 25, 1884, 310.

69. "Fine Arts: Fiftieth Annual Reception of the Brooklyn Art
Association: An Excellent Collection of Water Color Drawings,"
Brooklyn Daily Eagle, March 24, 1885.

70. "Brooklyn Artists," *Brooklyn Daily Eagle,* April 11, 1885, 4.

71. "The Spring Water Color Exhibition," *Brooklyn Daily Eagle,* March
19, 1884.

72. "Fine Arts: The Spring Exhibition of Water Colors at the Art
Association Galleries," *Brooklyn Daily Eagle,* March 15, 1884.

73. Marlor 1970, 74–75; James R. Campbell, "The Pratt Institute,"
Century Magazine 46 (1893), 870.

74. Roth 1988.

75. "Local Studios: A Fine Variety of Pictures Enjoyed at the Abode of
J. M. Falconer," *Brooklyn Daily Eagle,* September 24, 1893, 21.

76. Paintings loaned from Falconer's collection were Thomas Cole's
Titan's Goblet (no. 493); Cole's *Salvatore Rosa Sketching Banditti* (no.
494); and Jasper Cropsey's *Petrarch's Home, Italy* (no. 495). The lender
listed as C. J. Falconer is either an error or another member of the
Falconer family. These works were in Falconer's estate sale.

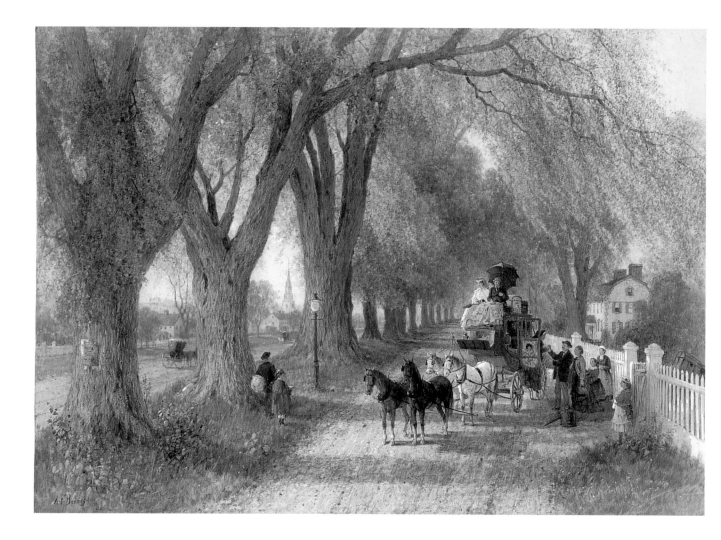

2

THE EXHIBITION WATERCOLOR IN AMERICA

BARBARA DAYER GALLATI

36

Albert Fitch Bellows (1829–83). *Coaching in New England*, c. 1876. Transparent and opaque watercolor with touches of gum varnish over black chalk on cream, moderately thick, rough-textured wove paper. 24⅞ x 35⅞ in. (63.2 x 91.1 cm). Signed lower left: *A. F. Bellows*. 06.334, Bequest of Caroline H. Polhemus

"In 1876 the *Brooklyn Daily Eagle* reported, "Mr. Bellows has upon his easel a large watercolor drawing of a scene in a New England village street, in Midsummer. . . . The picture is intended for the collection of Mr. Polhemus."[1] The watercolor referred to was Albert Fitch Bellows' *Coaching in New England* (cat. no. 36), a work that became one of his best known and was, coincidentally, the first American watercolor to enter Brooklyn's collection in 1906.[2] That the watercolor attracted attention even before it was finished was unusual for works in that medium; its preview by the press places it in the realm of art production normally occupied by oil paintings, which, by virtue of their traditionally higher status in the artistic hierarchy, often received commentary in advance of their completion. The *Eagle*'s early coverage of *Coaching in New England* was not misguided, for the painting was later chosen to illustrate the 1877 exhibition catalogue for the American Society of Painters in Water-Colors (hereafter AWS). Already deemed by the critics "to stand at the head of our school of water-color painters," Bellows received greater than usual commendations for *Coaching*:

One of the most important pictures in the exhibition is "Coaching in New England" by Albert F. Bellows, which belongs to Mr. Henry D. Polhemus, of this city. It is a street scene in a New England village. There are long rows of broad branching elms, drawn in perspective, and in the immediate foreground a coach, or Concord stage is drawn up in front of a well to do home. The old, red coach with its gay load of ladies forms a bright object in the picture and concentrates its interest, but the chief beauty of the subject rests in the noble growth of elms, and the expression of quiet is characteristic of a New England hamlet. There is a fine display of drawing in the coach and horses and the trees and other objects in perspective, and the tone of the work is exceedingly such. For brilliancy of tone and firm and decisive handling, this work has no superior in the exhibition.[3]

Bellows must have anticipated the painting's appeal, given its close relationship to other watercolors by him that had already met with critical

Fig. 14.
Albert Fitch Bellows
(1829–83)
Sunday in New England, c.
1876
Watercolor on paper
The Cleveland Museum of
Art, Hinman B. Hurlbut
Collection

approbation, among them *Sunday in New England* (one of five watercolors he displayed at the 1876 Philadelphia Centennial Exposition; fig. 14) and *New England Village* (which had been shown at the society's annual exhibition the year before).[4] These New England subjects portraying a quaint village with its long avenue of stately elms were undoubtedly appealing to an audience keyed to appreciating the colonial revival imagery that then proliferated in American art, occasioned by the nation's centenary. At the same time the paintings must have been compelling by virtue of their size alone, since they were uncharacteristically large for watercolors. (Each measures approximately 25 × 36 inches.)

Bellows, who started his career as an oil painter, had begun to divide his time between oil and watercolor almost equally after his return from a trip to England in 1865 that he had made for the purpose of studying the art of the English and French watercolorists.[5] This is borne out by exhibition records and the publicized fact that he kept separate studios, one for oil and one for watercolor painting, in the rooms he occupied in the New York Studio Building at Fourth Avenue and Twenty-fifth Street.[6] By 1875 he was, according to an anonymous writer, one of the artists "destined soon to place [watercolor] on an equality with oil as a medium for the production of pictures."[7]

As suggested by the anonymous writer quoted above, there was growing mindfulness among artists and critics in the 1870s about the relationship and respective merits of paintings in oil and watercolor. Bellows' centrality in the exhibitions and reviews reflects those concerns, for it appears that he was among the first American artists to create watercolors that may be categorized as exhibition watercolors—works that were meant to compete successfully with oils in terms of visual power and thematic content. Working under the spell of English influence, it is likely that Bellows consciously borrowed from the established English tradition of the exhibition watercolor that was most commonly traced to the influence

of Joseph Mallord William Turner (1775–1851). For Bellows, who never attempted to achieve the myriad effects of Turnerian light and color, this influence may be located in his adoption of a large format for his watercolors, his switch to historicizing, nostalgic American subjects, and his tendency to give greater narrative emphasis in his compositions.[8]

Bellows' large watercolors had a part in provoking debates about watercolor's potential to extend beyond its conventional limitations. These discussions, as evidenced mainly by contemporaneous reviews, encompassed fundamental ideologies defining watercolor. Some writers argued for retaining the integrity of the medium by insisting that the classic watercolor wash technique should not be sullied by the use of gouache, Chinese white, or other mannered applications; others, who encouraged watercolor's parity with oils, advocated a free and creative use of the medium. Ancillary issues, such as scale, subject matter, durability, and even framing styles, were also grist for the debates, which arose at a time when watercolorists were struggling for attention and which died down once the medium had been securely established as a competitive artistic vehicle and market commodity.

THE BIG PICTURE

At the foundation of the exhibition watercolor controversy was the ostensibly simple matter of whether or not watercolor should continue as an accessory to the art of oil painting. The topic was invariably covered in the introductory paragraphs of reviews of the AWS exhibitions during the mid-1870s. As a writer for the *Art Journal* noted in 1875: "It is evident that the members of the Society, in entering the beautiful field of watercolour drawing, have done so with great earnestness, and more with the intention of using it for the production of pictures than as a mere diversion or adjunct for sketching. This fact is apparent in the works of many artists who have shown that, while water-colours are delightful for sketching purposes, they are also capable of producing all of the effects which are so attractive in oil-paintings."[9] The crux of the matter is amply demonstrated in comparing the two works by Thomas Sully included here (cat. nos. 37–39), one a sheet of loosely executed studies for finished oils, and the other (*Gypsy Maidens*), representing the type of highly finished, stippled watercolor technique he employed simultaneously.

37 *(above)*

Thomas Sully (1783–1872). *Six Figure Studies* (recto), c. 1837–38. Iron gall ink and watercolor on dark beige, medium-weight, moderately textured, antique laid paper. 8¹³⁄₁₆ × 11½ in. (22.4 × 29.2 cm). 1990.102.1a, Gift of the American Art Council

38 *(below)*

Thomas Sully (1783–1872). *Seven Figure Studies* (verso), c. 1837–38. Iron gall ink and watercolor on dark beige, medium-weight, moderately textured, antique laid paper. 8¹³⁄₁₆ × 11½ in. (22.4 × 29.2 cm). 1990.102.1b, Gift of the American Art Council

39

Thomas Sully (1783–1872). *Gypsy Maidens,* 1839. Transparent and opaque watercolor over graphite on cream, thick, rough-textured wove paper mounted to a thick paper. 16⅚ x 14⅚ in. (41.4 x 36.4 cm). Signed and dated lower left (initials in monogram): *TS. 1839.* 1991.213, Purchased with funds given by Mr. and Mrs. Leonard L. Milberg

While these examples of Sully's works help to illustrate the nature of the debate, they remain outside the scope of the present discussion by virtue of their historical distance from the cultural climate of New York in the 1870s.

The founders of the AWS were under duress to validate watercolor's importance relative to oil from the moment they staged their first exhibition in 1867. The concentrated display of watercolors inevitably invited comparisons between the two mediums.[10] Because most of the society's membership was drawn from the ranks of oil painters, the drive to promote watercolor cannot be seen as having grown out of professional rivalries between specialist camps. Instead, the mission to elevate the medium resulted from the artists' faith in its aesthetic potential, their desires to experiment and often break the assumed limits of the medium, and their quest to attract patrons for this branch of their art, which was officially anointed as a viable market alternative by the existence of a professional organization devoted to its display. By its being taken out of the province of the studio or plein-air sketching process and into the public sphere, watercolor was subjected to critical examination, which, in turn, helped to create an interest in and a demand for the work. As early as 1870, William Hart (1823–94), the society's first chairman of its board of control and a respected painter in oils, was mentioned in the press for his large watercolor *On the Moose River,* which "was painted as an experiment . . . the usual white margin of the water color being omitted, and the colors brought directly against the frame, giving it somewhat the appearance of an oil color."[11] If, as this report indicates, Hart had ambitions for his watercolors, they were unfulfilled. His absence from the society's 1873 exhibition was noted in the *Times,* with the telling comment, "we hear that painting water-colors does not pay."[12] The writer's correlation of the low market prices of watercolors with Hart's defection from the lists of exhibitors at the society was expanded: "Many persons imagine that a water-color is nothing more or less than a sort of cheap oil-painting; that it can be done in about a quarter of the time that it takes to execute a work in oil; that it will soon fade; that it makes 'no show whatever' when hung beside oils and that, consequently, it ought to be sold at about half the price of a work in that medium. We need hardly say that all these conclusions are entirely wrong, utterly false in fact, and based on an entire ignorance of the process of painting in water-colors, and of the first principles of art."[13]

The views expressed by the *Times*'s writer stood in opposition to the prevailing critical attitudes, which praised such artists as Fidelia Bridges for their compositions, which were "as purely and elegantly decorative as a good wallpaper design or a Japanese fan" and possessed just the right touch of poetic sentiment.[14] Indeed, the delicacy of watercolor defined its aesthetic capacities: "Aquarelle is a method of art which goes to the adornment of homes, and it partakes largely of the spirit of a decoration or object of furniture; it is more agreeable in proportion as it frankly confesses the quality, leaving to oil the manufacture of great gallery pictures and pieces of didactic authority."[15]

A challenge to correct opinions that minimized watercolor's value was forcefully delivered at the 1876 society annual by the number and prominent placement of large works by Samuel Colman, Louis Comfort Tiffany, Edwin Austin Abbey, R. Swain Gifford, and others. Critics noted that the hanging committee's decision to display these large paintings together in one room caused the gallery to be too crowded and thus deprived viewers of the atmosphere needed to study the works appropriately.[16] This show of strength was likely preparatory to the society's group exhibition planned for the Philadelphia Centennial Exposition later that year, an opportunity that promised watercolor practitioners their largest audience to date. Although a strong showing at the centennial was no doubt the society's goal, its immediate inspiration was probably derived from the works of foreign artists.

Considerable time had elapsed since the 1857–58 *Exhibition of English Art* (that was seen in New York, Philadelphia, and Boston) that had helped to fuel the advancement of Ruskinian taste in America. Nevertheless, the society had made regular and conscientious attempts to include works by European artists in its exhibitions. Its goal was to promote comparative criticism and to enhance public appreciation of the medium in general by establishing it in the context of a European lineage that went beyond the Ruskinian Pre-Raphaelitism, which had gripped the attention of American artists in the late 1850s and 1860s.[17] A large selection of English watercolors had been shown in tandem with the 1873 society annual. This show-within-a-show was organized by the noted English critic Henry Blackburn and did much to affirm the endeavors of American watercolorists who were beginning to produce works of greater complexity. Among the most admired of the English works shown at the society in the early 1870s were Thomas Faed's *Scott and His Friends* and George John Pinwell's *Great Lady,* both of which, in their respective expressions of English Victorian taste for history and genre subjects, demonstrated the radical differences between the work of the English school and the art of the majority of the American exhibitors, which seemed humble in technique and subject by comparison.[18] The young illustrator for *Harper's,* Edwin Austin Abbey (1852–1911), recalled his visit to the Blackburn collection, saying: "With them [the watercolors] he had a lot of black-and-white drawings. The originals of illustrations to Charles Reade's *Wandering Heir* by Fildes, Woods, and Mrs. Allingham, and many beautiful du Mauriers—of his best time—before he had stopped using Indian ink. These drawings were simply exquisite, and were a revelation to me. In that same exhibition was a water-colour by Pinwell—'The Great Lady;' this appealed to me more than anything I had ever seen in colour up to that time."[19]

Abbey's ambitions were fired by such experiences, which clearly set him on the path to his successful career as a watercolorist. His specialty of historical, picturesque figure paintings testifies to his appreciation of English art and surfaced early on with *The Stage Office,* which drew critical acclaim at the 1876 AWS exhi-

40

Edwin Austin Abbey (1852–1911). *Stony Ground,* 1884. Opaque watercolor on wove paper stretched onto a wooden panel. 28³⁄₁₆ x 48⅝ in. (71.6 x 123.2 cm). Signed and dated lower left: *E.A.A. 1884.* 70.7, Gift of American Paintings Galleries, Inc.

bition.[20] But for the refinement of his technique (for which he would continue to rely on gouache), his later efforts varied little from these initial excursions into the mode of the exhibition watercolor, as shown by *Stony Ground* (also known as *The Bible Reading;* cat. no. 40), which was displayed in 1884 at London's Royal Institute of Painters in Water-Colours and subsequently purchased by Andrew Carnegie.

Other, more well known artists added luster to their reputations by adopting foreign subjects and identifiably English techniques that advertised their travels abroad. R. Swain Gifford's *Homes in the Ziban, Desert of Sahara* was admired for its rich, transparent color that added to its "great force," and Tiffany was noted for his "large and spirited scene in front of a bric-a-brac shop in Switzerland."[21] Winslow Homer's small "sketches" also received positive note, but it was remarked, "he forgets at times, that the visitors to public exhibitions are not all artists, and are unwilling to accept crude suggestions in lieu of pictures."[22] The preceding quotation encapsulates a basic stance taken in the arguments for and against the exhibition watercolor in America; the writer associated large, finished works (or "pictures") with public taste, whereas Homer's "crude" sketches held greater artistic appeal.

The bulk of the critical honors for the 1876 society exhibition went to the organization's past president, Samuel Colman (1832–1920), who had recently returned from a three-year sojourn in Europe and North Africa.[23] Colman campaigned vigorously to reclaim his position as one of the country's preeminent watercolorists, as evidenced by an exhibition of forty-five of his watercolors at Snedecor Gallery late in 1875, which were deemed to "represent the highest

41

Francis Augustus Silva (1835–86). *View near New London, Connecticut*, 1877. Opaque and transparent watercolor over graphite on beige, moderately thick, slightly textured wove paper. 17 9/16 × 27 5/8 in. (44.6 × 70.2 cm). Signed and dated lower left: *F. A. Silva '77*. 46.195, Dick S. Ramsay Fund

development of water-colour painting."[24] Of his eleven contributions at the 1876 society annual that opened a short time thereafter, it was the imposing *Mosque of Sidi Hallui, Tlemeen, Algeria* that took the critical spotlight, its aesthetic worth affirmed by its similarity to the architectural subjects of two masters of the English exhibition watercolor, Samuel Prout (1783–1852) and James Duffield Harding (1797–1863).[25] Despite the general acclaim it garnered, reaction to the work was not uniformly positive. Colman's detractors doubted his artistic motives and asserted that he was catering to public demand and "painting for money."[26] He was also taken to task for his "use of body-color to such excess that in many cases it seems to have been laid on with a palette knife"—a fault that he was seen to share with the English watercolorist Edward Killingworth Johnson (1825–1923).[27]

Colman's strong presence in the 1876 exhibition and that of men like Gifford, Tiffany, Bellows, and even the young Abbey undoubtedly served as inspiration for other artists who followed suit with their own large watercolor productions. Francis A. Silva's sizable *View near New London, Connecticut* of 1877 (cat. no. 41) deserves consideration in this light along with the work of his more significant contemporary, William Trost Richards, whose interest in Colman's "big drawings" coincided with his own developing pursuit of watercolor on a large scale.[28] By 1877 Richards' name was added to the list of the society's exhibitors whose works dominated the walls, with respect not only to their scale but also to their use of opaque colors. His most noted piece was simply called *A Sketch,* so titled as if to amplify the disparities between its high finish and size and the humbler works normally deserving of the term. Although *A Sketch* remains unlocated, the detailed press commentaries devoted to it describe it well.[29] The artist's impres-

sive *Lily Pond, Newport* of 1877 (see cat. no. 69) probably corresponds closely to the lost *Sketch* in technique, since it is painted on the same type of "carpet paper" support and displays a marked use of opaque color.[30]

While some critics applauded Richards' adventurous explorations of a broader technique and unconventional materials, his work was nonetheless found wanting in sympathy. As the *Times* reviewer observed in 1878, "Mr. W. T. Richards . . . seems to extract nothing better than what his old work contained from the beautiful landscapes about Newport, R. I. The views are there, but the soul of the place is left out."[31] The same writer had already revealed his prejudices against large watercolors by cheering the "increase in the number of small pictures, and a comparative rarity of those gigantic spaces covered by water-color which fatigue the mind without rejoicing the sight."[32]

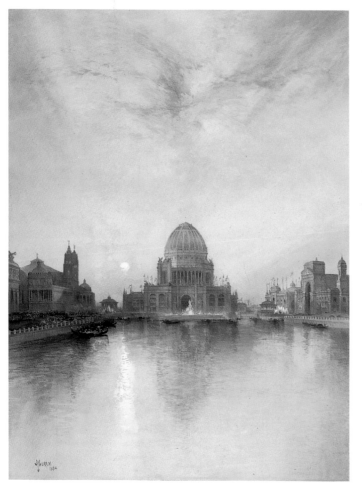

42

Thomas Moran (1837–1926). *Chicago World's Fair*, 1894. Transparent watercolor with opaque white highlights over graphite on cream, moderately thick, moderately textured wove paper. 29 × 21⁹⁄₁₆ in. (73.7 × 54.8 cm). Signed and dated lower left (initials in monogram): *TMoran / 1894*. 31.194, Bequest of Clara L. Obrig

Later that year (in August) Richards departed for England, where he would spend the next two years exploring a fresh, perhaps more receptive market for his work and renewing his already considerable acquaintance with the art of Turner and other English masters. The studies he made of the English coasts and countryside served to expand his subject matter and, once he returned to the United States in 1880, they formed the basis for much of his new work including an important 1882 commission from his patron of long standing, Elias Magoon. Titled *Cycle of Universal Culture Illustrated by the Graphic History of English Art*, the ambitious series consisted of seven watercolors representing distinctive phases of English history ranging from "mythical England" (Stonehenge) to "regal England" (Windsor Castle) and was executed in a style that was, for Richards, more than usually Turneresque in terms of wash application, higher-keyed color, and composition.[33] *Stonehenge* (see cat. no. 58), an enlarged version of the work created for the Magoon cycle, captures the mood of romantic melancholy that struck Richards as he observed the ancient monument in England: "It has that pathetic look which is peculiar to all human work which has reverted to Nature."[34] The retrospective frame of mind probably reflects Richards' own thoughts about his art at the time, for it corresponds with his acknowledgment that his own era of artistic relevance was passing, displaced by the art of the "new men" who formed the membership of the recently founded Society of American Artists. Even the great Turner was out of fashion with the Grosvenor Gallery set that was claiming aesthetic priority in London at the time.[35] The same can be said for Thomas Moran's *Chicago World's Fair* (cat. no. 42) which depicts the Administration Building in a florid and unmistakably Turneresque idiom and also marks the close of the most important phase of this artist's output. The last of Moran's great western trips had taken place in 1892 and he would spend much

43

Elihu Vedder (1836–1923). *The Cumaean Sibyl*, 1872. Black chalk and watercolor washes with touches of gum varnish on beige, moderately thick, slightly textured wove paper. 15⅞ × 22⅛ in. (40.3 × 56.2 cm). Signed and dated lower right (initials in monogram): *18V72*. 21.491.3, Bequest of William H. Herriman

of the remainder of his career producing brilliantly colored, albeit retardataire visions of Venice, which not only represent his flagging creative energies but also embody the last gasp of Turner's American influence.[36]

TRANSPARENT OR OPAQUE?

Size was not the only factor in the exhibition watercolor debates. This fact is clearly demonstrated by Elihu Vedder's *Cumaean Sibyl* (cat. no. 43), a work that seems not to have been exhibited in the artist's lifetime and whose purpose as either a finished work or a midprocess study remains ambiguous. As shown by the examples of Colman and Richards mentioned above, American artists began to increase their use of body color to create a more forceful, varied paint surface. As a result, the territory of the controversy expanded to include matters of durability, with one side insisting that the use of "pure watercolor" (or the technique restricted to the use of transparent washes) guaranteed the permanence of the work, whereas the use of body color ultimately promised a cracked and damaged paint surface. Although the question of durability had long been a topic of interest among watercolor specialists, the pros and cons of the matter were often imaginatively reformed to accommodate the views of those contesting the merits of watercolor versus oil.[37] Arguments were posed in favor of using unadulterated watercolor for the sake of preserving the work. These views, although mistaken in their conclusions, which promulgated the idea that a properly painted watercolor was no more subject to discoloration than an oil, reinforced the notion that

watercolorists should maintain the integrity of the medium and consequently discouraged inventive technical approaches.

Whatever their reasoning was, the majority of the critics registered among the pro-transparent contingent. Clarence Cook reminded his readers of the value of "pure" watercolor technique by heroicizing its history: "Fresco-painting is water-color painting pure and simple, and fresco-painting is the medium by which some of the greatest minds that ever worked have expressed themselves. Michael Angelo, indeed, is reported to have said that oil-painting was for women and children, not for men."[38] Cook went on to note with perceptible relief that most of the contributors to the 1878 society annual had resumed painting in pure watercolor, thus improving the general character of the exhibition. While Cook strove to enforce purist watercolor values, he did not minimize the inherent value of the medium. Other writers, however, remained convinced of watercolor's secondary position in the arts. As one reviewer concluded, "It does seem unnecessary to encroach upon the province of oils with another method of work, so long as oils will do all that is required. Strictly speaking, water-colors ought to be sketches, and hence unpretentious."[39]

In some instances criticism took on a moral tone, with writers equating transparent watercolor technique with "truthfulness," "legitimacy," and "simplicity."[40] The moralizing tendency was discerned by a writer for the *Century* magazine who pegged it as puritanical in its source:

This Puritanism, then, makes us a little obtuse to, and a good deal afraid of, anything that looks mellow, languid, or luxurious; so that when a painter does exhibit signs of a strong feeling for color, we are apt to fight shy of him. Water-colors are crisp, clear, and, unless in the best hands, crude; but even crudeness is not so terrible to us as richness of color. Narrower limits and greater simplicity of water-color drawing predispose Americans to excellence in that branch, just as the wider range and greater complexity of oil-painting cause many of those who venture into that field to produce compositions rank or turgid in color.[41]

Under these circumstances the future looked dim—not only for watercolor, but for the whole of American art as well.

PRETTY OR PETTY?

In 1877 the phenomenon of the exhibition watercolor at once hit its stride and began its downward turn with the critics, who just a few years before had eagerly anticipated watercolor's equality with oil painting. A good deal of printer's ink was given over to discussions lamenting the predominance of pictures of "larger than average size":

With watercolors this is hardly likely to be a favorable trait, for modesty of size is especially requisite in a style of painting which for good reason does not rank as high as oil-painting. . . . Water-color painting seems so especially adapted for happy thoughts,

44

Samuel Colman (1832–1920). *Late November in a Santa Barbara Cañon, California,* c. 1886–88. Transparent and opaque watercolor with touches of pastel on rose-tinted, moderately thick, moderately textured wove paper. 12 × 15 in. (30.5 × 38.1 cm). Signed lower right: *Saml Colman.* Inscribed lower left: *Santa Barbara, Cala.* 77.102.2, Dick S. Ramsay Fund

pretty bits of landscape, clever turns of figure that are not quite worth perpetuating in the gravity of oils that the idea of plodding for a long while over great expanses of paper partakes of the nature of elaborate jokes.[42]

The West Room contains a good many interesting sketches, and shares with the East Room the enviable distinction of excluding, for the most part, those large water-colors whose size affects one with a sense of toil in the artist. There are more light and spritely pictures in the West Room, little sheets of paper that have caught a passing mood happily, and so fulfilled the legitimate raison d'être of water-color drawing.[43]

While the *Times* articles quoted above represented the more forceful aspects of critical opinion opposing the exhibition watercolor format, other writers registered their disapproval more subtly by praising the works that conformed to the conservative ideals of watercolor painting and ignoring the larger works altogether. For example, the *Art Journal*'s writer (Susan N. Carter) led off an 1877 review with a lengthy examination of Winslow Homer's progress in the medium, thereby relegating the issue of the exhibition watercolor to a secondary position in her review not only in terms of how many inches down in the text it eventu-

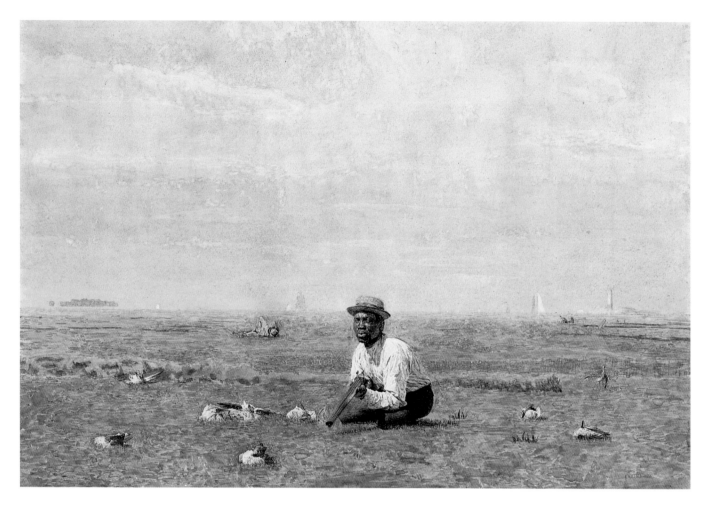

45

Thomas Eakins (1844–1916). *Whistling for Plover*, 1874.
Transparent watercolor and small touches of opaque watercolor
over graphite on cream, moderately thick, moderately textured
wove paper. 11⁵⁄₁₆ × 16¹¹⁄₁₆ in. (28.7 × 42.4 cm). Signed lower
right: *Eakins 74.* 25.656, Museum Collection Fund

ally appeared but also in terms of the extensive coverage given to Homer's mod-
est works that stood in sharp contrast to large, elaborately worked pieces.[44] It is
interesting to note as well that, in addition to extolling the nonetheless "crude"
(and small) watercolors of Homer, reviewers attempted to dampen enthusiasm
for larger works by praising the smaller submissions of artists who also had exhi-
bition-scale pieces on view in the same exhibition. For instance, Bellows' *New
England Homestead* was said to be "overwrought, [it] lacks both freedom and pre-
cision, and oversteps the proper limitations of water-colour." Yet his smaller
works in the same exhibition were praised.[45] The same pattern of criticism held
true for Alexander Helwig Wyant and Colman (cat. no. 44), whose small, freely
brushed landscapes were preferred to their large ones. Thomas Eakins' contribu-
tions proved "that delicacy does not of a necessity mean weakness" (cat. no. 45).[46]

A cautionary note must be inserted here, for it would be foolhardy to base a
reading of this complex period of watercolor's history solely on the contents of
the press commentaries available. Ultimately the greater history of American art
and culture must be kept in mind if a more accurate interpretation of the water-
color medium's history is to be determined in relation to, among other things, the

46

Louis Ritter (1854–92). *Capri,* 1889. Transparent watercolor
with touches of opaque watercolor over graphite on cream,
moderately thick, rough-textured wove paper. 10⅝ × 14⅝ in.
(27 × 37.1 cm). Signed, dated, and inscribed lower left: *Louis
Ritter / Capri '89.* 85.177, Purchased with funds given by
Mr. and Mrs. Leonard L. Milberg

general decline in the Hudson River school of landscape painting, the effect of
the centennial (especially with respect to the development of stronger nationalis-
tic sentiments among writers and artists), the political and aesthetic concerns that
led to the foundation of the Society of American Artists in 1877, the rise of the
Aesthetic Movement, and, of course, the individual talents and choices of the
artists themselves. What is more, a methodology that relies principally on press
reviews to guide cultural interpretations runs the risk of ignoring the activities of
artists like Louis Ritter (cat. no. 46) who were not affiliated with the major, New
York–based art organizations. Yet the reviews are valuable tools in documenting
general patterns of artistic activity and reception. They may also be seen as cat-
alytic agents for the directions *some* artists took in their work; as examples of
"wishful" writing that was intended to encourage or discourage certain stylistic
inclinations; or as examples of the journalists' perennial need for a new angle.

One of the reasons why critical support for the exhibition watercolor faltered
seems to lie in the overall perception that American artists did not exist in an en-
vironment conducive to the creation of imagery that matched the importance of
that inspired by European culture. Correct or not, this view received widespread
coverage, as exemplified in an 1880 article that appeared in *Scribner's Monthly,*
which focused on the premise that "there is no outlet here for the largest thoughts

and highest inspirations of the artist mind and hand."[47] The author called into play the issues of the poor market for American art (which competed weakly with European painting) and the degrading position in which American artists found themselves as they catered to popular or market taste. The writer concluded that the lack of patronage forced artists to paint for the "houses of the land," which therefore imposed a small scale on their work and, by the same token, a pettiness of subject matter. As a result, according to the anonymous author:

Men cease to think largely, grow petty in their subjects, reach out into striking mannerism for the sake of effects that cannot be produced in a natural way, and lavish on technique the power and pains that should go into great designs and a free and full individual expression. The recent exhibition of water colors in this city showed how far into pettiness the artists in that line of work have gone. There was much that was bright and pretty and attractive, but how irredeemably petty it all was! It may be said that nothing can be expected of water colors beyond the representation of petty things, but we remember three large watercolor exhibitions in London, all open at the same time, where there were pictures so large and important and fine, that thousands of dollars were demanded for them and commanded by them.[48]

In essence, the *Scribner's* writer had no quarrel with the idea of the exhibition watercolor as long as the breadth of form and content were harmonious. And, unlike other writers, who had precluded the possibility of a fine, important exhibition watercolor by virtue of the inherent limitations of the medium, the writer quoted here cited cultural limitations as the root cause for the dearth of meritorious art in America, regardless of medium. Discussions of style or technique, while they remained major elements of critical commentary, were gradually balanced by concerns about subject matter. Much of this had to do with the younger generation of painters who were returning from European training. By 1880 the works of the old guard—Colman, Richards, Bellows, and Falconer—shared the galleries with paintings by William Merritt Chase (1849–1916), Mary Cassatt (1845–1926), J. Carroll Beckwith (1852–1917), Robert Blum (1857–1903), and Walter Shirlaw (1838–1909). Granted, the occasional comment surfaced about the inadvisability of watercolors imitating oils, but such affairs were no longer the driving theme of the reviews. The critics turned, instead, to commenting on the more topical matters provoked, for instance, by the incursion of the Munich-derived realism that challenged accepted notions of appropriate subject matter. Chase's *Sketch* (a small watercolor of a black model) generated the following opinion:

It shows a freedom of handling, and vivid effect, but must be considered purely from the point of view suggested by the title. The subject, a Congo negro, with his mouth wide open, cannot be called an agreeable theme. Other things being equal, we must protest strongly in favour of the importance of choice of subject in Art. It is not an indifferent affair for artists of repute and influence, like Leible [sic] and many of the Munich school, to select subjects in which beauty and sentiment are altogether ignored. The grotesque or

47

Robert Frederick Blum (1857–1903). *Green Grocery in Rome,*
1881. Formerly known as *Market Scene, Spain.* Watercolor over
charcoal on cream, medium-weight, moderately textured
antique laid paper. 17⅛ × 21⅞ in. (43.5 × 55.6 cm). Signed and
dated lower center: *Blum 1881.* 23.75, Frederick Loeser Art Fund

the horrible in Art is admissible only as a foil to beauty, like an occasional discord in an
opera, but not as the substance of which it is composed.[49]

At about the same time Robert Blum was gaining prominence for his water-
colors, which afforded reviewers additional aesthetic matters to digest, including
the influence of James McNeill Whistler (1836–1903), the Spaniard Mariano For-
tuny (1838–74), and Japonism. In 1881 Blum showed six Venetian subjects at the
society's exhibition, for which he received remarkable attention. Writing about
his *Venetian Bead Stringers,* Maria Van Rensselaer commented: "The brightly col-
ored group was delightful and if we have passed to the consideration of the sepa-
rate small figures, we found them cleverly individualized—well drawn and en-
tirely real in effect, though there had been no so-called 'finish' applied in their
making. . . . I think there was nothing of home production on these walls quite
as good as this picture of Mr. Blum's."[50] Blum also made his presence felt at the
Brooklyn Art Association that year, showing *Green Grocery in Rome* (cat. no.
47).[51] That writers focused on larger aesthetic questions in watercolor exhibition
reviews signifies that the medium had reached a level of professional, market, and
critical acceptance that no longer necessitated pleas for its viability or arguments
against its violating prescribed limits. By the same token, the exhibition water-
color became a nonissue.

The close of the active critical debate about watercolor and its potential to compete with oils was not accompanied by a parallel disinterest on the part of artists in creating large works. This is proved by the number of works in Brooklyn's collection that qualify as exhibition watercolors and were painted after 1880 (the year that effectively marks the end of concentrated critical attention to the issue). These post-1880 watercolors range from Arthur Parton's large, densely worked *Niagara Falls* (cat. no. 48) to the small, but no less solidly painted watercolors by Lawrence Carmichael Earle and Claude Raguet Hirst (cat. nos. 49, 50). Considered together, the three paintings embody the salient points involved in the original exhibition watercolor controversies.

In the case of the Parton, one is obliged to resolve the sublime power of the subject with the artist's choice to depict it in watercolor. Furthermore, the manipulation of the medium—an admixture of wash and gouache—achieves a variety of atmospheric and material effects that recalls the opaque manner that had set the critics on edge. *Niagara Falls* stands out in Parton's oeuvre as a particularly ambitious effort and is a relatively rare example of his essays in watercolor production.[52] Earle's *Model in Dutch Costume* occupies the opposite end of the watercolor spectrum. Despite its modest size, it commands its share of attention

48

Arthur Parton (1842–1914). *Niagara Falls,* c. 1880. Transparent and opaque watercolor on cream, thick, moderately textured wove paper. 21 × 29¹¹⁄₁₆ in. (53.3 × 75.4 cm). Signed lower right: *Arthur Parton.* 70.174, Gift of Henfield Foundation

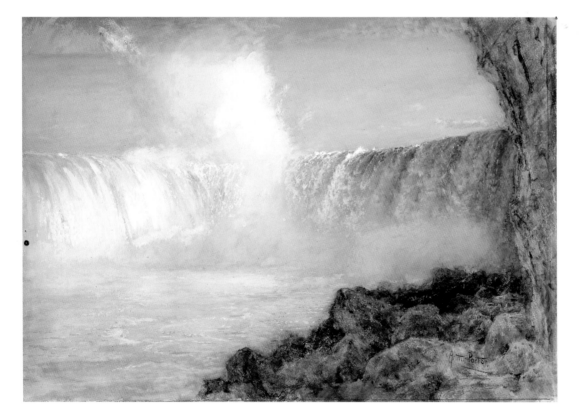

when it hangs among oils of equal or larger scale by virtue of the solid buildup of opaque surfaces that are placed against the unusual foil of gold paint. The subject itself—a head study of a model in period costume—is not uncommon, especially for a Munich-trained artist such as Earle. What does stand out is the dramatic intensity that the artist invested in this watercolor, a work tentatively identified as *La Belle Hollandaise* that represented Earle in his 1888 debut at the National Academy of Design. Hirst's *Bookworm's Table* exhibits comparable strength, which she attained through the careful stippling of brilliant color to create a rich surface that indeed rivals the visual intensity of an oil. These paintings of unassuming size owe much of their power to the fact that they are enclosed in relatively heavy molded and carved frames that present the paintings as if they were oils. Although few oil paintings have come down to us in their original frames, even fewer watercolors remain housed in the frames in which they were initially displayed. This is especially unfortunate with respect to exhibition watercolors, where the manner of framing is critical to their reception in the contest with oils.

While framing techniques were undoubtedly as important to watercolorists as they were to painters in oil, only a few passing remarks in the press concerning

this matter have been located thus far. The AWS itself issued a circular outlining its policy on framing according to the following preamble and resolutions adopted at its May 5, 1874, meeting:

WHEREAS, It is the opinion of this Committee that frames, such as are enumerated in the resolution following, are detrimental to the general beauty and harmony of effect which should be one of the attractions of every collection of pictures, and moreover, increase the difficulty of hanging according to intrinsic merit;

THEREFORE BE IT RESOLVED, That Pictures having frames of other than square or parallelogram external form, or with ornaments extending beyond the simple rectilinear outline; deep frames, such as are commonly used for oil color pictures; frames with shadow-boxes of dark wood or that extend more than half an inch beyond the frame in any direction [a footnote at the bottom of the circular stated, "The Committee would discourage the use of shadow-boxes altogether"]; frames constructed wholly or in part of velvet, or dark colored wood, of parti-colors, or striped with black, white, or any positive color; or measuring in depth or thickness more than two and one half inches, cannot be admitted to the exhibitions of this Society.

AND BE IT FURTHER RESOLVED, That no mat or flat, properly so-called, shall exceed four inches in width.

AND FINALLY, That the use of frames all gold, and of mats of gold or of white only, is strongly recommended.

The Committee do not find any objection to the use of light colored woods in framing, when in harmony with gold.[53]

The composition of the committee (Gilbert Burling, Albert Baldwin, Francis A. Silva, R. Swain Gifford, and William Magrath) and the governing body of the society (headed by James Smillie)—some of whom were proponents of the exhibition watercolor—suggests that the framing resolutions should not be interpreted as a move to block the display of works in that mode. Yet the enforcement of the resolutions would have certainly hampered artists who wished their watercolors to assume visual parity with oils. In writing about the next society exhibition, the reviewer for the *Nation* focused on the effects of the resolutions:

The walls, covered with the small, even, low-relief frames usual for water-colors, looked beautifully regular and dense. . . . But we have never understood the reason why aquarelles, as if by a necessity of their being, must be framed in bas-relief and with vast flat mats. . . . We suppose that it would be heterodox not to submit, since our native Water-color Society has raised the theory to the sanctity of a dogma in its recent circulars of instruction; but we feel . . . that each picture an artist paints is a rule unto itself and unto its arrangement; that the frame should express the necessity, the proper relief, and, as it were, the complement of each separate motif. . . . The liberty of perfect adaptation should, in fact, be allowed to every sort and description of cartoon or paper picture—a species which includes the widest variety of all and the greatest ups and downs of effect.[54]

Apparently, a sufficient number of the society's membership also found cause to object to the framing restrictions; at the January 19, 1876, meeting of the board of control, the hanging committee was "given discretionary power to suspend the

Fig. 15.
Detail of frame belonging
to Henry Roderick
Newman's *The Priest's
Garden* (cat. no. 51)
Brooklyn Museum of Art,
88.39, Purchased with funds
given by Mr. and Mrs.
Leonard L. Milberg

Fig. 16.
Detail of "Ruskin frame,"
a style preferred by Henry
Roderick Newman for his
watercolors after 1881
Photograph courtesy of
Vance Jordan Fine Art Inc.,
New York

rules in regard to framing."[55] The brief experiment in controlling installation design by imposing rules on frame styles affected only the 1875 exhibition.

Henry Roderick Newman (1843–1917) was an artist for whom frame design played a demonstrably important role in the presentation of his watercolors. Newman, whose professional activity extended into the twentieth century, was undoubtedly the most conspicuous American proponent of the exhibition watercolor of his time.[56] However, the circumstances of his expatriate lifestyle (he took up permanent residence in Florence in 1874) and his lasting allegiance to Ruskinian principles removed him from the mainstream of American art culture to the extent that his work is just now enjoying its most concentrated attention.[57] A fortunate result of this situation is that many of Newman's recently "rediscovered" paintings (which are now entering the market mainly from private English collections) are still housed in their original frames and decorative gold mats. One such example is the intricately carved gold frame (fig. 15) for Brooklyn's *Priest's Garden* (cat. no. 51). As Royal Leith also points out, Newman frequently chose what is called a "Ruskin frame" for the display of his works (fig. 16), some of which manifested a dramatic increase in dimension in the late 1870s.[58] The artist's professional beginnings are defined by his membership in the Association for the Advancement of Truth in Art, and, by his own admission, he never diverged from the meticulous Pre-Raphaelite facture and preference for watercolor that informed his early aesthetic.[59] Newman's perverse joining of a radically controlled application of paint with a large format testifies to what may be considered his obsessive need to justify watercolor as an important medium and his desire to perpetuate the Ruskinian notions that linked the creation of art with moral purity expressed in the labor of the painter.[60] Although Newman relied chiefly on his exacting watercolor technique to transmit these sentiments, a more symbolic reading of *Grapes and Olives* (cat. no. 52) has been suggested that alludes to verses from the gospel of Matthew describing the Last Supper.[61] For the most part, however, Newman's late watercolors may be seen as compelling visual documents of his nomadic existence, which included protracted stays in Egypt and Japan. Brooklyn's fine examples of the artist's late work, *Daibutsu at Kamakura, Japan* (cat. no. 53) and *Captives of Ramses II* (cat. no. 54), entered the collection in 1907. Their early placement in a collection outside the Boston area, where Newman's American reputation was the strongest, is perhaps indicative of his close friendship with the noted Egyptologist Charles Edwin Wilbour, who was the principal force in the formation of the Museum's distinguished holdings in Egyptian art and research materials.[62]

52 *(opposite, above left)*

Henry Roderick Newman (1843–1917). *Grapes and Olives,* 1878. Watercolor over graphite on cream, thick, rough-textured wove paper. 26 × 16¾ in. (66 × 42.5 cm). Signed and dated lower left: *H. R. Newman / 1878.* 1996.90.2, Dick S. Ramsay Fund

53 *(opposite, above right)*

Henry Roderick Newman (1843–1917). *Daibutsu at Kamakura, Japan,* 1898. Watercolor over graphite on off-white wove paper attached to secondary paper and mounted to a wooden panel and strainer by the artist. 20 × 14 in. (50.8 × 35.6 cm). Signed, dated, and inscribed lower left: *H R Newman / Kamakura / 1898.* 07.270, Gift of Alfred T. White

54 *(opposite, below)*

Henry Roderick Newman (1843–1917). *Captives of Ramses II,* 1907. Watercolor over graphite on cream, thick, smooth-textured wove paper mounted to paper and canvas that are wrapped around a wooden board. 20 × 40¹⁄₁₆ in. (50.8 × 101.8 cm). Signed, dated, and inscribed lower left: *H R Newman / Abu Simbel / 1907.* 07.458, Gift of Alfred T. White

55 *(right)*

Ben Shahn (1898–1969). *Existentialists,* 1957. Transparent and opaque watercolor and ink on off-white, moderately thick, slightly textured wove paper mounted to a very thick laminated woodpulp board. 39¹⁵⁄₁₆ × 26 in. (101.4 × 66 cm). Signed lower right: *Ben Shahn.* 59.27, Dick S. Ramsay Fund

EPILOGUE

While today's watercolor practitioners are no longer seen in the context of a unified movement, the tradition of the exhibition watercolor continued in the work of such twentieth-century artists as Ben Shahn (cat. no. 55) and Morris Graves (cat. no. 56) and is still carried out in the work of such contemporary artists as Patricia Tobacco Forrester (fig. 17) and Philip Michelson (cat. no. 57), both of whom have coincidentally explored the imagery of plant life with an intensity reminiscent of their Ruskinian predecessors, but have achieved their results

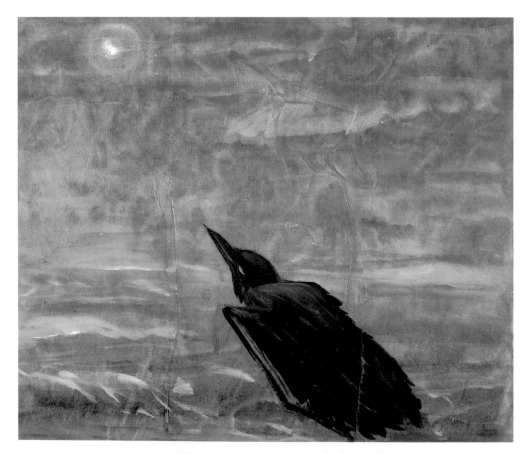

56 *(opposite, above)*

Morris Graves (b. 1910). *Moon Mad Crow in the Surf,* 1943. Transparent and opaque watercolor on cream, thin, slightly textured, translucent laid paper. 25¾ × 30½ in. (65.4 × 77.5 cm). 1991.109.2, Gift of Mrs. Milton Lowenthal

57 *(opposite, below)*

Philip Michelson (b. 1948). *Croton,* 1979. Watercolor over graphite on off-white, very thick, rough-textured wove paper. Watermark: Arches FRANCE / 15 / Arches FRANCE / 15. Embossed mark: Veritable Papier D'Arches / Fin / Fin. 22⅝ × 30¼ in. (57.5 × 76.8 cm). Signed and dated lower right: *Philip L. Michelson © 1979.* 79.106.3, Gift of Mr. David C. Temple

through distinctly different means and intentions. As shown by *Croton,* Michelson's process in particular represents the antithesis to Ruskinian technique. His richly saturated, heavily worked surfaces are deliberate and practically based contradictions to the transparent properties associated with the medium and are begun with the artist's scrubbing the paint with an acrylic brush into the grooves of the rough papers he uses. From there he applies a series of washes in a manner that recalls the glazing techniques used for oils.[63] The surface he achieves allows for in-process changes that can be made by scraping away the paint and making the needed revisions. Michelson's use of the medium is unfettered by any theory or practice other than his own, thus reflecting the nature of contemporary art practices. However, in his urge to push the watercolor medium to its physical limits to create a work of extraordinary visual impact, Michelson helps to perpetuate the tradition of the exhibition watercolor in America.

NOTES

1. "Fine Arts," *Brooklyn Daily Eagle,* May 25, 1876, 3.
2. The painting was purchased by the Brooklyn collector Henry D. Polhemus. It came into the Museum as part of the bequest of his widow, Caroline Herriman Polhemus, which included the marble *Pandora* by Chauncey Bradley Ives, oils by Thomas Waterman Wood, Platt Powell Ryder, Arthur Quartley, as well as works by European artists.

Fig. 17.
Patricia Tobacco Forrester
(b. 1940)
Regal Buckeye, 1977
Watercolor on paper
Brooklyn Museum of Art,
78.9, Caroline Polhemus
Fund

3. "Fine Arts: Fifth Winter Exhibition of the American Society of Painters in Water Colors," *New York Times,* January 28, 1872, 3; "Fine Arts. American Society of Painters in Water Colors," *Brooklyn Daily Eagle,* January 22, 1877, 3.

4. S. N. C. [Susan N. Carter]. "The Tenth New-York Water-Colour Exhibition," *Art Journal* 3 (1877), 96.

5. "Albert F. Bellows, N.A., and His Pictures," *Art Journal* 1 (1875), 116. The date of Bellows' trip to England is variously given as 1865 and 1867. The latter date is provided in S. G. W. Benjamin, *Our American Artists* (Boston: D. Lothrop, [1879]; repr., New York and London: Garland Publishing, 1977), n.p. (hereafter Benjamin 1879).

6. Benjamin, 1879, n.p. Other critics, some of whom still gave lengthy discussions of Bellows' work in their columns, believed that his artistic skills had declined by 1876: "The time was when Mr. A. F. Bellows seemed to be the leader of the water-color school. His cool, green lanes, ivy-hidden towers and cottages, old mills and dark mill-ponds, with their shadowy trees, awoke an irresistible desire in those who looked on them to visit the land that afforded studies for these pictures [England], but Mr. Bellows seems to have already given us his best work. Certainly his 'Sunday Afternoon in New England' (no. 51) is not up to his usual standard. The foliage is weak, woolly and colorless, and the whole composition, though carefully painted, fails to impress. Much better work than this is shown in several of his smaller pictures." The same writer noted, however, that the picture had been sold to a Chicago collector for $1,000. (The top sale price was $1,500 for Samuel Colman's *Mosque of Sidi al-Halwi, Tlemcen, Algiers,* which was purchased by J. Jacob Astor.) "Water-Color Exhibition at the Academy of Design," *New York Times,* February 6, 1876, 10.

7. "Albert F. Bellows, N.A., and His Pictures," *Art Journal* 1 (1875), 116.

8. The history of the exhibition watercolor in England has received considerable, but not exhaustive, attention. See, especially, Jane Bayard, *Works of Splendor and Imagination: The Exhibition Watercolor, 1770–1870,* exh. cat. (New Haven: Yale Center for British Art, 1981), and Andrew Wilton, "The Exhibition Watercolour," in *The Great Age of British Watercolours 1750–1880,* exh. cat. (London: Royal Academy of Arts; Munich: Prestel-Verlag, 1993), 259–64. No comparable study of the exhibition watercolor in an American context exists. Turner's role in validating the exhibition watercolor in America was widely acknowledged despite the fact that only a few of his watercolors were known to the general American audience: "While the art [of watercolor] remained on the Continent, it occupied a very subordinate position. . . . But during the last century it was developed in England to great dimensions, so that in one sense, in its complicated modern form, water-colors may be said to have originated there. Turner did much to build up the taste for elaborate watercolors which artists before him had founded." "Are Water-Colors Serious?" *New York Times,* February 3, 1878, 6.

9. "American Society of Painters in Water-Colours," *Art Journal* 1 (1875), 91.

10. "Art Matters," *American Art Journal* (April 6, 1867), 374.

11. "Art Notes: William Hart's Water Colors, etc.—Coming Summer Exhibition at the National Academy," *Brooklyn Daily Eagle,* June 27, 1870, 2.

12. "The Water-Color Collection," *New York Times,* February 9, 1873, 5.

13. Ibid.

14. "Fine Art," *Nation* (February 4, 1875), 84.

15. Ibid.

16. "Fine Arts: The Water-Color Exhibition," *New York Tribune,* February 12, 1876.

17. See Linda S. Ferber and William H. Gerdts, *The New Path: Ruskin and the American Pre-Raphaelites,* exh. cat. (New York: Brooklyn Museum and Schocken Books, 1985) (hereafter Ferber and Gerdts 1985).

18. Faed's *Scott and His Friends* was shown at the 1873 AWS exhibition and received substantial praise: "It shows in a striking manner what can be done with body-colors in the hands of a master. So rich, so pure, so brilliant are the tints of this old picture painted in 1849, that it looks as if it had come straight from the studio, while those beside it had been faded with time." "The Water-Color Collection," *New York Times,* February 9, 1873, 5. In 1874 a writer pointed to Pinwell's *Great Lady* as "the gem of the collection." "Fine Arts: American Society of Painters in Water-Colors," *New York Times,* February 1, 1874, 3.

19. Quoted in E.V. Lucas, *Edwin Austin Abbey, R.A.: The Record of His Life and Work* (New York: Charles Scribner's Sons; London: Methuen, 1921), vol. 1, 38. Abbey's memory did not always serve him accurately; Lucas incorrectly lists the date of the Blackburn exhibition as 1875; the Pinwell was shown at the AWS in 1874 and seems not to have been part of the 1873 Blackburn collection display. Owing to his love for British literature, Abbey may well have been familiar with Pinwell's art prior to seeing examples of it in person, since Pinwell was a highly respected illustrator. Pinwell's *Gilbert à Becket's Troth* (also known as the *Saracen Maid,* 1872, Lady Lever Art Gallery, Port Sunlight) had received exceptional praise in the (London) *Art Journal* on the occasion of its display at the Old Water-Colour Society in 1872. See Christopher Newall, *Victorian Water Colours* (Oxford: Phaidon Press, 1987. Pinwell's watercolors continued to influence Abbey after the American expatriated to England. See Lucas, vol. 1, 111.

20. "Fine Arts: Exhibition of Water-Colors at the Academy of Design," *New York Herald,* January 30, 1876.

21. "The Water-Colour Exhibition, New York," *Art Journal* 2 (1876), 92.

22. Ibid.

23. For Colman, see Wayne Craven, "Samuel Colman (1832–1920): Rediscovered Painter of Far-Away Places," *American Art Journal* 8 (May 1976), 16–37.

24. "Samuel Colman." *The Art Journal* 2 (1876), 32.

25. "The Water-Colour Exhibition, New York," *Art Journal* 2 (1876), 92. Reviewers in 1876 had difficulty with the painting's title. One writer actually admitted defeat and referred to the painting as *The Mosque of 'Somebody or Other' in Algeria.* "Fine Arts. The Water-Color Exhibition," *New York Tribune,* February 12, 1876. The subject of the painting

was undoubtedly the mosque of Sidi al-Halwi in Tlemcen, Algeria.

26. "Fine Arts: The Water-Color Exhibition," *New York Tribune,* February 12, 1876. To a degree the critic was correct inasmuch as some of Colman's large watercolors were painted on commission. See, for example, *Brooklyn Daily Eagle,* November 9, 1876, which states that Colman's *Cathedral at Durham* was a commissioned work.

27. "The Water-Color Exhibition," *New York Tribune,* February 19, 1876.

28. See Linda S. Ferber, *William Trost Richards (1833–1905): American Landscape and Marine Painter* (New York: Garland Publishing, 1980), 280 (hereafter Ferber 1980).

29. Susan N. Carter, "The Tenth New York Water-Colour Exhibition," *Art Journal* 3 (1877), 96.

30. Carpet paper is a soft, thick paper that was used as padding between carpets and floors. See Sue Welsh Reed and Carol Troyen, *Awash in Color: Homer, Sargent, and the Great American Watercolor* (Boston: Museum of Fine Arts, Boston, in association with Bulfinch Press, Little, Brown, 1993), 80 n. 2.

31. "American Water-Color Society," *New York Times,* February 2, 1878, 5.

32. Ibid.

33. Linda S. Ferber, *William Trost Richards: American Landscape & Marine Painter, 1833–1905,* exh. cat. (Brooklyn Museum, 1973), 90 (hereafter Ferber 1973).

34. Ibid.

35. "Current Opinion on Landscapes and Water-Colours," *Art Journal* 4 (1878), 94.

36. For Moran, see Carol Clark, *Thomas Moran: Watercolors of the American West* (Austin: University of Texas Press, for the Amon Carter Museum of Western Art, 1980), and Nancy K. Anderson, *Thomas Moran,* exh. cat. (Washington: National Gallery of Art and New Haven: Yale University Press, 1977).

37. See the American Society of Painters in Water-Color's 1868 pamphlet, *Water-Color Painting: Some Facts and Authorities in Relation to Its Durability.*

38. C. C. [Clarence Cook], "The Water-Color Society," *New York Tribune,* February 9, 1878.

39. "Are Water Colors Serious?" *New York Times,* February 3, 1878, 6.

40. One reviewer of the 1876 society exhibition wrote: "In looking through the exhibition it was noticeable that several of our leading artists . . . have departed, in their manner of treatment, from the delightful simplicity of water-colour drawing as originally practiced, by a resort to the wholesale use of solid or body colours." *Art Journal* 2 (1876), 93. In 1878 John Moran wrote: "There is to us an unquestionable mistake committed by those artists who strive to make water-colours usurp the functions of oils, and are not content with the legitimate results obtainable from aquarelles." *Art Journal* 4 (1878), 91.

41. "Watercolor and Americans. Culture and Progress: The Art Season of 1878–1879," *Century* (June 1879), 310.

42. "Watercolors," *New York Times,* January 21, 1877, 7.

43. "Display of Water-Colors," *New York Times,* January 28, 1877, 6.

44. S. N. C. [Susan N. Carter], "The Tenth New York Water-Colour Exhibition," *Art Journal* 3 (1877), 95.

45. "The American Water-Colour Society's Exhibition," *Art Journal* 4 (1878), 91.

46. Ibid.

47. "Pettiness in Art," *Scribner's Monthly* (May 1880), 146.

48. Ibid.

49. "American Water-Colour Society." *Art Journal* 6 (1880), 91.

50. Quoted in Bruce Weber, "Robert Frederick Blum (1857–1903) and His Milieu" (Ph.D. diss., City University of New York, 1985), 120–22 (hereafter Weber 1985).

51. See Weber 1985, 122, where he identifies Brooklyn's watercolor by Blum (formerly known as *Market Scene, Spain*) as *Green Grocery in Rome.*

52. Although Arthur Parton exhibited regularly at the National Academy of Design throughout his career, little is known about his life or his work in watercolor.

53. A copy of the circular is in the papers of the American Watercolor Society, roll N68-8, frame 471, AAA. The text was reprinted almost in its entirety (minus the note about shadow-boxes) in *Watson's Art Journal* (June 27, 1874), 96.

54. "Fine Arts. The Water-Color Exhibition—Loan Exhibition of the Union League," *Nation* (February 4, 1875), 84.

55. American Water Color Society Papers, roll N68-8, frame 485, AAA..

56. The finest examination of Newman's career to date is Royal W. Leith, *A Quiet Devotion: The Life and Work of Henry Roderick Newman* (New York: Jordan-Volpe Gallery, 1996) (hereafter Leith 1996).

57. For the first modern scholarly attention to Newman's career, see Kent Ahrens, "Pioneer Abroad: Henry R. Newman (1843–1917), Watercolorist and Friend of Ruskin," *American Art Journal* 8 (November 1976), 85–98. The Newman revival was energized mainly by the research in preparation for Ferber and Gerdts 1985.

58. Leith 1996, 23.

59. Ibid., 7.

60. Newman is quoted as saying, "Art which is the most sacred thing in the world, should not be pursued as an amusement, but should be held by a man as the most holy thing like a religion." Helen Zimmern, "An American Watercolorist," *New York Sun,* September 7, 1890, 15.

61. This is suggested by Holly Pyne Connor in her entry on the painting in Ferber and Gerdts 1985, 207.

62. Newman's *Captives of Ramses II* and *Daibutsu at Kamakura, Japan* were given to the Museum by one of its trustees, Alfred T. White. At this writing it has not been determined if White and Wilbour were acquainted in 1907, but such a connection might then provide a clue as to the origins of White's association with Newman.

63. Susan Stowens, "Philip Michelson: Giving a Photographic Appearance to Imagined Subjects," *American Artist* (April 1986), 94.

3

THE POWER OF PATRONAGE: WILLIAM TROST RICHARDS AND THE AMERICAN WATERCOLOR MOVEMENT

LINDA S. FERBER

58

William Trost Richards (1833–1905). *Stonehenge,* c. 1882. Opaque watercolor and pastel on cream, thick, rough-textured wove paper. 23⅛ x 36⅜ in. (58.7 x 92.4 cm). Signed lower left: *Wm T. Richards.* 83.199, Gift of George Klauber

William Trost Richards (1833–1905) was already an established Philadelphia landscape and marine painter in oils when he began to flourish about 1870 as one of the most productive and successful participants in the movement; his activity continued to the peak of watercolor's popularity in the early 1880s.[1] Whereas landscape subjects—Richards' focus as a painter during the first twenty years of his career—were also treated in watercolor (see cat. no. 64), the artist's turn to the medium is inextricably linked to his growing interest in the shore (see cat. nos. 61–63), an exploration begun in the 1860s. Summertime excursions were documented at first by drawings and plein-air oil studies of Nantucket, Mount Desert, the Isles of Shoals, and Atlantic City—charting the artist haunts which were rapidly becoming resort destinations attractive to a prosperous postwar middle class. These coastal excursions stimulated the regular use of watercolor as well—initially as "notes" for oil paintings. By 1870 watercolor was established in Richards' repertoire as a major mode of expression for the varieties of coastal topography and atmospheric effects that would figure prominently in his oils as well. During this period, he produced a body of exceptional work in the medium, focusing mainly on subjects drawn from his travels along the northeastern coast from New Jersey to New England as well as to the White Mountains and, in 1878, to England.

Despite the fact that he was esteemed and imitated in the 1870s as one of the best watercolor painters in America, Richards' contribution is underrecognized today. This is particularly ironic when we learn that many of his works were commissioned and collected during the 1870s and early 1880s by two very influential patrons—Elias Lyman Magoon (1810–86), a prominent Baptist clergyman and art crusader, and George Whitney (1820–85), a wealthy Philadelphia manufacturer of railroad car wheels.

Both patrons had well-established reputations as important collectors of European and American art. Both shared a zeal to promote Richards' watercolors to a national public; the latter through vigorous marketing, and the former via gifts to public collections. Moreover, their generous loans to the annual exhibitions of the American Society of Painters in Watercolors from 1872 to 1880 served to establish Richards' reputation in the medium. Richards was elected an active member as early as 1870 but requested instead honorary status. In 1872 he became (and remained) an associate member, exhibiting at the society with some regularity for the rest of his long career.[2] Both Magoon and Whitney—based largely on their holdings of Richards' works—were elected honorary members–connoisseurs in 1874. Between them, by 1880, Magoon and Whitney owned more than 150 exhibition watercolors, the cream of Richards' watercolor production. The disposal of their separate holdings in the first half of the 1880s—Magoon's as gifts to the Metropolitan Museum of Art (1880) and Vassar College (1882) and Whitney's at auction following his death in 1885—virtually marked the end of Richards' peak production years. The saga of this decade and a half of dual patronage, recorded in letters between artist and patrons, and the fate of these two collections are central to a discussion of Richards' career as a painter in watercolors. These well-documented episodes are also instructive in a consideration of the complexity of artist-patron relationships in the late nineteenth century as international market forces began to have an effect on the American art market. The American watercolor movement itself—the sudden rise in popularity of the watercolor medium —may be interpreted as the recognition by artists and dealers of an attractive commodity for the rising middle-class consumer: works of art smaller than oil paintings easily accommodated in modest domestic settings, and much less expensive. Magoon and Whitney also interpreted the implications of this broad appeal in a positive manner. For Magoon it reinforced his belief in democratic trends and in watercolor as an "educational force," and Whitney, who often acted as Richards' sales agent, recognized the financial rewards possible for both artist and patron-investor. The motives of each collector informed his relationship with the artist and influenced not only the choice of medium but the selection of subjects as well. Between them, each in his own way, these collectors provided the catalyst for Richards' extraordinarily rich production in the medium beginning about 1870.

Fig. 18.
William Trost Richards
(1833–1905)
Study of Harebells and Red Clover, 1860
Watercolor and pencil on paper
Brooklyn Museum of Art, 72.32.9, Gift of Edith Ballinger Price

RUSKIN AND TURNER

Richards had used watercolor occasionally in the 1850s for sketching out-of-doors. After 1860, we find watercolor used in combination with pencil for detailed studies of botanical subjects such as *Study of Harebells and Red Clover* (1860; fig. 18). These lovely drawings were made in preparation for oil paintings and watercolors such as *Red Clover, Butter-and-Eggs, and Ground Ivy* (1860; fig. 19) which reflected the artist's Ruskinian preoccupation of that period. About 1857 Richards

had been one of the artists who embraced the English critic John Ruskin's doctrine of absolute truth to nature; an enthusiasm that earned him membership in the short-lived American Pre-Raphaelite movement. Ruskin also presented a persuasive case for the use of watercolor as a major medium for artistic expression, an argument that was instrumental in the rise of American interest in the medium in the 1860s. The Ruskinian circle of artists included watercolor specialists, like Richards, who favored highly detailed landscapes and botanical subjects—among them John William Hill (see cat. nos. 28–30), John Henry Hill (see cat. nos. 31–33), Henry Farrer (see cat. nos. 34, 35), Henry Roderick Newman (see cat. nos. 51–54), and Fidelia Bridges (see cat. no. 15). Ruskin's popular manual, *The Elements of Drawing* (1857), was very influential in the United States during the second half of the nineteenth century. He devoted the last of its three chapters to a detailed discussion of the use of watercolor and its importance. His examples were drawn from the British watercolor school, and his primary, though not only, model for the student was the English master Joseph Mallord William Turner.[3]

Fig. 19.
William Trost Richards
(1833–1905)
*Red Clover, Butter-and-Eggs,
and Ground Ivy,* 1860
Watercolor on paper
The Walters Art Gallery,
Baltimore

Turner's work was already well known in America primarily via reproductive engravings after his oil paintings and the many book illustrations published after his famous watercolor vignettes. Several generations of American painters, beginning with Washington Allston in the 1820s, had found his work compelling.[4] Richards' fellow Philadelphians, James Hamilton (cat. no. 59) and Thomas Moran (see cat. no. 42), were also deeply influenced. Ruskin's ardent defense and eloquent descriptions of Turner's paintings as the epitome of modern landscape practice in the five volumes of *Modern Painters* (1843–60) had familiarized an even wider American public with his work. By 1856 Magoon, an avid Anglophile, had brought the first original watercolors by Turner (acquired on the advice of Ruskin) to America. These five sheets were the gems of a large collection of British watercolors and American paintings then housed in his New York library. Although we associate Turner's watercolors with the nearly abstract veils of colored medium that characterize his late work, the models most admired and emulated by nineteenth-century Americans were like those acquired by Magoon: the meticulous and brilliant watercolors executed to be engraved as vignettes illustrating books of poetry and travel.

In 1864 Magoon sold this collection to Matthew Vassar for twenty thousand dollars to form the core of an art gallery for the latter's recently founded Vassar Female College in Poughkeepsie, New York.[5] Like Ruskin, Magoon fervently believed that works of art could be used not only for aesthetic refinement but for intellectual and moral development as well. "All the best mind of the world," he wrote, "has been expressed in artistic forms, and these are the true exponents of civilization everywhere." His plan for completion of Vassar's art gallery collection included "at least one hundred oil paintings" by European and American masters and, more surprisingly, "at least another hundred water-color pictures would be required." "First," he continued, "because, out of America, [watercolor] is the

best art intrinsically, and, for female culture, it is the best everywhere."[6] Writing in 1864, just before the advent of the American watercolor movement, Magoon's natural focus as a connoisseur was "out of America," on the British watercolor school that had formed the substance of his own collection. His conviction that the medium was the best instrument "for female culture" suggests the persistent association of watercolor with schoolgirl's handiwork even within the progressive sphere of Vassar's experiment in advanced education for young women. At about this time Richards himself was not only much preoccupied with Ruskinian issues but was also teaching. His private pupils included Fidelia Bridges, whose career-long specialization in the watercolor rendering of flowers and birds was based on Ruskin's ideas and Richards' early instruction.[7]

As an ambitious young artist in Philadelphia in the late 1850s, Richards may well have known of Magoon's collection and his Turner watercolors, both of which were covered in the *Crayon* in 1856 and 1857.[8] However, his first opportunity to see original watercolors by the master would come later, in 1866, on a trip abroad financed by George Whitney. On a visit to London, Richards was able to study the famous Turner watercolors at the National Gallery. The Turner Bequest of 1851—a large collection of oil paintings and works on paper left by the artist to the nation—was a mecca for American visitors to that city eager to see the revered works extolled by Ruskin. Early in 1857, the London correspondent William Michael Rossetti reported to the *Crayon*'s readers on the first public access to "a sample of this splendid gift made to England, by one of her noblest sons."[9] Richards' Philadelphia cohort Thomas Moran, for whom Turner would be a lifelong model, had visited the collection in 1861. His fellow American Pre-Raphaelite, John Henry Hill had paid his respects to the English master's watercolor achievement in 1864.[10]

By the time Richards returned from Europe in December 1867, the American Society of Painters in Watercolors had opened its first exhibition in New York. Fresh from London and the Turners, Richards must have been encouraged to use the medium by the highly publicized success of this American venture. His work—*Lake Avernus,* about 1868 (unlocated)—was exhibited for the first time in the third annual of 1869–70. The view of a volcanic lake near Naples had been sold with the help of Whitney soon after completion for a high price of two hundred dollars.[11] Described as "a gem," *Lake Avernus* was greatly admired: "A wide prospect of green-clad hills, and the round lake nestling in their midst like a diamond set in emerald. The whole tone green and juicy, like the beautiful tints of Durand."[12] This watercolor must have been similar (though much larger) to the exquisite little *Torre di Schiavi* of about 1870, another favorite tourist site (cat. no. 60). This domed mausoleum, part of an extensive ancient villa outside Rome, was the most popular ruin after the Claudian aqueduct on the Campagna. The distinctive round tower set against a distant view of the purple-hued Sabine Hills had been painted in oils by American artists from Thomas Cole in the 1830s to Sanford R. Gifford and Thomas H. Hotchkiss in the 1860s.[13] Richards' watercolor interpretation of the famous site on the rolling green expanse of Campagna beneath a canopy of blue sky is based on a small pencil drawing made on the site in 1867 (formerly E. P. Richardson collection).

Magoon, who had taken the pulpit of the Broad Street Baptist Church in Philadelphia in 1867, was already acquainted with Richards' works when the two met in 1870. At that moment, the reverend was attracted by plein-air studies in watercolors the artist had recently executed at Atlantic City.[14] Magoon seems to have determined immediately that he had found an American master of watercolor whose work measured up to the English school—his "American Turner." Years later, with customary grandiloquence, Magoon recalled the compelling impact of that first encounter and recounted the motives that fueled his collecting:

Love of Beauty early led me to seek enjoyment in such transcripts of Nature as my limited resources could command. The passion grew by what it fed on; and, as my collection increased, the delight it both developed and enlivened became intense. It was at the very culmination of that pleasure that Providence put all the material then in hand where its educational force might contribute to the highest culture of many other minds as it had ennobled my own.

Then I resolved to buy no more pictures, but give myself wholly to teaching others. . . . Years elapsed even when near you, before a purpose of long standing was executed in forming your personal acquaintance.

That first interview, so frank and simple, was an event the most pleasing of the kind I have experienced. What chats, tramps, sketchings, love-letterings, and picture-makings we have since perpetrated![15]

Six years after the 1864 sale to Vassar, Magoon was clearly eager to begin collecting anew. Whereas his first collection had held both European and American

works in oil and on paper, Magoon would now focus his energies primarily on a single American artist, acquiring some eighty-five watercolors by Richards over the next decade. The reverend also participated directly in the generation of many of these works, often traveling with the artist on sketching expeditions and dictating the subjects to be painted. In turn, Magoon's enthusiasm and the promise of steady commissions inspired many of the artist's finest works in the medium.

One of these watercolors now in Brooklyn's collection shows the artist at the top of his form. *A High Tide at Atlantic City* (1873; cat. no. 63), is a splendid example of one of Richards's signature subjects and of his watercolor style in the early 1870s. He was among the earliest artists to visit Atlantic City—possibly by 1859 and certainly by 1860. The very recent origin of Atlantic City was in fact the story of a daring capital venture. Philadelphia investors completed a railroad in 1854 to Absecon Island, then a desolate site on the Atlantic Ocean some sixty-two miles from Philadelphia, where the same group had purchased hundreds of acres of oceanfront property. A seaside colony was rapidly developed and with it an appetite for images of the region. By 1873 Richards was identified with New Jersey coastal scenery: the "landscape of . . . Atlantic City." "In his scenes," reported *Lippincott's Magazine,* "we have the infinitude of soft silver beach, the rolling tumultuousness of a boundless sea . . . crests of undulating sand-hills."[16] Richards' works like this one were also very much in keeping with contemporary American watercolor taste for a high degree of finish, combining "the merit of fidelity" with "rare delicacy in touch."[17] These were the works that earned him recognition by 1873 as one of "the best known watercolor painters of America"[18] and were the subjects that first drew Magoon's attention.

Magoon had been born in New Hampshire, however, and his abiding love of the region would also stimulate Richards to return to landscape painting. In April 1872 Magoon wrote to Benson Lossing of his intention to spend most of June in the White Mountains, continuing: "That most admirable Christian artist, William T. Richards proposes to accompany me. What the result may be I cannot say."[19] In fact, Magoon had offered Richards "one hundred dollars per day,

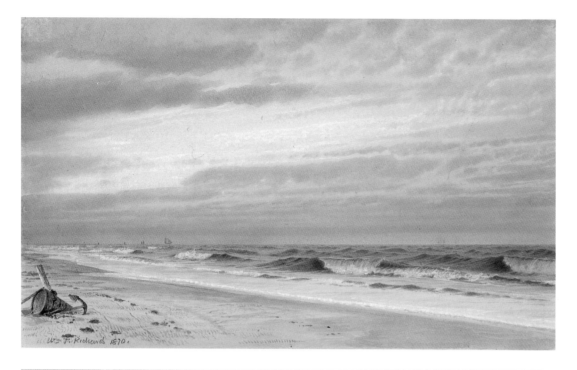

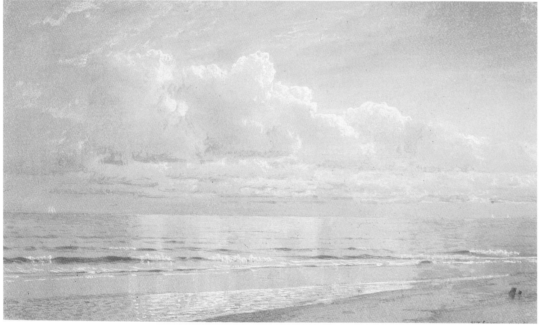

for ten days, if he would go with me and sketch in color from actual scenes of natal interest." By November, Magoon reported, "I am now paying an additional ten hundred to work up as many outlines he took after my commission was filled."[20] Painter and patron made another expedition together in 1874, and a series of White Mountain subjects was executed as portfolio watercolors between 1872 and 1874. One such pencil "outline" (Brooklyn Museum of Art) served as the study for at least two watercolors dated 1874: Magoon's daytime vista of *Lake Winnipiseogee at Weir's Landing* (1874; fig. 20), and a pendant in Brooklyn's

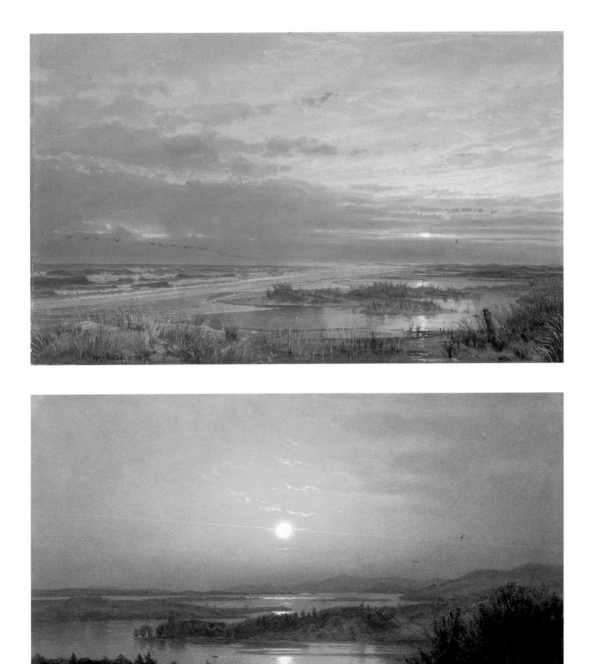

Fig. 20.
William Trost Richards
(1833–1905)
*Lake Winnipiseogee at Weir's
Landing,* 1874
Watercolor on paper
George M. and
Linda H. Kaufman

63 *(opposite, above)*

William Trost Richards (1833–1905). *A High Tide at Atlantic City,* 1873. Opaque watercolor on cream, moderately thick, moderately textured wove paper. 8⁷⁄₁₆ × 13¹⁵⁄₁₆ in. (21.4 × 35.4 cm). Signed and dated lower left: *W. T. Richards 1873.* 86.142, Purchased with funds given by Mr. and Mrs. Leonard L. Milberg

64 *(opposite, below)*

William Trost Richards (1833–1905). *Lake Winnispesaukee at Weir's Landing, Nocturne,* 1874. Transparent and opaque watercolor on a greenish beige, moderately thick, slightly textured wove paper. 8⅞ × 13⅝ in. (22.5 × 34.6 cm). Signed and dated lower right: *Wm T Richards 1874.* 1992.170.1, Gift in memory of Grace Richards Conant

collection showing the very same view (including the train and steamer) by moonlight (cat. no. 64). At Weir's Landing, on what is today known as Lake Winnipesaukee, the trains from Boston discharged passengers for the steamers that took them across the lake to Centre Harbor, the subject of another Magoon watercolor (Metropolitan Museum of Art). From there travelers took the stages for Conway, New Hampshire, and the famous scenery of the White Mountain range to the north. Site-specific subjects such as *A High Tide at Atlantic City* and *Lake Winnipiseogee at Weir's Landing* belonged to the well-established tradition of recording venues along the routes of picturesque excursions (cat. nos. 65, 66).

For Magoon, however, these sites were charged with an even grander significance. The reverend was a messianic believer in both cultural and political manifest destiny, articulating his belief in a book-length sermon published in 1856 under the revealing title *Westward Empire; or, the Great Drama of Human Progress.* He proclaimed that the cycle of history was to culminate in America with the "Age of Washington."[21] Accordingly, he interpreted coastal subjects like *A High Tide at Atlantic City* as the edge of the North American continent charged with national significance echoing the cyclical programs of earlier works of art such as Thomas Cole's *Course of Empire* (1836; New-York Historical Society), and Asher B. Durand's *Progress* (1850; Gulf States Paper Corporation, Tuscaloosa, Alabama). Years afterward, still commissioning marine subjects from Richards, he wrote of the Atlantic coast in 1884: "Out of midnight and nocturnal storm, day rises triumphantly, with radiant beams shooting through ragged and flying squadrons high, as on serried majesties below. That will be your Sea, with all western civilisation to come."[22] The White Mountains, with its famous Presidential Range dominated by Mount Washington, surely appealed to Magoon not only as his "native Granite Hills" but as an embodiment of geography as history.

Magoon also charted a welcome democratic trend in patronage:

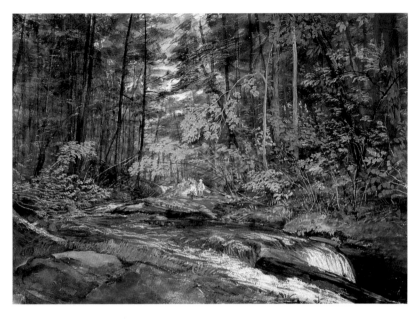

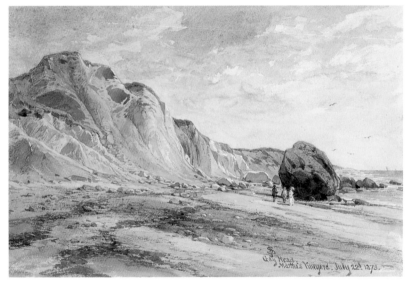

Palaces are emptied of useless princes and unproductive aristocrats, in order that remains of antiquity . . . may find refuge therein, under the protection of the populace who crowd with reverent enthusiasm to their contemplation. . . . Free governments alone afford a soil suitable . . . to the growth of every species of excellence. Therefore no country can be better adapted than our own to afford a final abode for the best speci-mens of the old world as models to the new. . . . We are yet a young people, engrossed with all the distracting cares and toils incident to the primary subjugation of a virgin continent. And yet, perhaps nowhere else are the masses more eager to enjoy beautiful art. Private collections are rapidly multiplying, numerous exhibitions are profusely visited, and public monuments are munificently sustained.[23]

In Philadelphia, Magoon's own collection was displayed in the library of his house at 1319 Girard Avenue. Forty watercolors occupied "all the available wall in

good light" with another fifty-five "mounted under glass" held in cabinets. A printed brochure from the late 1870s catalogues a portion of the collection and announces Magoon's weekly Thursday "Reception" (fig. 21), indicating that he, like other private collectors, made works available to the public on a regular basis by issuing a standing invitation: "These can be studied leisurely by persons who have a special appreciation of sublime scenery, portrayed by superior art." More than a gesture of noblesse oblige, however, public access to his treasures was central to Magoon's democratic beliefs. "More than a thousand intelligent admirers crowded my parlor," he reported proudly in 1883, to view the *Cycle of Universal Culture,* his last important commission for Richards "during the ten days [the watercolors] were on view."[24]

GEORGE WHITNEY

More conventional motives and agendas fueled Richards' long-time friend and patron George Whitney, a steady collector of his paintings since the early 1860s as well as those of other contemporary American and European artists. The splendid art gallery (fig. 22) that adjoined his residence at 247 North Eighteenth Street was, like Magoon's more modest library, open on a limited basis "by presentation of the visitor's card." A Philadelphia guidebook of 1875 described Whitney's "gallery and watercolor room" as "filled with specimens of modern art, well-nigh perfect, and among which selections of American artists are well mingled."[25] First among the Americans represented in the gallery was Richards, with eleven of his most important oil paintings. In 1870, his appetite probably whetted by Magoon's excitement, Whitney also became an enthusiastic collector of Richards' watercolors. We may also speculate that Whitney's accelerated purchases of Richards' watercolors beginning in 1873 were related to the recently built gallery,

Fig. 21.
Pamphlet listing watercolors on exhibition at Elias L. Magoon's Philadelphia residence, c. 1877
Pennsylvania Academy of the Fine Arts Archives

which included an alcove for their display. During the years between 1873 and 1876, Whitney covered the walls of the watercolor room, visible here, with some sixty exhibition watercolors. The sharp reduction in numbers purchased after that date (he bought fewer than twenty over the next six years) suggests that he may simply have run out of wall space. The glimpse of this room offered in the photograph shows framed watercolors hung in double tiers on the wall and stacked on an easel. The alcove also functioned as a music room and conformed to the contemporary custom of hanging watercolors separately from oil paintings. At the time of his death in 1885, Whitney possessed seventy-six exhibition watercolors as well as a fascinating collection of almost two hundred miniature watercolors (fig. 23), the latter a product of their regular correspondence over a decade.[26]

In contrast to Magoon's peripatetic habits, Whitney was largely confined to Philadelphia by pressing business and, later, by poor health. He clearly enjoyed the watercolors not only as works of art but also as a series of vicarious tours to fashionable American watering places from Atlantic City to Newport and, later, as armchair excursions to the famous coastal and historic sites of Great Britain. Artist and patron quickly settled into a mode of correspondence that served the personal and entrepreneurial interests of both. This took the form of richly descriptive letters from the artist, which, beginning in 1875, were accompanied by miniature watercolor compositions duly annotated upon receipt with date and a title by Whitney. These served not only as visual mementos but also as product samples: examples of subjects that would be produced on the scale of portfolio or exhibition watercolors on commission. The designation of these delightful miniatures as "Coupons," in a pun on business parlance, underscores the economic interests that informed the relationship of artist and patron. Both artist and collector seem to have quickly realized the potential of the coupons as stimulants to commissions. Whitney wrote in 1876: "I can quote the market here as being 'active' and Coupons in demand by many admirers who have seen the samples."[27] The finished products were, of course, always on view in Whitney's watercolor room as well.

THE DISCOVERY OF NEWPORT

In 1874 Richards and his family, which now included five children, settled for the summer in a cottage at

Fig. 22. *(above)*
George Whitney's art gallery at his Philadelphia residence with a view of the adjoining watercolor gallery, c. 1885 Photograph by George B. Wood, Jr. (1832–1910) George Whitney Papers, Archives of American Art, Smithsonian Institution

Fig. 23. *(below)*
William Trost Richards (1833–1905)
Coupon of Stonehenge, 1879 Watercolor on paper Manney Collection

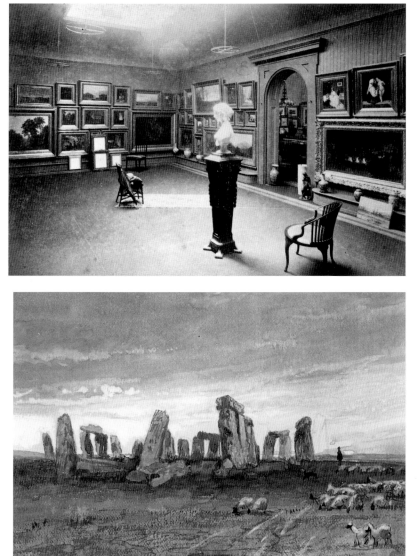

Newport, Rhode Island. Newport's variety of scenery and atmosphere captivated Richards as thoroughly as it had such fellow painters as John F. Kensett, John La Farge, and Worthington Whittredge. In the postwar boom, old towns like Nantucket and Newport were being redefined. Their seaside locales were promoted as therapeutic retreats—physical and spiritual—for urban dwellers. An undifferentiated quaint eighteenth-century past was also exploited as part of the colonial revival. The last quarter of the century has aptly been defined as one of "nostalgic touring."[28] Richards' removal to Newport as a summer outpost signals his embrace of perhaps the most resonant site for picturesque and nostalgic subjects. Newport also provided a population of socially and intellectually prominent patrons. By the end of the first season, Richards determined to make Newport a permanent summer residence, writing to Whitney: "I have made some new walks and discovered new beauties, and believe that I could from Newport scenery make more charming pictures than I have ever dreamed of before."[29] Subsequent summers were spent "prospecting," as he called it, for new subjects, and he filled sketchbooks with studies for oils and watercolors. An important series of Newport watercolors and gouaches executed for both Whitney and Magoon was based on these drawings. Picturesque landmarks on Aquidneck Island—Newport Harbor (cat. no. 67), Sakonnet River (cat. no. 68), and Lily Pond (cat. no. 69)—appear in Richards' repertoire along with subjects drawn from neighboring Conanicut Island, whose rugged headlands and coves provided the artist with an "inexhaustible" source of subjects (cat. no. 70). The island, also known as Jamestown, was already under development in the early 1870s, but the southern end was still wild and uninhabited. It was this area that Richards roamed for inspiration and where he was to select a site in 1881 for a summer house, Graycliff. As usual, Magoon came to participate in the selection of subjects while Whitney remained a prisoner of business in Philadelphia.

A NEW STYLE

In the later 1870s and early 1880s—seeking to work in watercolor more on the scale of oil painting—Richards executed a series of monumental works in a bold combination of transparent and opaque watercolor that marked a deliberate and much admired departure. Richards was undoubtedly referring to his new technique when he wrote to Whitney in August 1876: "I am trying to widen the limits of my material and I am having a hard fight—What with unsuccessful experiments and an ever widening perception of the loveliness of nature and of the utter futility of any material, I am not having a jolly time. I am learning a great deal, probably have never learned more in a summer, but I don't think it shows yet."[30] The addition of Chinese white to watercolor pigments created a medium known as body color, whose characteristics paralleled to some degree the forceful color and density of oil paint. This technical development was embraced by many artists as a distinct advantage over the difficulties and limitations of the

wash or transparent manner. However, the general development in the last quar-
ter of the nineteenth century toward the use of gouache or body color was not
without its critics. The relative merits of transparent and opaque watercolor be-
came a debated issue in America, as it had been for some time in England.

Concurrent with and certainly related to Richards' increasing use of body color
or gouache was his interest in working on a larger scale than the portfolio size pa-
pers traditionally associated with the intimacy of the watercolor medium. Other
Americans, including Thomas Moran (see cat. no. 42), Arthur Parton (see cat.
no. 48), a student of Richards' in the early 1860s, Albert F. Bellows (see cat. no. 36),

67 *(opposite, above)*

William Trost Richards (1833–1905). *Calm before a Storm, Newport,* c. 1874. Transparent and opaque watercolor on cream, moderately thick, moderately textured wove paper. 8¹³⁄₁₆ × 13⁹⁄₁₆ in. (22.4 × 34.4 cm). Signed lower left: *Wm. T. Richards.* 74.30.2, Dick S. Ramsay Fund

68 *(opposite, below)*

William Trost Richards (1833–1905). *The Sakonnet River,* c. 1876. Opaque watercolor over graphite on blue, moderately thick, slightly textured wove paper. 6⅞ × 13¹¹⁄₁₆ in. (17.5 × 34.8 cm). 74.30.3, Dick S. Ramsay Fund

69 *(above)*

William Trost Richards (1833–1905). *Lily Pond, Newport,* 1877. Transparent and dry, opaque watercolor, with possible applications of wetted pastel/chalk on brown, very thick, rough-textured paper ("carpet" paper) formerly mounted to a thick woodpulp board. 22⅞ × 36⅞ in. (58.1 × 93.7 cm). Signed and dated lower center: *W.T. Richards 1877.* 1989.6, Purchased with funds given by Mr. and Mrs. Leonard L. Milberg

70

William Trost Richards (1833–1905). *Rhode Island Coast: Conanicut Island,* c. 1880. Transparent watercolor with touches of opaque watercolor on cream, moderately thick, slightly textured wove paper. 10 x 14⁷⁄₁₆ in. (25.4 x 36.7 cm). 53.229, Bequest of Anna T. Brewster through the National Academy of Design

and Edwin Austin Abbey (see cat. no. 40), were also painting very large water-colors at this time. These works, discussed in chapter 2, were collectively referred to as exhibition watercolors. Richards had discovered a new support that allowed him to work on a grander scale: rolls of a gray-hued textured paper used for lin-ing beneath carpets, which he cut into two-by-three-foot sheets.

Richards' "new style" was very well received in 1877 at the tenth annual exhi-bition of the Water Color Society where he submitted a Newport subject titled simply *A Sketch.* "W. T. Richards appears this year in a new style," commented the *Art Journal,* "worked up on a dark rough paper, which in many places appears in its natural hue, and the artist has very freely used white in the admixture of his colours. . . . The picture is strong, and, while the colour is not warm nor beauti-ful, it is rich and effective." The title itself also signaled that Richards had adopted an advanced style. The deliberately nonspecific title—*A Sketch*—re-moved his view of Paradise Valley from the context of the topographical pic-turesque. His reward was critical admiration focused not on subject matter but, enthused the *Tribune,* on a general effect "which excites the imagination and clings to the memory."[31] Another large painting of that year, *Lily Pond, Newport* (see cat. no. 69), portrays an unconventional terrain handled with a limited breadth and a strong plein air effect. These quiet valleys and freshwater ponds im-mediately adjacent to the ocean were a distinctive aspect of Newport scenery to which La Farge and Kensett had also been drawn.

That summer, Richards happily reported to Whitney about sales to Augusta

Astor and Catherine Lorillard Wolfe: "I do find that the drawings are very popular, and they certainly are more important looking than the small drawings of previous summers."[32] The prominence of such New York patrons signaled that the medium in America had not only become popular but fashionable as well. Richards did not, however, cease working on a small scale, and often these watercolors also demonstrate density and brilliance of hue that reflect the increased use of body color (see cat. no. 68).

ENGLAND AND THE 1880S

By the late 1870s Richards was well known as a skilled interpreter of the American coastline in both oils and watercolors. His fascination with the geological complexities of such terrain undoubtedly played a role in motivating the artist to spend two years exploring the varieties of coastal scenery in England from August 1878 to September 1880. Another catalyst for such an extended tour was a pressing need to expand not only his subject matter but also his market as well in the face of changing American taste. "I am afraid the Time is past," he wrote to Whitney from England, "when the American people can hunger for my pictures if they ever did. I feel that I am an old fogy, and can expect little favor in competition with the new men. If I can be a 'new man' here for a little while it is as much as I dare hope for."[33]

During this two-year period, Richards refreshed his repertoire with excursions along the coasts of Cornwall, Devon, and Dorset. The sketchbooks recording these walking tours are rich with drawings—many enhanced with watercolor—of the spectacular reaches of coastline and the delights of local village color that made these southern counties an artist's destination from the time of Turner. These sketchbooks fueled busy winters in a London studio, where Richards produced oils and watercolors for the American and English exhibitions and dealers. Tintagel, site of King Arthur's legendary castle on the summit of the cliffs of Cornwall, was the destination for several sketching forays. This site vied with Land's End in Richards' estimation as the finest coastal scenery in southern England. For the artist and his audience, the Arthurian associations of the subject had been recently enriched by the publication of Alfred Lord Tennyson's *Idylls of the King*. Richards would treat the subject repeatedly both in watercolors and oil during the 1880s. Our small gouache, *Seascape with Two Figures: Tintagel, Cornwall, England* (cat. no. 71), depicts the spectacular cliffs from below.

Another compelling destination was Salisbury Plain and the famous prehistoric site of Stonehenge. "We spent two days [there]," he reported to Whitney, "I had it on my mind and it took that long to work it off! . . . Stonehenge is more interesting than I had thought it would be; partly because of its lonely situation in the middle of a wide undulating grassy plain. There is no tree or bush within a mile of it; the shepherds drive their flocks on the long slopes, and sunshine and cloud chase each other round the wide horizon. It has that pathetic look peculiar to all human work which has reverted to Nature. Architectural enough to be a

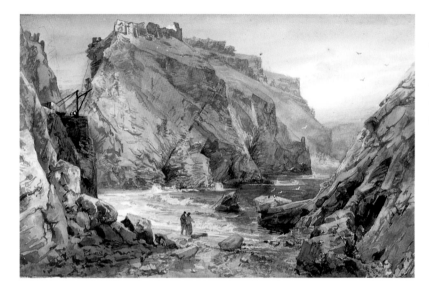

71

William Trost Richards (1833–1905). *Seascape with Two Figures: Tintagel, Cornwall, England,* 1878–80. Transparent and opaque watercolor over graphite on cream, moderately thick, slightly textured wove paper. 6½ × 10 in. (16.5 × 25.4 cm). 1993.212.7, Gift of Edith Ballinger Price

ruin, and as rude and moss covered as though ages ago it had been left by some glacier."[34] The artist's impressions were duly conveyed to Whitney via a coupon as well (see fig. 23). Richards would continue to mine these English studies in both oil and watercolor for the next two decades.

In the early 1880s he developed the subject of Stonehenge into two exhibition watercolors; one for Magoon (private collection) and the other (see cat. no. 58) related to the reverend's last commission for Vassar College: the *Cycle of Universal Culture Illustrated by the Graphic History of English Art.* Our watercolor is a monumental version of Vassar's *Mythical England, Stonehenge* (1882). This suite of seven watercolors, completed in 1882, was intended to represent the history of England embodied in the major monuments of each age and in the historic styles of that nation's great watercolor school.[35] The ideas driving the series once again recapitulated Magoon's premise in *Westward Empire.* Then in his seventies, Magoon retained not only his patriotic positivism but also his love for that most English (and now American) of mediums. In response to both, Richards deliberately affected an old-fashioned style and composition, including a probable nod to the plate depicting Stonehenge in Turner's famous series of mezzotints, the *Liber Studiorum* (1807–19).

Richards had greatly enjoyed renewing firsthand acquaintance with the early English watercolor school during his sojourn. "Indeed there is a great deal to be learned about water colour drawing in London," he wrote to his brother-in-law from England in 1879, "and I wish I had the time to copy some of the Turners which after all are the most consummate pieces of art which have ever been produced in that material."[36] Unbeknownst to the artist, on the other side of the Atlantic, Magoon was about to make a grand philanthropic gesture modeled on the Turner Bequest of 1851 and inspired by his conviction that Richards was the Englishman's American equivalent in the watercolor medium. Shortly before his return, Richards learned that the reverend had presented eighty-five of his water-

colors to the Metropolitan Museum of Art shortly before its opening in New York City's Central Park early in 1880. Magoon's conviction that private collections should be available to "the masses eager to enjoy beautiful art" had motivated him in 1864 to sell his first collection to Matthew Vassar for use in the curriculum of the college. This was not his only agenda. Magoon also believed in a kind of cultural manifest destiny; not only territorial expansion westward but the inevitable appropriation of all earlier art by the United States: "The whole world of ancient art is moving toward this great western theatre of its finest and sublimest development," Magoon had written in 1856. "We believe that this country will yet possess the chief [art] treasures of England, as that mighty nation has heretofore gathered to herself the choicest productions of anterior times."[37] His pioneering efforts to accumulate the watercolors of the English school were partly motivated by this conviction as well as his belief in the watercolor medium as an effective educational vehicle.

The Metropolitan Museum of Art had been founded in 1870; a decade later the collections were moved to Central Park to be housed in the new red brick building designed by Calvert Vaux and Jacob Wrey Mould. These included the Cesnola Collection of Antiquities and a collection of European old masters,[38] undoubtedly harbingers to Magoon of the consolidation of the world's treasures he predicted would take place in the "Age of Washington." Early in 1880, before the new museum opened, Magoon contacted the director, Louis P. di Cesnola, regarding his wish to place the collection in the museum: "Let us begin," he declared, "with a *Richards Gallery* for America, all that the *Turner* is for England."[39]

The gallery installation apparently recapitulated the interior of Magoon's Girard Street library, fulfilling the reverend's dream of unlimited public access: "The Museum, as first opened, promises much. Great numbers attend, especially on free days. . . . Bookcases are going up round the base [of the gallery], about the same proportion to the wall-height as those in my library. From these to the ceiling crimson drapery will be hung, relieving your gems, all of which are in new frames."[40] While the installation delighted the donor, the ersatz domestic environment also served to isolate the watercolors, preserving the traditional media hierarchy within the larger institutional setting. Richards, himself, seems to have felt a certain ambivalence about the whole matter of the gift, reporting to Whitney on his visit: "Met dear Dr. Magoon in N.Y. He was happy over the Drawings in Metropolitan. They do look very nice, I am gladest of all that they have moved people to feel for the good Dr. some of the affection and respect he so well deserves—Oh how I wish the drawings were better."[41] The artist lamented that Magoon had not informed him of the plan. "Had I known of his intention, I would have made some exchanges with him and bettered his collection; but he never hinted of any such thing to me."[42]

The installation opened in October, and "the Richards collection" was politely noted in the press: "They depict various scenes in the White Mountains, on Cape Ann, and in the vicinity of Newport, with the peculiar exquisiteness

that characterizes Mr. Richards's work."[43] In fact, this permanent retrospective of work from the 1870s was a two-edged affair at the very moment when that once-admired "exquisiteness" was no longer current in the context of the rising taste for bravura effects and painterly handling in both watercolor and oil. By 1880 critical opinion and collectors' taste were turning to the broader handling of Winslow Homer and Robert Blum. Richards had recognized the impending state of affairs when he left for England. Magoon's optimism, however, was unshaken. "But my dear cooperative," he reassured the artist after their visit to the Metropolitan Museum, "the best thing for both of us, ultimately will be the 'Metropolitan' affair. Art in America will grow. . . . *But we were in at the start!* . . . Thousands will come in contact with you daily."[44] Ironically, by this time, Richards' watercolor production had slackened considerably, and the momentum of the movement itself would begin to decline within a very few years. The decade also took a heavy toll among the artist's circle of friends and patrons. A year before Magoon's death in 1886 at the age of seventy-six, Richards suffered an even more profound and premature loss.

THE WHITNEY SALE

On March 6, 1885, George Whitney died in Philadelphia. The funeral service was at home. Richards was a pallbearer. "The remains reposed in a cloth-covered, silver-mounted casket, in Mr. Whitney's art gallery."[45] The setting was a fitting one because it marked the beginning of the end for that important private collection. Whitney had been in considerable debt. Nine months later, the entire collection of 106 American and 146 European paintings would be placed on exhibition in New York at Chickering Hall before a three-night sale mandated to meet the estate's financial obligations. The concentration of eighty-seven oils and watercolors by Richards was inevitably remarked on. The artist was again subjected to the scrutiny of the press, this time under far less positive circumstances. "The large collection of water colors by William T. Richards forms a distinct feature of this collection," reported one Philadelphia paper, "Mr. Whitney was sometimes credited with having 'discovered' Mr. Richards."[46] Reflecting on the much-discussed artistic generation gap, the *New York Evening Post* wrote: "No better chance could possibly be found for a voyage of discovery into the past of American art—a past so recent that most of these men are living and painting to-day, and yet so far away that these . . . [artists] seem infinitely more remote from the young painter of to-day than Franz Hals or Velasquez."[47] It cannot have been a pleasant thing for Richards—with some twenty years of painting ahead of him—to be consigned to the role of a "venerable ancestor."

Samuel P. Avery, the prominent dealer and an old friend of both Whitney and Richards, arranged the auction and tried to place the best light on the Richards holdings. A supplemental catalogue was prepared, illustrated by the artist with

Fig. 24.
Title page with a vignette by
William Trost Richards from
the illustrated catalogue
*The Works of Mr. Wm. T.
Richards in the Collection
of . . . Mr. George Whitney,
of Philadelphia,* December
8–16, 1885
Private Collection

pen drawings after his watercolors and further embellished with his commentary on a number of works (fig. 24). "You know how sad I am that the pictures must now be scattered," Richards wrote to Avery. "Wherever they may go, I hope that their sincerity at least will prove them to be worthy of the influences which have had so much to do with whatever of value there may be in my work."[48] Predictably, however, the forced sale at one time of so many works already out of fashion was a financial disaster for the estate and a severe critical blow to Richards' reputation.[49]

REDISCOVERY

Nevertheless, efforts continued in this century to place work in public collections. The first watercolors to join this collection came from the bequest of the artist's daughter, Anna Richards Brewster (1870–1952). In 1952 she sought to give her share of the Richards estate (one-fifth of the drawings, sketchbooks, watercolors, and paintings in the Newport studio when the artist died in 1905) to the National Academy of Design.[50] More than five hundred works were accepted by the academy for distribution to museum collections through the country, including this one. Later generations of the artist's family have continued to enrich and expand Brooklyn's holdings: in the 1970s with Edith Ballinger Price, a granddaughter of the artist, and continuing in the 1980s with gifts from the family of another granddaughter, Grace Richards Conant. Richards' watercolors are also well represented in the collections of the Museum of Fine Arts, Boston; the National Academy of Design; and the Cooper-Hewitt, National Design Museum, Smithsonian Institution. The Metropolitan Museum of Art also remains a repository of some of Richards' finest watercolors. Such a large body of accomplished work leaves no doubt that the medium should be considered as important a part of Richards' total achievement as it is of Homer's, Sargent's, and Eakins'. Lauded during the artist's lifetime and later forgotten, these beautiful works are a wonderful rediscovery. Some of the best among them are included here from the exquisite portfolio watercolors of the early 1870s to the masterful large exhibition watercolors of 1877 and 1882.

NOTES

1. For Richards' watercolors see Museum of Fine Arts, Boston, *M. & M. Karolik Collection of American Water Colors and Drawings, 1800–1875* (Boston: Museum of Fine Arts, Boston, 1962), vol. 1, 264–66; Linda S. Ferber, *William Trost Richards: American Landscape & Marine Painter, 1833–1905,* exh. cat. (Brooklyn Museum, 1973); Barbara Novak and Annette Blaugrund, *Next to Nature: Landscape Paintings from the National Academy of Design* (New York: National Academy of Design, 1980), exh. cat., 132–47 (hereafter Novak and Blaugrund); Linda S. Ferber, *William Trost*

Richards (1833–1905): American Landscape and Marine Painter (New York: Garland Publishing, 1980), 259–98 (hereafter Ferber 1980); Kathleen A. Foster, "Makers of the American Watercolor Movement, 1860–1890," (Ph.D.diss., Yale University, 1982), 101–60 (hereafter Foster 1982); Linda S. Ferber, *"Never at Fault": The Drawings of William Trost Richards,* exh. cat. (Yonkers: Hudson River Museum, 1986); *American Watercolors from the Metropolitan Museum of Art* (New York: American Federation of Arts, in association with Harry N. Abrams, 1991), 87–88; Sue Welsh Reed and Carol Troyen, *Awash in Color: Homer, Sargent, and the Great American Watercolor* (Boston: Museum of Fine Arts, Boston, in association with Bulfinch Press, Little, Brown, 1993); Carol M. Osborne, "William Trost Richards's Drawings at Stanford," *Drawing* 14 (March–April 1993), 121–24; Dita Amory and Marilyn Symmes, *Nature Observed, Nature Interpreted: Nineteenth-Century American Landscape Drawings and Watercolors from the National Academy of Design and Cooper-Hewitt National Design Museum, Smithsonian Institution,* exh. cat. (New York: National Academy of Design, 1995), 120–46.

2. The society's minutes record one side of an interesting dialogue with the artist. February 1, 1870: "The following gentlemen were then elected . . . W. T. Richards as active members;" May 3, 1870: "a letter from Mr. W. T. Richards, Phil. asking to be made an honorary member instead of active"; February 7, 1871: "Mr. W. T. Richards of Philadelphia having declined to become an active member of this society, was unanimously elected Honorary Member." AWS Minutes, roll N68-8, frames 440, 441, 446. Richards' reluctance to join the society was without doubt related to his current embroilment in what he termed "Art politics" in a dispute between the Philadelphia Artists' Fund Society and the Pennsylvania Academy of the Fine Arts. In June 1870 he resigned from the latter and announced his intention "to retire from membership in all Art Associations." See Ferber 1980, 179–80 and 202–5 nn. 8–10.

3. For Richards as an American Pre-Raphaelite and the movement in general, see Ferber 1980, 127–77, and Linda S. Ferber and William H. Gerdts, *The New Path: Ruskin and the American Pre-Raphaelites,* exh. cat. (New York: Brooklyn Museum and Schocken Books, 1985) (hereafter Ferber and Gerdts 1985). For Ruskin and watercolor, see Foster 1982 and Foster, "The Pre-Raphaelite Medium: Ruskin, Turner, and American Watercolor," in Ferber and Gerdts 1985, 79–107.

4. For American response to Turner in the first half of the nineteenth century, see Marcia Briggs Wallace, "The 'Great Bear' and 'the prince of evil spirits': The American Response to J. M. W. Turner before the Advent of John Ruskin" (Ph.D. diss., City University of New York, 1993).

5. For Magoon's collection, see Ella M. Foshay and Sally Mills, *All Seasons and Every Light: Nineteenth-Century American Landscapes from the Collection of Elias Lyman Magoon,* exh. cat. (Poughkeepsie, N.Y.: Vassar College Art Gallery, 1983) (hereafter Foshay and Mills 1983).

6. "Report of the Committee on the Art Gallery of Vassar Female College, 1864," reprinted in Vassar College Art Gallery, *Selections from the Permanent Collection* (Poughkeepsie, N.Y.: Vassar College Art Gallery, 1967), xi–xiii. Although the committee consisted of five members, Magoon's language and ideas inform the plan.

7. For Bridges, see May Brawley Hill, *Fidelia Bridges: American Pre-Raphaelite,* exh. cat. (New Britain, Conn.: New Britain Museum of American Art, 1981).

8. "Sketchings. Our Private Collections. No. VI. [Rev. E. L. Magoon]," *Crayon* 2 (December 1856), 374; "Gleanings and Items," 3 (May 1857), 158.

9. William M. Rossetti, "Foreign Correspondence, Items, etc.: The Turner Bequest," *Crayon* 4 (January 1857), 23–24.

10. Ferber and Gerdts 1985, 273 and 166.

11. William T. Richards to George Whitney, January 26, 1869, William Trost Richards Papers, Archives of American Art, Smithsonian Institution (hereafter Richards Papers AAA), quoted in Ferber 1980, 267, 293.

12. "Art. The American Society of Painters in Water Colors," *Aldine* 7 (May 1875), 340. The *New York Tribune* had praised *Lake Avernus* for its "delicious general effect" when it was shown in 1870. *New York Daily Tribune,* February 12, 1870, 1, quoted in Foster 1982, 119 .

13. Charles C. Eldredge, "Torre dei Schiavi: Monument and Metaphor," *Smithsonian Studies in American Art* (fall 1987), 15–33.

14. This author and others have long assumed that Richards and Magoon met in Atlantic City. This is based on the narrative offered by the Metropolitan Museum of Art: "Mr. Richards, while spending the summer of 1870 at Atlantic City, made several water-color sketches as notes for oil paintings. Some of the sketches being seen by Dr. E. L. Magoon at his first interview with the artist, the present collection was then and there begun." The Metropolitan Museum of Art, *Handbook No. 6: Loan Collection of Paintings, in the West Galleries,* exh. cat. (New York: Metropolitan Museum of Art, 1881), 27. It is more likely, however, that the two actually met in Philadelphia through the agency of mutual acquaintances in that city's art circles. Magoon's language implies such.

15. Elias Lyman Magoon to Richards, May 4, 1875, roll 2296, frames 355–57, Richards Papers AAA.

16. "A New Atlantis," *Lippincott's Magazine of Popular Literature and Science* (June 1873), 612.

17. *New York Daily Tribune,* February 15, 1872, 2, quoted in Foster 1982, 122.

18. "Art: The Exhibition of Water Colors," *Aldine* (April 1873), 87, quoted in Ferber 1980, 274.

19. Magoon to Benson Lossing, April 10, 1872, Elias Lyman Magoon Papers, Special Collections, Vassar College Library, Poughkeepsie, N.Y. I am grateful to Meredith Ward for bringing this letter to my attention and for access to her unpublished seminar paper, "'The mighty power of eye and heart': Elias Lyman Magoon as a Patron of Watercolors" (Columbia University, 1994).

20. Magoon to Martin Brewer Anderson, November 11, 1872, Anderson Papers, Department of Rare Books and Special Collections, University of Rochester Library, Rochester, N.Y.

21. Magoon, *Westward Empire; or, the Great Drama of Human Progress* (New York: Harper & Bros., 1856) (hereafter Magoon 1856).

22. Magoon to Richards, April 15, 1884, roll 2296, frames 946–47, Richards Papers AAA.

23. Magoon 1856, 385–86.

24. Magoon to Anderson, April 2, 1883, Anderson Papers, Department of Rare Books and Special Collections, University of Rochester Library, Rochester, N.Y.

25. For Whitney's collection of American and European paintings, see Linda S. Ferber, *Tokens of a Friendship: Miniature Watercolors by William T. Richards* (New York: Metropolitan Museum of Art, 1982), exh. cat. (hereafter Ferber 1982).

26. Ferber 1982 catalogues and documents the collection of "Coupons."

27. Whitney to Richards, July 12, 1876, roll 2296, frames 432–34, Richards Papers AAA.

28. Dona Brown, *Inventing New England: Regional Tourism in the Nineteenth Century* (Washington: Smithsonian Institution Press, 1995), 8–9 and throughout.

29. Richards to Whitney, August 23, 1874, roll 2296, frames 333–40, Richards Papers AAA. See also Linda S. Ferber, "William Trost Richards at Newport," *Newport History, Bulletin of the Newport Historical Society* 51 (winter 1978), 1–15.

30. Richards to Whitney, August 20, 1876, roll 2296, frames 440–42, Richards Papers AAA.

31. Susan Nichols Carter, "The Tenth Annual New York Water-Color Exhibition," *Art Journal*, n.s., 3 (1877), 96; "Tenth Exhibition of the Water-Color Society," *New York Daily Tribune*, January 22, 1877, 3.

32. Richards to Whitney, October 1, 1877, roll 2296, frames 513–15, Richards Papers AAA.

33. Richards to Whitney, July 1, 1879, roll 2296, frames 669–74, Richards Papers AAA.

34. Richards to Whitney, October 29, 1878, roll 2296, frames 582–85, Richards Papers AAA.

35. For the *Cycle of Universal Culture*, see Ferber 1980, 330–34, 344–45, 567–70; Foster 1982, 155–58, 160; Foshay and Mills 1983, 81–83.

36. Richards to Charles Matlack, November 26, 1879, collection Timothy Matlack Warren.

37. Magoon 1856, 384–85.

38. Calvin Tomkins, *Merchants and Masterpieces: The Story of the Metropolitan Museum of Art* (New York: E. P. Dutton, 1970), 35, 41, 56–58.

39. Magoon to General di Cesnola, February 18, 1880, Metropolitan Museum of Art Archives, quoted in Stuart P. Feld, "Two Hundred Years of Water Color Painting in America," *Antiques* 90, no. 6 (December 1966), 841.

40. Magoon to Richards, May 19, 1880, roll 2296, frames 779–80, Richards Papers AAA.

41. Richards to Whitney, October 29, 1880, roll 2296, frames 819–22, Richards Papers AAA.

42. Richards to Whitney, March 17, 1880, roll 2296, frames 761–64, Richards Papers AAA.

43. American Art Chronicle: Museums and Collections," *American Art Review* 2 (1880), 36.

44. Magoon to Richards, November 9, 1880, roll 2296, frames 826–7, Richards Papers AAA.

45. "Funeral of George Whitney," *Philadelphia Public Ledger and Daily Transcript,* March 11, 1885, 4.

46. "Mr. Whitney's Pictures," unidentified Philadelphia newspaper [November] 1885. Author's files.

47. "The Whitney Collection," *New York Evening Post,* December 9, 1885.

48. Richards to Samuel P. Avery, November 10, 1885, quoted in the American Art Association, New York, *The Works of Mr. Wm. T. Richards in the Collection of American and Foreign Paintings to Be Sold on Account of the Estate of the Late George Whitney, of Philadelphia,* December 16–18, 1885, 4.

49. Ironically, Magoon's Richards Gallery would also be dispersed. After being exhibited together for many years, most of the watercolors were deaccessioned by the Metropolitan Museum and sold at auction in 1929. American Art Association, New York, *Paintings Including Seventy-Five Watercolors by William Trost Richards, N.A. Property of the Metropolitan Museum of Art. Sold by Order of the Trustees,* February 7, 1929, nos. 1–32.

50. For the Brewster Bequest, see Novak and Blaugrund 1980, 51–52.

WATERCOLORS BY WINSLOW HOMER AT THE BROOKLYN MUSEUM OF ART

LINDA S. FERBER

Winslow Homer (1836–1910). *Fresh Air,* 1878. Watercolor with opaque white highlights over charcoal on cream, moderately thick, rough-textured wove paper. 20¹⁄₁₆ × 14 in. (51 × 35.6 cm). Signed and dated lower right: *Winslow Homer / 1878.* 41.1087, Dick S. Ramsay Fund

During a career spanning more than fifty years, Winslow Homer (1836–1910) produced approximately three hundred oil paintings and more than double that number of watercolors.[1] By the 1890s the latter were as eagerly sought by admirers as his oils. Homer's prediction, "You will see, in the future I will live by my watercolors," has proven to be accurate.[2] What the artist might well have meant by "live" in this oft-quoted remark was to "make a living"—always a preoccupation for the businesslike Homer. In the grander sense one can also argue strongly that watercolors are, indeed, the medium in which Homer "lives" and is, perhaps, most widely known today. While the major private collectors of his day and ours have always vied for his works, Homer's standing in the public memory as a "national" painter is enshrined primarily in the holdings of American art museums. During the artist's lifetime, beginning in 1890, his oil paintings entered public collections in Milwaukee, Boston, and Philadelphia as well as in New York, Washington, and Brooklyn. In 1909 former mayor of Brooklyn Charles Schieren (1842–1915) presented Homer's early painting *The Unruly Calf* (1875; private collection) to the Brooklyn Institute of Arts and Sciences.[3] The first Homer watercolor to enter a public collection was acquired in 1894 by the Museum of the Rhode Island School of Design in Providence; in 1899 the Museum of Fine Arts, Boston, accessioned its first Homer watercolors.[4] The Metropolitan Museum of Art bought twelve watercolors just before the Winslow Homer memorial exhibition held there in 1911.[5] That exhibition paid tribute to Homer's achievement in watercolor; it included some twenty-eight in an exhibition of fifty-one works. Boston's memorial exhibition, held at the same time, included fifty-two watercolors among fifty-nine works.[6] These major retrospectives organized by museums in the two cities in which he had conducted his career consolidated Homer's already

unassailable reputation as a great American artist. William Howe Downes's biography, *The Life & Works of Winslow Homer,* published in 1911, was an early and distinguished entry in a still-steady stream of what that author coined "Homeriana" devoted to the appreciation and study of Homer's achievement.[7]

Less known is the early role in securing Homer's place in the pantheon played by the museum of Brooklyn's recently expanded Institute of Arts and Sciences through the purchase of a dozen watercolors early in 1912. Ranging in date from about 1885 to 1904, and including Caribbean, Florida, Canadian, and Maine subjects, these works form the core of today's well-known collection of twenty-three watercolors.[8] As significant an event as that purchase, and virtually forgotten today, was Brooklyn's organization in 1915 of the first museum exhibition devoted to a comprehensive look at nearly seventy watercolors by Homer dating from 1873 to 1904. This landmark survey exhibited a number of works apparently never shown before and offered the public of 1915 their first in-depth look at Homer's early watercolors of the 1870s. *Water Colors by Winslow Homer* attracted nearly as much attention in the press and among critics as the memorial retrospectives held four years before. An element of the excitement generated by the exhibition, on view in the fifth-floor American painting galleries from October 16 to November 7, was the fact that not far from this temporary installation was displayed Brooklyn's famous collection of watercolors by another American artist celebrated for his work in the medium, John Singer Sargent (see fig. 25).

This chapter considers the reception of Homer's watercolors by attempting to reconstruct the moment and the motives that led to the purchase of 1912 and the exhibition of 1915. First, it describes the milieu and speculates about the incentive for the purchase—one of the earliest from Homer's estate. It then suggests the role these motives played in stimulating the exhibition several years later. Next, it observes response to the exhibition as an agent in the process of forming public opinion about the relative merits of Homer's oils and watercolors. The criticism and commentary generated by Brooklyn's exhibition also introduced Homer's watercolors into the then-heated debate on modernism. Last, we will consider Homer's work in the context of cultural nationalism, speculating about the popular compulsion (which continues) to interpret him in opposition to Sargent who was cast as the ultimate cosmopolitan.

THE PURCHASE OF 1912

The Brooklyn Museum's dramatic and much-publicized acquisition of eighty-three Sargent watercolors in 1909 was doubtless one of the elements stimulating the Homer purchase. Less than two years later, executive committee minutes for January 9, 1912, authorized the purchase of twelve watercolors from the artist's estate for six thousand dollars (cat. nos. 73–78). Part of the price was to be provided by Museum funds, and the balance was to be raised by subscription.[9] The transaction was duly reported to the institute trustees by William H. Crittenden

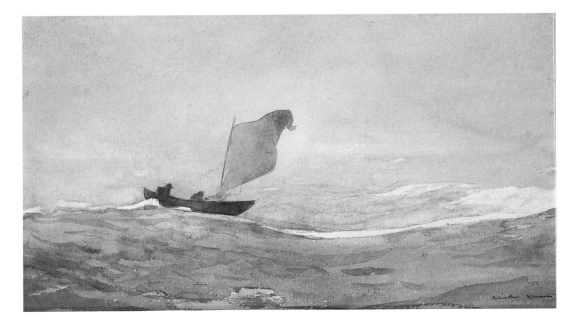

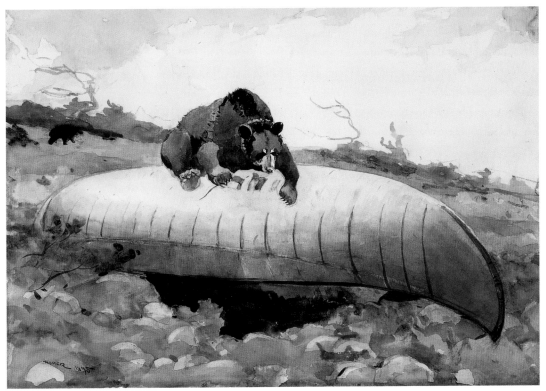

73 (above)

Winslow Homer (1836–1910). *Blown Away*, c. 1888. Watercolor over graphite on off-white, thick, rough-textured wove paper. 10⅛ × 19 1/16 in. (25.7 × 48.4 cm). Signed lower right: *Winslow Homer*. 11.543, Museum Collection Fund and Special Subscription

74 (below)

Winslow Homer (1836–1910). *Bear and Canoe*, 1895. Watercolor with touches of gum varnish over graphite on cream, moderately thick, moderately textured wove paper. 14 × 20 in. (35.6 × 50.8 cm). Signed and dated lower left: *Homer 1895*. 11.541, Museum Collection Fund and Special Subscription

(1859–1947), acting chairman of the Committee on the Museum, at the board meeting on February 9.[10] Arrangements for George F. Of (1876–1954), an artist who ran a framing business in New York, to prepare the works for display were approved by the executive committee on February 13.[11] On May 5, the *Brooklyn Daily Eagle* informed readers of the coup: "A group of striking water color paintings by Winslow Homer recently acquired by the Brooklyn Institute directors, are now on exhibition in the Museum Gallery of American Painters."[12] Brooklyn pioneered among museums in 1907 by establishing a separate suite of skylit galleries in the Museum's west wing for the display of American works, a focus that provided another reason to pursue works by an artist already hailed as a national treasure.[13]

Immediately after Homer's death late in 1910, museums competed for those watercolors left in the artist's possession. Downes quotes the New York dealer William Macbeth's recollections of a visit to the artist at his Prout's Neck studio the summer before Homer's death: "There were a few unframed watercolors and perhaps a dozen others, framed and on his walls, that stirred and delighted me beyond measure. He told me of their expected destination, and I knew that he would never part with them during his lifetime."[14] Charles S. Homer Jr. (1834–1917), the artist's brother, heir, and executor of his estate, oversaw the sales of watercolors to public collections after Homer's death. Homer himself had promised the Metropolitan Museum of Art access to the works held in the Prout's Neck studio, probably the very ones noted by Macbeth. The Worcester Art Museum negotiated for a dozen watercolors with Homer's New York gallery, M. Knoedler & Company.[15]

The Brooklyn Institute trustees, however, approached the artist's estate directly. The Homer family had connections in Brooklyn. Trustees may have been acquainted with the artist's uncle, Arthur W. Benson (1814–89), who had been president of the Brooklyn Gas Light Company and a resident of Brooklyn Heights.[16] Charles Homer, Jr., who lived in New York City, also had business interests in Brooklyn, as a principal in the firm Valentine & Company, producers of fine coach varnishes.[17] About 1872 the senior Homers moved from Belmont, Massachusetts, to Brooklyn, living at several addresses in the neighborhood of Brooklyn Heights until Mrs. Homer's death in the spring of 1884.[18] Henrietta Maria Benson Homer (1809–84) had been an amateur watercolor flower painter who exhibited in the 1870s and 1880s at the Brooklyn Art Association, as did her son.[19] There is no record that Winslow Homer ever visited the new Museum building, which had opened in 1897 on Eastern Parkway near Prospect Park, although he was probably aware of the Brooklyn Institute at its former location on Washington Street. William Henry Goodyear (1846–1923), a Yale-trained scholar and curator of fine arts at Brooklyn since 1899, had met Homer only once: "The only personal memory which the writer has of Winslow Homer," he recalled in 1912, "is that of spending an evening with a small company of artists and Bohemians—perhaps half a dozen people—in the late seventies, when during the

75 *(opposite, above)*

Winslow Homer (1836–1910). *Shore at Bermuda*, c. 1899. Formerly *Shore at Nassau*. Watercolor over graphite on off-white, moderately thick, moderately textured wove paper. Partial watermark: J WHAT. $13^{15}/_{16}$ x $21^{1}/_{16}$ in. (35.4 x 53.5 cm). Signed lower right: *Homer*. 11.539, Museum Collection Fund and Special Subscription

76 *(opposite, below)*

Winslow Homer (1836–1910). *Shooting the Rapids*, 1902. Transparent watercolor over graphite on off-white, moderately thick, moderately textured wove paper. Partial watermark: AN 1901. $13^{15}/_{16}$ x $21^{13}/_{16}$ in. (35.4 x 55.4 cm). Signed and dated lower right: *Homer / 1902*. 11.537, Museum Collection Fund and Special Subscription

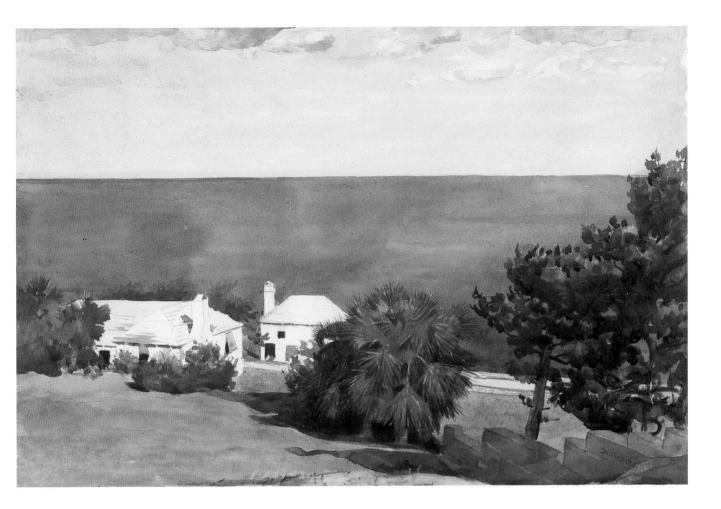

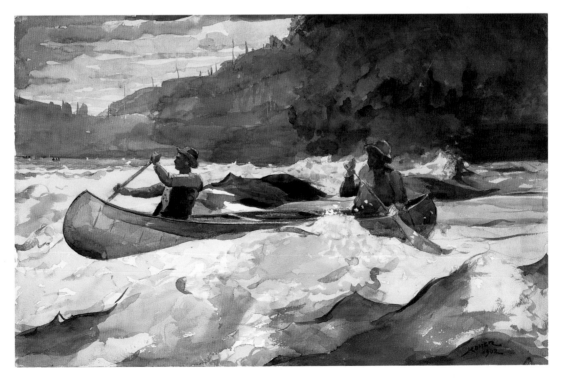

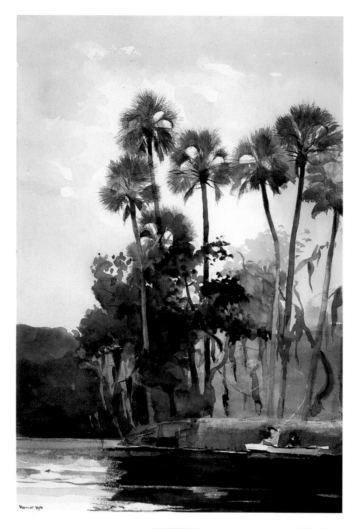

77 (left)

Winslow Homer (1836–1910). *Homosassa River,* 1904. Watercolor over graphite on cream, moderately thick, moderately textured wove paper. 19¹¹⁄₁₆ × 13⅞ in. (50 × 35.2 cm). Signed and dated lower left: *Homer 1904.* 11.542, Museum Collection Fund and Special Subscription

78 (below)

Winslow Homer (1836–1910). *In the Jungle, Florida,* 1904. Transparent watercolor with touches of opaque watercolor over graphite on off-white, moderately thick, moderately textured wove paper. 13¹⁵⁄₁₆ × 19¹¹⁄₁₆ in. (35.4 × 50 cm). Signed and dated lower left: *1904 HOM [ER].* 11.547, Museum Collection Fund and Special Subscription

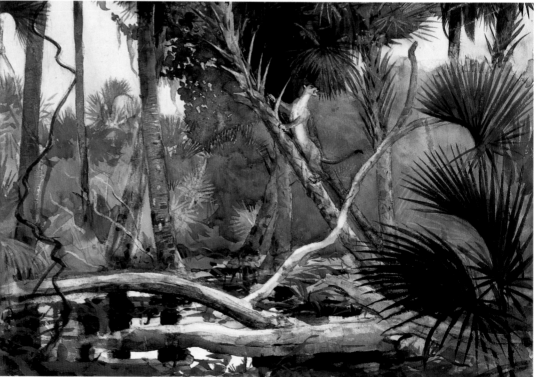

entire evening Homer did not open his lips."[20] As a scholar, however, Goodyear had lauded Homer's work and reproduced three of his oil paintings in his 1894 art historical survey, *Renaissance and Modern Art*.[21]

A number of institute trustees and Brooklyn collectors also admired Homer's work. These trustees included Schieren, whose gift of 1909 has been mentioned, and Walter H. Crittenden. Crittenden, a Brooklyn lawyer and active trustee for many years, seems to have taken the lead in the matter of the purchase. Frank Lusk Babbott (1854–1933), who would join the board in 1915, had several years earlier purchased Homer's oil painting *Driftwood* (1909; Museum of Fine Arts, Boston), from Knoedler. Both he and William A. Putnam (1848–1936), Crittenden's brother-in-law, who would join the board in 1914, may already have owned the Homer watercolors they would lend to the 1915 exhibition. Sidney B. Curtis (1887–1950) was a financier and member of an old Brooklyn family that had owned three watercolors since 1906. At that time his mother, Grace, a native of Maine and then in failing health, had corresponded with Homer about the possibility of acquiring a Prout's Neck subject. Homer responded by sending her, with his "compliments[,]three sketches of the Maine coast." "I am quite through with them," the artist had written, "and I take pleasure in presenting them to you." The exchange of letters had been published in Downes's book to demonstrate the "tender and beautiful side" of the artist's character.[22] These "sketches" must be the three Prout's Neck watercolors of 1883 left to the Museum by Curtis

79

Winslow Homer (1836–1910). *Maine Cliffs,* 1883. Watercolor over charcoal on cream, thick, rough-textured wove paper. 13⅜ × 19³⁄₁₆ in. (34 × 48.7 cm). Signed and dated lower right: *Homer 1883*. 50.184, Bequest of Sidney B. Curtis in memory of S. W. Curtis

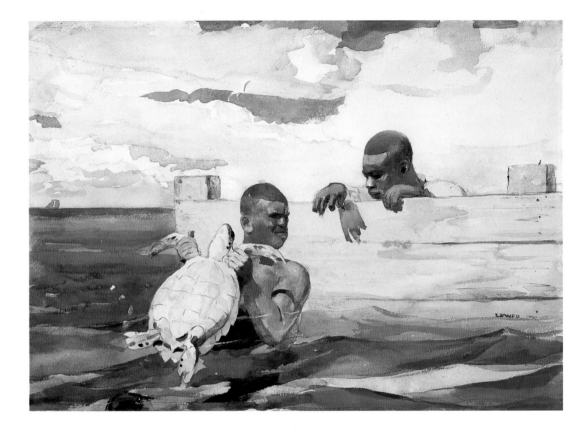

80

Winslow Homer (1836–1910). *The Turtle Pound*, 1898.
Watercolor over graphite on off-white, moderately thick,
rough-textured wove paper. Partial watermark: MAN 189[8?] /
B. 14¹⁵⁄₁₆ × 21⅜ in. (37.9 × 54.3 cm). Signed and dated lower
right: *Homer 1898*. 23.98, Sustaining Membership Fund, Alfred
T. White Memorial Fund, A. Augustus Healy Fund

in 1950: *Through the Rocks* (see fig. 40), *Maine Cliffs* (cat. no. 79), and *The North-easter*. Hamilton Easter Field (1873–1922), the artist and critic who had lent *The Turtle Pound* (1899; cat. no. 80) to the Metropolitan Museum's 1911 memorial exhibition, came from a family long resident in Brooklyn Heights.[23]

The May 1912 Museum *Bulletin* featured an article by Goodyear about the recent purchase. Goodyear quoted Downes's biography of Homer at length, emphasizing both the "national" and strongly "individual" character of these works. "The present purchase," Goodyear continued, "adds materially to the importance of the Museum's own collections and also offers a valuable supplement to the fine examples in the Metropolitan Museum."[24] The Metropolitan's dozen watercolors included nine Caribbean subjects, two Florida subjects, and a single Adirondack theme. Brooklyn's dozen had been selected, according to Goodyear, as "typical" watercolors covering, like those acquired by the Metropolitan, the last two decades of Homer's career. Works ranged in date from 1885 to 1904 and were slightly more varied in subject matter, deriving from the artist's sojourns in Florida, the Bahamas, Canada, and at Prout's Neck. Goodyear also ranked the watercolors by dividing them into several types, interpreting them according to a hierarchy that seems to have been based on his estimation of their degree of finish. One wonders whether he might also have discussed these works with Charles Homer, who readily provided information about dates and exhibition records. First and foremost were four "collector's pictures," compositions Goodyear con-

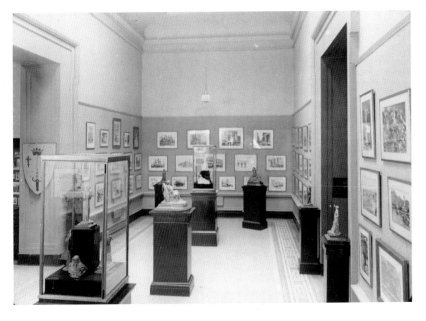

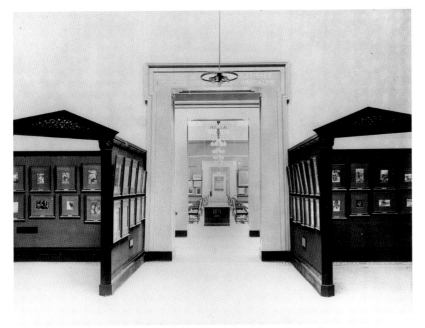

Fig. 25. *(above)*
Installation of watercolors
by John Singer Sargent and
sculptures by Bessie Potter
Vonnoh, c. 1913
Brooklyn Museum of
Art Archives

Fig. 26. *(below)*
The Tissot Gallery, after
1900
Brooklyn Museum of
Art Archives

sidered "equal to any that the artist ever painted." They included *Blown Away* (cat. no. 73) and *Shooting the Rapids* (cat. no. 76). Then came four "artist's pictures"—in Goodyear's terms "color sketches of high rank"—among them *In the Jungle* and the other Florida subjects. Next were three "painter's sketches," which the curator believed had been "made as memoranda for practice, or for later development into pictures"—which included *Shore at Bermuda*. Goodyear's commentary suggests that Brooklyn's selection was intended to satisfy standards of connoisseurship and also to offer some insight to Homer's working process. *Bear and Canoe* was singled out by Goodyear as "a well executed color sketch, apparently of a semi-humorous character."[25] A note in the Museum *News* several months after the purchase went on view acknowledged recent loans of additional works by Homer, five watercolors and an oil painting, and suggested another rationale for building the holdings of Homer watercolors. "With these additions the Winslow Homers in the American Gallery have an importance balancing the water colors by Sargent in the permanent possession of the Museum."[26] Early in 1909 A. Augustus Healy (1850–1921), president of the institute, had made headlines by masterminding Brooklyn's acquisition of all but three of Sargent's watercolors then on exhibition in the New York galleries of M. Knoedler & Company. The internationally acclaimed portrait painter's American debut in watercolors that February had been an event attended by great fanfare in the press, among critics and, one assumes, fellow artists. Alfred Stieglitz recollected the event: "Sargent! A name to conjure with. These were the famous water colors. Every American has heard about them. I had seen them when originally shown at Knoedler's. I remember the crowds. Men and women. Fashionable ones. The hushed excitement."[27] Knoedler happened to be Winslow Homer's dealer as well. On February 20 *American Art News* reported: "Winslow Homer was in town this week and visited the Knoedler Galleries. He looked and seemed well."[28] Homer probably knew that the entire Sargent exhibition had been purchased by the Brooklyn Institute of Arts and Sciences for twenty thousand dollars that same month. The artist may also have been aware of Brooklyn's equally celebrated earlier purchase

in 1900 of James Jacques Tissot's *Life of Christ* series, a modern interpretation of the New Testament story in 345 carefully researched and highly detailed opaque watercolors (fig. 38). These had been acquired for the Museum on the advice of Sargent himself. Both the Tissot and Sargent collections were permanent features displayed in their own galleries (figs. 25 and 26). As mentioned above, as late as 1921, Stieglitz could still easily recall the public attention attending each of these purchases. Knowing his brother's wishes to have his watercolors kept together, Charles's awareness of these famous public holdings already devoted to the watercolor work of two artists of international stature would surely have influenced him to look favorably on a direct approach from Brooklyn's trustees.

THE WATERCOLOR EXHIBITION OF 1915

The Museum's association with Homer's watercolors did not cease with the 1912 acquisition. By the spring of 1915 a broader context was sought for Brooklyn's representation of Homer's watercolor work as well as an opportunity for the Museum to introduce the public to the full range of his achievement in the medium. Plans were well under way in May for a large loan exhibition that would be the first museum retrospective devoted to Homer's watercolors. It is tempting to speculate that Kenyon Cox's article, "The Watercolors of Winslow Homer," which had appeared in the October 1914 issue of *Art in America,* might have played a catalytic role.[29] The Museum's watercolor, *Blown Away,* about 1888, was illustrated (cat. no. 73). However, admiration for Homer's watercolors was hardly a new phenomenon. Homer had enjoyed a major reputation in the medium for decades. We have noted that the 1911 memorial exhibitions, especially that in Boston, recognized the achievement and importance of the watercolors. However, unlike the career-length chronology of oil paintings—from 1865 to 1910— the watercolor selections had concentrated on works painted after 1880, especially those painted from 1889 on, acknowledged then as the beginning of Homer's "maturity" in the medium. Brooklyn's exhibition placed on display some sixty-nine watercolors ranging in date from 1873 to 1904. *Watercolors by Winslow Homer* opened in mid-October for a three-week period to a great deal of attention in the press: "The smaller, Western gallery near the main gallery for paintings, has been re-decorated for the exhibition of . . . works by Homer, while on either side of the approach to the room where Homer's works are shown, the Institute collection of twelve of his watercolors is seen brought from their former arrangement," reported the *Eagle.*[30] The seven lenders included Homer's family and personal circle, a major New York collector and four Brooklyn collectors. Mr. and Mrs. Charles S. Homer lent thirteen works (cat. no. 81) and the late Lawson Valentine's daughter, Almira Houghton Pulsifer, and her husband, eighteen watercolors.[31] Valentine, a long-time friend of the Homer family, had been in the varnish business with Charles. He had also been owner of a country property in Mountainville, New York, where Winslow Homer often visited and where he

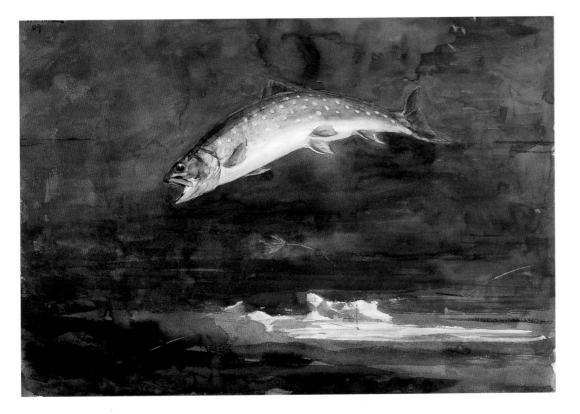

81

Winslow Homer (1836–1910). *Jumping Trout,* 1889. Watercolor over graphite on cream, medium-weight, moderately textured wove paper. 13¹⁵⁄₁₆ X 19¹⁵⁄₁₆ in. (35.4 X 50.6 cm). Signed and dated upper left: *Homer / 89.* 41.220, In memory of Dick S. Ramsay

painted the so-called *Houghton Farm* series in the 1870s (see cat. no. 72). Valentine (and his brother Henry) had acquired many of these watercolors, and so this rich period was well represented in the exhibition.[32] Charles Gould, a prominent New York lawyer and longtime collector of Homer's work, made twenty works available, ranging in date from 1881 to 1903 and in subject from Tynemouth to the Bahamas. The watercolors on loan were displayed in discrete units by lender; an arbitrary installation device to be sure, but nevertheless one that in this case demonstrated a fortuitous and striking chronological coherence. This was largely due to the balance of the Pulsifer loans of the *Houghton Farm* series with Gould's spectacular survey of Homer's production from 1881. The comprehensive nature of the exhibition—chronologically and in terms of subjects—was hailed by reviewers as a revelation. "No similar opportunity to study Winslow Homer's work has ever been previously offered to those interested in American art and in good pictures," commented the *Eagle.*[33]

Goodyear had been joined in planning the exhibition by the two energetic trustee-collectors Crittenden and Putnam, who were the primary liaisons with Homer, Pulsifer, and Gould, negotiating loans and arranging for photography. The curator prepared a checklist for visitors to the exhibition that included a biographical note. Goodyear also wrote a lengthy article in the October *Museum Quarterly,* reinforcing the premise that the major contribution and innovation of the exhibition was assembling these seldom-seen works for the public. He recalled that "a comprehensive knowledge of the Homer watercolors . . . was

impossible to any of us during his lifetime" and suggested that the Brooklyn exhibition "brought to a climax the gathering force of a revolutionary reversal of some of our most deep-seated ideas about this artist, simply by showing a very large collection of his works in this medium." Intended to fill a lacuna in knowledge of Homer's career, the exhibition seems, in Goodyear's words, also to have been for many "a blank surprise," shaking "the orthodox opinion of Homer's art."[34] Behind the scenes, the curator had worked skillfully to stimulate critical interest in the exhibition. A revealing letter written before the exhibition opened pinpoints his intention to collect human interest anecdotes from the key lenders. These included personal reminiscences of the artist, how the works had been obtained, and the identities of the youthful models in the Houghton Farm paintings.[35] He sought in particular to enhance the newsworthy status of those works never before exhibited. Capitalizing on this fact, he also requested permission to photograph the Homer and Pulsifer loans "for press publication."

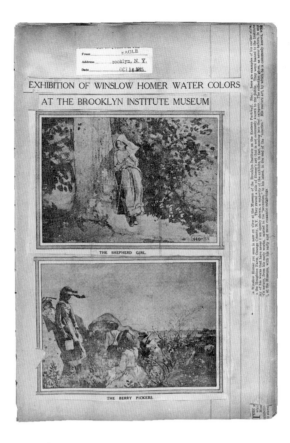

Fig. 27.
"Shown here are examples of his earlier style . . ." Clippings from the *Brooklyn Daily Eagle,* October 16, 1915
Brooklyn Museum Yearbook (clipping scrapbook, 1915–18, p. 23) Brooklyn Museum of Art Archives

Some of this human-interest material was prepared by Goodyear as publicity for the Brooklyn press; other information would be offered as "exclusives" to tempt critics from Manhattan to make the trip to the Museum. A survey of the public and critical reception to the exhibition suggests that his efforts were worthwhile. The exhibition was covered not only in the metropolitan area but received national attention as well. The *Rochester Post* reported: "[O]f all the current exhibitions, interest has centered in the loan collection of the paintings of Winslow Homer installed at the Brooklyn Museum of Art. It is safe to say that never before has there been so widespread a migration of Manhattan art lovers to their sister borough as this fine collection has attracted. . . . [I]n it are shown for the first time more than forty of Homer's pictures and among them are included work of periods covering more than 20 years of his artist life."[36]

The newspapers seized on the novelty and nostalgic appeal of the early watercolors in which Homer's focus on the playful world of childhood contrasts with his work after 1880. The Gloucester and Houghton Farm subjects, some of which had been shown at the American Watercolor Society in the 1870s but which were new to twentieth-century audiences—received not only wide verbal but visual coverage in the press as well (fig. 27) The *Eagle* noted the "surprise" of works from the 1870s: "The value of the assemblage, as a whole, lies in the contrast between Homer's early and his later and sterner style."[37] The *New York Sun* singled out "the early performances" and noted that "most of them have not been shown

82 *(opposite, above)*
Winslow Homer (1836–1910). *Fisher Girls on the Beach, Cullercoats,* 1881. Watercolor over graphite on off-white, moderately thick, rough-textured wove paper. 13⅛ × 19⁷⁄₁₆ in. (33.3 × 49.4 cm). Signed and dated lower left: *Winslow Homer 1881.* 41.219, Museum Collection Fund

83 *(opposite, below)*
Winslow Homer (1836–1910). *Women on Shore with Lobster Pot,* 1882. Transparent watercolor, graphite, and opaque watercolor on cream, moderately thick, smooth-textured wove paper. 7¾ × 12³⁄₁₆ in. (19.7 × 31 cm). Signed and dated lower left: *Homer 1882.* 28.213, Frederick Loeser Fund

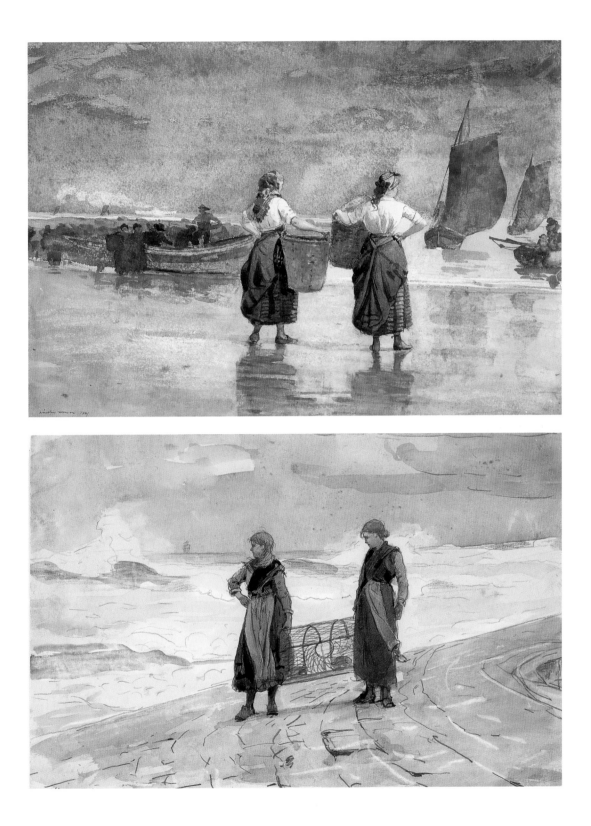

heretofore and all are unfamiliar."[38] The *World* claimed that "about fifty of them have never before been placed on public view. Visitors may thus see work that is practically new to them, by an artist who enjoyed uncommon popularity through an active career of half a century."[39] Brooklyn's exhibition proved to be a revelation to a generation familiar only with Homer's work after the 1880s sojourn at Tynemouth (cat. nos. 82, 83). The two Houghton Farm subjects in the Museum collection today were not in the 1915 exhibition, although they were in the Valentine family holdings. *Shepherdess Tending Sheep* (1878) and *Fresh Air* (1878), which had been a star of the 1879 Watercolor Society exhibition (fig. 28), had belonged to Henry Valentine, Lawson's brother, and were purchased by the Museum from his descendants in 1941.[40]

Press coverage continued throughout the run of the exhibition. On October 24, a *Brooklyn Citizen* headline alerted the reader: "Last Chance to See Homer's Art at the Museum: In view of the short duration of the Winslow Homer water color loan exhibition at the Brooklyn Museum . . . it is desirable that its remarkable importance should be realized by the public before the removal and dispersion of the

pictures."[41] Variations of this notice ran in other papers as well. On November 5 William Howe Downes reported to Homer's hometown admirers in the *Boston Evening Transcript*: "The loan exhibition of Winslow Homer's watercolors at the Brooklyn Institute of Arts and Sciences is attracting a great deal of public interest, as was to have been expected. It will come to an end next Sunday afternoon."[42]

After closing in Brooklyn, the exhibition traveled to the Century Association for a Manhattan venue before final dispersal of the watercolors to the lenders.[43] The Valentine-Pulsifer collection would remain in family hands for many decades. However, those watercolors belonging to Charles Gould would not. Gould's entire block of watercolor loans as well as his major oil painting, *The Herring Net*, were sold through Knoedler to Martin A. Ryerson of Chicago immediately after the exhibition.[44] Today these works are in the Art Institute of Chicago. It seems curious (and unfortunate) that, having gathered such a trove of privately held works, the Brooklyn trustees did not purchase for the Museum (or themselves) from the exhibition. Nevertheless, Homer watercolors owned by the families of Brooklyn collectors Curtis and Babbott would ultimately come to the Museum as bequests (cat. no. 84).

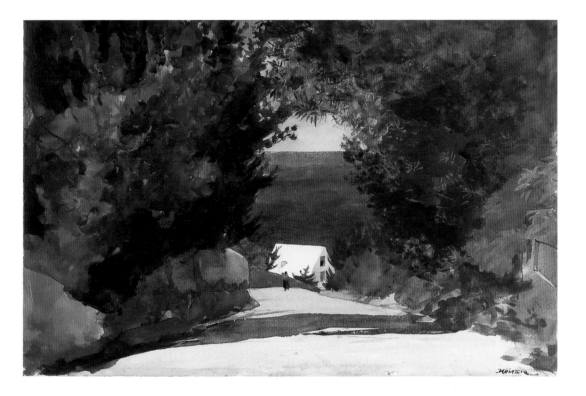

84

Winslow Homer (1836–1910). *Road in Bermuda,* c. 1899–1901. Watercolor over graphite on cream, moderately thick, rough-textured wove paper. Partial watermark: AN 1899. 14 × 21¹⁄₁₆ in. (35.6 × 53.5 cm). Signed lower right: *Homer.* 78.151.3, Bequest of Helen B. Sanders

WINSLOW HOMER IN 1915

Five critical years had passed since Homer's death. For many, he was already a fixture of history even at the time of his death. A comment by William Macbeth published by Downes reflected the current opinion of many about the status of the master: "His artistic record was made long ago, and it adds a brilliant chapter to the annals of truly American art."[45] Only two and a half years earlier, the Armory Show had created a sensation and a schism by presenting a survey of avant-garde European and American artists and styles to the public. Although the avowed goal of the Brooklyn exhibition was to expand Homer scholarship, the organizers must have been mindful that a focus at that moment on both Winslow Homer and the watercolor medium would be especially potent in the current debates about modernism. Watercolor had already been designated as a "modernist medium" by both supporters and foes of American modernism.[46] Advocates of modernism embraced a fascination with artist process, with spontaneity and experimentation. These attributes seemed to be virtually embodied in the watercolor medium with its close alliance to the sketch and the artist's creative process in contrast to the planned and carefully executed exhibition picture. Georgia O'Keeffe's *Blue* series of 1916 demonstrates the most advanced exploration of the possibilities of the medium for pure abstraction during these years. John Marin's *Deer Isle* and Max Weber's *Study for Russian Ballet,* both painted in 1914, reflected their enthusiastic appropriation of avant-garde European styles for watercolor work (see cat. nos. 101, 105–9). All three artists embraced the medium as an

important exhibition vehicle, handling its challenges with great technical finesse. Marin, in particular, paid frequent tribute to Winslow Homer as both ancestor figure and inspiration.

Nevertheless, Homer's watercolors occupied unstable ground in the modernist camps. On his 1921 visit to the Brooklyn Museum, Stieglitz would admire them with reservations: "Hanging on the walls opposite [the Sargent watercolors] were the far-famed Winslow Homer's. Truly water colors. *Direct*. Well seen. Virile power. I was glad to see them again. They had their own life and yet in a deeper sense the Homers are primarily nothing more than the highest type of Illustration. Naturally John Marin and his watercolors were in my mind."[47] In the context of modernist experimentation, Homer's naturalist vision was "well seen" but creatively limited—"nothing more than the highest type of Illustration." Marin's *Deer Isle,* interpreting the Maine coast, Homer territory, in a cubist vocabulary conveyed by a matrix of transparent washes was precisely the kind of watercolor Stieglitz and the modernists had "in mind."

The year before Brooklyn's exhibition, the aforementioned Kenyon Cox (1856–1919), a well-known muralist and teacher, had published a monograph, *Winslow Homer*.[48] Cox knew Homer's work well and had written perceptive criticism about his work as early as 1885. He was also an outspoken critic of modernism.[49] Cox acknowledged watercolor as the perversely perfect "modern" medium. He wrote: "The highest perfection of oil painting depends upon complicated processes which are almost impossible to the painter from nature, impatient to set down his observations while they are immanent to his mind; and these processes our modern painters have, for the most part, forgotten. The perfection of watercolor depends largely, upon directness and rapidity." "It is, finally, this immediacy of impression, this instantaneousness of vision," Cox wrote, "that is in itself the great charm of Homer's watercolors." He nevertheless discounted such charm as purely sensory, a pleasure that is "keen" but "a pleasure of a somewhat lower kind." "If you share the modern love for facts and have anything of the modern carelessness of art you will ask for nothing more," the critic warned, "and will prefer such notes to any possible works of art that might be constructed from them." Ultimately, Cox was forced by his critical position to demote watercolor in his own final accounting of the creative wealth of Homer's total production: "They are marvelous, they are admirable, they are distinguished, but they are sketches. They remain the small change of that great talent which could produce Eight Bells or the Fox Hunt."[50]

In the wide response to the 1915 exhibition of Homer's watercolors, which expanded the number of works in Brooklyn's permanent display by nearly sevenfold, we can follow the process by which each camp extolled, accommodated, or rejected Homer. Most reviews and articles focused on the retrospective nature of Brooklyn's watercolor exhibition: "Many visitors will be surprised when they see the idylls of country life painted in the early 70s."[51] Reviewers interpreted the work of the seventies as a journey into both Homer's youth and America's past.

Captivated by the nostalgic subjects of children, they sentimentally equated Homer's early years as an artist with the nation's youth. "This exhibition is really a life review of thirty-six busy years," commented the *World*.[52] Another likened the exhibition to "a pictorial biography."[53]

A few commentators, however, sought to locate their critical response to Homer's watercolors within the debates being waged about modernism. One claimed modernist currency for Homer's watercolors by perceiving in them a "primitive strength":

Someone once said that one of his water colors looked as if it had been painted by an "intellectual savage," and there is in Homer's paintings, especially his water colors, that primitive strength which is associated with savagery; yet they have also the intellectual quality of works by the masters, and for this reason they not only stir the imagination but satisfy the esthetic sense. He accomplished that toward which the post-impressionists and so-called modernists supposedly strive, but through perfectly natural expression rather than affected effort. For this reason it is doubly valuable that these water colors should be exhibited at this time.[54]

Homer's niche as a modernist watercolor progenitor was hardly secure, however. Willard Huntington Wright dismissed Homer from the modernist family tree in a peppery review in the *Forum:*

Homer's work is no better and no worse than 20 English academicians; and the time has come for an honest and unsentimental consideration of his healthy but slight, talent. . . . His reputation is due more to America's ignorance of things artistic, than to his own inherent worth. Without doubt he was one of our greatest native painters during the last generation; but in that lies no cause for enthusiasm. In a country of blind men, the one-eyed man is king. Let us accord him great sincerity, an instinct for sedulous labor and an overpowering desire to do great things; but let us do it in whispers, lest Europe laugh. . . . A. P. Ryder, in the next room to the watercolors hung in the Brooklyn Institute, is really more artistic in Homer's own manner; and Sargent, whose watercolors are also nearby, is more fluent and illustratively and technically more interesting. Whistler is a better artist; so is Henri. The desire to apothesize Winslow Homer has in it more of patriotism than of pure aesthetic judgement; and since we are now rapidly shedding our provincialism . . . we can well afford to stifle our untutored eulogy of him.[55]

Wright's position, however, was extreme. Eulogy prevailed.

THE "TWO WINSLOW HOMERS"

One great asset of the 1915 exhibition was the absence of oil paintings. Babbott's *Driftwood* (1909; Museum of Fine Arts, Boston), the only oil painting listed in the catalogue, was displayed elsewhere in the American galleries. The memorial retrospectives of 1911 had highlighted the problem of comfortably integrating the two bodies of Homer's work within a single exhibition space. Moreover, the nagging perception of a certain deficit in the oil medium had long persisted in the

Homer criticism. The admitted awkwardness of some of the oil paintings demonstrated technical limits in that medium as opposed to the artist's consistent fluency and brilliant handling of watercolor. The *Christian Science Monitor* expressed an opinion that was widely held in a review of Brooklyn's 1915 exhibition: "There is seldom a sense of complete mastery in Homer's handling of oils. The dramatic 'Gulf Stream' . . . is one of his rare triumphs over the oleaginous. But the technique of water color he carried to something like a magical pitch of perfection."[56] Always an undercurrent as well was the tension imposed by the celebrity of Homer's (and Sargent's) watercolor production as a challenge to the subordinate position of watercolor to oil painting in the traditional academic hierarchy of mediums. Goodyear was undoubtedly referring to these sensitive issues when he sought to conciliate both camps by proposing the contrivance of "two Winslow Homers": "Let us hope that the growing interest . . . in Homer's masterly and beautiful watercolors, may not lead us to forget the imperishable greatness of his best oil painting. The pendulum may swing that way for a time, but if it does, it will swing back again."[57] This device continues to serve nicely in negotiating positions for oil and watercolor as separate and equal, a position we are probably most comfortable with today and that, in fact, acknowledged the goals of the American watercolor movement of which Homer was a part.

HOMER AND SARGENT: RIVALS OR PEERS?

Brooklyn's exhibition of 1915 also served to fuel another ongoing skirmish in the watercolor wars about the relative merits of Homer's and Sargent's work, a debate that had probably begun around the time of the latter's 1909 American watercolor exhibition and the Brooklyn purchase. Critics frequently made comparisons between the watercolor production of the two artists as exemplary of equally brilliant but fundamentally opposing approaches to the use of the medium. These comparisons and perceived oppositions quickly became (and have remained) vehicles used by artists, art historians, and critics to promote or debate a number of agendas from the relative merits of transparent and opaque watercolor methods to cultural nationalism.

In 1914 Cox interpreted the contrast in the artists' approaches to the medium as one of as artistic self-consciousness versus instinct: "Sargent seems to be thinking a little of the brilliancy of his method, whereas Homer is thinking single-mindedly, of the object or the effect to be rendered." This implied criticism became more explicit in the reviews of the 1915 exhibition at Brooklyn, which provided a compelling (and premeditated) invitation to compare eighty-some watercolors by Sargent with nearly seventy by Homer. The *Christian Science Monitor* noted: "He fairly rivals Sargent here and the opportunity to make this astonishing comparison is not the least of the attractions of this exceptional show."[58] Many reviews mentioned the physical proximity of these works and its effect on the visitor: "[S]ince the museum owns a large group of Sargent's water

colors that hang just outside the entrance to the room where the Homers are shown, it affords a splendid opportunity to study how well one of our 'older masters' painted in a medium in which the younger man is supposed to have spoken almost the last word."[59] "In going to the gallery where these pictures are placed," wrote the *Kansas City Star*, "the visitor passes through the room which holds the Sargent water colors, and it is impossible not to make some comparisons. The difference leaps forth unescapably. Homer, in his intense absorption in what he saw, in his stalwart unconcern for the approbation of the crowd, offers the most striking contrast to the brilliant, the scintillating virtuosity of Sargent displaying itself for the sake of applause! Homer is essentially serious, Sargent comparatively frivolous."[60] Other reviewers argued for artist parity: "Near the rooms in which the fifty or more examples of his achievement in this medium are hung is the gallery containing the Sargent watercolors. To pass from one to the other is to realize that the two men stand on the same plane in the boldness and precision of their workmanship."[61]

The installation plan focused, of course, on Homer, but it clearly incorporated Sargent into the universe of the exhibition, reinforcing the comparison already established by the continuing display of the permanent collections. Other museums also sought to institutionalize the comparison. Those that had already purchased blocks of watercolors by Homer subsequently acquired blocks of watercolor by his "rival." The Museum of Fine Arts, Boston, had purchased forty-five works by Sargent in 1912, the Metropolitan Museum acquired ten in 1915, and Worcester bought eleven Sargent watercolors in 1917.[62] That same year the Carnegie Institute capitalized on the comparative phenomenon with a two-person exhibition, *Winslow Homer & John Singer Sargent: An Exhibition of Water Colours*. The organizers reassembled many Homer watercolors from the Brooklyn exhibition and balanced them by also borrowing eighteen works by Sargent, most lent by Brooklyn and Worcester. Having thus formalized the "competition," the Carnegie's director, John Beatty, then argued for truce in his catalogue remarks. His text is a short sermon on Sargent's "exceptional opportunities" abroad contrasted to Homer's "struggle against adversity." These opposing parables of artist origin end with an apologia for Homer's American origins and subject matter that recalls Henry James's rueful concession written many years before, that Homer could, through sheer force of will, make American sites as viable as Sargent's glamorous European and Middle Eastern subjects.[63]

The association of Homer's style and subjects with American character and place began early in the literature. The highly ambivalent position adopted by the cosmopolitan James about Homer's oil paintings in 1875 applied as well to the "raw little aquarelles" he had seen earlier that year at the Watercolor Society exhibition: "We frankly confess that we detest his subjects. . . . He has chosen the least pictorial features of the least pictorial range of scenery and civilization; he has resolutely treated them as if they were pictorial, as if they were every inch as good as Capri or Tangier; and, to reward his audacity, he has incontestably

succeeded."[64] Over time, James's very perceptive and highly qualified praise became the cause for celebration. Homer's subjects escalated into metaphors for cultural nationalism and nativism as well as gender-driven muscularity. By the time of the 1915 exhibition, Homer had ascended to an incontestable position as "our 'national' painter": "It is, of course, a matter of established orthodoxy to find in Winslow Homer the typical figure representing the essential character of American painting," commented the *New York Evening Post*: "Most of us have stopped counting, and so can no longer remember how many times the names of Walt Whitman and Winslow Homer have been linked together as our two purely American artists."[65]

After 1909, in the contest for "most native," Sargent's watercolors provided the European foil to Homer's, just as the American expatriate painter James McNeill Whistler was opposed to Homer's homegrown talent in the oil medium. "Sargent and Whistler developed their talents abroad and lived most of their lives abroad, and it is not too much to say that their distinguishing qualities have a European flavor," commented the *New York Sun*. "But Winslow Homer was in no way hyphenated. His contribution to art history could never have been made by a Frenchman or German. He not only held fast to our rocks and shore, . . . but he lived through our greatest national crisis, the civil war, and recorded many episodes in it from first hand observation."[66] Critical tolerance for "hyphenated" origins would be replaced in the following decades by increasingly strident claims for Homer's nativism.

THE WATERCOLOR EXHIBITION OF 1921

In 1921 Brooklyn attempted to position both Homer and Sargent as ancestor figures for American watercolor in another landmark exhibition. It included work of both conservative artists such as Childe Hassam and Joseph Pennell along with such "moderns of the moderns" as Marin, Charles Demuth, and Marguerite Zorach. This survey of some 365 watercolors by 53 artists was anchored in generous displays of the Museum's collections of both Homer and Sargent watercolors. The highly positive response to the 1921 exhibition provided the catalyst for a series of watercolor programs over the next forty years. *Exhibition of Water Color Paintings by American Artists* was the first of the Museum's biennials—later expanded to an international field—which would continue until 1963.

In 1924 William Crittenden provided funds for the Museum to purchase William O'Donovan's diminutive but nonetheless striking bronze, *Bust of Winslow Homer* from the Macbeth Gallery (fig. 29).[67] By that date Homer's great Caribbean watercolor *The Turtle Pound* (1898) had been acquired from the estate of Hamilton Easter Field (see cat. no. 80). Both were on exhibition as shown in an undated photograph of an installation of the Museum's collection of Homer watercolors (possibly taken on the occasion of the centennial of the artist's birth in 1936; fig. 30). Mounted on a tall, slender pedestal, the bust functions like a

Fig. 29.
William R. O'Donovan
(1844–1920)
Winslow Homer, 1876
Bronze
Brooklyn Museum of Art,
24.429, Museum Collection
Fund

kind of classical herm marking the space as a sacred and ceremonial precinct. The artist presides, flanked by double registers of his "far famed" watercolors. A period piece in itself, the installation presents the perfect emblem of the enduring cult of personality that continues to inform the popular appreciation of Winslow Homer's watercolors, an appreciation that was in part shaped by Brooklyn's 1912 purchase and the 1915 exhibition.

Fig. 30.
Installation of Homer
watercolors and William R.
O'Donovan's *Winslow
Homer*, between 1924
and 1941
Brooklyn Museum of
Art Archives

NOTES

1. Helen A. Cooper, *Winslow Homer Watercolors,* exh. cat. (Washington, D.C.: National Gallery of Art, 1986), 16. This well-illustrated overview of Homer's watercolors is an excellent introduction to the subject. An extensive Homer chronology, exhibition listing and bibliography are found in Nicolai Cikovsky Jr. and Franklin Kelly, *Winslow Homer,* exh. cat. (Washington: National Gallery of Art, 1996), 391–418.

2. Lloyd Goodrich, *Winslow Homer* (New York: Whitney Museum of American Art, 1944), 159.

3. In 1890 Frederick Layton acquired *Hark: The Lark* (1882) for his public gallery, now the Milwaukee Art Museum. James Mundy et al., *1888: Frederick Layton and His World,* exh. cat. (Milwaukee: Milwaukee Art Museum, 1988), 60. The Pennsylvania Academy of the Fine Arts acquired *The Fox Hunt* (1893) in 1894, and the Museum of Fine Arts, Boston, received *The Fog Warning* (1885) the same year. In 1906 the Metropolitan Museum of Art acquired *Cannon Rock* (1895), *The Gulf Stream* (1899), and *Searchlight on Harbor Entrance, Santiago de Cuba* (1901). *A Light on the Sea* (1897) entered the collection of the Corcoran Gallery of Art in 1907. (*The Unruly Calf* was deaccessioned in 1950.)

4. *Waiting for the Start* (1889) was acquired by the Museum of the Rhode Island School of Design in 1894. The Museum of Fine Arts acquired four watercolors in 1899: *Leaping Trout* (1889), *Trout-Fishing, Lake St. John, Quebec* (1895), *Indian Camp, Montagnai's Indians, Pointe Bleue, Quebec* (1895), and *Quananiche Fishing* (1897).

5. Albert Ten Eyck Gardner, "Metropolitan Homers," *Metropolitan Museum of Art Bulletin* 7 (January 1959), 139–41. I am grateful to Abigail Booth Gerdts for bringing this article to my attention.

6. *Catalogue of a Loan Exhibition of Paintings by Winslow Homer,* exh. cat. (New York: Metropolitan Museum of Art, 1911), nos. 24–51; "Memorial Exhibition of the Work of Winslow Homer," Boston, February 8–March 8, 1911 (no catalogue published).

7. William Howe Downes, *The Life & Works of Winslow Homer* (Boston: Houghton Mifflin, 1911) (hereafter Downes 1911).

8. Six of the works in the 1912 purchase are included in the exhibition. The others are *Glass Windows, Bahamas* (about 1885), *Key West, Negro Cabins and Palms* (1898), and

House and Trees in Bermuda (about 1899). *Two Flamingoes, Tampa* was deaccessioned in 1941. *Fishing the Rapids, Saguenay River, Quebec* (1902) and *The Shell Heap* (1904) were deaccessioned in 1976.

9. "Minutes," January 9, 1912 Board of Trustees and Executive Committee, October 13, 1911, to July 23, 1913, no. 12, 73, Brooklyn Museum of Art Archives (hereafter Minutes 1912).

10. Minutes 1912, 100.

11. Minutes 1912, 106.

12. "Winslow Homer Display in Institute Museum," *Brooklyn Daily Eagle,* May 5, 1912.

13. Teresa A. Carbone, "Historic American Paintings in The Brooklyn Museum: A Brief History of the Collection," in *Masterpieces of American Painting from The Brooklyn Museum,* exh. cat. (New York: Jordan-Volpe Gallery, 1996), 10.

14. Downes 1911, 248.

15. Susan E. Strickler, "American Watercolors at Worcester," in *American Traditions in Watercolor: The Worcester Art Museum Collection,* exh. cat. (New York: Worcester Art Museum, Abbeville Press, Publishers, 1987), 12–14 (hereafter Worcester 1987).

16. Arthur W. Benson lived at 214 Columbia Heights. I am very grateful to Abigail Booth Gerdts, Director, The Lloyd Goodrich and Edith Havens Goodrich Whitney Museum of American Art, Record of Works by Winslow Homer, for her generous assistance and cooperation in making this and the information in the following two notes available to me.

17. The business was located at 364 Ewen Street. For the Homer-Valentine family connection, see Linda Ayres, "Lawson Valentine, Houghton Farm, and Winslow Homer" in *Winslow Homer in the 1870s: Selections from the Valentine-Pulsifer Collection,* exh. cat. (Princeton, N.J.: Art Museum, Princeton University, 1990), 18–26 (hereafter Ayres 1990).

18. According to Abigail B. Gerdts, the senior Homers probably moved to Brooklyn when their son Charles relocated to New York for business in 1872 (letter to the author, May 29, 1997).

19. Clark S. Marlor, *A History of the Brooklyn Art Association with an Index of Exhibitions* (New York: James F. Carr, 1970), 230.

20. William H. Goodyear, "Water Colors by Winslow Homer in the Museum of the Brooklyn Institute of Arts and Sciences," *Bulletin of the Brooklyn Institute of Arts and Sciences* 8 (May 4, 1912), 388 (hereafter Goodyear 1912).

21. William H. Goodyear, *Renaissance and Modern Art* (New York: Flood and Vincent, 1894), 280, 285–86.

22. Downes 1911, 17.

23. For Field, see Doreen Bolger, "Hamilton Easter Field and His Contribution to American Modernism," *American Art Journal* 20 (1988), 78–107.

24. Goodyear 1912, 388.

25. Ibid.

26. Brooklyn Institute of Arts and Sciences, *Museum News* 8 (March 1913), 86.

27. Alfred Stieglitz, "Regarding the Modern French Masters, A Letter," *Brooklyn Museum Quarterly* 8 (July 1921), 110 (hereafter Stieglitz 1921).

28. "With the Artists," *American Art News* 7 (February 20, 1909), 3. I am grateful to Barbara D. Gallati for bringing this reference to my attention.

29. Kenyon Cox, "The Watercolors of Winslow Homer," *Art in America* (October 1914), 404–15. The article was an excerpt from his recently published *Winslow Homer* (New York: [Frederic Fairchild Sherman], 1914) (hereafter Cox 1914). Goodyear refers to Cox's discussion of Homer's watercolors and cites passages from his text.

30. "Homer Exhibit on the Parkway," *Brooklyn Daily Eagle,* October 17, 1915.

31. By May 25, these 31 watercolors had been placed on loan at the Museum (Old Accession Record Binder, nos. 12546 and 12547, Brooklyn Museum of Art Registrar).

32. Ayres 1990, 18–26.

33. "Brief Homer Exhibition," *Brooklyn Daily Eagle,* October 24, 1915.

34. William H. Goodyear, *Water Colors by Winslow Homer* exh. checklist (Brooklyn: Museum of the Brooklyn Institute, 1915); William H. Goodyear, "The Watercolors of Winslow Homer: 1836–1910," *Brooklyn Museum Quarterly* 2 (October 1915), 380, 370, 367 (hereafter Goodyear 1915).

35. William H. Goodyear to William H. Crittenden, Records of the Department of Painting and Sculpture: Exhibitions, Water Colors by Winslow Homer (file no. 1221), Brooklyn Museum of Art Archives, October 5, 1915.

36. "New York Letter," *Rochester Post Express,* November 10, 1915.

37. "Homer Exhibit on the Parkway," *Brooklyn Daily Eagle,* October 17, 1915.

38. *New York Sun,* October 24, 1915.

39. "News of the Art World," *New York World,* October 17, 1915.

40. Ayres 1990, 72, 74.

41. "Last Chance to See Homer's Art at the Museum," *Brooklyn Citizen,* October 24, 1915.

42. "Homer's Watercolors," *Boston Evening Transcript,* November 5, 1915.

43. "The collection of works by Winslow Homer recently shown at the Brooklyn Museum is now at the Century Club." *American Art News,* January 1, 1916, 6. The exhibition opened on December 8, 1915, and had closed by January 18, 1916. I want to thank curator of the Century Association, Jonathan Harding, for confirming this information.

44. "Knoedler Firm Buys 21 Winslow Homers," *New York Herald,* November 19, 1915.

45. Downes 1911, 249.

46. See Carol Troyen, "A War Waged on Paper: Watercolor and Modern Art in America," in Sue Reed and Carol Troyen, *Awash in Color: Homer, Sargent, and the Great American Watercolor* (Boston: Museum of Fine Arts, Boston, in association with Bulfinch Press, Little, Brown, 1993), xxxv–lxxiv (hereafter Reed and Troyen 1993).

47. Stieglitz 1921, 111.

48. Cox 1914, 58–66.

49. Wayne Morgan, *Kenyon Cox* (Kent, Ohio: Kent State University Press, 1994), 83, 214–23.

50. Cox 1914, 60, 62, 66, 64, 65–66.

51. "Homer Exhibit on the Parkway," *Brooklyn Daily Eagle,* October 17, 1915.

52. "News of the Art World," *New York World,* October 17, 1915.

53. "New York Letter," *Rochester Post Express,* November 10, 1915.

54. *Providence Journal,* November 7, 1915.

55. Willard H. Wright, "Modern American Painters—and Winslow Homer," *Forum* 54 (December 1915), 671–72.

56. "New York Art Exhibition and Gallery News," *Christian Science Monitor,* October 23, 1915.

57. Goodyear 1915, 383–84.

58. Cox 1914, 60; *Christian Science Monitor,* October 23, 1915.

59. "Pictures with 'Punch' at Brooklyn Museum," *New York Evening Mail,* October 16, 1915.

60. *Kansas City Star,* October 29, 1915, quoting the *New York Evening Post.*

61. "Water-Color Drawings by Winslow Homer, Never before Exhibited, Are Now on View at the Art Museum of the Brooklyn Institute," *New York Times Magazine,* October 17, 1915.

62. Reed and Troyen 1993, 151; *American Watercolors from the Metropolitan Museum of Art* (New York: American Federation of Arts, in association with Harry N. Abrams, 1991), 140; Worcester 1987, 14–16.

63. John W. Beatty, "Winslow Homer & John Singer Sargent," in *Winslow Homer & John Singer Sargent: An Exhibition of Water Colours,* exh. cat. (Pittsburgh: Carnegie Institute, 1917), 2–3.

64. Henry James, "On Some Pictures Lately Exhibited" *Galaxy,* July 1875, reprinted in *The Painter's Eye: Henry James; Notes and Essays on the Pictorial Arts* (London: Rupert Hart-Davis, 1956), 96–97.

65. "Art Notes: Winslow Homer Water Colors at the Brooklyn Museum," *New York Evening Post,* October 23, 1915.

66. "Homer Watercolors to be on View To-day," *New York Sun,* October 16, 1915. Bruce Robertson has dealt with the subject of Homer as a figure of cultural nationalism in "Americanism and Realism," in *Reckoning with Winslow Homer: His Late Paintings and Their Influence,* exh. cat. (Cleveland: Cleveland Museum of Art, 1990), 63–80.

67. A bronze in the Pennsylvania Academy of the Fine Arts was cast by the academy from the original plaster dated 1876 owned by Thomas Eakins in 1911. Another cast is in the Metropolitan Museum of Art. O'Donovan collaborated with Eakins on the high-relief equestrian portraits of Lincoln and Grant on the Soldiers and Sailors Memorial Arch at Grand Army Plaza in Brooklyn.

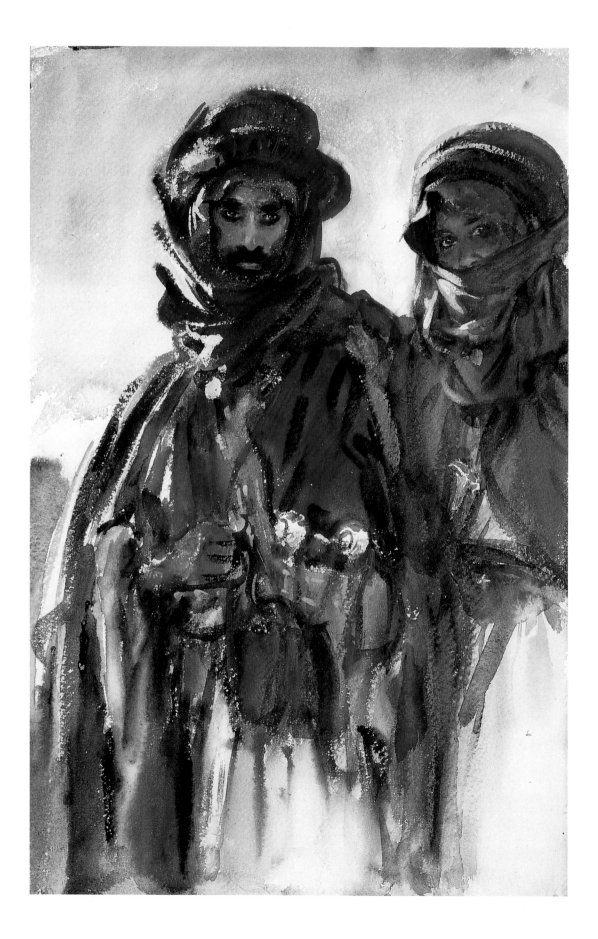

5

CONTROLLING THE MEDIUM: THE MARKETING OF JOHN SINGER SARGENT'S WATERCOLORS

BARBARA DAYER GALLATI

85

John Singer Sargent (1856–1925). *Bedouins,* c. 1905. Transparent watercolor with touches of opaque watercolor on off-white, thick, rough-textured wove paper. 18 x 12 in. (45.7 x 30.5 cm). 09.814, Purchased by Special Subscription

In February 1909 the Brooklyn Institute of Arts and Sciences purchased eighty-three of the eighty-six watercolors by the famous American painter John Singer Sargent (1856–1925) that were then on display at the New York galleries of the prestigious M. Knoedler & Company.[1] This purchase, often recounted in the Sargent literature, represents the first notable acquisition of the artist's work in the watercolor medium by a public institution and has been consistently cast in history as a bold move, swiftly negotiated in less than a week.[2] The institute's landmark bid to acquire these works seems especially daring given that Sargent's watercolors were virtually unknown to American audiences and, until 1903, had not been publicly displayed in England, where he resided.

The Sargent watercolor display at Knoedler's made a stunning impact on the public and critics alike, all of whom were taken by surprise by the freshness and virtuosity exhibited in the "sketches" of an artist who was deemed the foremost portrait painter of the time.[3] Although the watercolors were advertised mainly as Sargent's leisure pursuits, they gained a deep respect; for many viewers the exotic images of Bedouin tribesmen (cat. no. 85), lush vegetation, scenes of Italy and ships on the Mediterranean (cat. nos. 86–88), and the artist's friends on holiday (cat. no. 89) demonstrated more fully the painter's great talents than did the portraits he produced in his London studio.

The test of time as played out over the nearly nine decades since the 1909 Knoedler exhibition has proved the wisdom of the institute's purchase. Yet several questions remain: why would any institution seek to bring into its collection such a large number of paintings executed in what was still considered a minor medium by a contemporary American artist? This was an era when most American museums were still Eurocentric in their acquisition policies and had not yet begun to focus on building collections of

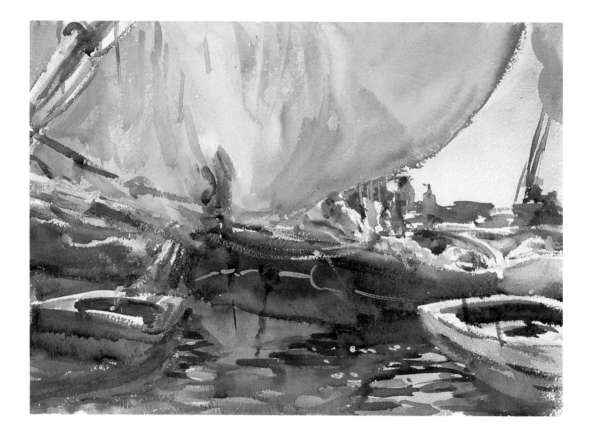

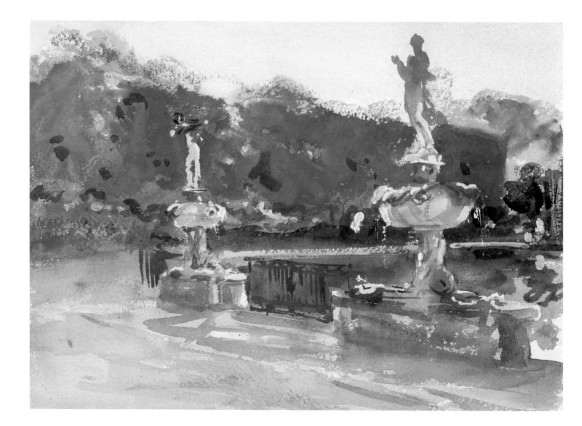

86 *(opposite, above)*

John Singer Sargent (1856–1925). *Melon Boats,* c. 1905. Transparent and opaque watercolor with small touches of gum varnish over graphite on white, thick, rough-textured wove paper. 14 × 20 in. (35.6 × 50.8 cm). 09.829, Purchased by Special Subscription

87 *(opposite, below)*

John Singer Sargent (1856–1925). *Boboli Gardens,* c. 1907. Transparent and opaque watercolor over graphite on off-white, thick, rough-textured wove paper. 10 × 14 in. (25.4 × 35.6 cm). 09.818, Purchased by Special Subscription

88 *(above, right)*

John Singer Sargent (1856–1925). *White Ships,* 1908. Transparent watercolor with touches of opaque watercolor over graphite on off-white, thick, rough-textured wove paper. 13⅞ × 19⅜ in. (35.2 × 49.2 cm). Signed and inscribed verso upper center: *In Majorca / John S. Sargent.* 09.846, Purchased by Special Subscription

89 *(below, right)*

John Singer Sargent (1856–1925). *In a Hayloft,* 1904. Transparent watercolor with touches of opaque watercolor on cream, thick, moderately textured wove paper. Partial watermark: VHATMAN 1897. 16 × 12 in. (40.6 × 30.5 cm). 09.824, Purchased by Special Subscription

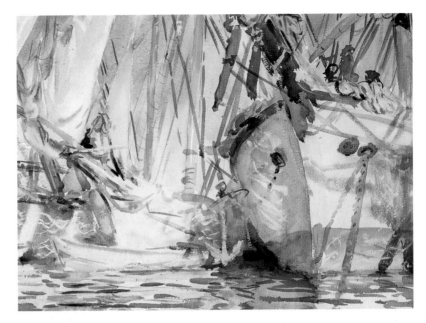

contemporary American oils, let alone watercolors. Another unanswered question, though one more frequently asked, centers on why Sargent would have been eager to market his watercolors in this manner and at this time. Press reports announcing the acquisition noted that Sargent had made the watercolors available

for purchase through Knoedler's on the contingency that if they were sold, they were to go "only to some museum in an Eastern State or to some large Eastern collector, with the requirement that the collection should be kept together for public exhibition."[4] That Sargent placed such conditions on potential sales implies that he considered his watercolors to be important. But most accounts of his estimation of his work in this medium contradict this view and are generally in accord with Richard Ormond's comments about the artist's attitudes: "He occasionally exhibited and sold these works [oil sketches and watercolors], but did so haphazardly and without caring. His watercolours lay around his studio in great bundles, and it was only with the greatest difficulty that he could be persuaded to show, let alone sell, his work."[5] Ormond goes on to say, however, that after 1900 watercolor "almost became Sargent's favourite medium," but regrettably omits additional discussion that adequately explores how and why this came to be so, beyond the commonly (and rightly) held belief that the artist had turned to watercolor as a respite from the creative limitations imposed on him by commissioned portraiture and the time-consuming work exacted by the Boston Public Library mural project.[6]

By contextualizing the 1909 acquisition within the previously separate histories of Sargent's watercolor activity and the Brooklyn Museum (or the Institute, as it was then known), a more meaningful scenario emerges concerning the marketing and acquisition of Sargent's watercolors, one that suggests that the artist should be credited with having charted a course to encourage general respect for the medium and to enhance interest in his own watercolor output specifically with a view toward engineering his emancipation from commissioned portraiture. This is not to say that Sargent waged an overt campaign to market his watercolors in the commercial sphere, for that type of approach does not correspond with what is known of the public modesty and personal reticence of the artist. What is meant, however, is that Sargent not only enjoyed the process of watercolor painting but also came to view it as a means to deflect attention from his reputation as a portraitist. Through the careful orchestration of events that are outlined here, it will be shown that Sargent did, in fact, create a market demand for his watercolors that allowed him to reduce his portrait activity without having to relinquish his position of priority in the artistic spotlight. Sargent's practice of responding to existing market tastes and prudently revising his artistic goals according to

91 *(above)*

John Singer Sargent (1856–1925). *Santa Maria della Salute,*
1904. Transparent watercolor with small touches of opaque
watercolor over graphite on off-white, thick, rough-textured
wove paper. 18³⁄₁₆ X 23 in. (46.2 X 58.4 cm). Signed and dated
lower left: *John S. Sargent 1904*. 09.838, Purchased by
Special Subscription

92 *(right)*

John Singer Sargent (1856–1925). *Mountain Fire,* c. 1903.
Transparent watercolor with touches of opaque watercolor on
white, thick, rough-textured wove paper. 14¹⁄₁₆ X 20 in. (35.7 X
50.8 cm). 09.831, Purchased by Special Subscription

those tastes can be traced to the beginning of his professional activity and, as Marc Simpson has recently pointed out, "Sargent seems to have been, in the choices and decisions of his career no less than with his brush, exceptionally canny."[7]

The majority of the eighty-six watercolors in the 1909 Knoedler exhibition had already been put to the critical test before the London art audience in a series of solo exhibitions at the Carfax Gallery (in 1903, 1905, and 1908) and in less concentrated displays at the New English Art Club and at the Royal Society of

Painters in Water-Colours throughout that six-year period.[8] Sargent's colorful, light-filled visions of Venice (cat. nos. 90, 91), Spanish soldiers, Bedouin gypsies, and Alpine scenes (cat. no. 92) came as revelations to the English critics whose reportage generally relied on such descriptive terms as "astonishing," "amazing," and "miraculous."[9] Few writers either knew or acknowledged that Sargent was not a newcomer to the medium. In truth, he had used watercolors since boyhood, mainly for informal studies, but skillfully enough to have elicited the approval of Whistler when the two met in Venice in 1874.[10] Evidence that Sargent's approach to the medium was more than casual is proved by his exhibition of two watercolors at the Paris Salon of 1881, both of which were titled *Vue de Venise* (nos. 3413 and 3414).[11]

In large part, however, watercolor remained a private affair for Sargent, with the chief public confirmation of his interest in it (before 1903) being the introduction he wrote for the Goupil Gallery, London, exhibition in 1892 of watercolors by his English friend Hercules Brabazon Brabazon (1821–1906).[12] Brabazon can best be described as a gentleman-painter whose love for the process was well known among his many artist friends. Sargent was one of several men who persuaded the elderly Brabazon to forego his amateur status by displaying his work publicly for the first time at the advanced age of seventy-one. The broad, delicate washes that characterize Brabazon's small watercolors present a minimal purity rarely manifested in Sargent's work in the medium. Yet the similarly reductive approaches to form displayed in Brabazon's *Mentone* (fig. 31) and Sargent's *Tangier* (fig. 32) are enough to suggest that Sargent's admiration for the older artist's work may have encouraged his occasional experimentation with Brabazon's slight, lyrical style, which Sargent lauded for its "exquisite sensitiveness."[13]

The Carfax Gallery's *Loan Exhibition of Sketches and Studies by J. S. Sargent*, held in the spring of 1903, can be interpreted as an exploratory exercise on Sargent's part, launched to gauge the advisability of future showings of his watercolors. The exhibition consisted of thirty works, a mixture of relatively unassuming oil sketches and watercolors, which, in comparison to the grand-manner style to which his audience was accustomed (as represented by *The Acheson Sisters,* shown at the Royal Academy the previous year), appeared fresh, lively, and intimate inasmuch as the subjects were of the artist's choice. As one reviewer remarked: "The water-colours of Mr. Sargent are astonishingly brilliant. If some of his oil-portraits seem more alive than the people who sat for them, so these water-colour drawings of Venice seem almost brighter than the brightness of Europe's most radiant and ethereal city. The waters are wetter than water. Everything is given with the intensity of a dream. One wonders whether Mr. Sargent's visual power is greater than normal, since he seems to see things more vividly than they are seen of others."[14] Another writer confidently concluded that the exhibition was "one of the most remarkable that has been held in London for quite a long time."[15]

The only strong chord of dissension was sounded by the critic for the *Athe-*

naeum, who has been identified by Stanley Olson as the artist-critic Roger Fry (1866– 1934).[16] The lengthy, unsigned review characterized Sargent's work as "vulgarly picturesque . . . distinguished not by the quality of his perception, let alone imagination, but merely by the certainty and the facility of his notation of what he perceives."[17] This opinion was in keeping with the usual stance on Sargent's art taken by the *Athenaeum*'s reviewer, regardless of medium. If Olson is correct in identifying the writer as Fry, then this marks the advent of Fry's increasingly strident attacks on Sargent, whose art he ultimately condemned for its "uniform superficiality."[18] Interestingly, Sargent's 1903 Carfax exhibition had been immediately preceded there by a solo show of Fry's oils and watercolors, thus suggesting that Fry would have been particularly sensitive to any comparisons prompted by the presumably coincidental back-to-back scheduling of the two exhibitions.

In 1904 Sargent exhibited for the first time with the Royal Society of Painters in Water-Colours (now called the Royal Watercolour Society and hereafter referred to as the RWS). The timing of his debut at the RWS was well chosen, since it coincided with the organization's centenary celebration and should be taken as an indication of the artist's awareness of the advantages of entering England's officialdom of watercolor painting when public interest would be at a heightened pitch. Of the five works Sargent contributed, three can be identified as Venetian subjects by their titles.[19] The reviewer for the *Illustrated London News,* after commenting on the overall success of the exhibition, noted the proliferation of Venetian scenes that year and singled out Sargent's depiction of the façade of Santa Maria della Salute as the "newest Venetian view of all," praising it for its frank unsentimentality and freedom in handling.[20] The same writer also noted that Sargent had returned as an exhibitor at the New English Art Club (hereafter the NEAC) after an absence of ten years and vaguely implied that the timing of his reappearance might carry special significance with respect to the "war waged against Burlington House [the Royal Academy] by Mr. Mac-Coll [the critic D. S. MacColl, later keeper of the National Gallery of Modern Art, London] and other English Clubmen." It is doubtful that Sargent's resumed affiliation with the NEAC had anything to do with the wider spectrum of exhibition politics in London in terms of his making a "large statement." However, it is likely that his return to the NEAC in 1904 was motivated by a desire to distance himself—not from the academy per se—but from the public's monolithic perception of him as a society portraitist.[21] Thus, at the same time that his imposing *Countess of Lathom* was on view at the academy, London viewers could also see examples of Sargent's nonportrait work in watercolor at both the RWS and the NEAC.[22]

93

John Singer Sargent (1856–1925). *A Tramp,* c. 1906. Transparent watercolor with small touches of opaque watercolor over graphite on off-white, thick, rough-textured wove paper. 20 × 14 in. (50.8 × 35.6 cm). 09.810, Purchased by Special Subscription

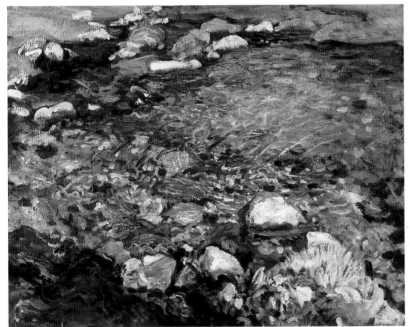

Sargent was elected an associate of the RWS shortly after he first exhibited with the organization in 1904. His artistic presence exerted a revitalization within the society's ranks, or at least, he was hailed as an inspiration for the more staid membership of the group (whose work was characterized as "cramped in spirit and hand") to return to the stylistic spontaneity and freedom of men like Joseph Mallord William Turner, Peter De Wint (1784–1849), and John Sell Cotman (1782–1842), who were among the founders of the great English watercolor tradition. The same writer continued, "Mr. Sargent's extreme energy has not allowed him to accept the sleepy and confined convention that he found [at the RWS]. His two drawings, the first to greet the visitor at the Society's gallery in Pall Mall East, show how swift may be the execution, and how vivid the results of watercolour; and the success of such efforts will do much to banish pettiness of manner and meanness of matter from its prevailing position."[23] Termed "triumphs of reality," Sargent's watercolors began to take on the material representation of the hopes for renovating watercolor practice in England.

Reviewers persisted in emphasizing the strength of Sargent's watercolors in no uncertain terms. Commentary on the 1907 summer exhibition of the RWS admiringly castigated Sargent for putting the rest of the exhibitors to shame:

Mr. John Singer Sargent, R.A., has almost played "the deuce" this year with the summer exhibition of the Royal Society of Painters in Water Colours. This is its one hundred and forty-eighth display, and it is scarcely fair of the Academician to expose its general weakness in so uncompromising a fashion. . . . The Hanging Committee, for the sake of a number of its colleagues, should have placed [Sargent's] drawings together on a screen separated from other works. The laboured sketches hanging round them look empty, senile efforts compared with the titanic force of Mr. Sargent's sketches.[24]

One of the three watercolors by Sargent at the 1907 exhibition was most likely Brooklyn's *Tramp* (cat. no. 93), which seems to have been known under the title of *A Vagrant* until the 1909 Knoedler exhibition.[25]

Sargent was elected to full membership in the RWS in 1908, and he deposited his diploma painting, *Bed of a Glacier Torrent* (fig. 33), that year.[26] It is instructive to consider the nature of the watercolor that Sargent chose to represent him for

Fig. 33. *(above)*
John Singer Sargent
(1856–1925)
Bed of a Glacier Torrent,
c. 1904
The Diploma Collection of
the Royal Watercolour
Society, London, adopted by
Diners' Club International
Photograph: Courtauld
Institute of Art, London

Fig. 34. *(below)*
John Singer Sargent
(1856–1925)
Val d'Aosta, c. 1909–10
Oil on canvas
Brooklyn Museum of Art,
69.52, A. Augustus Healy
Fund

posterity for, more than any of the watercolors he displayed at this time, it signals the larger aesthetic concerns then emerging in his oils in its demonstration of the workings of a more abstract vision. *Bed of a Glacier Torrent* was probably the same watercolor Sargent exhibited at the RWS in 1905 (no. 2, *Bed of Torrent*), which was described as "a boulder-strewn bed of a torrent" and praised for its "bold effect realised with curious completeness, though with utmost economy of means."[27] If this is the same work, then its close-up horizonless view of the rocky streambed was likely a product of his first summer stay at Purtud in the Val d'Aosta in 1904 and looks forward to an important series of oils featuring a similarly abstract approach to a landscape subject (e.g., *Val d'Aosta*, fig. 34). This example of new imagery appearing first in watercolor before being "serialized" in oil helps to elucidate the role of watercolor in Sargent's process in constructing a body of work outside portraiture. Rather than uniformly treating watercolors as preparatory studies, it seems that Sargent took advantage of the psychological freedom offered by watercolor to explore more radical compositions. If he observed them to be successful in finished watercolors, he then pursued the same motifs in oil.[28]

Sargent's watercolors were again featured in a solo loan exhibition at the Carfax Gallery in April 1905, the inaugural show at the gallery's new spaces on Bury Street. Forty-four of the forty-seven works on view were watercolors, all but six of which belonged to the artist. (Two belonged to Asher Wertheimer and one each to Evan Charteris, Percy Landon, Philip Wilson Steer, and Wilfrid-Gabriel von Glehn [later de Glehn].) Among the three oils on view was the artist's famed *Portrait of Madame X* (*Madame Pierre Gautreau*; 1884, Metropolitan Museum of Art), which had scandalized audiences at the 1884 Paris Salon and precipitated the close of the French phase of Sargent's career. The painting had remained in Sargent's possession and had not been on public view since its notorious Paris debut. Whereas its inclusion in the Carfax Gallery exhibition may have been merely a mechanism to attract a greater audience, there may have been a subtle strategy behind the seemingly odd decision to show the sensational formal oil portrait painted more than twenty years earlier in the company of relatively recent watercolors.[29] Quite simply, the painting's reputation centered on the issue of artistic choice and the priority of the work of art over the need to satisfy public and private expectations of portraiture. In that context the oils and watercolors in the 1905 Carfax exhibition shared an aesthetic motive that allowed them, regardless of how disparate they were in terms of subject and medium, to be seen against the conceptual foil of the portrait genre. Added consideration is merited by the exhibition's overall tone of exoticism which was established by the decadent aura attached to *Madame X* and carried out in the foreignness or "otherness" of the two less controversial oils (no. 13, *The Egyptian*, and no. 35, *A Javanese Dancer*) and in the subjects of many of the watercolors themselves, which resonated with the sensations of Mediterranean heat, light, and indolent days.

Once again, the anonymous reviewer for the *Athenaeum* (most probably Fry)

faulted the watercolors for their lack of substance but acknowledged their technical brilliance ("What a place Queluz must be! and yet Mr. Sargent's rendering would do equally well for some scenic effect at Earl's Court").[30] On the whole, however, critics found cause to marvel at the watercolors for the very reasons that Fry (?) railed against them. D. S. MacColl—ever on the opposite side of the aesthetic fence from Fry—remarked, "all are wonderful in the power of summary expression of architecture and other forms with a few dashes of the brush. It is not the work of a brooder or dreamer; it is more like an athletic exercise with shape and space and light."[31]

By the close of the second Carfax exhibition Sargent could confidently bank on his watercolors to hold their own, whether they were seen in the context of the RWS and the NEAC or shown with the spectacular *Madame X*. Over the next several years he followed the same pattern of exhibiting a select few at the RWS and the NEAC exhibitions, a practice that culminated in a final, large London exhibition of forty-eight watercolors and two oils at the Carfax in 1908 that opened to equally effusive praise. Because none of these works had been available for purchase (as the Carfax pamphlets prominently note), Sargent had accumulated a body of work that had received the valuable critical stamp of approval and had become extremely popular with London audiences. Sargent's management of his watercolors in this manner can be construed as a deliberate manipulation of supply for the ultimate goal of creating a ready market demand. Regardless of the artist's actual intent as it concerns the market, the watercolors became an eminently salable commodity complete with an impressive pedigree of exhibition history and favorable reviews. What is more, by 1908 Sargent's reputation was virtually unchallenged, and few of his legions of admirers would have passed up the opportunity to purchase anything from his hand, especially if presented with the prospect of purchasing a watercolor that would command far less money than a portrait.

As soon as Sargent's eighty-six watercolors went on view at the Knoedler galleries on February 15, 1909, there was a flurry of newspaper coverage. Each report reiterated that the show was an "artistic sensation."[32] During the show's two-week run, a variety of press notes updated readers concerning the crowds attending (including the fact that Winslow Homer had visited the galleries).[33] The details of the arrangements between Sargent and Knoedler for the exhibition are unknown, but it is most likely that the gallery's London representatives first approached the artist to open negotiations. Often overlooked, both then and now, is the fact that it was a two-artist show, with the galleries shared by Sargent's watercolors and sixty-three by his friend, the Boston-born Edward Darley Boit (1840–1915).[34] The two men had known each other for more than twenty-five years, as documented by Sargent's marvelously unconventional 1882 portrait of Boit's daughters (Museum of Fine Arts, Boston). Boit's participation in the exhibition is curious and may be attributed to Sargent's well-known generosity toward less celebrated colleagues in terms of encouragement and support. According to a number of

reports, Sargent had suggested a joint exhibition twenty years earlier.[35] It is likely that Sargent expected that the public exposure garnered by the joint exhibition would prove helpful to his friend. Unfortunately for Boit, his art suffered in the comparisons demanded by the proximity of his work with Sargent's—if comparisons were made at all. Hindsight does nothing to amend these opinions if we may judge from Boit's *Venice: Afternoon on the Grand Canal* (fig. 35).[36] Royal Cortissoz was the most outspoken on this matter and wrote of Boit's watercolors: "In ordinary circumstances one might glance with mild interest. But, placed in juxtaposition with what Mr. Sargent has done in the same medium, they simply crumple up and, in a figurative sense, disappear. The contrast is too cruelly vivid for its lesson to be ignored. . . . The dual character of this exhibition is particularly to be regretted, inasmuch as it has deprived Mr. Sargent of valuable space."[37] Thus, what must have originally been an act of kindness on Sargent's part manufactured the opposite of the desired result. His own watercolors seemed that much more stunning next to Boit's pedestrian efforts, none of which apparently sold out of the 1909 exhibition. Boit fared much better in 1912, when his watercolors were again displayed with those of Sargent at a show at Knoedler's, from which the Museum of Fine Arts, Boston, purchased forty-five Sargents and thirty-eight Boits. Ironically, Boston's acquisition of Boit's watercolors may have had as much to do with a desire to support a "local" artist as it did with the institution's wish to secure Sargent's masterful portrait of Boit's daughters for the collection. The 1912 article in the *Museum of Fine Arts Bulletin* announcing the purchase of the Sargent and Boit watercolors concludes with a reference to the Sargent portrait: "This picture Mr. Boit recently lent to the Museum in Boston, with the promise that he would leave it there as long as he lived. It is an added reason for paying joint tribute to the two men."[38] (The portrait entered Boston's collection in 1919 as a gift from Boit's daughters.)

What was it about Sargent's watercolors that stirred the New York audience? Certainly New Yorkers were accustomed to seeing works in the medium on a regular basis. There were the annual exhibitions of the AWS, and watercolors were also included in the displays at the National Academy of Design and the Society of American Artists (before its 1906 merger with the National Academy of Design). They were also part of the regular fare at Knoedler's, where, between 1898 and 1909, there were fifteen solo shows of watercolors by artists including Winslow Homer, Paul de Longpré, F. Hopkinson Smith, William Trost Richards, Aston Knight, and Anthony Dyer. Part of the initial attraction that Sargent's work held was unquestionably related to the aura of exclusivity surrounding his

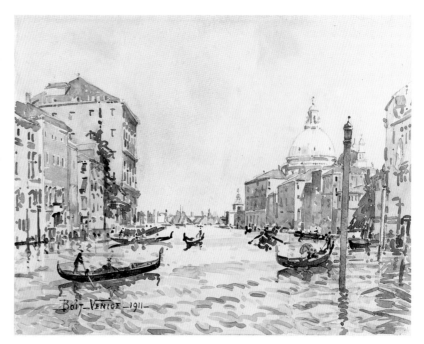

Fig. 35.
Edward Darley Boit
(1840–1915)
Venice: Afternoon on the Grand Canal, 1911
Watercolor on paper
Picture Fund, 1912.
Courtesy, Museum of Fine Arts, Boston

watercolor production. Newspaper reports emphasized that it was the first time Sargent's watercolor drawings were available in any number to American viewers. Of course, Sargent's name alone was enough to draw a crowd, but the element of curiosity about nonportrait works by an artist whose career was defined by portraiture in the public mind fueled even greater interest. The knowledge that many of these same works had been acclaimed by London audiences probably played on an inherent American sense of cultural inferiority and reinforced the desire of viewers to be among the first to see these rare items for the purpose of measuring opinion against the judgment of the English.[39] Once seen, their spectacular appeal could not be denied, and the watercolors were universally declared works of genius. Cortissoz must again be cited as the most thorough and thoughtful writer who covered the show. A lengthy portion of his text is quoted here as a representative example of the tone and content of the numerous, shorter commentaries that appeared during the run of the exhibition:

It is hard to say which is the more impressive, the freshness and individuality with which each subject is invested or the technical mastery everywhere disclosed. Mr. Sargent has made himself free of the very genius of water color. It is suggestive to note, by the way, that in one respect he is, indeed, more felicitous in his handling of this medium than in his oil paintings. The color in the latter is not always rich in quality. As has more than once been pointed out in these columns, Mr. Sargent's color is frequently wanting in deep transparency, in timbre. But in these sketches of his the color is beyond praise, it is true and it is beautiful. Best of all, it is gloriously saturated in light. Turning his back on the studio in which he has produced so many masterpieces of portraiture, he has plunged into the open air as into an element. Nature, living and breathing, is reflected in these water colors. They vibrate with energy. And, running through the riot of light and color, you feel the force of a great artist's knowledge. How magnificently sure and right it all is! Only a man of genius could have done this work.[40]

Like the English before them, American critics remarked on Sargent's ability to transform a familiar subject into a refreshingly new vision. A large *Santa Maria della Salute* consistently drew comment, not only for its masterful demonstration of the painter's technical prowess but also for its innovative point of view, "being shown from the rear, with a tangle of shipping in the foreground."[41] Also particularly admired were the austere simplicity of *In Switzerland* (cat. no. 94) and the "oriental lushness" of *Gourds* and *Pomegranates* (cat. nos. 95, 96).

Sargent, whose guiding aesthetic was recorded by Martin Hardie as being "en art tout ce qui n'est pas indispensable est nuisible" (in art everything that is not indispensable is useless), must have been gratified in the knowledge that his concept was appreciated by viewers.[42] In fact, critical responses focused on this aspect of the artist's facture, recognizing that within the layers of virtuosity—an integration of wash, masking, blotting, body color, impasto, and reserve techniques that may at first seem overwhelmingly chaotic—lay the evidence of superb control over the medium. In essence, the secret of Sargent's success as a watercolorist was his ability to achieve a rare and exquisite balance between

94 *(above, right)*

John Singer Sargent (1856–1925). *In Switzerland,* by 1904. Watercolor over graphite on off-white, thick, moderately textured wove paper. 9⅝ × 13⅟₁₆ in. (24.4 × 33.2 cm). 09.827, Purchased by Special Subscription

95 *(below, right)*

John Singer Sargent (1856–1925). *Gourds,* c. 1908. Transparent and opaque watercolor over graphite on white, thick, rough-textured, wove paper. 14 × 20 in. (35.6 × 50.8 cm). 09.822, Purchased by Special Subscription

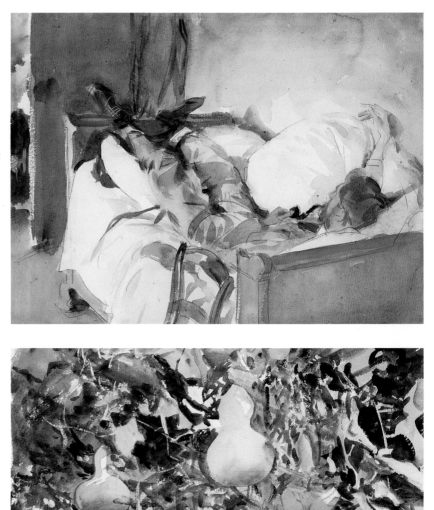

painterly freedom and discipline, both of which could come only from years of looking and painting. The coordination of mind and brush is supremely evident in what is perhaps the best known of Sargent's watercolors *Bedouins* (see cat. no. 85). The viewer's eye is immediately drawn to the finely modeled faces of the two figures, who return our own gaze with a mixture of directness and curiosity. From there, however, as the eye travels down the length of the bodies, the depiction of form becomes less distinct and trails off into an abstract suggestion of material and shape. This transition from the detailed representation of form to one of abstraction is not a product of careless bravura technique but is, instead, calculated to approximate the process of seeing and is predicated on the artist's assumption

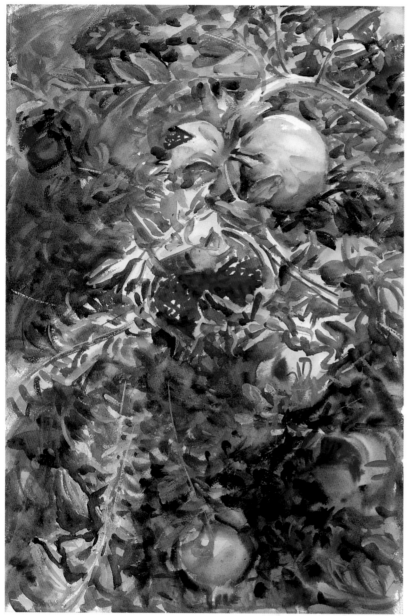

96

John Singer Sargent (1856–1925). *Pomegranates,* 1908.
Transparent watercolor with touches of opaque watercolor
over graphite on cream, medium-weight, moderately textured
wove paper. Partial watermark: RKEY MILL 1906
ENGLAND. 21¼ × 14⁷⁄₁₆ in. (54 × 36.7 cm). 09.832,
Purchased by Special Subscription

that the viewer is naturally drawn to the arresting faces of the pair. Thus, in Sargent's art as in life, the primary object of sight remains in focus while all else is reduced to a blurring of shapes and colors. What is more, the regular hatched strokes that relieve the intensity of the blue in areas of the drapery contradict the notion of undisciplined spontaneity and signal that the rest of Sargent's watercolors deserve close examination to reach a full appreciation of the precarious balance between planned and impromptu effects in his work. Each of the lengthier reviews emphasized this aspect of Sargent's watercolors and decreed their visual impact equal to that of his oils, thus making the watercolors even more magnetic because of the medium's notorious challenge to artistic control.

A few days before the close of the 1909 exhibition, a second round of newspaper reports announced that the Brooklyn Institute of Arts and Sciences had purchased all but three of the Sargents on display at the Knoedler galleries. Credited with engineering the acquisition was the institute's president, A. Augustus Healy, who, after having seen the exhibition on the previous Monday, quickly made known the institute's wish to purchase the Sargents. The press placed predictable emphasis on the monetary value of the pieces, and, although the actual purchase price was not released, reports documented the insured value of the works at twenty-five thousand dollars and encouraged speculation on the final price as agreed on in wire communications with the London-based Sargent.[43] The reports also mentioned Healy's personal friendship with the artist, a relationship that deserves further attention in analyzing the circumstances of the purchase.

Aaron Augustus Healy (1850–1921) was a Brooklyn-born businessman who, after being educated at Brooklyn Polytechnic Institute, entered the leather-manufacturing company (A. Healy & Sons) led by his father, Aaron. An astute businessman himself, Augustus Healy (as he was known to distinguish him from his father) increased the family's already substantial wealth and, like his father, became a dedicated collector and patron of the arts.[44] Augustus Healy was one of the original incorporators of the Brooklyn Institute of Arts and Sciences in 1890 and joined the board of directors in 1895. He served as president of the Brooklyn Institute from 1895 to 1920, retiring to honorary board status in 1920. He was also a member of the New York City Art Commission and a director of the Brooklyn Academy of Music. In addition to the considerable gifts of art that he made to the Museum over his lifetime, he left the institution an important bequest of twenty paintings and drawings, a large cash legacy, and a trust fund that reverted to the Museum on the death of his widow.[45]

The connections between Sargent and Healy had already exerted considerable influence on the development of the Museum's collection before 1909. In 1897 Sargent had helped facilitate Healy's purchase of Giovanni Boldini's famed portrait of James McNeill Whistler from its owner, the artist Paul Helleu (1859–1927), a work that Healy presented to the Museum in 1909. In 1907 Healy had commissioned Sargent to paint his portrait (fig. 36), which was probably intended for the Museum at the time of its execution and which entered the collection as part of Healy's bequest in 1921. Healy's awareness of Sargent's desires to reduce his portrait activity must be taken as a given, not only because his own sittings took place at a time when Sargent was becoming more publicly adamant about taking fewer commissions but also because Healy purchased the artist's exotic genre painting *Dolce far Niente* (fig. 37). This canvas is exemplary in its demonstration of the new range of subject matter Sargent was investigating at the time, and its thematic kinship with Sargent's *Zuleika* (cat. no. 97) is worth noting.[46]

The institute's precedent-setting purchase of Jacques Joseph Tissot's series the *Life of Christ* was probably the most significant event in preparing the way for the 1909 acquisition of Sargent's watercolors. And, once more, the connections

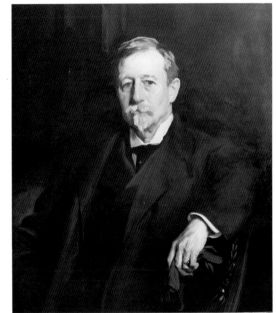

Fig. 36.
John Singer Sargent
(1856–1925)
Portrait of A. Augustus Healy,
1907
Oil on canvas
Brooklyn Museum of Art,
21.50, Bequest of A.
Augustus Healy

John Singer Sargent (1856–1925). *Zuleika,* c. 1906. Transparent watercolor with touches of opaque watercolor over graphite on off-white, thick, rough-textured wove paper. 10 × 13¹⁵⁄₁₆ in. (25.4 × 35.4 cm). 09.847, Purchased by Special Subscription

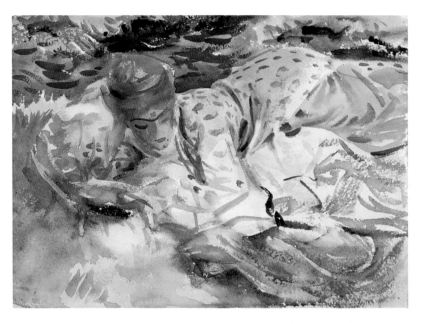

Fig. 37.
John Singer Sargent
(1856–1925)
Dolce far Niente, c. 1907
Oil on canvas
Brooklyn Museum of Art,
11.518, Bequest of A.
Augustus Healy

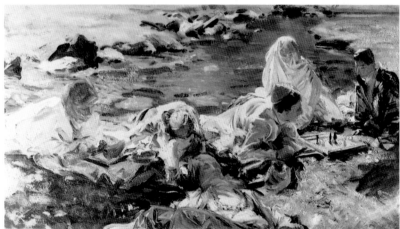

between Healy and Sargent have a bearing on the negotiations to secure the French painter's biblical series that were undertaken partly on the strength of Sargent's advice. Already commonly known as the Tissot Collection by the time the institute accessioned it in 1900, the series consisted of 461 works (5 oils, 345 watercolors, and 111 ink drawings), which had been executed from 1886 to 1894. The illustrations were products of painstaking research conducted by the French painter in a quasi-archaeological mode that involved several study excursions to the Holy Land. This process reiterated a familiar pattern set by the English Pre-Raphaelite William Holman Hunt (1827–1910) for his own biblical subject paintings and which, as Christopher Wood has noted, relied on a historical approach to the life of Jesus in a rational, antiquarian fashion that appealed to the Victorian mentality.[47] Tissot, like many of his contemporaries, had fallen under the spell of fin-de-siècle spiritualism and, as a result, combined a rationally based

historicism with mystical overtones, which, in Tissot's case, intersected with the Roman Catholic religious revival that swept France in the late nineteenth century. Tissot's own renewal of his religious convictions inspired this grand project, which resulted in the greatest public success of his artistic career: the exhibition of 270 works from the collection at the Salon du Champ-de-Mars in 1894. The Tissot Collection was subsequently shown in London in 1896 and in Paris again in 1897 before it began a tour of the United States. As was the case with the Sargent watercolors, the reputation of the Tissot Collection preceded it. This was proved by the eager audience that was in attendance when the illustrations were first exhibited at the Brooklyn Art Association's Montague Street galleries in January 1899.[48]

The Board of Trustees minutes for the Brooklyn Institute of Arts and Sciences reflect that by May 1899, the committee for the art museum had reason to believe that it was possible to raise the money necessary to purchase the Tissot Collection, and it was authorized to solicit funds by subscription for that purpose. In that connection the collection was again placed on view at the Brooklyn Art Association galleries for a "return engagement" from March 31 to April 16, 1900, before going on view in the exhibition rooms of the National Academy of Design, beginning April 20.[49] From all indications, an arrangement to purchase had already been contracted by the institute and the minutes show that the net proceeds from entrance fees were to be applied to the sixty thousand dollar purchase price.[50]

The institute waged a highly publicized campaign to raise the funds. This included periodic updates in Brooklyn newspapers that announced the amount yet to be raised and listed the names of donors and the amounts they had pledged. A series of lengthy scholarly arguments favoring the purchase written by the Museum's curator, William H. Goodyear, was published in the *Brooklyn Eagle*, possibly calculated to offset negative factors that might have arisen regarding the religious subject matter, the medium (traditionally considered inferior), and the great expense. To heighten enthusiasm, reports also mentioned Augustus Healy's grueling twelve-hour train journey made to visit the artist in France, the artist's receipt of offers from other institutions in Europe and America to purchase the collection, and Tissot's agreement to install the works at Brooklyn personally because his discussions with Healy had been so favorable. In the end, the philosophy behind the purchase was summed up in the following words: "Moreover, the possession of such a collection by Brooklyn will in itself make Brooklyn a more attractive and interesting place. It will give character and standing to the Museum which contains it, and people will come from far and near to visit the collection, as they journey now to Dresden to see the Sistine Madonna."[51]

Although the Tissot Collection has not sustained the immense public interest that belonged to it originally, it occupies a meaningful place in the Museum's holdings in terms of the development of American public collections and especially with respect to the current revitalized scholarly and market interest in Tissot's career.[52] By the time of the Sargent watercolor purchase, the popularity of

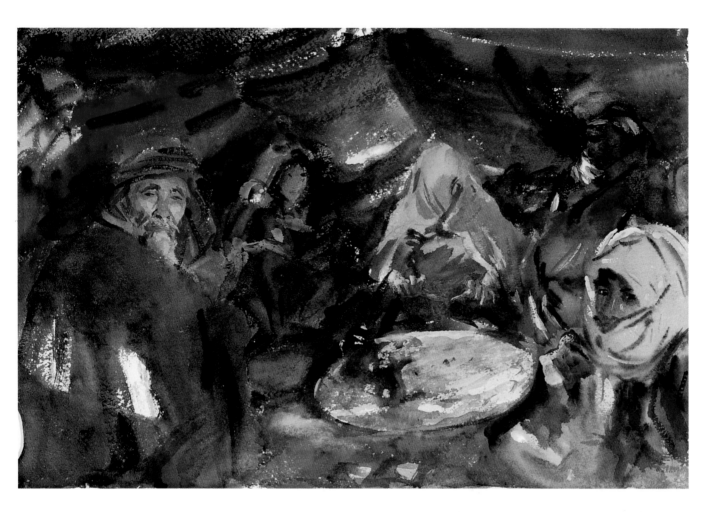

98

John Singer Sargent (1856–1925). *Arab Gypsies in a Tent*, 1905.
Transparent watercolor with touches of opaque watercolor on
off-white, thick, rough-textured wove paper. 12 × 18 in.
(30.5 × 45.7 cm). 09.807, Purchased by Special Subscription

Fig. 38.
Jacques Joseph Tissot
(French, 1836–1902)
*The Magi on Their Way to
Bethlehem*, c. 1888
Gouache on paper
Brooklyn Museum of Art,
00.159.30, Purchased by
Public Subscription

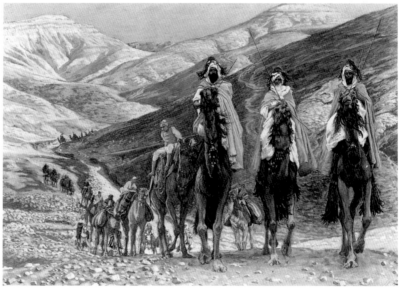

the Tissots had lessened; yet an unidentified writer for the Museum's *Bulletin* who declared the Sargents "the most important acquisition of a collection of paintings in the history of our Brooklyn Museum" also allowed that "from an historical, humanitarian, and religious point of view the Tissot paintings [were] the more important."[53] Crucial to the issue at hand is Sargent's support of the acquisition, a role that is documented in a brief article by the Museum's director, William Henry Fox, written in tribute to Sargent shortly after the artist's death. Fox opened his essay stating that the Museum "may claim specially close and friendly relations with the late John S. Sargent" and cited as proof "his correspondence, his repeated visits to the Museum, and . . . the advice he gave and the personal efforts he made to secure for the Brooklyn Museum modern painting of enduring worth." Fox credited Healy's long friendship with the painter as central to the relationship between Sargent and the institution and then offered the following on the Tissot purchase:

The water colors of J. James Tissot, illustrating the Life of Christ, were acquired by the Trustees fortified largely by Sargent's endorsement of their artistic merit. He used to say, "It is a mistake to look on these illustrations as alone religious in feeling, literary in their allusions, or simply 'erudite' in their exposition of types and costume. They are all this but they are much more from the aesthetic standpoint. Technically they are remarkable as showing Tissot's knowledge of composition, form and color. They are the work of a man of intellect and intuitive knowledge of human motive. . . . You should be proud to possess this collection."[54]

Apart from his usual willingness to support fellow artists, there is no other specific evidence that explains why Sargent would have advocated the institute's purchase of the Tissot Collection. Indeed, it seems remarkable that Sargent would have promoted this endeavor, given that the styles of the two artists are so fundamentally opposed, as shown here by the pairing of Tissot's *Magi on Their Way to Bethlehem* (fig. 38) and Sargent's *Arab Gypsies in a Tent* (cat. no. 98). There are, however, sufficient parallels between the artists' respective experiences that may afford insight into Sargent's sympathies for Tissot. Sargent must surely have been aware of Tissot's art before the Frenchman's return to Paris in 1882 following the eleven prosperous years he had spent in London. In 1883 a major exhibition of more than one hundred paintings summing up Tissot's work of the previous decade was displayed in Paris at the Palais de l'Industrie. Their paths inevitably intersected socially and professionally, especially through their friendships with the French painter Paul Helleu. Perhaps more relevant to Sargent's own artistic concerns was the largely lukewarm, but occasionally vituperative reception given to Tissot's series of fifteen large canvases titled *La Femme à Paris*. This series, shown at Galerie Sedelmeyer, Paris, in 1885 and at the Arthur Tooth Gallery, London, in 1886, was a visual survey of the *parisienne* which, in a strangely pedagogical way, set out to classify the modern female beauties of Paris according to type as determined by occupation and fashion.[55] Tissot's unorthodox series was exhib-

ited shortly after Sargent's own *Madame X* had elicited the sensationally hostile reactions at the Salon of 1884. Because of this conjunction of events, Sargent may have felt a vague kinship with Tissot for, although it is a formal portrait, *Madame X* may be seen to stem from the same urge to explore the nature of a conspicuously identifiable type of fashionable Parisian woman. The most salient point of sympathy between the two men, however, may have been their explorations of eastern Mediterranean regions, Tissot's having been done in preparation for the *Life of Christ* and Sargent's done in preparation for his mural project at the Boston Public Library, the subject of which was the History of Religion. Although the artists' aesthetic and technical approaches differed greatly, both painters were engaged in gathering on-site visual information via the watercolor medium from which they could construct their own versions of religious history. Sargent may have felt another sympathetic link with Tissot because he, too, had tried his hand at depicting the life of the Old Testament David as his part in a failed joint publication project for a new illustrated edition of the Bible.[56]

It is without doubt that the institute's purchase of the Tissot Collection opened the way for the 1909 acquisition of the Sargent watercolors by establishing a precedent for accessioning a large body of watercolors by a contemporary artist by public subscription. In the case of the Sargents, however, an energetic publicity campaign to raise the purchase funds was not necessary, so great were his reputation and the artistic (rather than didactic) appeal of the works themselves. Just as the Tissots were forecast to act as magnets to draw visitors through the doors of the Museum, commentators on the Sargent purchase acknowledged that "it was a wise move on the part of [the] institution, for there will be pilgrimages to the Eastern Parkway in the future that would not have taken place but for the Sargents."[57]

Other American museums quickly followed suit in their respective quests to acquire groups of Sargent's watercolors: in 1912 the Museum of Fine Arts, Boston, purchased forty-five, the Metropolitan Museum purchased ten in 1915 and, after a long sequence of discussions begun in 1913, the Worcester Art Museum acquired eleven in 1917.[58] It is worth noting that in each instance, Sargent figured in the negotiations—not necessarily with respect to financial terms (in regard to which he was extremely generous)—but with respect to the meting out of what had become highly sought-after examples of his art. Sargent probably derived great pleasure when, in 1921, he wrote to Knoedler, "In answer to your inquiry and to any similar inquiries please reply that I do not paint portraits anymore."[59] Shortly after the Sargent estate sale in London in 1925, a Knoedler representative reported, "Yes, the Sargents did bring big prices. . . . A mass of his water colours are in museums like Boston and Brooklyn, and will subsequently become as scarce as Turners. All this will tend to establish a new value for Sargent, and he will rise to the level Winslow Homer has reached."[60] Admittedly, the dealer was referring to monetary value, but his predictions were correct in that Sargent and Homer now stand together as the greatest of America's watercolorists, whether

they are judged on the auction floor, in scholarly writings, or by general audience response. Had it not been for his apparently deliberate management of his watercolors in the market sphere, the trajectory of Sargent's rise to prominence as a watercolorist would have likely taken a markedly different course—or might not have occurred at all.

NOTES

1. The institute did not purchase three of the eighty-six watercolors on view at Knoedler's (no. 67, *Sketchers*; no. 83, *Mrs. Wilfred von Glehn*; and no. 86, *Spanish Soldiers*), presumably because the artist had pledged them elsewhere. It was later discovered that the "wrong" *Spanish Soldiers,* bearing a personalized inscription, had been delivered to the institute (09.839) and the one intended for the institute delivered to a private party in England. In January 1926 the Museum deaccessioned through M. Knoedler & Co. thirty-two of the watercolors and another ten in April 1927. A letter from the Museum's director, William H. Fox, to a trustee, Frank L. Babbott, indicates that Sargent was aware of the possibility of such deaccessions. "I saw Mr. Sargent yesterday morning at the Copley Plaza Hotel in Boston. Mr. Sargent tells me that there was no understanding nor 'discussion' as he put it, regarding our purchase of his water colors. . . . He disclaimed any right to control their subsequent disposal, but said, very modestly, 'if you really want my opinion, I should not object to their going to another museum, but I should not be pleased if I thought they were to go into the hands of a "piratical" dealer who would speculate on their value by selling them at high prices to private individuals.'" The Museum postponed deaccessioning during the artist's lifetime most likely out of respect for Sargent, secure in the knowledge that the watercolors would ultimately sell at a higher price. W. H. Fox to Frank L. Babbott, March 7, 1924, BMA Archives, Directors File 1920–24, 688. Babbott.

2. Numerous newspaper articles (some of which are cited below) announced the 1909 purchase. The earliest mention of the Museum's acquisition in a nonperiodical publication may be that found in T. Martin Wood, *Sargent* (London: T. C. and E. C. Jack; New York: Frederick A. Stokes, [1909]). The most thorough treatments of Sargent's work in watercolor to date are Donelson F. Hoopes, *Sargent Watercolors* (New York: Watson-Guptill Publications in cooperation with the Metropolitan Museum of Art and the Brooklyn Museum of Art, 1972) and Annette Blaugrund, "'Sunshine Captured': The Development and Dispersement of Sargent's Watercolors," in Patricia Hills, *John Singer Sargent*, exh. cat. (New York: Whitney Museum of American Art, in association with Harry N. Abrams, 1986), 209–49 (hereafter Blaugrund 1986).

3. For the best account of Sargent's reputation and activities in America, see Trevor J. Fairbrother, *John Singer Sargent and America* (New York: Garland Publishing, 1986) (hereafter Fairbrother 1986).

4. "Sargent Paintings Sold," *American Art News* (February 27, 1909), 1.

5. Richard Ormond, *John Singer Sargent: Paintings, Drawings, Watercolors* (New York: Harper & Row Publishers, 1970), 68. Evan Charteris also notes Sargent's reluctance to sell his watercolors and the artist's habit of referring to them by absurdly derogatory titles (e.g., "Troglodytes of the Cordilleras," "Idiots of the Mountains," or "Intertwingles"). He attributed this habit to "the play of a humble spirit" and stated that the titles "sprang from no affectation and were due to no desire to belittle what he had done, but were shot to the surface from an undercurrent of boyishness which

never left him, from a horror of pomposity and portentousness about his art, and even, one might say, to check and damp down any tendency in others to an excess of admiration." Evan C. Charteris, *John Sargent* (New York: Charles Scribner's Sons, 1927), 178–79.

6. See chapter 4 in Fairbrother 1986, 208–78, for an account of Sargent's mural commissions and his concomitant disenchantment with portraiture.

7. Marc Simpson, *Uncanny Spectacle: The Public Career of the Young John Singer Sargent,* exh. cat. (New Haven: Yale University Press; Williamstown, Mass.: Sterling and Francine Clark Art Institute, 1997), 69 (hereafter Simpson 1997).

8. Because many of Sargent's watercolors are neither signed nor dated, and because many often depict similar subjects, it is sometimes difficult to establish exhibition histories.

9. See, e.g., "Art Notes," *Illustrated London News,* June 6, 1903, 880, 882; "Sketches and Studies by Mr. J. S. Sargent, R.A.," *Graphic* (May 30, 1903), 730; "The Royal Water-Colour Society," *Graphic* (April 15, 1905), 454; and E. M., "Art Notes," *Illustrated London News,* June 6, 1908, 828.

10. Martin Hardie, *J. S. Sargent: VII. Famous Watercolor Painters* (London: The Studio; New York: William Edwin Rudge, 1930), 1 (hereafter Hardie 1930).

11. Société des Artistes Français pour l'Exposition des Beaux-Arts de 1881, *Salon de 1881.* The two works are identified in Simpson 1997, 174, as *Café on the Riva degli Schiavone, Venice,* (1880; private collection) and *A Venetian Interior* (1880; collection of Mr. and Mrs. Harry Spiro).

12. The text of Sargent's introduction to the catalogue of the 1892 Brabazon exhibition at the Goupil Gallery in London is reprinted in C. Lewis Hind, *Hercules Brabazon Brabazon, 1821–1906: His Art and Life* (London: George Allen, 1912), 85–86. For Brabazon, see also *Art and Sunshine: The Work of Hercules Brabazon Brabazon, NEAC, 1821–1906* (London: Chris Beetles, 1997).

13. The nature of Brabazon's possible influence on Sargent is discussed briefly in Blaugrund, 1986, 217–18. Sargent's renewed interest in watercolor in the 1890s may also have been stimulated indirectly by Dodge Macknight's watercolors. Sargent had allowed Macknight the use of his London studio for three weeks in 1890 for the purpose of mounting an exhibition of his watercolors. See *Dodge Macknight 1860–1950, Loan Exhibition of Watercolors,* Museum of Fine Arts, Boston, 1950.

14. "Art Notes," *Illustrated London News,* June 6, 1903, 880 and 882.

15. "Sketches and Studies by Mr. J. S. Sargent, R.A.," *Graphic* (May 30, 1903), 730.

16. Stanley Olson, *John Singer Sargent: His Portrait* (London: Barrie & Jenkins, 1986), 236.

17. "Mr. Sargent at the Carfax Gallery," *Athenaeum* (May 23, 1903), 665. I am grateful to Richard Finnegan of Adelson Galleries, Inc., Sargent Catalogue Raisonné Project for bringing this and other *Athenaeum* reviews to my attention.

18. Roger Fry, *Transformations* (London: Chatto & Windus, 1926), 129. That Fry would have considered Sargent's art anathema is understandable in view of his aesthetic values, which, as Charles Harrison points out, rested on the belief that art must express the "imaginative life" rather than "actual life." See Harrison, "Critical Theories and Practice of Art," in *British Art in the Twentieth Century: The Modern Movement,* exh. cat., ed. Susan Compton (London: Royal Academy of Arts; Munich: Prestel-Verlag, 1987), 51.

19. The works by Sargent on view were no. 86, *A Spanish Barracks;* no. 103, *A Garden Vase;* no. 107, *The Facade of La Salute;* no. 230, *A Venetian Trattoria;* and no. 239, *The Grand Canal.*

20. "Art Notes," *Illustrated London News,* April 16, 1904, 584.

21. The NEAC (in which Sargent was one of the early members) was traditionally associated with progressive, antiacademic art practice. It was the venue at which Sargent took the opportunity to show some of his most advanced work, including *Paul Helleu Sketching with His Wife* (1889; Brooklyn Museum of Art) in 1892. Sargent also occasionally attempted to revise his profile as a portraitist at the Royal Academy by submitting landscape subjects, e.g., *Mountains of Moab* (R.A., 1906, no. 383).

22. NEAC exhibition records do not include the medium of works shown. However, *Spanish Soldiers* (NEAC, 1904, no. 11) may be identified as a watercolor and Sargent's other exhibit, *Stable at Cuenca* (NEAC, 1904, no. 53), as an oil according to "Two Art Galleries," *Graphic* (April 16, 1904), 519.

23. W. M., "Art Notes," *Illustrated London News,* April 29, 1905, 626.

24. "Painters in Water Colours: Mr. Sargent's Pictures," *Manchester Courier,* April 13, 1907. The author is grateful to Simon Fenwick, Archivist, Royal Watercolour Society, for providing this material from the society's scrapbooks.

25. *A Vagrant* was also shown at the 1908 Carfax exhibition as no. 5. Since subsequent watercolor exhibitions do not include a work by that title and since a work titled *A Tramp* is not recorded until the 1909 Knoedler exhibition (which included previously exhibited works), it is likely that the two titles refer to the same painting.

26. Simon Fenwick of the RWS also kindly supplied a copy of the 1908 RWS annual report documenting Sargent's deposit of his diploma work. In a letter to the author of April 8, 1997, Fenwick points out that, while *Bed of a Glacier Torrent* has been published elsewhere as *River Bed,* the correct title is the one used here. RWS sale records for the years 1904 through 1912 (exclusive of those for 1905, which are unlocated) show that Sargent sold only one work out of the RWS exhibitions (1911, no. 31, *Sketching,* for 100 pounds). It is not known if Sargent placed restrictions on the sale of the works he showed at the RWS, but since the works exhibited at the Carfax exhibitions were advertised as "loans" (primarily from the artist's collection), it is likely that the watercolors displayed in London from 1903 to 1908 were not for sale.

27. "The Royal Water-Colour Society," *Graphic* (April 15, 1905), 454.

28. The interrelationships between Sargent's watercolors and oils having similar subjects requires closer examination.

29. The catalogue entry for *Madame X* in Doreen Bolger Burke, *American Paintings in the Metropolitan Museum of Art, Volume III, A Catalogue of Works by Artists Born between 1846 and 1864* (New York: Metropolitan Museum of Art, 1980), 235, mistakenly states that the painting was shown at the Carfax Gallery in 1909. There is, of course, the possibility that the general viewership was ignorant of *Madame X*'s history and may not have caught the full meaning of its presence in the exhibition. Such a possibility does not, however, diminish the contextual inflections the painting held for Sargent. I thank Elizabeth Oustinoff of Adelson Galleries, Inc., Sargent Catalogue Raisonné Project, for sharing the Carfax exhibition catalogues and other Sargent watercolor exhibition records.

30. "Sargents at the Carfax Gallery," *Athenaeum* (April 1, 1905), 408–9. At the time this book entered the final phases of production, another fine volume devoted to Sargent was published: Warren Adelson et al., *Sargent Abroad: Figures and Landscapes* (New York, London, Paris: Abbeville Press, 1997). In it Elizabeth Oustinoff states that the author of the *Athenaeum* review cited here was not Fry, but does not give reasons for this conclusion or suggest the writer's identity. See her essay, "The Critical Response" in *Sargent Abroad: Figures and Landscapes,* 225. The question of the review's authorship will doubtless be settled in future publications.

31. D. S. MacColl, "Museums and Exhibitions," *Saturday Review* (April 1, 1905), 412.

32. See, e.g. *Sun,* February 19, 1909. Clipping files, Knoedler Archive. I am grateful to Melissa de Medeiros, Archivist, Knoedler Archive, for her invaluable assistance with this research.

33. "Art Notes," *American Art News* (February 20, 1909), n.p.

34. See Erica Hirshler's biographical entry for Boit in Trevor Fairbrother, *The Bostonians: Painters of an Elegant Age, 1870–1930,* exh. cat. (Boston: Museum of Fine Arts, Boston, 1986), 201. Boit, who had graduated with a law degree from Harvard, gave up law to study art in Europe. Although he exhibited occasionally at the Paris Salon, Boit's reputation as an artist centered in his native Boston, where he exhibited at Doll & Richards, the Boston Art Club, and other venues. He lived a privileged life, dividing his time between his homes in Europe and the United States.

35. "Water Colors at Knoedler's," *American Art News* (February 20, 1909), 1. An unsigned article in the *Bulletin of the Brooklyn Institute of Arts and Sciences* (February 1909), 160, states: "The Exhibition of the works of these two artists was in fulfilment of a compact entered into between Mr. Sargent and Mr. Boit many years ago when they were comparatively young artists. These two warm personal friends agreed at some time to exhibit collections of their paintings conjointly. This year for the first time has it been practicable for them to fulfill their pledges."

36. At this writing the author has been unable to obtain a reproduction of a Boit watercolor that may be securely identified as one shown at the 1909 Knoedler exhibition. The painting reproduced here is one of the thirty-eight by Boit purchased by the Museum of Fine Arts, Boston, out of the 1912 Knoedler exhibition of Sargent's and Boit's watercolors.

37. [Royal Cortissoz], "A Master's Sketches: Mr. John S. Sargent as a Painter of Water Colors." Newspaper clipping, Knoedler Archive.

38. J. G., "The Water-Colors of Edward D. Boit and John S. Sargent," *Museum of Fine Arts Bulletin* (June 1912), 18–21.

39. Several of the newspaper reports mentioned the prior English showings. The *Sun* (February 19, 1909) stated flatly that "all London went to admire" the Sargents at the Carfax. Clipping files, Knoedler Archive.

40. [Royal Cortissoz], "A Master's Sketches: Mr. John S. Sargent as a Painter of Watercolors."

41. "Many Good Pictures," *Brooklyn Eagle,* February 17, 1909. BIAS Scrapbooks, Art Reference Library, Brooklyn Museum of Art.

42. Hardie 1930, 1.

43. "Brooklyn Buys Sargent Pictures," *New York Herald,* February 20, 1909; "Sargent Paintings Sold," *New York Times,* February 20, 1909. Clipping files, Knoedler Archive. The actual purchase price was $20,000.

44. "A. Augustus Healy, Arts Patron, Dead," *New York Times,* September 29, 1921. The senior Healy was noted as a "pioneer among collectors" in the Brooklyn community. His collection included the work of the French Barbizon painters and Adolphe Bouguereau. "Brooklyn's Art Collections," *Collector* (January 1, 1890), 34.

45. Details regarding A. Augustus Healy's gifts to the Museum are found throughout the Brooklyn Museum of Art Archives.

46. The exact date of Healy's purchase of *Dolce far Niente* is unknown. The work was probably painted at Purtud in the Val d'Aosta, Italy, during Sargent's summer visit to that area in 1907 and was shown at the 1909 summer exhibition of the NEAC. By 1911 Healy had placed it on long-term loan to the Museum and it formally entered the collection on his death in 1921.

47. For a summary history of Tissot's *Life of Christ,* see Christopher Wood, *The Life and Work of Jacques Joseph Tissot (1836–1902)* (London: Weidenfeld and Nicolson, 1986), 143–55, and Michael Wentworth, *James Tissot* (Oxford: Clarendon Press, 1984), 174–97 (hereafter Wentworth 1984).

48. Considerable press and periodical attention was given to the collection and its tour, most notably Cleveland Moffett, "J. J. Tissot and His Paintings of the Life of Christ," *McClure's Magazine* (March 1899), 386–96, an article which, as Wentworth points out, was patently commercial in its intent because *McClure's* had entered into an agreement regarding reproduction rights for the collection from which the publisher stood to profit greatly.

49. Newspaper reports touted the United States tour, which was reputed to have earned the artist upwards of $100,000 from admission fees. The admission charges for the Brooklyn venue were twenty-five cents; for the NAD, fifty cents. Through apparently cagey public

relations, visitors were encouraged to visit the exhibition while it was still in Brooklyn to avoid the crush in Manhattan, thus enhancing the sense of urgency about viewing the collection and in the hopes of securing greater gate receipts that would be applied to the purchase price. See "The Institute's Urgent Appeal, Members Asked to Give Only $5 Each for the Tissot Pictures," *Brooklyn Times,* March 30, 1900. BIAS Scrapbooks, Art Reference Library, Brooklyn Museum of Art.

50. The narrative put forth here is based on the Brooklyn Institute of Arts and Sciences Board of Trustees Minutes recorded on January 8, 1899, May 26, 1899, and April 6, 1900, Brooklyn Museum of Art Archives.

51. "Institute's Plan to Buy Tissot's Life of Christ," Unidentified newspaper clipping, BIAS Scrapbooks, Art Reference Library, Brooklyn Museum of Art.

52. The details of the history of the Tissot Collection and its acquisition deserve more investigation in their own right, but for the purposes of this essay such a discussion must be omitted.

53. "The John S. Sargent Collection of Water Color Paintings," *Bulletin of The Brooklyn Institute of Arts and Sciences* (January 30, 1909), 160.

54. William Henry Fox, "John Singer Sargent and the Brooklyn Museum," *Brooklyn Museum Quarterly* (July 1925), 113. It is unfortunate that the correspondence between Sargent and the Museum mentioned by Fox is not located at the time of this writing.

55. For an assessment of *La Femme à Paris,* see Wentworth 1984, 154–73.

56. Donelson F. Hoopes, *Sargent Watercolors* (New York: Watson-Guptill Publications, 1970), 17.

57. *Globe* (March 2, 1909). Clipping files, Knoedler Archive.

58. Accounts of these acquisitions are provided in Sue Welsh Reed and Carol Troyen, *Awash in Color: Homer, Sargent, and the Great American Watercolor* (Boston: Museum of Fine Arts, Boston, in association with Bulfinch Press, Little, Brown, 1993); *American Watercolors from the Metropolitan Museum of Art* (New York: American Federation of Arts, in association with Harry N. Abrams, 1991); and Susan E. Strickler, "American Watercolors at Worcester," in *American Traditions in Watercolor: The Worcester Art Museum Collection,* exh. cat. (New York: Worcester Art Museum, Abbeville Press, Publishers, 1987).

59. Letter from John Singer Sargent, February 28, 1921, Copley Plaza, Boston, to M. Knoedler, New York, Knoedler Archive.

60. Letter from C. C. [Charles Carstairs?] to C. R. Henschel, August 6, 1925, Knoedler Archive.

6

LANGUAGE, WATERCOLOR, AND THE AMERICAN WAY

BARBARA DAYER GALLATI

"Diversity has become the Muse of America." So declared Malcolm Vaughan in his review of the Brooklyn Museum's 1931 watercolor biennial.[1] It would be easy to dismiss Vaughan's statement as merely empty commentary designed to provide a thematic slant for his article. Indeed, as large, comparative exhibitions became the order of the day, it also became increasingly difficult for newspaper reviewers to rise to the challenge of delivering meaningful summaries of exhibitions containing hundreds of works. As a result, many of the reviewers, trained as journalists, adhered to newspaper style and resorted to lead-in paragraphs that contained sweeping statements on the condition of the arts, but (partly because of space allotments in the newspaper layout) failed to carry out their themes because of the imperative to report facts. This was a contributing factor to the decline in the quality of art coverage in the daily presses throughout the 1930s and 1940s, a cursory survey of which discloses that by then newspaper art writing was often reduced to listing whose work was shown and little else. Vaughan, however, was one of the more thoughtful newspaper columnists of that time, and as the body of his article is considered, it reveals not only that he had a point of view but also that his thinking reflected a subtext that had existed in American watercolor criticism since the late 1870s.

Vaughan's assumptions are made clear in his optimistic statement: despite the multiplicity of styles and subjects that manifested themselves in American art (and specifically watercolor), there was to be found within it a unified national character. Whether this premise was well founded or not is irrelevant inasmuch as Vaughan's views were shared by other writers and thereby gain meaning as indicators of desire or belief on the part of a segment of society. What is most telling is that Vaughan and many of his contemporaries *wanted* a recognizably American art to exist in service of

a broader movement toward national identity and that they promoted this ideal in their columns.[2] In that respect Vaughan and his fellow art columnists—among them, Emily Genauer, Helen Appleton Read, Elizabeth McCausland, and Henry McBride—responded to a larger cultural trend by popularizing the ideas of writers like Van Wyck Brooks, Paul Strand, and Paul Rosenfeld, who espoused the idea of a national culture and who had the luxury of elaborating their thoughts in longer essays which, however, reached a narrower audience.[3] The push for a national cultural identity must be seen within the greater history of the era during which nationalistic feelings determining immigration policies, American participation in the two world wars (and concomitant swings in and out of isolationist foreign policies), and the Depression (and the government response to it, which generated a new brand of nationalism through federal support of the arts). Against this backdrop of political and social change, watercolor emerged as the "American medium" mainly as a result of the daily presses' denatured reiterations of theories which were more thoroughly explicated in critical journals.[4]

This chapter outlines the critical attitudes that, for a short time, situated watercolor production at the center of the mounting claims for a definably American artistic expression. What it will show is that the labors to advance the idea of watercolor as a primary expression of Americanness ultimately failed because critical faith was invested in the idea of the medium and the characteristics associated with it, the enumeration of which relied on a discrete system of language that had become standardized in the nineteenth century. The standardized language used to discuss watercolor helped to substantiate the conclusion that watercolor materially demonstrated national identity; it stabilized perceptions of watercolor and consequently endowed it with a sense of tradition. By adopting this approach, however, writers subordinated the role of the artist in the creative process and also absolved themselves of the responsibility of analyzing subject matter in any detail. In this regard the message was truly in the medium.

Vaughan's determination to establish a sense of cultural unity within diversity is plainly revealed in his celebration of watercolor:

It is clear that among the American school, variety has become a goal in itself. The exhibition tells us that numerous American painters now consider variety to be an instrument of vision. Thus we may find a poetic landscape, a realistic still life, an abstract portrait and a romance in genre, all from the brush of one man. . . . Yet there is a common denominator among all the Americans. The exhibition makes happily clear that our artists, as a school, still cling to draftsmanship as the soundest basis of water color painting. We have produced not one important luminist who has abandoned the glory of line for the dazzle of the prism. Line is masculine, color feminine. As a result of our reliance on line, the American section of the display seems splendidly virile, sturdy and forceful.[5]

Although the passage quoted above might be looked at as nonsensical in the long run, who would dare criticize a writer whose thinking paralleled the nation's motto, "E pluribus unum"? Vaughan was not alone in his treatment of the 1931

biennial. Another reviewer, writing for the *New York Evening Post,* also adopted a patriotic approach: "The Brooklyn Museum long ago put itself on record in favor of water color as a medium particularly congenial to the American temperament and scene when it acquired the splendid group of pictures by Homer and Sargent at a period when water color painting was considered a rather amateurish by-product of the serious business of painting in oils. . . . The museum has further affirmed its belief in the dignity of this medium through biennial shows which have demonstrated better than any formal thesis how well water color painting accords with a modern freedom of individual technique suited to subject matter and revealing the essentials of design by a few, simple factual statements."[6] Throughout the 1930s and 1940s writers often remarked on the particular aptitude Americans had for watercolor painting. This opinion was at the core of Helen Appleton Read's review of the 1934 American Watercolor Society annual, in which she contended that the exhibition "affirms once more the instinctive predilection and flare which the American artist evinces for the water color medium. . . . It is no accident that more American artists use water color more effectually to set down their reactions to the world about them than they do oils. The medium lends itself to native traits of spontaneity and haste and impatience with theorizing."[7] The fact that none of these writers supported their statements by citing specific examples of artists or works is significant and augurs the disintegration of the ideas they promoted. Indeed, without the benefit of knowing when the passages quoted here were written, it might be possible to attribute them to a nineteenth-century source, for they echo the nationalist ideas that are at the foundation of what now stands as "the American watercolor tradition."[8] For a variety of reasons, nineteenth-century writers had also concluded that "water-colors lend themselves better to the artistic qualities of our painters than oils, and the public understand and like them better."[9] A writer for the *Aldine,* reviewing the 1875 AWS exhibition, managed to introduce associative correlations between freedom, purity, watercolor, and America in a single sentence: "Nothing so manifests the essential vigor and freedom of American artists from technical mechanisms, and 'manner,' as the ease and power with which they drop the oils, and mix their thoughts with the purest natural element [*water*color]."[10]

By the early decades of the twentieth century, watercolor had assumed a higher profile as the ideal means to document the nation's cultural progress. Because the medium's physical properties demanded of artists a quickness, facility, decisiveness, and confidence (to get it right on the first stroke), the process of watercolor painting came to stand as an easily understood metaphor for the active American spirit. What is more, watercolor provided virgin artistic territory, which, as Marilyn Kushner has pointed out, had not been "colonized" or "recently identified with any particular country."[11] The metaphorical links established between the course of the country's development and the development of its arts had already taken strong root in the creation and interpretation of nineteenth-century landscape paintings (in oil) and, as will be seen, seemed to work equally well when

they were applied to discussions of watercolor.[12] Elizabeth McCausland based her assessment of Lloyd Goodrich's 1945 exhibition, *American Watercolor and Winslow Homer*, on the fundamental premise that "in the whole sociohistoric process, the arts were organically involved."[13] From there she launched a brief but ambitiously conceived discussion founded on the principle of progressive evolutionary patterns manifested in the histories of nations, capitalism, liberty, and democracy. McCausland then appended watercolor to this conceptual device: "With the Great Awakening and the Enlightenment, the tempo of the democratic process accelerated. The birth of parliamentary institutions was a further step toward liberty. . . . In this chain, the 19th century looms as the period of the quantitative fulfilment of technological production. In the field of intellectual history, ideas developed along a parallel course, and so, too, in the field of art. The rise of watercolor is such a phenomenon." Critical to McCausland's thinking was the notion that watercolor embodied freedom:

If oil painting gave the artist freedom from the wall [i.e., mural painting], water color gave him freedom from the studio. The habit of working directly from Nature which grew up among 19th century landscape painters was surely facilitated by a medium as fluid and portable as water color. But more important is the kind of emotional and psychological attitude permitted by the medium's own qualities. It freed the painter from solemnity and pompousness. Something in the light, diaphanous character of water color echoed the quick, rapid pace of history in that burgeoning time. Or if a deeper organ note was needed, there was the rich, somber majesty of Homer's later water colors. . . . Perhaps the very fact that water color came into its own in a period of broadening democratic hopes is the reason that a certain snobbism still persists about its use.[14]

McCausland's deliberate insertion of watercolor into a historical continuum based on the precept of progess and driven by democratic values validated the medium's American status and aligned it with a pattern of thought leading out of the previous century's ideology of manifest destiny. In terms of subject matter, the same issue had already been resolved. With the country's discovery period completed and the continent settled, the potential for national accomplishment resided in technological advancement—most notably in urban centers, where the skyscraper became symbolic of the country's assumption of power on a new level. The concept of the pioneering spirit applied equally well to the past and to the inventions that created the new American image built on the strength of its urban-technical vitality that continued to transform the landscape. In his 1927 essay, "The Americanization of Art," Louis Lozowick merged the ideas of the historical and modern landscape by alluding to the requisite conquest of nature in the transformation of American civilization: "The history of America is a history of stubborn and ceaseless effort to harness the forces of nature—a constant perfecting of the tools and processes which make the mastery of these forces possible. The history of America is a history of gigantic engineering feats and colossal mechanical construction. . . . The dominant trend in America of today, beneath

100

Edmund D. Lewandowski (b. 1914). *Industrial Composition,* 1939. Watercolor over graphite on off-white, moderately thick, rough-textured wove paper. Partial watermark: HAYLE MILL LINEN–5. Countermark: HANDMADE / HANDMADE. Partial embossed stamp: Line / Grumbac. 21¹⁵⁄₁₆ × 29¹⁵⁄₁₆ in. (55.7 × 76 cm). Signed and dated lower right: *E.D. Lewandowski 1939.* 41.513, Dick S. Ramsay Fund

all the apparent chaos and confusion is towards order and organization which find their outward sign and symbol in the rigid geometry of the American city."[15] Within such thinking, nineteenth-century images of the continent's natural wonders—the Natural Bridge or Niagara—could easily be replaced by images of the Brooklyn Bridge or generic, iconic compositions indicative of expansion, production, and progress such as Edmund Lewandowski's *Industrial Composition* (cat. no. 100). Watercolor accommodated this process of transposition as well, for it was truly the medium of exploration; its portability facilitated the artist's sovereignty over or "possession" of the landscape subject, since it allowed the direct transcription of nature. As McCausland observed, watercolor freed the artist from the studio, and with that came movement, action, and the potential for spontaneity, all of which, in turn, were in the catalogue of the modernist vocabulary.

Despite the radical shift in emphasis from the natural landscape to the man-made, the iconography of the city was capable of carrying the same meaning embodied in American landscape subjects of the previous century: the mastery of nature through the mechanism of progressive expansion. By associating watercolor with the dynamism of urban life, watercolor was gracefully incorporated into the same methodological and philosophic construct that satisfied a need for asserting a history of a native cultural tradition. Yet implicit in the manufacture

of a "tradition" as opposed to mere "history" is continuity. And, while a semblance of continuity had been established in at least one area of subject matter (the transformation of the landscape), there was yet to be made a case for a watercolor tradition as a whole. As Vaughan recognized, there was little evidence of stylistic unity among American watercolorists, although the properties of watercolor technique offered a continuity of sorts by allowing for a consistent vocabulary that was as useful for describing the watercolors of Winslow Homer as it was for the modernist works of John Marin.

By the 1920s Americans had barely had time to conceive of themselves as a nation in historical terms, let alone cultural ones. However, as events and facts accrued, a history formed, even if that history was not accompanied by consistent cultural patterns that encompassed literature, the arts, or even laws governing the states (which to this day are not uniform). The visual arts, rooted in the soil of Europe, had survived transplantation to the new land but had not sufficiently matured to a point where painting, architecture, or sculpture could be called truly American because the element of tradition had not yet entered the American experience. The essence of a cultural tradition caught hold in the conceptual continuity evinced by the idea of progress as it applied to the iconographies of nineteenth-century landscape and the early-twentieth-century cityscape, respectively. The energies supporting urban growth invariably became equated with the notion of the modern American spirit. Of all the arts practiced in America in the early twentieth century, watercolor has been most closely aligned with the idea of the modern American spirit—mainly because of the formal experimentation for which its practitioners were noted.[16] What may be of greater importance in tracing the rationale behind watercolor's temporary elevation to the role of "the American medium" (which made it the locus of an identifiably national cultural tradition) is the language used to describe it, which linked it to the past and glorified it in the present.

The use of the term *American* to describe specific aesthetic qualities exhibited by watercolors was often reserved for discussions of Winslow Homer's art, which was frequently seen as a product of "a robust and healthy eye and taste," despite its tendency to crudity or rawness in facture.[17] A passing study of reviews of Homer's watercolors yields a set of words—among them, *vigorous, sturdy, natural, truth, vitality,* and *fresh*—that were consistently applied to his art and bred associations with the preferred characteristics of a stereotypical American national identity. His art was straightforward and it appealed to large audiences because it was so thoroughly unpretentious, approachable, and hence democratic.

A direct line may be drawn between nineteenth-century critics' attempts to locate in Homer's watercolors a specifically American essence and those of later writers—for instance, Albert Gallatin and Paul Strand.[18] Gallatin had placed great store in the fact that "Homer came of pure New England stock," as if that were enough to explain his conclusion that "his art is intensely American."[19] For Strand, Homer was "the simple vision of the American pioneer spiritualized . . .

IOI

John Marin (1870–1953). *Deer Isle,* 1914. Watercolor on white, very thick, rough-textured wove paper. 15 1/16 × 19 in. (38.3 × 48.3 cm). 1996.150.3, Bequest of Mrs. Carl L. Selden

[who] saw the elemental in America as a spirit rather than as a purely material utility." It is here that John Singer Sargent was temporarily sidelined from the contest for supremacy in American watercolor because, as Strand wrote, "he escapes the reality of American life, both physically and in spirit."[20]

In their efforts to certify the existence of an American watercolor tradition, Gallatin, Strand, and others unanimously nominated John Marin (1870–1953) as the principal figure in this mission. Marin's work, which was executed mainly in watercolor, was positioned as the dynamic bridge that connected Homer's nineteenth-century naturalist landscape vision with the modernist trends of early-twentieth-century American art. Out of a need to create a new hero of mythic stature to fill the gap left by Homer's death in 1910, critics eagerly cast Marin in

the role of the grand isolate, working in a purely intuitive mode, without influence, but for that of Paul Cézanne (1839–1906), who had replaced Turner in the pantheon of artistic forebears.[21]

Marin's marvelous *Deer Isle* (cat. no. 101) makes clear the reasons for his great appeal. A pristine spot of Maine wilderness is set like a small gem against the whiteness of the paper, its boundaries faceted by hints of Cubist and Futurist leanings and colored by gentle, reductive washed passages. Marin's gift was that of lyric clarity; his ability to blend the brittle sharpness of sunlight as it defines form with a lean, poetic sensibility confirms the inventiveness of his mind and eye. His art seduced critics into writing a level and volume of prose that no other artist of his generation inspired—all of them echoing the same sentiment, that "Marin has schooled himself to no one's taste but his own."[22] Yet to see the painter as independent of influence misrepresents the process of his development during which he studied English watercolor masters and experimented with styles that suggested, if not confirmed, his knowledge of Whistler, the Impressionists, the Fauves, the Cubists, and the Futurists.[23] And, as it has been pointed out, his claims to have been untouched by such major movements should be interpreted to mean that he did not deliberately copy them.[24] Marin's capacity to synthesize avant-garde styles for the purpose of expressing an identifiably American iconography—whether it was the coast of Maine or the Woolworth Building—led Lloyd Goodrich to rhapsodize that Marin "was as much his own man as Homer was."[25] The perception of Marin as an independent was further fed by his abstention from organized artists' groups and his practiced avoidance of anything that bordered on the theoretical. These qualities fit the idealized American profile, in which individualism and action were prized over communal or intellectual activities.[26] The majority of reviewers were fearless in their convictions of Marin's rightful succession to the status of America's leading painter of watercolor. This is evidenced in Herbert Seligmann's blunt assertion that "Marin is kin to Winslow Homer only he is greater."[27] More to the point in the context of this essay, however, is the language Seligmann employed to characterize Marin's art ("Fresh, clean, free and powerful, are words one can use of Marin"), which is congruent with the language engaged to portray Homer's work.[28] Paul Rosenfeld's treatment of Marin's art in "American Painting" also relies on words once devoted to Homer and at the same time interjects a literary sensibility by referring to Marin's content as poetry: "Fused with the French delicacy, there has come to exist a granite American crudeness. So strong and rough has Marin's water-colour become, that the elders complain he has transcended the natural limits of the medium. What he has done indeed, is to liberate the medium, and express through the liberation the nature-poetry he feels."[29]

Language and its influence on the perception of visual arts take on particular relevance when consideration is given to the frequency with which the name of the poet Walt Whitman (1819–92) occurs in discussions of both Homer and Marin.[30] On one level, Whitman functioned as the model for the "American

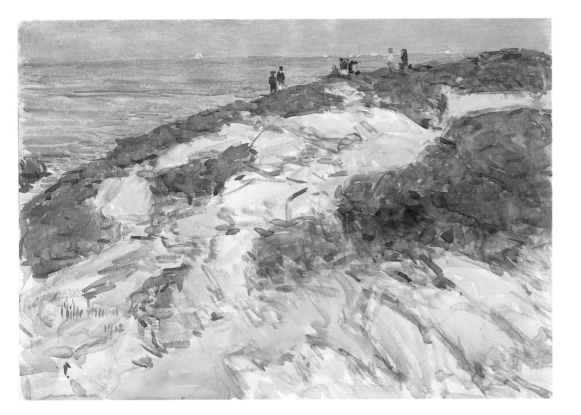

102

(Frederick) Childe Hassam (1859–1935). *Sunday Morning, Appledore,* 1912. Watercolor over graphite on cream, thick, moderately textured wove paper. 13¹⁵⁄₁₆ x 19¹⁵⁄₁₆ in. (35.4 x 50.6 cm). Signed and dated lower left: *Childe Hassam / 1912.* 24.104, Museum Collection Fund

artist" against whom all others would be measured. The poet's stature as an exemplar of American creativity was habitually mentioned in art writing, a common example of which is found in an editorial in the *Touchstone Magazine*: "In literature America has produced a man whose influence over human thought and feeling has spread over the earth, Walt Whitman. Let us prepare now for the time when an American painter or sculptor will exert an equal influence."[31] As Linda Ferber points out in chapter 4, a writer for the *New York Evening Post* had lost count of the number of times the names of Whitman and Homer had been linked. Marin's reputation was similarly enhanced (or defined) through references to Whitman. As Strand wrote: "Marin is seen carrying on in his work, undeliberately surely, the essential vitality of the Whitman tradition. His is a true embracement of this everyday American world, without however being caught in the sentimental trap of swallowing it whole in the effort to seize upon it. . . . He is seen to be one of the few contemporary workers in any medium who is contributing to what may truthfully be called an American culture."[32] Matthew Baigell has referred to more direct delineations of correspondences between the poet's and Marin's work, citing Rosenfeld's admiration of the latter "for its richness of touch, sensuality, crudeness and roughness"—the same qualities that he found prevailing in Whitman's verses.[33] The confluence of language brings us full circle; that is, in these few examples we find the same cluster of words to describe the poetry of Whitman and the watercolors of Homer and Marin—all of which differ substantially in formal terms.

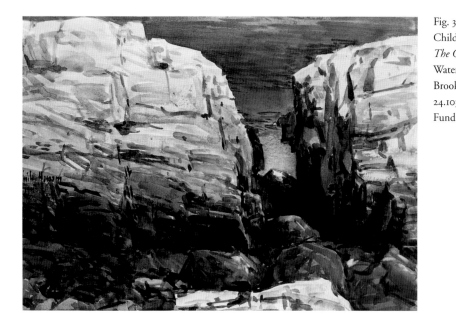

Fig. 39.
Childe Hassam (1859–1935)
The Gorge, Appledore, 1912
Watercolor on paper
Brooklyn Museum of Art,
24.103, Museum Collection
Fund

Marin's priority over his older contemporaries Childe Hassam (1859–1935) and Maurice Prendergast (1859–1924) possibly owes as much to his "Americanness" as it does to the modernity of his art (if we should choose to separate the two). Although Hassam's fine series of Isles of Shoals watercolors of 1912 (among them cat. no. 102 and fig. 39) are no less American in subject than Homer's and, in fact, exhibit closer formal relationships with the watercolors of Homer (e.g., fig. 40), than do those of many of his contemporaries, his long identification with Impressionism weakened his currency among critics searching for Homer's successor. In Strand's opinion, "[Hassam] has not created out of his knowledge of impressionism something intrinsically his own and of the American milieu."[34] As for Prendergast, Strand deplored the artist's betrayal of the initial promise he demonstrated at the Armory Show in favor of an "effete formula," which was judged the result of his removal from the "hot flux of life around him."[35] Ironically, Prendergast—whose subject matter of urban parks and crowded beaches (cat. no. 103) overlapped with that of his urban realist colleagues in the Eight—ultimately failed to win the support of writers in search of the vitality that symbolized America. Interestingly, the watercolors of Hassam, Prendergast, Arthur B. Davies, and other noted specialists in the medium did not elicit the critical language of "freedom, nature, virility, or freshness" that would have signaled their Americanness.

Marin's affiliation with Alfred Stieglitz (1864–1946) contributed enormously to his reputation as an artist working outside official channels and, at the same time, lent a veneer of exclusivity to his art

Fig. 40.
Winslow Homer (1836–1910)
Through the Rocks, 1883
Watercolor on paper
Brooklyn Museum of Art,
50.183, Bequest of Sidney B.
Curtis in memory of S. W.
Curtis

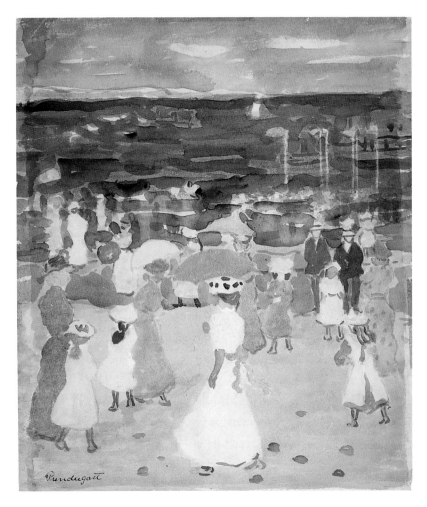

103

Maurice B. Prendergast (1859–1924). *Sunday on the Beach,* c. 1896–98. Watercolor over graphite on cream, moderately thick, moderately textured wove paper. 17¾ × 13⁵⁄₁₆ in. (45.1 × 33.8 cm). Signed lower left: *Prendergast.* 65.204.9, Gift of Mr. and Mrs. Daniel Fraad, Jr.

and public persona.[36] As a prominent figure in the New York art community and as an arbiter of taste, Stieglitz had few rivals. His part in introducing modernist European art to a New York audience is well documented, as is his support of a small group of innovative American artists, which included Marin, Marsden Hartley, Oscar Bluemner, Max Weber, Arthur Dove, Abraham Walkowitz, and Georgia O'Keeffe. His succession of galleries—the Little Galleries, 291, the Intimate Gallery, and, the last, An American Place—provided the platform for Stieglitz's philosophy that decried the wholesale adoption of the "isms" of modern art in favor of the individual's internalization of modern forces to the service of unique—and American—art production. As demonstrated by the variety exhibited in the small selection of works by artists of the Stieglitz group in this exhibition, there was no single style advanced by Stieglitz other than that which expressed a genuine embodiment of the contemporary spirit.

A survey of the exhibitions mounted at 291 from 1905 to 1917 reveals Stieglitz's partiality to watercolors.[37] Of the European artists who received solo exhibitions at the gallery, the shows of drawings and watercolors by Rodin (1910), Cézanne (1911), and Picasso (1911) probably held the most powerful influence over Stieglitz's American protégés and helped to ratify watercolor as a primary instru-

ment for modernist experimentation in America.[38] Although Abraham Walkowitz (1878–1965) is not reported to have visited 291 before 1911, his *Isadora Duncan #29* (cat. no. 104) makes it difficult to imagine that he had not seen the Rodin watercolors shown at the gallery in 1910. The finely drawn contours of the dancer's body and the wash of pale, transparent color seem evidence enough in the attempt to document Walkowitz's knowledge and emulation of Rodin's watercolor style.[39] Yet even Walkowitz, who stands as a lesser light within the constellation of Stieglitz's artists, was insistent in his Americanness here by means of his obsessional focus on Isadora Duncan (he created a series of 40 watercolors and pastels of the dancer, which he gave to the Museum in 1939), whose notoriously free dance performances transformed her into an icon of the modern American spirit. By coincidence, Walkowitz's close friend Max Weber (1881–1961) is represented here by another dance subject, *Study for Russian Ballet* (cat. no. 105). Although, in this instance, Weber used watercolor as a preparatory tool, the energetic application of the paint results in a work that is perhaps just as satisfying as the finished oil (fig. 41), which reads as a more studied declaration of modernist formal principles.

Weber's association with Stieglitz was short-lived, ending abruptly in 1911.[40] Others of the American artists featured at 291, however, remained closely affiliated with the gallery, among them, Georgia O'Keeffe (1887–1986) and Arthur Dove (1880–1946). O'Keeffe devoted much of her energies to watercolor during the teens because the random effects afforded by the free-flowing medium facilitated her investigations into the relationship between intuitive and conscious aspects of the creative process. Her remarkable set of four watercolors, *Blue No. 1–4* (cat. nos. 106–9), clearly demonstrates the latitude for innovation that the medium permits and relates directly to her study with Arthur Wesley Dow at Teachers College, Columbia University, in 1914–15. Dow, whose art theories were based partly on Japanese and Chinese aesthetics, downplayed three-dimensional illusionism in favor of flattened abstract elements of composition through line, shape, color, and contrasts of light and dark values. O'Keeffe's elegant repetitions of simple, rounded forms punctuated by a few carefully placed diagonals reach a formal conclusion that is distinctly calligraphic in nature. The intellectual control exerted in paring down the composition is countered by the spontaneity implicit in the movement of the medium itself; the heavily watered brush—unguided by preparatory lines—worked a series of unplanned though complementary physical effects as the fragile paper reacted to the water's pooling and drying. O'Keeffe's drawings and watercolors of this period stimulated critics to examine her art in metaphysical terms: "Here are emotional forms quite beyond the reach of conscious design, beyond the grasp of reason—

104

Abraham Walkowitz (1878–1965). *Isadora Duncan #29*, c. 1915. Watercolor and ink over graphite on off-white, medium-weight, moderately textured laid paper. Watermark: VOLUME / MIMEO / BOND / E. 14 × 8½ in. (35.6 × 21.6 cm). Signed lower left: *A. Walkowitz*. 39.174, Gift of the artist

105

Max Weber (1881–1961). *Study for Russian Ballet*, 1914.
Watercolor with touches of pastel on cream, medium-weight,
moderately textured laid paper. Watermark: MBM *(FRANCE)
INGRES D'ARCHES*. 18⅝ × 24⁹⁄₁₆ in. (47.3 × 62.4 cm). Signed,
dated, and inscribed lower right: *Max Weber 1914 / Russian
Ballet*. 88.205, Gift of Edith and Milton Lowenthal

Fig. 41.
Max Weber (1881–1961)
Russian Ballet, 1916
Oil on canvas
Brooklyn Museum of Art,
1992.11.29, Bequest of Edith
and Milton Lowenthal

yet strongly appealing to that apparently unanalyzable sensitivity in us through which we feel the grandeur and sublimity of life."[41] Her early works on paper embody the joyous meshing of form and color to create images that register as mysterious yet universal symbols.

In contrast to O'Keeffe, whose most important watercolor work dates to the first decade of her professional activity, Arthur Dove worked in watercolor throughout his career, often using it for plein-air sketches that inspired larger paintings in other media. As Barbara Haskell has noted, however, Dove considered these small sheets of transparent watercolor (e.g., cat. no. 110) as finished works.[42] Milton Avery (1893–1965) also adopted this practice; his watercolor renderings of the coast of the Gaspé Peninsula (*Road to the Sea,* cat. no. 111), executed on high-quality paper stock and on a large scale, were obviously meant to function as independent works yet also served as studies for oils that were completed sometimes years later.[43] While both Avery and Dove remained tightly bound to

108 *(above, left)*
Georgia O'Keeffe (1887–1986). *Blue #3,* 1916. Watercolor on
cream, thin, very smooth textured, gampi-fibered wove paper.
15⅞ × 10¹⁵⁄₁₆ in. (40.3 × 27.8 cm). 58.75, Dick S. Ramsay Fund

109 *(above, right)*
Georgia O'Keeffe (1887–1986). *Blue #4,* 1916. Watercolor on
cream, thin, very smooth textured, gampi-fibered wove paper.
15¹⁵⁄₁₆ × 10¹⁵⁄₁₆ in. (40.5 × 27.8 cm). 58.76, Dick S. Ramsay Fund

110 *(opposite, above)*

Arthur Dove (1880–1946). *Untitled*, c. 1938. Watercolor and ink on cream, moderately thick, rough-textured wove paper. 5 × 7 in. (12.7 × 17.8 cm). Signed lower center: *Dove*. 1992.112, Purchased with funds given in memory of Priscilla Crosby Lewis and Gift of the American Art Council

111 *(opposite, below)*

Milton Avery (1893–1965). *Road to the Sea*, c. 1938. Transparent watercolor with small touches of opaque watercolor over black chalk on off-white, moderately thick, rough-textured wove paper. 22½ × 30⅝ in. (57.2 × 77.8 cm). Signed lower right: *Milton Avery*. 43.104, Dick S. Ramsay Fund

112 *(above, right)*

Oscar Bluemner (1867–1938). *Loving Moon*, 1927. Watercolor, possibly with a surface coating, on cream, medium-weight, slightly textured wove paper mounted to thick black woodpulp board. 9¹⁵⁄₁₆ × 13⁵⁄₁₆ in. (25.2 × 33.8 cm). Signed lower center (name in monogram): *Blüemner*. Inscribed verso with name, address, title, and framing instructions. 1996.150.9, Bequest of Mrs. Carl L. Selden

113 *(below, right)*

Marguerite Zorach (1887–1968). *Half Dome, Yosemite Valley, California*, 1920. Watercolor over graphite on off-white, moderately thick, slightly textured, wove paper mounted to off-white wove paper. 10 × 13⅜ in. (25.4 × 34 cm). Signed and dated lower right: *M. Zorach / 1920*. 66.234, Gift of Mr. and Mrs. Tessim Zorach

the figuration of nature, Dove's imagery more eloquently speaks to his closeness with the land. As O'Keeffe commented, "Dove comes from the Finger Lakes region. He was up there painting, doing abstractions that looked just like that country, which could not have been done anywhere else."[44] Rather than recording the look of a place, Dove sought to realize the essential rhythm or life force of the natural world and thus may be seen as a bearer of the romantic tradition in American landscape painting. To a lesser degree, the watercolors of Oscar Bluemner (*Loving Moon*, cat. no. 112) and Marguerite Zorach (*Half Dome, Yosemite Valley, California*, cat. no. 113) also testify to the artists' romantic responses to nature through the operation of color as an emotionally expressive tool.

Although it is doubtful that Marin, O'Keeffe, and Dove—the artists at the nucleus of the Stieglitz circle—set about their work with the intention of creating a particularly American vernacular, they were inevitably interpreted as harbingers of American cultural independence.[45] Such identification was owed chiefly to their association with Stieglitz and was reiterated in articles throughout the 1920s and 1930s that connected the spontaneity, fluidity, freedom, and freshness of their art with the character of American life. Elizabeth McCausland, referring to Marin, O'Keeffe, and Dove, concluded, "these painters, one believes, are as American as Stieglitz, as truly one with the romantic ebb and flow of American energies. . . . For [in] the work of these artists . . . freedom as a way of life is justified."[46] The notion of freedom was amplified in examinations of O'Keeffe's art because of her sex. Writers and, at times, other artists were drawn irresistibly to the novelty of a strong woman painter and focused on the presumed revelation of her gender in her art. This, too, was intertwined with the ideas of Americanness and freedom, as shown by comments made by Oscar Bluemner: "In this our period of woman's ascendancy we behold O'Keeffe's work flowering forth like a manifestation of that feminine causative principle, a painter's vision new, fascinating, virgin American."[47]

The artists of 291 were indirectly encouraged to use watercolor as a result of Stieglitz's practice of showing works on paper by modern European masters. Their own modernist experiments were interpreted as evidence of the cultural energy of the nation, expressed in a new idiom that relied on an aesthetic language that was American in spirit and form because it retained a traditional, romantic emphasis on landscape (or natural) elements. The deeply rooted American intellectual habit of constructing philosophic meaning by associating the indigenous landscape with a developing national culture was extended into the twentieth century primarily by the romantic modernism of Marin, O'Keeffe, and Dove. Thus, their art fulfilled the critics' need to claim or assert a heritage that was traceable to the nineteenth century and simultaneously allowed Marin and his contemporaries to be seen as innovators who were developing an authentic American art. The fact that their formal sources originated in Europe did not impede arguments for their "Americanness," and, in that respect, the artists of the Stieglitz group may be seen to have fully and smoothly domesticated foreign aesthetics mainly through their work on paper. As Marsden Hartley concluded, "There is then a fine American achievement in the art of watercolor painting [which] may safely be called at this time a localized tradition. It has become an American realization."[48]

That Marin and, to a lesser extent, Dove and O'Keeffe dominated the critical discussions is a symptom of the flawed logic that allowed watercolor to assume the all-purpose role of demonstrating a unified American artistic outlook. The unity perceived among the three painters more likely stems from their common connections with Stieglitz, who was a source of encouragement, information, and inspiration. The critics' reliance on Marin especially derives more from their

recognition of him as a powerful artist in his own right, which recognition was then manipulated to buttress arguments for an American tradition, expressed in a vernacular dependent on nineteenth-century conceptions of American art. It must also be pointed out that the principal purveyors of what is here identified as the standardized critical language of watercolor were writers who were closely associated with Stieglitz—namely Strand, Rosenfeld, and Hartley. Their active promotion of an American art may have been lodged in a defensive strategy to deflect attention from the European influences that Stieglitz was famed for having introduced to the New York audiences.

As Hartley observed in 1921, watercolor had attained a newfound legitimacy in the hierarchy of American art. Indeed, the medium had effectively entered the mainstream of the visual arts, and subsequent writers generally incorporated works executed in watercolor into their discussions of movements or monographic treatments of artists for the sake of illustrating larger thematic or stylistic issues. This is not to say, however, that watercolor per se was featured, a condition that kept the door open for those who persisted in complaining that the medium retained a secondary status. The work of Charles Demuth, whose watercolor production outstrips his work in oils in both quality and volume, may be cited as a case in point. Although he was primarily a watercolorist, Demuth's art is usually examined in terms of its iconography and not according to divisions constructed on the basis of medium.[49]

Fig. 42.
Charles Demuth (1883–1935)
Three Male Bathers, 1917
Watercolor on paper
Brooklyn Museum of Art,
82.245, Gift of John D. &
Paul L. Herring, in memory
of H. Lawrence Herring

Demuth's watercolors are especially pertinent to the ideological maneuvers employed by commentators whose purpose it was to locate watercolor production as a sign of American cultural advancement: they simply did not lend themselves to the construct of tradition that was forming for watercolor. Gallatin was forced to hedge a bit but managed to state that Demuth's watercolors were "essentially American in feeling."[50] Demuth's talent could not be ignored, but critics—obligated to give Demuth his due—had difficulty in couching his art in "American" terms to comply with the fairly solidly established tripartite equation of watercolor = modern = American.[51] If his early experience of modernism aligned him with other Stieglitz artists and opened him to the use of watercolor, his own temperament and taste excluded his art from the polemics of "Americanism" that dominated the thinking of writers in their quests for a native artistic idiom. Thus, although Forbes Watson appreciated Demuth's "excessive finesse" and

114

Charles Demuth (1883–1935). *Still Life: Peaches,* c. 1922.
Watercolor over graphite on cream, moderately thick,
moderately textured wove paper. 12 × 18⅛ in. (30.5 × 46 cm).
24.91, Gift of Alfred W. Jenkins

Fig. 43.
Charles Demuth (1883–1935)
Roofs and Steeple, 1921
Watercolor on paper
Brooklyn Museum of Art,
50.159, Dick S. Ramsay
Fund

could declare that "water color fits him like a glove," there was at the basis of his
art a mannered delicacy that made him the "Whistler of his little circle" and,
therefore, slightly foreign in outlook.[52] Strand praised Demuth as well, lauding
him for enlarging the "scope of [watercolor's] expressiveness," but held back from
giving his unqualified approval because Demuth had "yet to disentangle himself
from the sophistication of contemporary French influence."[53] In essence, the frail
elegance of Demuth's watercolors—especially his still lifes and figure pieces (cat.
no. 114 and fig. 42)—disqualified them from contention as exemplars of the ro-
bust dynamics of American life.

115 *(right)*

Preston Dickinson (1891–1930). *Street in Quebec,* 1926. Pastel, graphite, and opaque watercolor on cream, medium-weight, slightly textured wove paper. 22⅛ × 17 ³⁄₁₆ in. (56.2 × 43.7 cm). Signed and dated lower left: *Preston Dickinson '26.* 26.430, Gift of Frank L. Babbott

116 *(below)*

George Copeland Ault (1891–1948) . *Woodstock Landscape,* 1938. Watercolor over graphite on white, very thick, rough-textured wove paper. 15¼ × 21⅛ in. (38.7 × 53.7 cm). Signed and dated lower right: *G.C. Ault '38.* 67.132, Gift of Mrs. George C. Ault

117 *(left)*

Thomas Hart Benton (1889–1975). *Lassoing Horses,* 1931. Watercolor over graphite on cream, medium-weight, slightly textured wove paper mounted to a secondary paper. 21¼ × 27¾ in. (54 × 70.5 cm). Signed and dated lower right: *Benton / 31.* 35.948, John B. Woodward Memorial Fund

118 *(opposite)*

Reginald Marsh (1898–1954). *Girl on 14th Sreet,* 1939. Transparent and opaque watercolor over graphite (recto and verso) on cream, thick, rough-textured wove paper. 22⅜ × 15⅜ in. (56.8 × 39.1 cm). Signed and dated lower right center: *Reginald Marsh 1939.* 39.414, Gift of Friends of Southern Vermont Artists, Inc.

Demuth's Precisionist associations, however, brought him into focus as an artist whose work could be identified as American. The cool, immaculate lines of his architectural subjects, for example, *Roofs and Steeple* (fig. 43), held their appeal on multiple grounds. Not only did they demonstrate the successful adaptation of European avant-garde styles to American purposes, but there was also something in the spare, clean lines and lucid watercolor washes used to depict American churches or factories that summoned associations with Puritan attitudes built on the melding of strong religious beliefs and the work ethic. The Precisionist works of Demuth and such of his contemporaries as Preston Dickinson (cat. no. 115), George Ault (cat. no. 116), and Edmund Lewandowski partook of a stylistic phenomenon that was received as wholly American, but the issue of medium was ignored.[54] This in itself is strange, for the use of watercolor to Precisionist ends is antithetical to the traditional conceptions of the medium's purposes inasmuch as the anti-atmospheric, flat, planar surfaces, hard edges, and graphic control that define the style run counter to the notions of vitality, freedom, light, and movement consistently attached to watercolor production. The basic incompatibility of the Precisionist style and the medium's character as it was traditionally understood most likely accounts for the lack of attention given to the role of watercolor in the Precisionist oeuvre.

A similar situation arose with the watercolors of artists who were affiliated with other movements in the 1930s, for instance, Thomas Hart Benton (cat. no. 117), Stuart Davis (see cat. no. 99), and Reginald Marsh (cat. no. 118), whose watercolors reflect the larger concerns of their art and have not provoked substantive

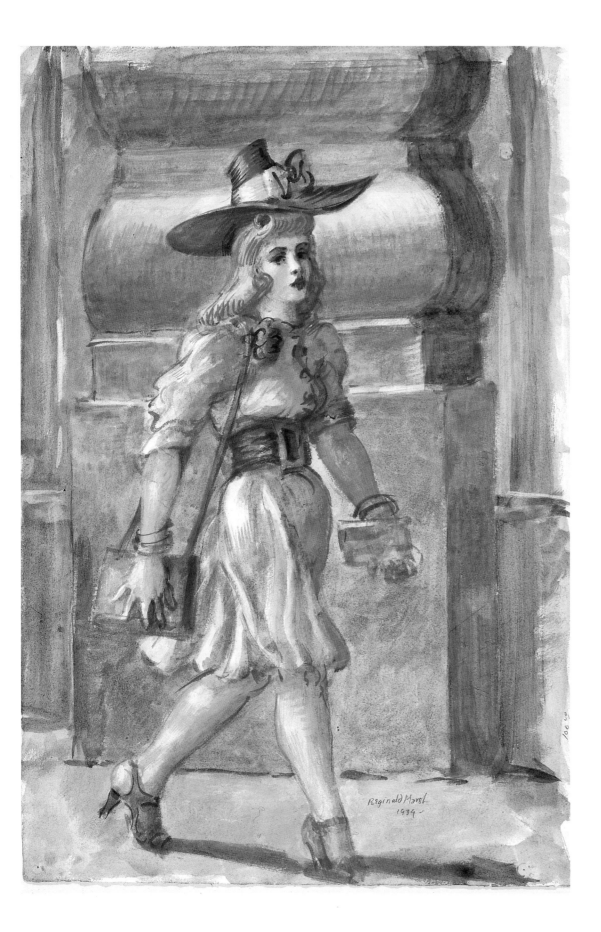

119

Charles Burchfield (1893–1967). *February Thaw,* 1920.
Transparent and opaque watercolor over graphite on off-white,
moderately thick, slightly textured wove paper. 17¹⁵/₁₆ × 27¹⁵/₁₆
in. (45.6 × 71 cm). Signed and dated lower right: *Chas
Burchfield / 1920.* Inscribed verso: *The Thaw by Charles
Burchfield / The Sunwise Turn.* 21.104, John B. Woodward
Memorial Fund

commentary directed to their use of the medium. Only Goodrich, in his 1945 exhibition catalogue *American Watercolor and Winslow Homer,* made a serious attempt to propose Marsh as a major figure in the history of American watercolor but was unconvincing in his weakly conceived conclusion: "[Marsh's] emphasis on form and design, and on the greatest substance obtainable in the medium, is fertile in suggestions of even greater future possibilities for watercolor than in its past."[55] Noticeably absent from the present discussion and those cited herein (with the exception of Goodrich) are Charles Burchfield (cat. no. 119) and Edward Hopper (see cat. no. 128), both of whom specialized in watercolor and attained positions of high regard as painters of individualized renditions of the American scene. Yet neither artist engaged the interest of writers for the purpose of promoting watercolor as the American medium. Possibly it was the mood of Gothic fantasy that permeated Burchfield's imagery, or the stolid, often static, realities of Hopper's architectural subjects that precluded their conscription in service of claims for discovering national cultural identity in watercolor. More likely, however, is that despite the persistence of ecstatic declarations of watercolor's particular ability to convey an American sensibility into the 1940s, the aura of energetic innovation the medium possessed in the hands of modernist practitioners had dissipated.[56] The language of freedom, spontaneity, and progress applied to watercolor by Strand and Rosenfeld (who wrote about specific artists and constructed valid arguments for their points of view) had been appropriated, nonetheless, and persisted to propel generic discussions of the medium in the press, where the myth of its power was perpetuated. Only E. P. Richardson made a notable attempt to pierce the chauvinistic attitudes that had settled on the medium in his review of Goodrich's 1945 Homer exhibition:

Watercolor certainly plays an unusually important part in American painting. Does this mean, as has often been suggested, that there is something in it especially appropriate to

the American temperament? We have had one major figure, Homer, to whose interests and working habits it was specially useful. . . . But aside from this tradition of greatness, there is no other discernible watercolor tradition, either of style or outlook, in America. We happen to have had since Homer several other powerful artists who prefer this medium and who have continued its use as a major form of expression down to the present. But it is the painters who make the medium, not vice versa.[57]

Ironically, Richardson echoed earlier patterns of art writing and closed his article with Whitman's words, "Produce great men. The rest follows." A short time after Richardson put the issue to question, the art world focused on the great men of Abstract Expressionism as the new agents of a distinctly American spirit (or at least a New York spirit), and watercolor was relieved of the burden of proving a national cultural identity.

NOTES

1. Malcolm Vaughan, "Brooklyn Museum Opens Huge International Show of Contemporary Watercolors," *New York American* (February 1, 1931). BIAS Scrapbooks, Art Reference Library, Brooklyn Museum of Art (hereafter Vaughan 1931).

2. For a summary of the ideas behind the urge for a national culture, see Matthew Baigell, "American Art and National Identity: The 1920s," *Arts Magazine* 61 (February 1987), 48–55.

3. See, e.g., Van Wyck Brooks, "Toward a National Culture," *Seven Arts* (March 1917), 535–47, and Paul Rosenfeld, "American Painting," *Dial* (December 1921), 649–70 (hereafter Rosenfeld 1921).

4. Watercolor's designation as the "American medium" came into casual use. See, e.g., F. Whitaker, "Watercolor, the American Medium," *American Artist* (June 1962), 64–75+.

5. Vaughan 1931.

6. "Brooklyn Exhibit, *New York Evening Post,* January 31, 1931. BIAS Scrapbooks, Art Reference Library, Brooklyn Museum of Art.

7. Read's comments are quoted as part of a compilation of recent watercolor reviews published under "Water Colors Are 'Waving a Gay Banner,'" *Art Digest* (November 15, 1934), 6. Margaret Breuning expressed similar ideas in 1926, saying, "Water color painting . . . seems particularly suited to the American temperament. Its swiftness and spontaneity reflect our swift intensity of living." "Contemporary Water Color Painters," *International Studio* (January 1926), 26.

8. I place "the American watercolor tradition" in quotation marks mainly because I am not convinced that the history of its usage in America necessarily qualifies it as a tradition (a term that denotes a certain homogeneity in development and/or result). Admittedly, this is a niggling point, but my reluctance to concede to an American watercolor tradition is keyed to how easily certain concepts become accepted—for example, "watercolor is the American medium."

9. "Watercolor and Americans: Culture and Progress. The Art Season of 1878–1879," *Century* (June 1879), 310.

10. "Art. The American Society of Painters in Water Colors," *Aldine* (May 1875), 339. I am grateful to Linda Ferber for bringing this review to my attention.

11. Marilyn Kushner, *The Modernist Tradition in American Watercolors 1911–1939,* exh.

cat. (Chicago: Northwestern University, Mary and Leigh Block Gallery, 1991), 2 (hereafter Kushner 1991).

12. For landscape imagery as an expression of cultural identity in the nineteenth century, see especially Barbara Novak, *Nature and Culture: American Landscape and Painting, 1825–1875* (New York: Oxford University Press, 1980), and Angela Miller, *The Empire of the Eye: Landscape Representation and American Cultural Politics, 1825–1875* (Ithaca, N. Y.: Cornell University Press, 1993).

13 Elizabeth McCausland, "Water Color and Homer at the Brooklyn Museum" (May 1945). BIAS Scrapbooks, Art Reference Library, Brooklyn Museum of Art.

14. Ibid.

15. Louis Lozowick, "The Americanization of Art," a 1927 essay for the Machine Age Exposition, reprinted in Janet Flint, *The Prints of Louis Lozowick: A Catalogue Raisonné* (New York: Hudson Hills Press, 1982), 18–19.

16. For discussions of watercolor and American modernism, see Kushner 1991 and Carol Troyen, "A War Waged on Paper: Watercolor and Modern Art in America," in Sue Welsh Reed and Carol Troyen, *Awash in Color: Homer, Sargent, and the Great American Watercolor* (Boston: Museum of Fine Arts, Boston, in association with Bulfinch Press, Little, Brown, 1993) (hereafter Reed and Troyen 1993).

17. Homer's work was consistently assessed in American terms. See, e.g., Susan N. Carter's 1877 review of the American Water Color Society mentioned only Homer in terms of "American" subject matter: "[In] 'Lemon,' by Winslow Homer, we recognised a typical American country-girl in a common calico 'blouse' waist, a buff stuff skirt, and a Yankee face." S. N. C., "The Water-Colour Exhibition," *Art Journal* 3 (1877), 94. Another reviewer stated, "when he paints our American country scenes of farmer life, puts over them an American sky and around them an American atmosphere, he is at his best," *New York Evening Mail*, April 23, 1877.

18. A. E. Gallatin, *American Water-Colourists* (New York: E. P. Dutton, 1922) (hereafter Gallatin 1922); Paul Strand, "American Water Colors at The Brooklyn Museum," *Touchstone Magazine, the Arts and American Art Student* (December 1921), 148–52 (hereafter Strand 1921).

19. Gallatin 1922, 8, 9.

20. Strand 1921, 151, 149.

21. See Henry Tyrrell, "American Aquarellists—Homer to Marin," *International Studio* 74 (1921), xxxi, where Tyrrell writes of Marin, Demuth, and other modernists, "These do not date from Turner, but take a new start with Cézanne."

22. Herbert J. Seligmann, "American Water Colours in Brooklyn," *International Studio* 74 (1921), clx (hereafter Seligmann 1921). Seligmann's article is a case in point with respect to Marin's dominance in watercolor coverage in the 1920s. He set out to review the 1921 American watercolor exhibition at the Brooklyn Museum and devoted more than half his text to a paean to Marin.

23. For a summary of Marin's career, see William Innes Homer, *Alfred Stieglitz and the American Avant-Garde* (Boston: New York Graphic Society, 1977) (hereafter Homer 1977).

24. Homer 1977, 92.

25. Lloyd Goodrich, *American Watercolor and Winslow Homer,* exh. cat. (Minneapolis: Walker Art Center, 1945), 67 (hereafter Goodrich 1945).

26. For a general discussion of the anti-intellectual strain in American culture, see Richard Hofstadter, *Anti-Intellectualism in American Life* (New York: Alfred A. Knopf, 1970).

27. Seligmann 1921, clix.

28. Ibid., clx.

29. Rosenfeld 1921, 664.

30. For an excellent collection of essays on Whitman and the arts, see Geoffrey M. Sill and Roberta K. Tarbell, eds., *Walt Whitman and the Visual Arts* (New Brunswick, N. J.: Rutgers University Press, 1992) (hereafter Sill and Tarbell 1992).

31. [Hamilton Easter Field], "Editorial," *Touchstone Magazine (The Arts and American Art Student)* 2, no. 2 (reviewing November 1921), n.p.

32. Strand 1921, 152. Strand may have been mistaken in assuming Marin's "undeliberate" continuation of the Whitman tradition. Marin's poetry, although it is not particularly accomplished, does exhibit stylistic similarities with Whitman's verses.

33. Matthew Baigell, "Walt Whitman and Early Twentieth Century American Art," in Sill and Tarbell 1992, 131. Baigell cites Rosenfeld's article, "The Water Colors of John Marin," *Vanity Fair* (April 1922).

34. Strand 1921, 150.

35. Ibid. Prendergast fared better with Goodrich, who characterized him as "one of the purest painters of his generation" and credited him with helping to "break the old bondage to photographic naturalism and bring back into painting the visual sensuousness that had been an element in Homer's art but that orthodox impressionism had lost in its search for naturalistic illusion" (Goodrich 1945, 55).

36. Stieglitz's style, as it were, was an eccentric admixture of snobbery and selfless promotion of his stable of artists. As Abraham Davidson points out, "Stieglitz did not bother—or refused—to list his galleries in the telephone directory." Yet he could nearly give away a piece of art to someone who seemed genuine in their appreciation of it. Abraham Davidson, *Early American Modernist Painting, 1910–1935* (New York: Harper & Row Publishers, 1981), 17.

37. See Homer 1977, appendix 1, 295–98, which provides a chronological listing of the exhibitions at 291.

38. See Homer 1977, Kushner 1991, and Troyen in Reed and Troyen 1993 for general background in this connection.

39. Walkowitz might have seen watercolors by Rodin in Paris during his stay there in 1906–7, but it is more likely that his series of "Isadora" watercolors was stimulated by the 1910 Rodin exhibition at 291.

40. See Percy North, "Max Weber: The Cubist Decade," in *Max Weber:*

The Cubist Decade, 1910–1920, exh. cat. (Atlanta: High Museum of Art, 1991).

41. "The Georgia O'Keeffe Drawings and Paintings at '291,'" *Camera Work* (June 1917), 5.

42. Barbara Haskell, *Arthur Dove,* exh. cat. (San Francisco: San Francisco Museum of Art, 1974), 77, 123 n. 67 (hereafter Haskelll 1974).

43. Barbara Haskell, *Milton Avery* (New York: Whitney Museum of American Art, in association with Harper & Row Publishers, 1982), 29.

44. Quoted in Haskell 1974, 77.

45. Dove was sensitive to the critics' striving to define a specifically American art through Regionalism, as evidenced by Frederick S. Wight's reference to a conversation between Dove, Helen Torr, and Alfred Maurer shortly before Maurer's death in 1932: "When a man paints the El, a 1740 house or a miner's shack, he is likely to be called by his critics, American. These things may be in America, but it's what is in the artist that counts. What do we call 'American' outside of painting? Inventiveness, restlessness, speed, change. Well, then a painter may put all these qualities in a still life or an abstraction, and be going more native than another who sits quietly copying a skyscraper." Frederick S. Wight, *Arthur G. Dove* (Berkeley: University of California Press, 1958), 62 (hereafter Wight 1958).

46. Elizabeth McCausland, "Stieglitz and the American Tradition," in *America and Alfred Stieglitz: A Collective Portrait* (New York: Literary Guild, 1934), 228. McCausland had earlier distinguished Dove's watercolors from his oils, saying they were "freer." *Springfield Sunday Union and Republican,* 1932, cited in Wight 1958, 61.

47. Oscar Bluemner, "A Painter's Comment," in *Georgia O'Keeffe: Paintings, 1926,* exh. cat. (New York: Intimate Gallery, 1927), n.p., reprinted in Barbara Buhler Lynes, *O'Keeffe, Stieglitz, and the Critics, 1916–1929* (Ann Arbor, Mich.: UMI Research Press, 1989), 257–58.

48. Marsden Hartley, *Adventures in the Arts* (New York: Boni and Liveright, 1921; repr., New York: Hacker Art Books, 1972), 101.

49. This is true for Marin as well. When either artist is covered in survey literature their watercolors are usually illustrated, yet the text does not dwell on the place of watercolor in their oeuvres or in the context of American art. It is the imagery or stylistic source of their art that is emphasized.

50. Gallatin 1922, 22.

51. Troyen in Reed and Troyen 1993.

52. Forbes Watson, "Charles Demuth," *Arts* (January 1923), 77–78.

53. Strand 1921, 151.

54. This remains true, as witnessed by Gail Stavitsky's fine essay "Reordering Reality: Precisionist Directions in American Art, 1915–1941" in *Precisionism in America, 1915–1941: Reordering Reality,* exh. cat. (New York: Harry N. Abrams, in association with the Montclair Art Museum, 1995), 12–39.

55. Goodrich 1945, 95.

56. For example, James W. Lane declared watercolor the "king of American artistic mediums," in "Aquarella Americana: The Art at Its Best in Its Native Habitat: The Whitney's Great Historical Survey," *Art News* (February 15, 1942), 10.

57. E. P. Richardson, "Watercolor, the American Medium?" *Art News* (April 15–30, 1945), 20.

7

THE AMERICAN WATERCOLOR CANON FOR THE TWENTIETH CENTURY (OBSERVATIONS ON A WORK IN PROGRESS)

BARBARA DAYER GALLATI

120

Karl Schrag (1912–95). *Trees against the Sky,* 1946. Transparent and opaque watercolor, porous pen (felt-tip marker), crayon, ink, and mixed media on cream, moderately thick, slightly textured wove paper. Watermark: 1940 ENGLAND / B. 22⁹⁄₁₆ x 15⁷⁄₁₆ in. (57.3 x 39.2 cm). 47.113, Dick S. Ramsay Fund

In 1922 the artist-critic Albert E. Gallatin (1881–1952) wrote in the introduction to his *American Water-Colourists*: "To acquaint one's self with the drawings of American watercolourists, it is necessary, with the exception of Sargent and Winslow Homer, to seek out their work in various private collections." He continued, saying that American watercolorists could look only to "enlightened critics, amateurs and collectors" for encouragement and were "doomed to disappointment" should they expect attention from the government, museums, and organized art societies.[1] Gallatin was correct in his observations that American watercolorists had been neglected. This is borne out by the dearth of information on the medium in the body of American art-historical survey literature published since the genre's inception with William Dunlap's pioneering 1834 *History of the Rise and Progress of the Arts of Design in the United States.*[2]

Gallatin eschewed a historical approach (glibly stating that he would leave it to others to "parade the mediocre") and allowed that his slim volume merely offered a subjective overview of recent American achievements in watercolor that he deemed superlative.[3] Despite its summary nature, Gallatin's book represents a watershed in the formation of the canon for twentieth-century watercolor production. Eight of the ten artists he included—James McNeill Whistler, Homer, Sargent, Mary Cassatt, Childe Hassam, John Marin, Charles Demuth, and Charles Burchfield— have entered the artistic pantheon, the last three largely on the strength of their achievements in watercolor. Within this group of luminaries, Gallatin pronounced John Marin "supreme" in his mastery of watercolor techniques.[4] His inclusion of Walter Gay (1856–1937) and Dodge Macknight (1860–1950), on the other hand, signals the vagaries attached to the development of any hard and fast qualitative standard. Gay was never central to discussions of the medium (or American art in general), and his

presence may be attributed to Gallatin's close family connections with him, which may have skewed his judgment. Macknight, however, was at the height of his popularity at the time Gallatin was writing. Once noted for his dazzling "impressionist" style, his reputation declined rapidly after 1930 for reasons that are explored below.

Despite the impetus provided by Gallatin's *American Water-Colourists,* the proliferation of museum exhibitions devoted to contemporary watercolor, the emerging identity of watercolor as the "American medium" in modernist circles, and the long-standing exhibition activities of the AWS and the New York Water Color Club (which merged in 1941), it would be twenty years before the Whitney Museum of American Art would lend greater authority to the medium by mounting the first major exhibition devoted to the *history* of the American watercolor.[5] Curated by the art historian Alan Burroughs, the show included 224 works by seventy-four artists ranging from the colonial portraitist John Singleton Copley (1738–1815) to the urban realist Reginald Marsh (1898–1954). Although Burroughs admitted the absence of any momentous stylistic innovations that could be credited to contemporary watercolor practitioners, his premise for the show lay in the conviction that "the medium, instead of being subservient to other processes—engraving and oil painting—today competes with them and takes an independent and respected place in contemporary art."[6] The historical portion of the exhibition was made up of what looks to be a fairly random selection of works by such artists as Mather Brown (1761–1831), John L. Krimmel (1789–1821), and John Trumbull (1756–1843), none of whom are particularly noted for their accomplishments in watercolor. The seemingly arbitrary nature of the curatorial selection process for the historical section can be seen as a function of the less consistent use of watercolor in America before the founding of organizations linked specifically to the medium that served to regulate or standardize its practice in the professional arena. Homer and Sargent (represented by nine and six examples, respectively) occupied their customary positions as "the source of modern practice." And, as testified by the list of works by Hassam, Maurice Prendergast, Davies, George Luks, George Overbury "Pop" Hart, Alfred Maurer, Marin, Weber, George Bellows, Hopper, Demuth, Burchfield, George Grosz, Adolph Dehn, and Marsh, the roster of modern watercolor proponents for the first half of the twentieth century was virtually consolidated by 1942.[7]

Gauging from the institutions from which Burroughs borrowed in 1942 to construct his history of American watercolor, it may be observed that the watercolor canon in its infancy depended mainly on the early collecting policies of four museums: the Museum of Fine Arts, Boston, the Metropolitan Museum of Art, the Worcester Art Museum, and the Brooklyn Museum of Art. Subsequent curators and writers have taken similar routes for their interpretations of the "history" of the medium. Consider, for instance, three major contributions to the literature: Albert Ten Eyck Gardner's 1966 *History of Water Color Painting in America,*

Donelson Hoopes's 1977 *American Watercolor Painting,* and Christopher Finch's lavishly illustrated *American Watercolors* of 1986, each of which admirably (for its own time and in its own way) documents the same milestones in the medium, often illustrating the same works.[8]

In the same vein, Lloyd Goodrich's 1945 exhibition, *American Watercolor and Winslow Homer,* also sought to summarize the history of the medium in America—in this case with the specific purpose of introducing Homer's "pivotal contribution and the naturalism which he pioneered."[9] Goodrich touched the major bases—lady amateurs, colored drawings, view painters, and the Hudson River school—using such artists as Phoebe Mitchell, John James Audubon, John W. Hill, William Rickarby Miller, and Jasper Francis Cropsey to illustrate his points. The brief historical preamble introduced the first substantial chronological treatment of Homer's watercolors, which was fortified by commentary on watercolors by John La Farge, Thomas Eakins, and George Inness. The volume closed with short essays devoted to Maurice Prendergast, Edward Hopper, John Marin, Charles Burchfield, Reginald Marsh, and Adolph Dehn, all of whom were positioned as key players in perpetuating the Homer watercolor tradition in the twentieth century. Without taking away from Goodrich's enormous contribution to American art-historical studies, it must be said that his passion for Homer's work impaired his interpretation of historical and contemporary watercolor developments. His bias was clear to the reviewers in 1945, many of whom regretted the absence of works by Sargent in the show. And, in that connection, it should be noted that Goodrich devoted only one sentence to Sargent's watercolors, stating that they represented "the vice of mere technical display."[10] While acknowledging Homer's historical importance, the reviewer for the *New Yorker* perceived the flaws in Goodrich's thinking and wrote: "I think the show errs in giving Homer credit for almost all developments in water color since his time. He was a liberating influence, it is true, but if he was the 'father' of all modern American water color, it was an involved parentage. . . . Only six men since Homer are included in the show . . . and of these at least three—Maurice Prendergast, John Marin, and Adolf Dehn—clearly owe more to modern French influences than they do to Homer."[11]

The value of the artists and works featured in the surveys mentioned above is not questioned. Yet the manner in which the canon has developed must be, for the process of determining a watercolor canon is far more problematic than the one used for establishing a canon for oils mainly because watercolors are less accessible. Unlike oils, watercolors in public collections are rarely exhibited owing to their light sensitivity, and, if they are shown, it is the stellar works of those collections that are usually featured—not only for reasons of their established aesthetic quality but also because of the audience "pull" of name artists.[12] Because of watercolor's chronically inferior market status, a pattern of tracking sales and ownership has not become as systematized as that existing for oils. Furthermore,

of the many artists who have used watercolor, that aspect of their work is often overshadowed by their paintings in oils. However, the recent publication of several exhibition catalogues devoted to highlighting the American watercolor holdings of major museums has offered tantalizing evidence of the unknown depths of these collections, which, in turn, leads to the conclusion that, while there may be a canon, there is no viable history of watercolor production for the first half of this century.[13]

THE BROOKLYN MUSEUM WATERCOLOR BIENNIALS

The Brooklyn Museum's 1921 *Exhibition of Water Color Paintings by American Artists* signaled that the tides of watercolor's popularity had already begun to turn by the time Gallatin's *American Water-Colourists* appeared in 1922. As the introduction to the 1921 catalogue states, the exhibition was predicated on the belief that it would "appeal to the constantly growing interest in the medium of water color in which American artists, in recent years, have achieved such astonishing results."[14] The impressive assemblage of 365 watercolors included an eccentrically chosen group of paintings by such late-nineteenth-century artists as Robert Blum, J. Alden Weir, and John La Farge, whose *Diadem Mountain* (a 1919 gift to the Museum; cat. no. 121) was the centerpiece of the six works by him that were featured. Homer and Sargent (whose *Tramp* was the only catalogue illustration) were represented by seventeen and twenty works respectively—an emphasis that positioned them in their customary place as the culmination of watercolor "history" and the point from which the medium was launched on the road to modern usage.

The 1921 checklist is revealing in that it confirms the existence of an already

121

John La Farge (1835–1910). *Diadem Mountain at Sunset, Tahiti,* 1891. Illustration for *Reminiscences of the South Seas,* 1912. Transparent and opaque watercolor with natural resin varnish over selected areas on beige, moderately thick, smooth-textured wove paper. 16¾ × 22¼ in. (42.5 × 56.5 cm). Signed and dated lower right (initials in monogram): *JLF 91.* 19.80, Gift of Frank L. Babbott

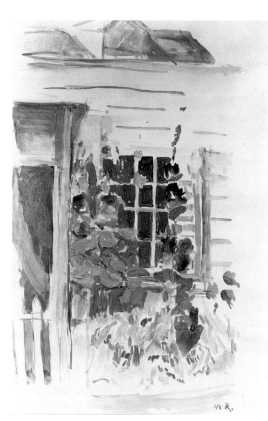

Fig. 44.
Mary Rogers (1882–1920)
Cottage Window, c. 1920
Watercolor on paper
Brooklyn Museum of Art,
21.49, John B. Woodward
Memorial Fund

emphatic divide between conservative and modernist taste that has governed the formation of the general history of twentieth-century American art. As the photographer-writer Paul Strand (1890–1976) observed in his lengthy review of the exhibition, the organizers adopted an inclusive rather than a selective attitude regarding the selection of paintings, a stance that brought, in his words, the "thinly feminine attempts" of Mary Rogers (fig. 44) into the same visual context as John Marin, whose work he credited with carrying on "the essential vitality of the Whitman tradition."[15] Strand appreciated the comparative opportunities the exhibition offered, but he lamented the absence of paintings by Georgia O'Keeffe, Thomas Hart Benton, Charles Sheeler, and Max Weber, which he felt could have been included had not the "anemic" work of Pennell or the "specious virtuosity" of Davies (e.g., cat. nos. 122 and 123) been so heavily represented.[16] Strand's long association with Alfred Stieglitz and the group of artists who exhibited at Stieglitz's gallery, 291, partially accounts for his reaction, which in this instance, however, registers as a highly constructive criticism of the selection, since he called for a more comprehensive survey. On a deeper level Strand's comments are rooted in his desire for the development of an art that was more identifiably "American," an attitude that explains his prejudices against Sargent, Davies, and Pennell, whose styles evoked notions of expatriation, fantasy, and Whistlerian delicacy, respectively.[17] Nevertheless, the range of works powerfully demonstrated the extraordinary energy and variety of contemporary watercolor practice by bringing together the works of newly established masters and contemporary innovators (e.g., Man Ray, Burchfield, Demuth, and Marin). In the end Strand expressed his hope that the Museum would stage future comparative exhibitions that would help create "what may be truthfully called an American culture."[18]

As if in answer to Strand's call, the Museum continued to mount contemporary watercolor exhibitions on a biennial basis. The shows, which sometimes included close to one thousand paintings, were designed to contextualize stylistic and technical trends as well as to feature the work of established and lesser-known American artists. In addition to positioning the Museum as a leader in the field of displaying contemporary watercolor, the acquisitions by the Museum from these shows also shaped the development of the institution's collection of twentieth-century watercolors and kept it in the forefront of collecting in that area until the last of the biennials in 1963. The purchasing pattern started with the Museum's historic acquisition of Charles Burchfield's *February Thaw* out of the 1921 exhibition (the first work by Burchfield to enter a museum). Subsequent purchases from the exhibitions included Lyonel Feininger's *Strand* (cat. no. 124) in 1931, Milton Avery's *Road to the Sea* in 1943, Karl Schrag's *Trees against the Sky* (see cat. no. 120) and Mark Rothko's *Vessels of Magic* (cat. no. 125) in 1947, Adolph Gottlieb's *Floating* (cat. no. 126) in 1949, James Brooks's *No. 1* (cat. no. 127) in 1951, and Sam Francis' *Yellow, Violet, and White Forms* (see cat. no. 148) in 1957.

A survey of the catalogues and commentaries documenting the twenty-two Brooklyn watercolor biennials presents a fascinating view of watercolor practice,

122 *(left)*

Joseph Pennell (1860–1926). *Brooklyn Bridge,* by 1921.
Transparent and opaque watercolor and black chalk on gray-
blue, moderately thick, rough- and pitted-textured wove paper.
13⅝ × 10¹⁄₁₆ in. (34.6 × 25.6 cm). Signed lower right: *Pennell.*
1994.166, Gift of Jerome B. and Renee Weinstein

123 *(below)*

Arthur B. Davies (1862–1928). *From the Quai d'Orléans,* 1925.
Opaque watercolor and colored pencil on beige, moderately
thick, moderately textured wove paper. 11¹⁄₁₆ × 15 in. (28.4 × 38.1
cm). Signed and dated lower left: *A.B. Davies—1925.* 26.409,
Gift of Arthur B. Davies

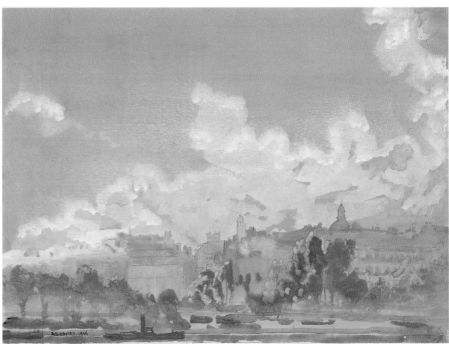

124

Lyonel Feininger (1871–1956). *Strand,* 1925. Watercolor and ink on beige, medium-weight, slightly textured wove paper. 11⅝ × 17⅛ in. (29.5 × 43.5 cm). Signed lower left: *Feininger.* Inscribed lower center: *Strand.* Inscribed lower right: *Dienst. d. 5.5.25.* 31.128, Museum Collection Fund

curatorial taste, and critical opinion as they were dictated by the ebb and flow of broader art movements and by the impact of world events. The biennials, which were most often international in scope, frequently provided concentrated groupings of foreign works. The 1923 exhibition included a selection of English drawings from the 1890s that highlighted the art of Aubrey Beardsley, along with pieces by the illustrators Phil May and Charles Keene and watercolors by John Singer Sargent (who was in the English section) and William Strang. Perhaps the most outstanding gathering of foreign works was the German section for the 1931 exhibition, which listed watercolors by Emil Nolde, Max Pechstein, Otto Dix, Erich Heckel, Paul Klee, Oscar Kokoschka, and Karl Schmidt-Rottluff, among others. The 1933 exhibition demonstrated the widest geographic range with an assemblage of paintings from Australia, France, Great Britain, Japan, Yugoslavia, Mexico, Palestine, Persia, the Soviet Union, Spain, and Sweden. The exhibitions were inevitably affected by World War II not only because of political sentiments but also because of limitations imposed on transport, which made the participation of some international contributors impossible. In turn, these factors caused curatorial attention to focus closer to home, as in the case of the 1941 exhibition that featured a selection of Canadian watercolors, or the 1943 exhibition that included works from Argentina, Brazil, Cuba, and Mexico. In 1945 the biennial was restricted to American art alone for the first time since 1921. The innovative comparative international approach soon regained momentum after the war, however, as documented by the reinstatement of European representation in 1947 with paintings by such artists as Giorgio Morandi, Stanley Spencer, Ben Nicholson, André Masson, and Jacques Villon. In 1955 a group of seventy-five contemporary Japanese watercolors was shown with a large number of works from France

125 *(opposite)*

Mark Rothko (1903–70). *Vessels of Magic,* 1946. Transparent watercolor with touches of opaque watercolor over graphite on white, moderately thick, rough-textured wove paper. 39 × 26⅞ in. (99.1 × 68.3 cm). Signed lower right: *Mark Rothko.* 47.106, Museum Collection Fund

126 *(above)*

Adolph Gottlieb (1903–74). *Floating,* c. 1948. Watercolor, graphite, and mixed media on cream, moderately thick, slightly textured wove paper. 20 × 26¼ in. (50.8 × 66.7 cm). Signed lower left: *Adolph Gottlieb.* 49.122, Carll H. de Silver Fund

127 *(right)*

James Brooks (1906–92). *No. 1,* 1951. Watercolor on cream, medium-weight, slightly textured, unsized laid paper attached to painted, pressed particleboard. 15⁹⁄₁₆ × 20¹¹⁄₁₆ in. (39.5 × 52.6 cm). 51.91, Carll H. de Silver Fund

Fig. 45. *(below)*
Isabel Whitney (1884–1962)
Flowers, c. 1917–23
Watercolor on paper
Brooklyn Museum of Art,
23.69, Museum
Collection Fund

and the United States. (For a complete listing of the nations represented in each of the biennials, see the Chronology in this catalogue.)

The history that is revealed by these checklists often validates the current canon, but, more often, it conflicts with established taste. This is particularly telling with the realization that both Hopper's *Mansard Roof* (cat. no. 128) and Isabel Whitney's *Flowers* (fig. 45) were purchased out of the 1923 exhibition. Each painting had received considerable attention in press reviews that generally praised Hopper, but surprisingly declared the now almost forgotten Whitney one of the "real finds" of the show.[19] More to the point is that a thorough study of these exhibitions and their reception offers a means to recover and situate artists whose names and works were at one time familiar to the American audience. Once recognized regional "schools" such as the "Cleveland Group," which was headed by Henry Keller and included Clarence Holbrook Carter (cat. no. 129), Paul Travis (fig. 46), Antimo Beneduce, and Walter Dehner,[20] are not only outside the canon, but outside the current history of the medium as well.

Patterns of taste are also disclosed as the curatorial duties of selecting the biennial passed from Herbert Tschudy (Brooklyn's curator of painting from 1925 to 1935 and a watercolorist himself) to John I. H. Baur and his successors, John Gordon, Hertha Wegener, and Axel von Saldern.[21] Tschudy (1874–1946) had joined the Museum's staff in 1899, originally hired to paint backdrops for installations and to document curatorial research expeditions by painting on-site watercolors. Tschudy (whose academic background included three years studying architecture

128 *(opposite, left)*

Edward Hopper (1882–1967). *The Mansard Roof,* 1923. Watercolor over graphite on off-white, moderately thick, moderately textured wove paper. 13⅞ × 20 in. (35.2 × 50.8 cm) . Signed, dated, and inscribed lower left: *Edward Hopper / Gloucester 1923.* 23.100, Museum Collection Fund

129 *(right)*

Clarence Holbrook Carter (b. 1904). *Sommer Brothers, Stoves and Hardware,* 1928. Watercolor over graphite on off-white, thick, smooth-textured wove paper. 15⅛ × 20⅛ in. (38.4 × 51.1 cm). Signed and dated upper right: *Clarence H. Carter.28.* 29.65, Carll H. de Silver Fund

Fig. 46.
Paul Brough Travis
(1891–after 1962)
Crater Lake, Ruanda, c. 1930
Watercolor on paper
Brooklyn Museum of Art,
31.139, Museum
Collection Fund

130

Jacob Lawrence (b. 1917). *Funeral Sermon,* 1946. Transparent
and opaque watercolor over graphite on cream, moderately
thick, rough-textured wove paper. Watermark: W & H Co.
29⅜ × 21⅛ in. (74.6 × 53.7 cm). Signed and dated lower right:
Jacob Lawrence 1946. 48.24, Anonymous Gift

at the University of Illinois and classes at the Art Students League), may be
judged remarkable for the breadth of his knowledge of contemporary art and the
evenhandedness of his selections for the biennials as well as for the other exhibi-
tions (sometimes as many as ten per year) for which he was ultimately responsi-
ble. Even before his official appointment as curator of painting and sculpture,
Tschudy had been assigned to organize the 1921 watercolor exhibition and may be
credited with turning the event into one of the institution's most respected series
of exhibitions. The now more well known art historian John I. H. Baur (1909–
87) assumed responsibility for the biennials after Tschudy's retirement in 1936,
seeing them through the turbulent years of the war and keeping the Museum in
the vanguard of collecting American art in all media. As curatorial generations
succeeded one another, so too did artistic generations, as witnessed by the even-

tual displacement of Homer, Sargent, and Marin in favor of Andrew Wyeth, Jacob Lawrence (cat. no. 130), and the nascent group of Abstract Expressionists who were strongly represented in Baur's 1947 biennial selection by Robert Motherwell, Theodore Stamos, William Baziotes, and Mark Rothko (who had made his first appearance in the 1935 biennial as Markus Rothkowitz). The momentum of the biennials decreased with Baur's 1952 departure for a curatorial post at the Whitney Museum of American Art (where he eventually served as director from 1968 to 1974). Although the 1953, 1955, and 1957 biennials organized by John Gordon (the museum's former publications secretary who was curator of painting and sculpture from 1952 to 1958) were in themselves admirable, there was a noticeable decline in press attention devoted to them and to watercolor in general. Assistant curator Hertha Wegener shouldered the task of the 1959 biennial in the interim between Gordon's departure and the appointment of the Munich-trained art historian Axel von Saldern, who served as paintings curator from 1961 to 1964. The rationale for terminating the biennials with the 1963 exhibition is not known, but it is reasonable to assume that a variety of factors—changing institutional priorities, lack of curatorial continuity and interest, and waning public and critical interest in watercolor—contributed to their demise.

The complexity of American watercolor activity and the excitement it generated acted as the constant critical refrain throughout the years of the biennials. Today the sense of that complexity has been lost as the canon as embodied in the current survey literature has synthesized the history of the medium into a manageable, but perhaps unduly abbreviated narrative. Although the Brooklyn watercolor biennials cannot be looked to as the sole barometer of watercolor pursuits in America, they nonetheless provide a useful model on which to base a methodology for a more complete investigation of watercolor's history.

IN THE COLLECTION, BUT NOT IN THE CANON

The process of selecting works for the present exhibition has prompted basic questions about how and why certain pieces entered Brooklyn's collection, why they have not received attention since their acquisition, and, by extension, why (although they possess intrinsic aesthetic merit) they have not entered (or have been dropped from) the canon as it has developed thus far. By implication, their presence here is intended to insert them into the history of American watercolor and to promote further dialogue on the value of adopting an inclusive historical view for the purpose of reassessing the canon.

At the outset, it must be recognized that several of the watercolors covered here are anomalies. They are included in the exhibition because they are of interest, but are by artists who, for a variety of reasons, are probably destined to remain beyond consideration for admission to any canon, whether it be restricted to watercolor or otherwise. Their mention here emphasizes the duality in museum collecting policies in that museums are generally charged with the often conflicting

responsibilities of documenting the (or a) history of art (an inclusive function) and of establishing a model of the highest standards within that history (an exclusive function).

Gordon Stevenson (1892–1984) is an artist whose work illustrates the problems set out above. For want of a better word, his *Catskill Stream* (cat. no. 131) can be classified as a sport in that it is atypical of his customary artistic activity (he painted society and presentation portraits in oil), and because it is superior in quality to the known body of his work, which can be called pedestrian at best.[22] The painting was one of several by him that were exhibited at the 1933 biennial (to no notice that can be documented) and was purchased by the Museum for one hundred dollars later that spring. In the context of the history of American watercolor practice, his work intersects with that of John Singer Sargent. Stevenson had studied formally with the Spanish painter Joaquin Sorolla y Bastida (1863–1923) and had received criticism from Sargent during a short stay in London. He subsequently adopted (possibly out of conscious emulation) Sargent's habit of spending his summers painting watercolor landscapes to "stretch his artistic muscles," as one writer put it.[23] While Stevenson's use of bold washes connects him with Sorolla and Sargent and his pattern of watercolor usage connects him with the latter, the almost lurid intensity of his palette suggests that he also admired the work of Dodge Macknight (see below), whose watercolors had achieved considerable respect in the years immediately preceding Stevenson's first documented activity in the medium. A broader historical view connects this work with the tradition of plein-air painting in the American wilderness and the artistic response to nature. Academic considerations aside, *Catskill Stream* registers as an unusually strong work by an artist who was able to capture, for a brief moment, satisfying passages of color and form that hint at artistic aspirations which were unfulfilled.

The career of Anna S. Fisher (1873?–1942) introduces thornier problems in the process of contextualizing her art.[24] Long ignored, Fisher's work is beginning to gather interest, primarily because of the gender issues it involves rather than because of its quality. An examination of her *White Roses* (cat. no. 132) raises questions about her professional status—she was elected a full academican at the National Academy of Design in 1932 and taught at Pratt Institute for forty-nine years—as it relates to stereotypical attitudes defining women artists, especially those whose subjects fall into the range of material traditionally designated as "women's subjects" (e.g., floral still life) executed in watercolor—a medium established early on as the mode of "lady amateurs." The fact that Fisher's art embodies the continuation of the strong academic tradition in American art also bears consideration since that aspect of history has been understudied, eclipsed by modernist biases that dominate the interpretation of American art of the first half of this century. Should her *White Roses* be measured against the earlier floral still lifes of the brothers John Ferguson (1841–1926) and Julian Alden Weir (1852–1919), for instance? Or should a discussion of the painting's merits be framed only within the parameters of contemporaneous art production? Finally,

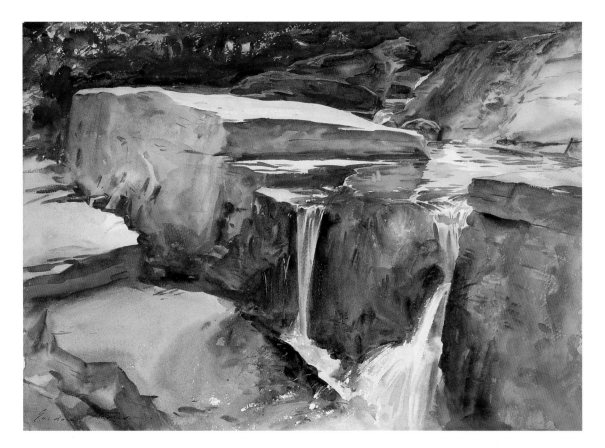

131 *(above)*

Gordon Stevenson (1892–1984). *Catskill Stream,* c. 1932.
Transparent and opaque watercolor over graphite on cream,
thick, rough-textured wove paper. 14 × 19¾ in. (35.6 × 50.2 cm).
Signed lower left: *Gordon Stevenson*; 33.483, John B. Woodward
Memorial Fund

132 *(right)*

Anna S. Fisher (1873?–1942). *The White Roses,* by 1922. Opaque
watercolor, graphite, touches of pastel, and touches of
transparent watercolor on cream, moderately thick, slightly
textured wove paper mounted to woodpulp paperboard.
24¹⁵⁄₁₆ × 19 in. (63.3 × 48.3 cm). Signed lower right: *Anna Fisher.*
22.90, Gift of Frank L. Babbott

thought must be given to local history and Fisher's contribution to the cultural life of Brooklyn through her years of teaching at Pratt, one of the Museum's neighbor institutions. Interestingly, that did not seem to be a concern of the organizers of the Museum's watercolor biennials. Only two watercolors by Fisher were displayed in 1925 (neither of which was purchased for the collection); *White Roses* entered the collection as a gift in 1922. The question of where (or if) Fisher belongs in the scheme of the developing canon(s) (i.e., feminist, academic, watercolor) is not answered here; instead, it is asked for the first time.

Other works, like James Guy's Surrealist *Broadcasting,* Howard Cook's *Foot Washing,* and John Wenger's *Coney Island,* were selected because of their respective demonstrations of the use of the watercolor by artists painting in the 1930s who were not necessarily specialists in the medium but who used it to fine effect and very differently. Of the three listed here Guy (1910–83) is the most recognized because of his importance in the history of American Surrealism.[25] Throughout the 1930s and 1940s he created a significant group of oil paintings that explored the social and moral issues generated by the Depression and the domestic and foreign political scenes. *Broadcasting* (cat. no. 133), a gouache executed under the auspices of the Works Progress Administration, displays Guy's use of dream imagery inspired by the Surrealism of Salvador Dalí (1904–89) and Yves Tanguy (1900–1955) to evoke the isolation and disorientation of the individual in contemporary society. The small figure in the distance stands exposed and helpless, apparently stopped in his tracks by the blast of words issued by the gesturing man holding the microphone on the left. Although the painting appears to have no

133

James Guy (1910–83). *Broadcasting,* 1936. Opaque watercolor on cream, moderately thick, moderately textured wove paper. 11 1/16 × 15 1/4 in. (28.1 × 38.7 cm). Signed and dated lower right: *Guy '36.* 43.150, Allocated by the W.P.A. Federal Art Project through the Museum of Modern Art

134

Howard Cook (1901–80). *Foot Washing,* 1935. Watercolor over graphite on cream, moderately thick, rough-textured wove paper. 23¼ × 32 in. (59.1 × 81.3 cm). Signed, dated and inscribed lower right: *Howard Cook 1935 / Alabama.* 37.355, John B. Woodward Memorial Fund

specific political agenda, its imagery conjures ideas of the power of the media to spread propaganda during an era fraught with choices regarding freedom—whether with respect to the Spanish Civil War, the Stalinist purges, Nazism, or the antilabor campaign of the media mogul William Randolph Hearst. In this way *Broadcasting* connects with Guy's more elaborate, iconographically explicit compositions that explore similar themes.

Howard Cook (1901–80) is best known for his work as a printmaker.[26] However, like many artists who matured artistically during the 1930s, he painted in oils, watercolors, and produced several mural paintings. He received his formal art training at the Art Students League and thereafter traveled widely, financed by his work as a merchant seaman or by occasional illustrating commissions, all the time recording his impressions of Europe, the Far East, Central America, and the eastern Mediterranean. In the mid-1930s he received a Guggenheim Fellowship that enabled him to tour the southern United States for the purpose of documenting American "types" ranging from Texas cowboys, the hill people of Appalachia, to the African Americans of the rural south. A selection of the works resulting from the trip was displayed at the Weyhe Gallery, New York, in 1937, where they were praised as "fine examples of sound craft[s]manship and alert observation" and judged to "form a vivid composite portrait of a selection of America and [to] constitute a social document of historical importance."[27] *Foot Washing* (cat. no. 134) was among the works on view and singled out as one of the finest pieces of the group. Painted in the small town of Eutaw, Alabama, in 1935,

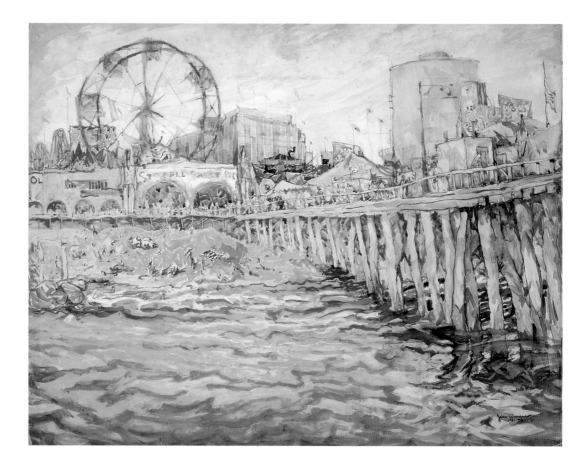

the watercolor documents a ceremony of spiritual cleansing witnessed by the artist that entailed the symbolic casting out of the devil through frenzied movements followed by a ritual washing of feet. The watercolor bears a stylistic kinship to the formal language of the Mexican muralists José Clemente Orozco (1883–1949) and Diego Maria Rivera (1886–1957) in its abstract treatment of form and space for the purpose of heightening emotional impact. But Cook's precise technique runs counter to the broad, painterly qualities characterizing their art. His absolute control over the medium bears a close relationship to his work as a printmaker, in which line takes precedence over other formal elements. *Foot Washing* was chosen by John Baur for display in the 1937 Brooklyn watercolor biennial from which it was purchased for the Museum's collection, and, so far as it can be determined, this is the first attention it has received since then.

The Russian-born John Wenger (1888/89–1976) was already a noted designer when he started to show his paintings and decorative screens at New York's Ferargil Galleries in 1926.[28] A group of his set designs had been displayed in the Brooklyn Museum's *Exhibition of Models of Stage Settings, Designs, and Drawings Illustrating the Scenic Art of the Theatre* in 1917. Credited with having transformed the art of stage design through his use of transparent gauzes and colored lights to create sets that reinforced the mood of the performances, Wenger found a ready audience for his oils and watercolors because of his established celebrity within

135 *(opposite)*

John Wenger (1888–1976). *Coney Island,* 1931. Transparent and opaque watercolor over graphite on off-white, moderately thick, slightly textured wove paper mounted to a woodpulp paperboard (Whatman Drawing Board). Signed and dated lower right: *John Wenger 1931.* 21¹³⁄₁₆ × 28³⁄₁₆ in. (55.4 × 71.6 cm). 67.238, Gift of the artist

136 *(right)*

David Levine (b. 1926). *Atlantis,* 1967. Watercolor over graphite on cream, thick, slightly textured wove paper. 14½ × 10⅝ in. (36.8 × 27 cm). Signed and dated lower right: *D. Levine 67.* 69.25, Dick S. Ramsay Fund

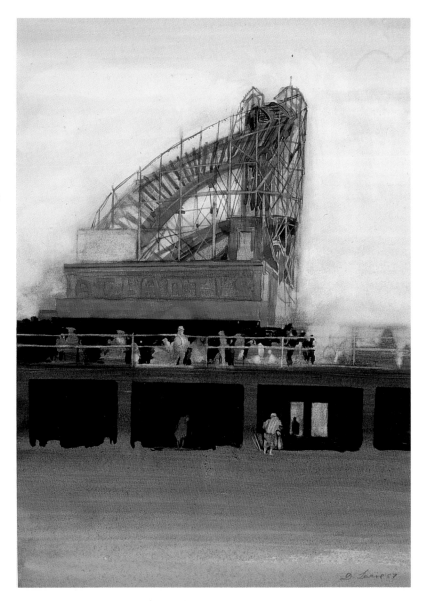

the theatrical and motion-picture communities. It was not until 1930 that he started using watercolor to a significant extent apart from design purposes, but once twenty of his watercolors were shown at the Montross Gallery in 1931, he drew note for his sheets of joyous color and lively forms that recalled his stage designs but functioned as independent works of art.[29] *Coney Island* (cat. no. 135) was in the Montross exhibit and was immediately requested by the Art Institute of Chicago for a year-long traveling exhibition. Although the work was never exhibited in the Brooklyn biennials (two other works by him were included in the 1933 exhibition), Wenger donated it to the Museum in 1967. Wenger's view of the beach and ferris wheel at Coney Island catches the riotous holiday energy of the moment through decorative patterns of shimmering pastel colors and reflected light that relate it to his work for the theater. In contrast to David Levine's *Atlantis* (cat. no. 136), in which the monstrous shape of the rollercoaster looms

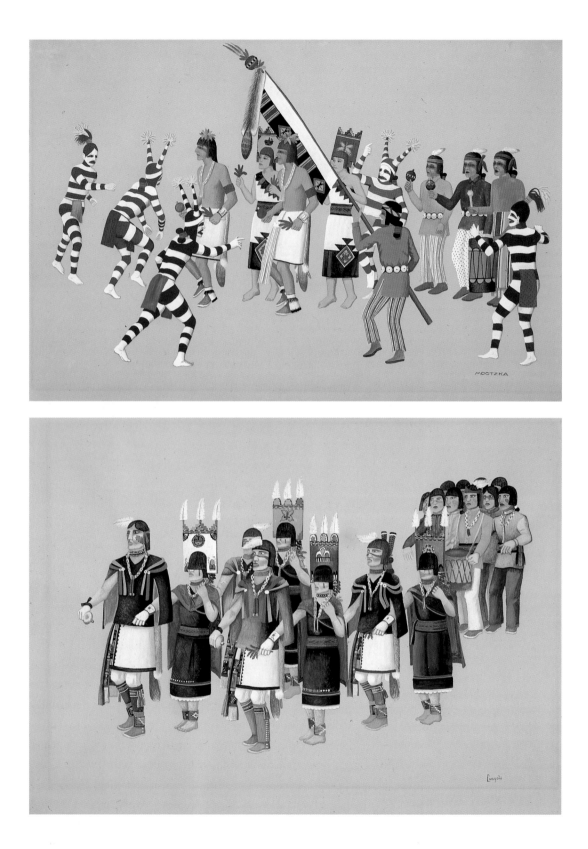

137 *(opposite, above)*

Waldo Mootzka (1903–40). *Fall Corn Dance,* 1930s. Opaque watercolor over graphite on beige, moderately thick, smooth-textured wove paper. 13 × 20 in. (33 × 50.8 cm). Signed lower right: *Mootzka.* 40.91, Dick S. Ramsay Fund

138 *(opposite, below)*

Louis Lomoyeva (b. 1920s). *Hopi Corn Dance,* 1930s. Opaque watercolor over graphite on beige, moderately thick, smooth-textured wove paper. 16 × 22 in. (40.6 × 55.9 cm). Signed lower right: *Lomoyeva.* 40.90, Dick S. Ramsay Fund

ominously, Wenger's painting stands as a pleasing period piece depicting the famous amusement park at the height of its popularity.

The consideration of watercolors by two Hopi tribesmen, Waldo Mootzka (1910–40) and Louis Lomoyeva (or Lomoyosta; b. 1920s) throws this discussion into a different perspective by introducing the works of Native American artists as candidates for entry into the larger scheme of American art history. Their watercolor activity places them at the intersection of Native American ritual artistry and the dominant Euro-American culture. As such, Mootzka and Lomoyeva may be seen as part of a modern movement spurred by, among other things, the effect of governmental agencies whose general purpose was to assimilate Native American populations into Euro-American society; the "rediscovery" of older tribal arts by Native Americans working on archaeological projects; and the cultural interaction promoted by the intense fascination with Southwest Native American art on the part of such artists and collectors as John Sloan, Mabel Dodge Luhan, Mary Hunter Austin, Alice Corbin Henderson, and Olive Rush.[30] The issues involved in discussing Mootzka's *Fall Corn Dance* (cat. no. 137) and Lomoyeva's *Hopi Corn Dance* (cat. no. 138) are far too complex for adequate treatment here. For the purposes of this essay, it must remain sufficient to note the emergence of various schools of Native American watercolorists that arose in the early part of the century that mark a radical change in the purpose of art production on the part of the makers, which stripped the process of image making of its original ritual function and placed it in the sphere of the marketplace for consumption by outsiders.[31] This shift in purpose went hand-in-hand with changes in museum practices, which entailed the reexamination of ethnological collections and resulted in the "elevation" of portions of those collections from the category of artifact to art. The current revisionist atmosphere that favors a multicultural approach in the definition and interpretation of American art calls for the next step to be taken in integrating the still essentially separate histories of Native American and Euro-American art into a coherent whole.

ILLUSTRATION OR ART?

The issue of illustration versus fine art has traditionally figured more strongly in discussions of watercolor than it has for oils. The hierarchy of the matter can be seen at its height in the critical estimations of Homer's early watercolors and his transition from illustrator to artist.[32] Until the recent advent of computer graphics, watercolor had been the medium of choice for illustrators and designers. The historical connections linking practical, illustrative purpose with watercolor have complicated the acceptance of the works of a number of artists into the realm of "high" art. The most conspicuous example of this ongoing debate is Norman Rockwell (1894–1978), whose popular appeal and technical prowess are undeniable but whose credentials for entry into the canon are grudgingly admitted by the scholarly community, if he is considered at all. Knowing that Rockwell's

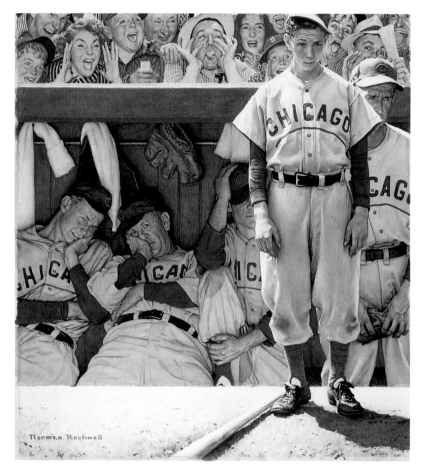

139 *(left)*

Norman Rockwell (1894–1978). *The Dugout*, 1948. Cover illustration for *Saturday Evening Post*, September 4, 1948. Transparent and opaque watercolor over graphite on two sheets of joined cream, moderately thick, moderately textured wove paper. 19 × 17¹³⁄₁₆ in. (48.3 × 45.2 cm). Signed lower left: *Norman Rockwell*. 71.124, Gift of Kenneth Stuart

140 *(opposite)*

Gerald H. Thayer (1883–1935) and Emma Beach Thayer (1850–1924). *The Cotton-Tail Rabbit among Dry Grasses and Leaves*, 1904. Illustration for *Concealing Coloration in the Animal Kingdom*, 1909. Opaque watercolor over graphite on cream, smooth textured paper-surfaced pulpboard. 18¾ × 19½ in. (47.6 × 49.5 cm). Signed and dated upper right: *Gerald H. Thayer / (Background / 1904 partly by E.B.T.)*. 20.645, Gift of Mrs. Harry Payne Whitney

Dugout (cat. no. 139) was commissioned for the cover of the September 4, 1948, issue of the *Saturday Evening Post* predisposes the viewer to approach the work as illustration. The realistic (photographically based) depiction of the downcast faces of members of the Chicago Cubs baseball team and their batboy captured at a low-point in a game at Braves' Field in Boston attaches a sensibility to the work that is at once documentary and nostalgic.[33] And, while it can be argued that the work is illustration, the opposite can also be maintained because the image was not generated by a specific narrative that existed before the actual experience of going to the game. Nor was it "made to order" at the behest of a patron, since the way in which the subject was to be treated was not predetermined. Viewed in the context of the high-art establishment's incipient promotion of Abstract Expressionism as the preferred American aesthetic at the same time Rockwell painted this work, it is possible to understand why this humorous, affectionate, and realistic image of American life has failed to gain respect in critical quarters and occupies a marginalized position within the sphere of high art. Yet, if Rockwell is considered within the broader history of American genre painting, there is an extremely fine line that separates Rockwell's work from that of nineteenth-century painters such as William Sidney Mount (1807–68), whose artistic

aims also included the creation of down-to-earth images that glorified or poked fun at American values and attracted wide audiences.[34]

Cotton-Tail Rabbit among Dry Grasses and Leaves (cat. no. 140), a collaborative effort by Gerald Thayer (1883–1935) and his stepmother, Emma Beach Thayer (1850–1924), must also be examined in the light of illustration. It was one of a series of works done by a combination of Abbott Thayer (1849–1921), members of his family, and some of his studio assistants, for the purpose of demonstrating the elder Thayer's theories of protective camouflage in nature.[35] The remarkable brushwork that details the varieties of texture and color is reminiscent of the formal strictures of the Ruskinian tradition. The pleasure derived from contemplating this work is, however, subordinate to the original purpose of its making; the aesthetic worth is a by-product and not the initial aim of the artists, who were enacting the process under the direction of another to prove a "scientific" hypothesis. Yet the appeal of the subject, the technical rigor displayed, and the painting's curious relationship to the high-art production of Thayer's studio have permitted this watercolor and others from the series entrée to the canon inasmuch as the camouflage demonstrations are invariably included in historical treatments of Abbott Thayer's art, albeit as addenda.[36]

The "taint" of illustration combined with geographic regionalism may have influenced the fate of Mitchell Jamieson's career in terms of his general lack of recognition. Jamieson (1915–76), who trained at the Abbott School of Fine Arts and the Corcoran School of Art, enjoyed a long and successful career as an art instructor at the Norton Gallery and School of Art and the University of Maryland, among other institutions. His talent received early notice with a solo exhibition of oils, watercolors, and prints held at the Whyte Gallery in Washington, D.C., in 1939, soon after his return from study in Mexico with the Czech artist Koloman Sokol. Although Jamieson worked in a variety of mediums and formats (ranging from magazine illustration to mural painting), his style remained representational, possessed of references to the human emotional and social conditions that testify to his alignment with the social realist tradition. These sensibilities lent themselves well to his activity as an official war artist during World War II, when he was assigned to document naval operations in the Pacific, the results of which were published in *Fortune* and *Life*. He was also an official NASA artist on the recovery ships of the Mercury 7 and Apollo 11 space missions as well as a volunteer artist in Vietnam for the U.S. Office of Military History.[37]

Although Jamieson's exhibition profile centers mainly on the Washington, D.C., area (where he had three solo exhibitions at the Corcoran in 1946, 1954 and 1960), he exhibited occasionally in New York during the late 1940s and early 1950s. *Pasquale's Vision* (cat. no. 141) was purchased out of the 1949 Brooklyn watercolor biennial, where it had received note as one of the best paintings in the American section (along with Ben Shahn's *Vanity* and Federico Castellon's *Women of Phoenicia*), despite its "conventional style."[38] By "conventional" it can only be assumed that the reviewer meant "representational," judging from the list

141 *(above)*

Mitchell Jamieson (1915–76). *Pasquale's Vision*, 1948. Black ink and watercolor on a white ground on medium-weight, smooth-textured paperboard. Stamp on verso: Ross Board / Scratch Board. 15¾ × 22¹⁄₁₆ in. (40 × 56 cm). Signed and dated lower right: *Mitchell Jamieson '48*. 49.121, Dick S. Ramsay Fund

142 *(right)*

Mark Tobey (1890–1976). *Island Memories*, 1947. Watercolor and mixed media on cream, medium-weight, moderately textured laid paper. Embossed stamp lower left corner: Strathmore Artist. 24¹³⁄₁₆ × 18¹³⁄₁₆ in. (63 × 47.8 cm). Signed and dated lower right: *Tobey / 47*. 49.117, Henry L. Batterman Fund

of artists who participated in the show, one of whom was Mark Tobey, whose *Island Memories* (cat. no. 142) was also purchased from the exhibition.[39] Reviewers apparently failed to note the kinship between the works of the two men, mainly because of the emotional resonance created by Jamieson's painting of the fragile, barefoot child who scrawls images of death on the pavement. Both share similar palettes of monochromatic grays and, though the Jamieson is undeniably representational, he employed an abstract vision, flattened, horizonless space, and calligraphic manner that Tobey took to the extreme. From the vantage point of 1990s pluralism, it is possible to appreciate Jamieson's approach as he straddled the increasing gulf between realism and Abstract Expressionism and to understand why his art fell out of favor after Abstract Expressionism took full command of the New York critical community's attention.

The watercolors of Leon Carroll (1887–1937) constitute a move from commercial art and interior design to a greater concentration on painting for its own sake. The extent or permanence of that transition is impossible to determine, owing to the painter's death only seven years after he started exhibiting.[40] Discovered by Katherine Dreier in the late 1920s, Carroll had his first solo show of watercolors at the Marie Sterner Galleries in New York in 1930, for which Dreier wrote the introduction to the catalogue. Although Dreier's name was powerful currency in modernist circles, her support alone cannot account for the exceptional amount of press attention Carroll received. His monumentalized visions of flowers (exemplified here by *Tiger Lilies,* cat. no. 143) quickly drew comparisons with the imagery of Georgia O'Keeffe. Although hailed by one writer as "O'Keeffe's rival," most reviewers acknowledged that the two artists approached their subjects from utterly different aesthetic positions.[41] Unlike O'Keeffe, who often divorced her floral subjects from the natural environment by isolating them against a flat ground, Carroll pulled the viewer in for an even closer view of his flowers by filling the pictorial space completely with a single blossom or portion of one.[42] As Dreier observed, "[Carroll] had a puckishness about him which somehow made one feel that the reason his flowers and plants were of such a fantastic size was the absurd conceit that . . . he himself had been able to enter the world of woodsprites and fairies to whom the flower world is enormous."[43] Darker fantasies suggested themselves as well: the critic Mary Fanton Roberts noted that Carroll's flowers sometimes evoked a sardonic mood.[44] The occasional intimation of evil comes not from fin-de-siècle notions of symbolist associations (which O'Keeffe inherited) but instead from the steely cleanness of line that Carroll used, which not only contradicted the idea of painterly freedom often associated with watercolor facture but also evinced a magical, surreal quality that lent a flawless machinelike perfection to organic forms.

143

Leon Carroll (1887–1937). *Tiger Lilies,* c. 1930. Watercolor over graphite on cream, medium-weight, slightly textured wove paper–surfaced pulpboard. 27½ × 21⅛ in. (69.9 × 53.7 cm). Signed lower right: *Carroll.* 30.968, Gift of Katherine S. Dreier

The status of an artist, once fully embraced by the establishment, but now in eclipse, offers another perspective on the fluctuations of taste and critical opinion. This situation is exemplified by the career of Dodge Macknight (1860–1950).[45] Unlike most artists of his generation, Macknight committed to a watercolor specialty early in his career, a choice made possibly as a result of his use of the medium gained through an apprenticeship in scene and sign painting in New Bedford, Massachusetts, and through his work for the Taber Art Co., a firm that sold fine-art reproductions. By 1884 he was in Paris, where he studied at the Atelier Cormon intermittently until 1886. Among his friends at the time was Vincent Van Gogh, whom he met at Arles during his frequent travels throughout France. Although the two artists worked in radically different styles, it is likely that Macknight's signature palette of unusual combinations of vibrant, high-key colors was in part inspired by Post-Impressionist (and later, Fauvist) color usage, the brilliant effects of which were heightened even more by his practice of plein-air painting in transparent washes of color on white paper.

In 1886 Macknight began to send regular shipments of his watercolors to Boston, where they were seen in a series of exhibitions at venues including Doll & Richards Gallery and the St. Botolph Club. From the start these displays provoked a flood of critical controversy in the Boston press with debates centering on Macknight's "impressionism" and radiant palette. His early detractors described his watercolors as "chromatic nightmares."[46] Yet, as his work matured and Boston audiences were gradually weaned from the deeply embedded taste for Barbizon art established by William Morris Hunt and his generation, Macknight rose to the top of the artistic ranks in that city, where he maintained his principal professional affiliations following his return from Europe in 1897. His phenomenal success is proved by the inclusion of forty-five of his watercolors with those of Homer and Sargent in a 1921 exhibition at the Boston Art Club. The watercolors of the three artists were again grouped in the Exposition d'Art Américain in Paris in 1923.

Macknight both benefited and suffered from the comparisons forced by his showings with the two giants of American watercolor. In the long run, it seems that he was caught in the middle of the debate concerning the merits of Homer *vs.* Sargent, with Macknight ultimately relegated to the periphery as a Sargent follower. What is more, his success in Boston had been so commercially rewarding that his shows consistently sold out, thus obviating the need (or indeed the possibility) to display his work elsewhere with any frequency.[47] When Macknight did make a rare showing in New York, for instance, he did so without the privileged "favorite son" status he had in Boston, and for an audience more accustomed to seeing a greater variety of watercolors on a regular basis. He nonetheless occasionally received support from unexpected quarters. Marsden Hartley, for example, credited Macknight with a "visual bravery" and discovered in his art the same "virility of technique to be found in Homer . . . [and] a passion for impressionistic veracity

which heightens his own work to a point distinctly above that of Sargent, and one might say above Winslow Homer."[48]

Macknight's concentrated representation in New England public collections reflects the regionalist base of his popularity, with the four works by him in Brooklyn's collection (bought out of the 1921 *Exhibition of Water Color Paintings by American Artists* organized by the Museum) standing as an exception to the general rule. Rather than taking the 1921 purchase as a sign of the Museum's eagerness to acquire Macknight's art in particular, the purchase must be seen as a demonstration of the Museum's newly established campaign to take the lead in collecting and displaying contemporary American watercolors. The catholicity of taste governing these acquisitions is reflected in a partial listing of works acquired by the Museum out of the 1921 show: Gifford Beal's *Ramapo Hills* (fig. 47), Charles Burchfield's *February Thaw* (see cat. no. 119), Rockwell Kent's *Lone Woman* (cat. no. 144), and Mary Rogers' *Cottage Window* (see fig. 44).

Macknight stopped painting in 1929 or 1930, reportedly paralyzed by grief over the death of his son. His professional inactivity, his reputation as a Sargent follower during a time when Sargent's popularity was on the wane, and the rise of modernist values virtually erased his name from subsequent discussions of American art. In retrospect, however, the bold color of his *Cape Cod in Autumn* (cat. no. 145) and the intriguing abstract qualities of his *Sand Dunes, Cape Cod* (cat. no. 146) mark him as an individual talent and are enough to suggest that Macknight's oeuvre deserves reexamination.

Like Macknight, Millard Sheets (1907–89) enjoyed substantial critical success in the first decades of his career. Although he painted in oils and completed a number of mural commissions, he was known primarily as a watercolor specialist.[49] He remained based in his native California over the course of his life but attained a national reputation through numerous solo and group exhibitions, starting with his first New York showing at the Milch Gallery in 1934, when his watercolors captured the critics' attention. The approbation he received was extraordinary, as demonstrated by the following quotation from Malcolm Vaughan that appeared in the *New York American*: "It is Millard Sheets' debut in New York, a debut of such merit that in making his bow in the East, this Westerner immediately proves himself worthy of a place among the peers of American water color painting. Our ablest master of the medium, Winslow Homer did not manifest at 28 years of age a higher talent. . . . As a measure of his artistic integrity it may be pointed out that his work is thoroughly American. He is as wholly native as Homer or Hopper, and as wholly unaffected, in his Americanism, as they."[50]

By 1936 Sheets's watercolors had already been acquired by the Brooklyn Museum, the Whitney Museum of American Art, the Rhode Island School of Design, as well as by several major West Coast museums and a list of private owners including the film director King Vidor and the actor Zeppo Marx. The Museum purchased *Hog Lot* (cat. no. 147) from the artist's California dealer, Dalzell Hatfield, shortly after Sheets's New York debut. The acquisition was influenced no

144

Rockwell Kent (1882–1971). *Lone Woman,* c. 1915–20.
Watercolor over graphite on white, moderately thick, rough-
textured wove paper. 9⅞ × 6¹⁵⁄₁₆ in. (25.1 × 17.6 cm). 21.131,
John B. Woodward Memorial Fund

Fig. 47.
Gifford Beal (1879–1956)
Ramapo Hills, 1916
Watercolor on paper
Brooklyn Museum of Art,
21.90, Museum Collection
Fund

145 *(above)*
Dodge Macknight (1860–1950). *Cape Cod in Autumn*, c. 1919. Watercolor over graphite on white, thick, rough-textured wove paper. Partial watermark: MAN 1901. 15¼ × 22⅛ in. (38.7 × 56.2 cm). Signed lower left: *Dodge Macknight.* 22.55, Frank Sherman Benson Fund and Frederick Loeser Fund

146 *(below)*
Dodge Macknight (1860–1950). *Sand Dunes, Cape Cod*, by 1921. Transparent watercolor with touches of opaque watercolor over graphite on white, moderately thick, rough-textured wove paper. Watermark: IN ENGLAND / UNBLEACHED ARNO. 17¼ × 24¹⁄₁₆ in. (43.8 × 61.1 cm). Signed lower right: *Dodge Macknight.* 22.57, Frank Sherman Benson Fund

147

Millard Owen Sheets (1907–89). *Hog Lot,* 1932. Watercolor over
graphite on off-white, very thick, rough-textured wove paper.
15⅞ X 23 in. (40.3 X 58.4 cm). Signed lower right: *Millard
Sheets.* 35.912, John B. Woodward Memorial Fund

148

Sam Francis (1923–94). *Yellow, Violet, and White Forms,* 1956. Transparent and opaque watercolor on off-white, moderately thick, rough-textured wove paper. 22⁷⁄₁₆ x 30⁷⁄₁₆ in. (57 x 77.3 cm). 57.70, Dick S. Ramsay Fund

doubt by the overwhelmingly positive critical response Sheets received, but the quality of the painting stands as the primary justification for the purchase of a work by a relative newcomer to the field. The rich coloration and deftly applied transparent washes testify to the artist's command of the medium. Another persuasive element in the acquisition decision was most likely the subject matter and its correlation with the then highly popular American Scene paintings that glorified the plainness and integrity of American life at the height of the Depression.

After the 1930s Sheets's art lost much of its appeal for the critical and museum establishments. A retrospective look at his output reveals a body of work that is decidedly uneven technically and generally lacking the thematic substance that his earliest efforts possessed. And, although it continued to sell well over his lifetime and he amassed honors and awards for his teaching and his art, Sheets's reputation survives mainly in terms of his regional popularity as a founder of the California School of Watercolor and is promoted mainly by his former students and colleagues.[51] The distinction between types of official and popular appeal noted here is especially significant in that it points up the existence of separate areas of professional artistic activity in watercolor that rarely intersect. Apart from Ralph Fabri's *History of the American Watercolor Society: The First Hundred Years,* little scholarly effort has been devoted to documenting the parallel history of the artists participating regularly in American Watercolor Society exhibitions to the present day.[52]

149

Paul Jenkins (b. 1923). *Phenomena Ever After,* 1980. Watercolor on white, very thick, rough-textured wove paper. 25 × 20¹⁄₁₆ in. (63.5 × 51 cm). 1994.212.2, Bequest of John Wesley Strayer

CLOSING NOTES

The cessation of the Brooklyn Museum's watercolor biennials in 1963 is indicative of the general decrease in interest in watercolor production, an observation that is supported by the lack of published material specifically devoted to the medium.[53] This does not, however, betoken a corresponding abatement in use, but merely the ongoing tendency to relegate watercolor to its traditionally secondary position in the hierarchical scheme of media values. As Jeffrey Wechsler has written, "Frequently, works of similar size, imagery and quality by the same artist follow a descending scale in price—oil on canvas, oil on paper, watercolor on paper. Artists who have specifically chosen to use watercolor and related mediums on paper as their major medium of expression not only generally receive lower prices for their works, but are viewed as somehow less ambitious, their oeuvres less significant."[54] Yet, as demonstrated by the work of Sam Francis (cat. no. 148) and Paul Jenkins (cat. no. 149), it is impossible to reach an understanding of

the respective aesthetics of these artists without considering the role of watercolor in the development of their art. Francis' *Yellow, Violet, and White Forms* is significant because it marks the radical shift that occurred in his style about 1956, when he began to use passages of brilliant color against large expanses of white ground. In achieving this mode of what has been called "stylized spontaneity," in which the paint is applied in seemingly random brushstrokes, drips, and splashes, Francis explored in watercolor the same elements that he transferred to his large canvases.[55] Watercolor may also be looked to as the seminal medium for Jenkins' mature aesthetic, which is characterized by the method of pouring paint on a support to achieve the effect of "veiled" color washes.[56]

From the present vantage point it seems that the matter of watercolor practice has been subsumed by the larger critical issues of the day, one of which is the question whether or not painting itself is "dead"—killed off by the multiplicity of aesthetic stances (including conceptual and performance art) that have entered the field of contemporary art in recent decades.[57] Painting is certainly alive and well, but the manner in which historians will treat it—and, by extension, watercolor—obviously remains to be seen. In the meantime, the opportunity exists to reevaluate our interpretation of watercolor history for the first half of this century.

NOTES

1. A. E. Gallatin, *American Water-Colorists* (New York: E. P. Dutton, 1922), viii, ix (hereafter Gallatin 1922).

2. Dunlap, himself a watercolorist, rarely mentioned watercolor practices in his survey of American art. Dunlap, *A History of the Rise and Progress of the Arts of Design in the United States* (1834; New York: Benjamin Blom, 1965). Watercolor also goes virtually unmentioned in current survey literature (see, e.g., Milton Brown [another painter of watercolors] et al., *American Art* (New York: Harry N. Abrams, 1988); Wayne Craven, *American Art: History and Culture* (Madison, Wis.: Brown and Benchmark, 1994); and Matthew Baigell, *A Concise History of American Painting and Sculpture,* rev. ed. (New York: Icon Editions, Harper Collins Publishers, 1996).

3. Gallatin 1922, viii.

4. Ibid.

5. For an excellent overview of the history of the modernist watercolor in America, see Carol Troyen, "A War Waged on Paper: Watercolor and Modern Art in America," in Sue Welsh Reed and Carol Troyen, *Awash in Color: Homer, Sargent, and the Great American Watercolor* (Boston: Museum of Fine Arts, Boston, in association with Bulfinch Press, Little, Brown, 1993), xxxv–lxxiv (hereafter Reed and Troyen 1993).

6. Alan Burroughs, *A History of American Watercolor Painting,* exh. cat. (New York: Whitney Museum of American Art, 1942), 14. The distinction between exhibitions devoted to the history of American watercolor and others that concentrated on contemporary developments is made here. An important example of the latter is the Newark Museum's 1930 *Modern American Watercolors.*

7. Of these, only Bellows does not regularly figure as a practitioner of watercolor. The only other contemporary artist was H. Broadfield Warren (1859–1934), an English-

born painter who had studied art at Harvard University with Charles H. Moore and Charles Eliot Norton. He later joined the Harvard Department of Architecture faculty as a watercolor instructor.

8. Albert Ten Eyck Gardner, *History of Water Color Painting in America* (New York: Reinhold Publishing, 1966); Donelson F. Hoopes, *American Water Color Painting* (New York: Watson Guptill Publications, 1977); and Christopher Finch, *American Watercolors* (New York: Abbeville Press, 1986). One has only to survey the credit lines for the illustrations in these volumes to learn how heavily these writers drew from just a few public collections for their material. Fifty-five of the 397 reproductions in Finch's book were of works in Brooklyn's collection. This observation is not so much a criticism of these authors, than it is an observation on the manner in which the canon has been formulated thus far. I have excluded Theodore E. Stebbins, Jr.'s *American Master Drawings and Watercolors: A History of Works on Paper from the Colonial Times to the Present* (New York, Hagerstown, San Francisco, London: Harper & Row, Publishers, in association with the Drawing Society, Inc., 1976) from the group because of its broader scope, although it is infinitely more scholarly. Sherman Lee's Ph.D. dissertation, "A Critical Survey of American Watercolor Painting" (Western Reserve University, 1941) is likewise omitted from discussion here owing to its limited availability.

9. Lloyd Goodrich, *American Watercolor and Winslow Homer,* exh. cat. (Minneapolis, Walker Art Center, 1945), 8.

10. Ibid., 43.

11. "The Art Galleries: Watercolors and Oils," *New Yorker* (May 26, 1945). BIAS Scrapbooks, Art Reference Library, Brooklyn Museum of Art.

12. Brooklyn's *Bedouins* by John Singer Sargent has been included in thirteen special exhibitions since it entered the collection in 1909. This number does not include periods of extended display in the Museum's permanent galleries, a practice that ceased in the 1970s. In contrast, other watercolors in the collection (e.g., Leon Carroll's *Tiger Lilies*), have not been displayed since they were acquired.

13. See especially Reed and Troyen 1993; *American Watercolors from the Metropolitan Museum of Art* (New York: American Federation of Arts, in association with Harry N. Abrams, 1991) (hereafter MMA 1991); and Susan E. Strickler, "American Watercolors at Worcester," in *American Traditions in Watercolor: The Worcester Art Museum Collection,* exh. cat. (New York: Worcester Art Museum, Abbeville Press, Publishers, 1987) (hereafter Strickler 1987).

14. *Catalogue of a Group Exhibition of Water Color Paintings by American Artists,* exh. cat. (Brooklyn: Brooklyn Museum, 1921), n.p.

15. Paul Strand, "American Water Colors at The Brooklyn Museum," *Touchstone Magazine* (*The Arts and American Art Student*) (December 1921), 150–51 (hereafter Strand 1921).

16. Ibid.

17. See chapter 6 herein for a discussion of watercolor as the "American medium."

18. Strand 1921, 152.

19. Helen Appleton Read, *Brooklyn Daily Eagle,* 1923, reprinted in "The Exhibition of Water Colors and English Drawings of the Nineties. Notices from the Press," *Brooklyn Museum Quarterly* (January 1924), 25.

20. Helen Appleton Read, "Watercolor Biennial," *Brooklyn Eagle,* 1929. BIAS Scrapbooks, Art Reference Library, Brooklyn Museum of Art.

21. Information about Tshudy, Gordon, Wegener, and von Saldern was kindly provided by Deborah Wythe, Archivist, Brooklyn Museum of Art.

22. See Cuthbert Lee, *Contemporary American Portrait Painters* (New York: Wm. Edwin Rudge, 1929), 106.

23. Ibid.

24. Information on Fisher was compiled from the following sources: "Obituary," *New York Times,* March 20, 1942, 19; Chris Petteys, *Dictionary of Women Artists: An International Dictionary of Women Artists Born before 1900* (Boston: G. K. Hall, 1985), 248; and Peter Hastings Falk, ed., *Who Was Who in American Art* (Madison, Conn.: Sound View Press, 1985), 202.

25. For an excellent assessment of Guy's art of the 1930s and 1940s, see Ilene Susan Fort, "James Guy: A Surreal Commentator," *Prospects* (1987), 125–48.

26. Betty Duffy and Douglas Duffy, *The Graphic Work of Howard Cook: A Catalogue Raisonné* (Washington, D.C.: Museum Press, 1984).

27. "A Cook Tour," *Art Digest* (February 15, 1937), 6.

28. *Exhibition of the Recent work by John Wenger Including Paintings, Screens, Decors,* Ferargil Galleries, New York, May 10–22, 1926. For a summary of Wenger's life and career up to 1925, see Carlo de Fornaro, *John Wenger* (New York: Joseph Lawren Publisher, 1925).

29. *Recent Watercolors by John Wenger,* Montross Gallery, New York, September 22–October 10, 1931.

30. See J. J. Brody, *Indian Painters and White Patrons* (Albuquerque: University of New Mexico Press, 1971), and W. Jackson Rushing, *Native American Art and the New York Avant-Garde: A History of Cultural Primitivism* (Austin: University of Texas Press, 1995).

31. *Fall Corn Dance* and *Hopi Corn Dance* were purchased in 1940 from the Thunderbird Shop, Santa Fe, New Mexico. Although they are not known to have received formal training, it has been suggested that both Mootzka and Lomoyeva may have been familiar with the work of Fred Kabotie, one of the most influential figures in the development of the Hopi school of modern painting and a major force in the revival of interest in historic Native American art. See also Patrick D. Lester, *The Biographical Directory of Native American Painters* (Tulsa, Okla.: SIR Publications, 1995), which provides the variant names under which these artists are known.

32. See, e.g., Kathleen Foster, "Makers of the American Watercolor Movement: 1860–1890" (Ph.D. diss., Yale University, 1982), 51, in which she states: "Homer disliked the growing affiliation between illustration and watercolor. He responded to it in 1875 by abandoning commercial art abruptly, and reducing the illustrative qualities in his watercolor work."

33. If anything, *The Dugout* is a collaborative piece. According to Kenneth Stuart, who gave the work to the Museum, he, Rockwell, and a photographer went to a Cubs–Braves double-header in Boston in May or June, 1948, with the idea of a *Post* cover in mind. Although they had arranged permission from the Cubs' owner and manager to photograph the team, Stuart did not pinpoint who was responsible for the final conception of the piece. Letter from Kenneth Stuart to Leonore Sundberg, February 28, 1972, Supplementary Accession File, Department of Painting and Sculpture, Brooklyn Museum of Art.

34. It should be noted that Mount's 1848 *Caught Napping* (*Boys Caught Napping in a Field*) (Brooklyn Museum of Art) was commissioned by George Washington Strong, who specifically requested that Mount paint a work recalling Strong's boyhood memories of his father and his brothers, which the artist couched in terms of the anecdotal rural humor then popular with his audience. See Teresa A. Carbone, *Masterpieces of American Painting from The Brooklyn Museum,* exh. cat. (New York: The Jordan-Volpe Gallery, 1996), 58–60.

35. Abbott Thayer's ideas on protective coloration were published in Gerald Thayer, *Concealing Coloration in the Animal Kingdom* (New York: Macmillan Company, 1909).

36. See, e.g., Nelson C. White, *Abbott H. Thayer: Painter and Naturalist* (Hartford: Connecticut Printers, 1951) and Ross Anderson, *Abbott Handerson Thayer,* exh. cat. (Syracuse, N. Y.: Everson Museum, 1982).

37. Biographical information on Jamieson is taken from a faculty profile published by the University of Maryland, Department of Art Studio Faculty, contained in the Vertical Files, Art Reference Library, Brooklyn Museum of Art.

38. Christopher E. Fremantle, "New York Commentary," *Studio* (September 1949), 91.

39. See *International Water Color Exhibition, 15th Biennial 1949* (Brooklyn Institute of Arts and Sciences, 1949), where Jamieson's *Pasquale's Vision* is no. 167 and Tobey's *Island Memories* is no. 218. The Jamieson was one of only eleven works illustrated out of the 222 works in the show that featured Belgian, Mexican, Cuban, and American watercolors. Among the other artists whose works were illustrated were Paul Delvaux, Charles Sheeler, René Magritte, and Charles Burchfield.

40. For biographical information on Carroll, see *The Leon Carroll Memorial Exhibition and Flower Paintings by Ruby Warren Newby,* exh. cat., intro., Katherine S. Dreier (Springfield, Mass: George Walter Vincent Smith Art Gallery, 1940) (hereafter *Leon Carroll Memorial Exhibition* 1940), and *The Société Anonyme and the Dreier Bequest at Yale University: A Catalogue Raisonné* (New York: Yale University Press, 1984) (hereafter *Société Anonyme* 1984).

41. "O'Keeffe's Rival," *Art Digest* (May 15, 1930), 10.

42. This is noted by Ruth L. Bohan in *Société Anonyme* 1984, no. 155.

43. *Leon Carroll Memorial Exhibition* 1940, n.p.

44. M. F. R. [Mary Fanton Roberts], "Leon Carroll's Magical Flower Paintings," *Arts & Decoration* (June 1932), 58.

45. For Macknight, see Desmond Fitzgerald, *Dodge Macknight: Water Color Painter* (Brookline, Mass.: privately printed by Riverdale Press, 1916) (hereafter Fitzgerald 1916); *Dodge Macknight, 1860–1950, Loan Exhibition of Watercolors,* exh. cat. (Boston: Museum of Fine Arts, Boston, 1950); and Karen E. Haas, "Dodge Macknight—painting the Town Red and Violet . . ." in *Fenway Court 1882* (Boston: Isabella Stewart Gardner Museum, 1983), 36–47.

46. Letter to the editor, R. J., "Nightmare Landscape," *Boston Evening Transcript,* 1891, reprinted in Fitzgerald 1916, 31.

47. Macknight exhibited only three times at the Pennsylvania Academy of the Fine Arts, in 1895, 1896, and 1899; he appears not to have exhibited with any New York artists' organizations.

48. Marsden Hartley, *Some American Watercolorists* (1921), repr. in "Documentary Sources in American Art," Martha Hutson, ed., *American Art Review* (May–June 1975), 95.

49. For Sheets, see Janice Lovoos and Edmund F. Penney, *Millard Sheets: One-Man Renaissance* (Flagstaff, Ariz.: Northland Press, 1984), and *Millard Sheets: Six Decades of Painting,* exh. cat. (Laguna Beach, Calif.: Laguna Beach Museum of Art, 1983).

50. Malcolm Vaughan in *New York American,* quoted in *Millard Sheets: New York Exhibition,* presented by Dalzell Hatfield (gallery address unspecified), May 1936.

51. Janice Lovoos, "The California School of Watercolor," *American Artist* (April 1987), 62–69, 86–91.

52. Ralph Fabri, *History of the American Watercolor Society: The First Hundred Years* (New York: American Watercolor Society, 1969).

53. A notable exception is Jeffrey Wechsler, *Watercolors from the Abstract Expressionist Era,* exh. cat. (Katonah, N.Y.: Katonah Museum of Art, 1990) (hereafter Wechsler 1990).

54. See Wechsler's "Fluid Dynamics: Notes on the Application of Watercolor and Related Mediums to the Abstract Expressionist Aesthetic," in Wechsler 1990.

55. James Johnson Sweeney, *Sam Francis,* exh. cat. (Houston: Museum of Fine Arts, Houston, 1967), 19.

56. Albert Elsen states about Jenkins' stylistic development, "It was his work with watercolor in Spain during 1959 that cleared the way for his use of acrylics, since then his preferred medium for painting." Albert Elsen, *Paul Jenkins* (New York: Harry N. Abrams, 1975), 24.

57. For a discussion addressing the rumored death of painting, see Jerry Saltz, "Critic's Diary. A Year in the Life: Tropic of Painting," *Art in America* 82 (October 1994), 90–101.

CHRONOLOGY OF THE AMERICAN WATERCOLOR MOVEMENT

THOMAS B. PARKER

This chronology attempts to construct through exhibitions, publications, schools, clubs, and the activities of artists and patrons, the evolution of the watercolor movement in this country from its first coherent efforts to the present day. Special emphasis has been given to the significant contributions of both Brooklyn and the Brooklyn Museum of Art.

Abbreviations:

AWS	American Watercolor Society, New York	
BAA	Brooklyn Art Association	
BIAS	Brooklyn Institute of Arts and Sciences	
NAD	National Academy of Design, New York	
NYWC	New York Water Color Club	
TBM	The Brooklyn Museum	

1841 Drawing classes taught at Brooklyn Apprentices Library (mechanical, architectural, landscape, figure).

1846 Brooklyn Female Academy opens; damaged by fire in 1853 and reopens the following year as Packer Collegiate Institute.

1850 Society for the Promotion of Painting in Water Colors organizes; continues until 1855 (later called the New York Water Color Society); members include John Mackie Falconer, Jasper Francis Cropsey, and John William Hill.

1851 Series of articles titled "The Art of Landscape Painting in Water Colors" published in the *Bulletin of the American Art-Union;* excerpted from an English publication of same title by T. L. Rowbotham, written c. 1850.

1853 *Exhibition of the Industry of All Nations* at New York Crystal Palace includes display of 31 watercolors staged by the New York Water Color Society.

1855 The *Crayon* published through 1861; the nation's first journal devoted to art matters and an influential advocate of watercolor and Ruskinian principles.

1855/56 The Reverend Elias Magoon of Philadelphia purchases from John Ruskin watercolors by Joseph Mallord William Turner, the first in the United States.

1857 *American Exhibition of British Art* travels to New York, Boston, and Philadelphia; contains almost 200 watercolors including works by Turner and John Ruskin's *Fragment of the Alps,* c. 1854–56.

Ruskin's *The Elements of Drawing* promotes use of the watercolor medium and explains its technique.

Formation of the Brooklyn Sketch Club.

1858 The Graham Art School is established in Brooklyn.

1859 Brooklyn Art Social forms (precursor to the BAA).

1861 BAA instituted; serves as the most important and active exhibitor of contemporary American art (oil paintings, watercolors, and sculpture) in Brooklyn from 1859 to 1890.

1863 Formation of the Society for the Advancement of Truth in Art, in New York City; the central organization of the American Pre-Raphaelite movement, which embraced watercolor as a primary medium.

Adelphi Academy opens in Brooklyn.

The New Path, the often radical voice of the American Pre-Raphaelites, published through 1865, although the society disbanded early in 1864.

1866 In conjunction with its annual exhibition at the NAD, the Artists Fund Society stages a loan exhibition of 130 watercolors leading to the founding of the AWS.

Formation of the American Society of Painters in Water Colors (later called the American Watercolor Society); founders include Falconer, William Hart, and Samuel Colman; early members include Cropsey, Albert Fitch Bellows, James Smillie, and Thomas Charles Farrer.

1867 *First Annual Exhibition of the Yale School of Fine Arts* is the first significant showplace of the American Pre-Raphaelites, whose work makes up 25 percent of the exhibition (total of 82 watercolors and drawings shown).

First Annual Collection of the American Society of Painters in Water Colors at the NAD (278 watercolors shown).

Brooklyn Academy of Design opens.

1868 Publication by AWS of pamphlet titled *Water-Color Painting: Some Facts and Authorities in Relation to its Durability,* written by a committee made up of Falconer, Bellows, W. Hart, Gilbert Burling, and Christopher Pearse Cranch to stimulate the patronage of watercolors.

1869 William Trost Richards first exhibits at AWS.

1872 BAA's Montague Street building completed; includes a small gallery designated as the Watercolor Room.

Free Schools of Design at BAA open.

1873 *English Collection of Water Colors and Sketches* organized by the English art critic Henry Blackburn and shown in conjunction with AWS's sixth annual exhibition; it is the society's largest and most cosmopolitan effort to date (204 works).

1874 James McNeill Whistler, Winslow Homer, Thomas Eakins, and Edwin Austin Abbey show for the first time at AWS.

1875	*First Exhibition of the American Society of Painters in Water Colors Held at the Galleries of the Brooklyn Art Association*; collaboration is the first all-watercolor exhibition at BAA (524 works).
1876	AWS watercolor display of more than 150 works at Centennial Exposition in Philadelphia; earns a Certificate of Merit.
	John La Farge first exhibits at AWS.
1877	Second watercolor collaboration between AWS and BAA included with the association's spring exhibition (100 works).
	Brooklyn Daily Eagle (August 1, 1877) reports BAA intent to establish an annual spring exhibition of watercolor.
1878	BAA devotes a separate gallery of the spring exhibition to watercolor (109 works).
	Regarding the BAA fall exhibition, the *Brooklyn Daily Eagle* (November 22, 1878) reports: "The [BAA] Committee have resolved this year to devote a large space in one of the main rooms to watercolors . . . an increase in interest in this department is expected" (number of works unavailable).
	Abbey, Bellows, Colman, Henry Farrer, and Richards exhibit watercolors at the Paris Universal Exposition (approximately 15 works).
1879	BAA spring exhibition includes 195 watercolors.
	Approximately 80 watercolors shown at BAA fall exhibition, including 19 by John William Hill, a memorial to the artist.
1880	Magoon donates 85 Richards watercolors to the Metropolitan Museum of Art.
1881	AWS and BAA collaborate on third watercolor exhibition (607 works); from that time until 1885 the spring exhibition is devoted to watercolor.
1882	AWS stages its most successful annual exhibition to date, showing 650 works culled from an initial pool of over 1,500 submissions, a record number.
	Artists rejected by AWS form their own Salon des Refusés at the American Art Gallery (300 works).
	BAA spring exhibition of watercolors (671 works).
1883	BAA spring exhibition of watercolors (331 works).
1884	BAA spring exhibition of watercolors (398 works).
1885	BAA spring exhibition of watercolors (344 works).
	The Boston Society of Water Color Painters organizes (male membership); founding members include Childe Hassam, Louis Ritter, and Ross Turner.
1887	The Boston Water Color Club organizes (female membership); early members include Laura Coombs Hills, Sarah Choate Sears, and Sarah W. Whitman; early exhibitors include Fidelia Bridges and Elizabeth Boott Duveneck.

Pratt Institute opens in Brooklyn with drawing class as its first offering.

1889 *First Annual Exhibition of Water Colors, Pastels, and Miniatures by American Artists* staged by the Art Institute of Chicago.

Thomas Eakins' *Dancing Lesson* (*Negro Boys Dancing*, 1878, collection of the Metropolitan Museum of Art) and Julian Alden Weir's *Preparing for Christmas* (c. 1888, unlocated) are the two American watercolors included at the Paris Universal Exposition.

1890 The New York Water Color Club organizes; original membership includes Childe Hassam, Albert Herter, and Ross Turner; approximately half the members are women.

Brooklyn Institute building on Washington Avenue badly damaged by fire.

1891 Brooklyn Art School opens under the auspices of BIAS and BAA.

1892 *First Annual Exhibition of Water Colors and Pastels* staged by the Art Club of Philadelphia.

A Collection of Water Colors, Designs and Decorations by Walter Crane, A.R.W.S. shown at BAA.

1896 Brooklyn Art School watercolor classes offered as part of a three-year decorative design course (continued until at least 1914).

1897 West wing of the Central Museum of the BIAS opens; five European watercolors lent by A. A. Healy in inaugural exhibition of more than 583 objects.

1899 James Tissot's *Life of Christ* series exhibited by TBM at the BAA's Montague Street Galleries.

1900 Tissot's *Life of Christ* series exhibited at the BAA to benefit TBM purchase fund, and later exhibited at the NAD.

TBM acquires Tissot's *Life of Christ*.

1904 *First Annual Exhibition of the Philadelphia Water Color Club* at the Pennsylvania Academy of Fine Arts; founding members include Thomas Anshutz, Hugh Breckenridge, and Colin Campbell Cooper; honorary members Abbey, John Singer Sargent, and Cecilia Beaux.

1905 NYWC holds small exhibition in London gallery.

AWS begins annual rotary exhibition that travels to such cities as Saint Louis, Cincinnati, Indianapolis, Detroit and Buffalo.

68 American watercolors from the Brooklyn collection of G. H. Buek displayed as part of exhibition program celebrating the opening of new central wing at TBM.

1906 *First Annual Exhibition of Water Colors by American Artists* staged by the Saint Louis Museum of Fine Arts.

Bellows' *Coaching in New England* (cat. no. 36) is first American watercolor to enter TBM collection.

1907 Alfred Stieglitz establishes his 291 gallery, where he often exhibits

modernist American and European watercolors.

TBM establishes American art galleries.

1909 Knoedler exhibits 86 Sargent watercolors from which TBM purchases 83 by subscription.

1910 The Metropolitan Museum of Art purchases 12 Homer watercolors from artist's estate.

1912 TBM acquires 12 Homer watercolors from artist's estate.

Museum of Fine Arts, Boston, purchases 45 Sargent watercolors.

1913 Galleries L and K at the Armory Show in New York are devoted to American and European watercolors and drawings (approximately 80 works); Americans represented exclusively in watercolor are John Marin (10 works), Oscar Bluemner (5 works), Stuart Davis (5 works), Maurice Prendergast (7 works), and Dodge Macknight (3 works).

1915 *Water Colors by Winslow Homer* organized by TBM.

The Metropolitan Museum of Art purchases 10 Sargent watercolors.

1917 Worcester Art Museum acquires 11 Sargent watercolors.

Winslow Homer and John Singer Sargent: An Exhibition of Water Colors organized by the Carnegie Institute.

1919 Brooklyn Water Color Club forms.

1921 *Exhibition of Water Color Paintings by American Artists* (first of TBM watercolor biennials) .

TBM purchases Charles Burchfield's *February Thaw* (cat. no. 119) from the biennial; first work by the artist to enter a museum collection.

First Annual International Exhibition of Water Colors at the Art Institute of Chicago.

Paul Strand publishes "American Water Colors at the Brooklyn Museum," *Arts* 2 (December 1921), 148–52.

1922 Albert E. Gallatin's *American Water-Colourists* published; first notable publication devoted to American watercolor.

First combined exhibition of NYWC and AWS.

1923 *Exhibition of Water Color Paintings, Drawings and Sculpture by American and European Artists* (2d TBM biennial; first with international scope; includes works from England with a section devoted to Aubrey Beardsley, Austria, Canada, France, Germany, and Sweden).

TBM purchases Edward Hopper's *Mansard Roof* (cat. no. 129) from the biennial.

1925 TBM acquires Thomas Eakins' *Whistling for Plover* (cat. no. 45).

Exhibition of Water Color Paintings, Pastels, and Drawings by American and European Artists (3d TBM biennial—works from England, France, and Soviet Union; works were not arranged by nationality of artist in the catalogue).

1926 TBM acquires Preston Dickinson's *Street in Quebec* (cat. no. 115) from the 1925 biennial.

1927 *Exhibition of Water Color Paintings, Pastels, and Drawings by American and European Artists* (4th TBM biennial—works from England and France; works were not arranged by nationality of artist in the catalogue).

1929 *Exhibition of Water Color Paintings, Pastels, and Drawings by American and European Artists and Miniatures by the Brooklyn Society of Miniature Painters* (5th TBM biennial—works from England, France, Germany, Sweden, Soviet Union, and Italy; works were not arranged by nationality of artist in the catalogue).
 TBM purchases Clarence Carter's *Sommer Brothers, Stoves and Hardware* (cat. no. 129) from the biennial.

1930 *Modern American Water Colors* organized by the Newark Museum; an important survey of American watercolors as a contemporary movement; curator Holger Cahill asserts the worldwide superiority of American artists in the medium.

1931 *Exhibition of Water Colors, Pastels, Drawings and Miniatures by American and Foreign Artists* (6th TBM biennial—works from Austria, England, France, and Germany).
 TBM acquires Lyonel Feininger's *Strand* (cat. no. 124) from the biennial.

1933 *A Group Exhibition of Architectural Water Colors by American Architects* at TBM.
 Exhibition of Water Colors, Pastels, Drawings and Miniatures by American and European Artists (7th TBM biennial—works from France and Germany).
 TBM acquires Gordon Stevenson's *Catskill Stream* (cat. no. 131) from the biennial.

1935 *Exhibition of Water Colors, Pastels, Drawings and Miniatures by American and Foreign Artists* (8th TBM biennial—works from Austria, France, Great Britain, Japan, Yugoslavia, Mexico, Palestine, Persia, Soviet Union, Spain, and Sweden).

1936 *Oil Paintings and Water Colors by California Artists: The Post-Surrealists* at TBM.
 First Annual Watercolor Exhibition of the San Francisco Art Association.

1937 *International Exhibition of Water Colors* (9th TBM biennial—works from France, Germany, and Mexico).
 TBM acquires Howard Cook's *Foot Washing* (cat. no. 134) from the biennial.

1939 *International Exhibition of Water Colors* (10th TBM biennial—works from England, France, and Switzerland).

1941 *Watercolors by Brooklyn Artists* at TBM.
 International Water Color Exhibition (11th TBM biennial—works from Canada).

Special Loan Exhibition of Contemporary American Watercolors at the Metropolitan Museum of Art.

Brooklyn Museum Art School opens.

NYWC and AWS merge.

1942 *A History of American Watercolor Painting,* exhibition at the Whitney Museum of American Art.

1943 *International Water Color Exhibition* (12th TBM biennial—works from Argentina, Brazil, Cuba, and Mexico).

TBM acquires Milton Avery's *Road to the Sea* (cat. no. 111) from the biennial.

1945 *International Water Color Exhibition* (13th TBM biennial—works limited to the United States).

Lloyd Goodrich's *American Watercolor and Winslow Homer,* organized by the Walker Art Center, Minneapolis, TBM, and the Detroit Institute of Arts; show also traveled to the M. H. deYoung Memorial Museum, San Francisco.

1947 *International Water Color Exhibition* (14th TBM biennial—works from Great Britain, Italy, and France).

TBM acquires Mark Rothko's *Vessels of Magic* (cat. no. 125) and Karl Schrag's *Trees against the Sky* (cat. no. 120) from the biennial.

1949 *International Water Color Exhibition* (15th TBM biennial—works from Belgium, Cuba, and Mexico).

TBM purchases Adolph Gottlieb's *Floating* (cat. no. 126), Mitchell Jamieson's *Pasquale's Vision* (cat. no. 141), and Mark Tobey's *Island Memories* (cat. no. 142) from the biennial.

1951 *International Water Color Exhibition* (16th TBM biennial—works from Denmark, Germany, and Switzerland).

TBM acquires James Brooks's *No. 1* (cat. no. 127) from the biennial.

1953 *International Water Color Exhibition* (17th TBM biennial—works from England and Holland).

1955 *International Water Color Exhibition* (18th TBM biennial—works from Japan and France).

1957 *Trends in Watercolor Today* (19th TBM biennial—works from Italy).

TBM acquires Sam Francis' *Yellow, Violet, and White Forms* (cat. no. 148) from the biennial.

1959 *20th TBM Biennial International Water Color Exhibition* (works from Canada and Mexico).

1961 *21st TBM International Watercolor Biennial* (works from Germany and Great Britain).

1962 *The M. & M. Karolik Collection of American Water Colors and Drawings, 1800–1875,* published by the Museum of Fine Arts, Boston, as a collection catalogue.

1963 *22nd TBM International Watercolor Biennial* (the Museum's last biennial—works from Yugoslavia and Sweden).

1966	Albert Ten Eyck Gardner's *History of Water Color Painting in America* published.
	Centennial Celebration of the American Watercolor Society, exhibited at the Metropolitan Museum of Art.
1969	Ralph Fabri's *History of the American Watercolor Society* published.
1972	*Homer and Sargent: Watercolors from the Brooklyn Museum,* exhibited at TBM with works from the Metropolitan Museum of Art.
	The Brooklyn Watercolor Society forms.
1976	Theodore Stebbins' *American Master Drawings and Watercolors,* exhibition and book.
1977	Donelson Hoopes's *American Watercolor Painting* published.
	Wash and Gouache: A Study of the Development of the Materials of Watercolor, exhibition organized by the Fogg Art Museum, Harvard University.
1982	Kathleen A. Foster's dissertation, "Makers of the American Watercolor Movement, 1860–1890."
1984	*The Brooklyn Museum: American Watercolors, Pastels, and Collages,* illustrated checklist published to accompany exhibition.
1985	*The New Path: Ruskin and the American Pre-Raphaelites,* organized by TBM; traveled to the Museum of Fine Arts, Boston.
	Brooklyn Museum Art School transferred to Pratt Institute.
1986	Christopher Finch's *American Watercolors* is published.
1987	*American Traditions in Watercolor: The Worcester Art Museum Collection;* exhibition and collection catalogue, Worcester Art Museum.
	Curator's Choice: The American Watercolor Movement, 1860–1900 organized by TBM.
1990	*Curator's Choice: American Watercolor Masters: Winslow Homer and John Singer Sargent* at TBM.
1991	*American Watercolors from the Metropolitan Museum of Art,* exhibition and catalogue, the Metropolitan Museum of Art and the American Federation of Arts.
1993	*Awash in Color: Homer, Sargent and the Great American Watercolor,* exhibition and catalogue, Museum of Fine Arts, Boston.
1997	Centennial of TBM's landmark McKim, Mead & White building; name changed to the Brooklyn Museum of Art.

INDEX OF ARTISTS IN THE EXHIBITION

This book accompanies an exhibition of watercolors held at the Brooklyn Museum of Art, Spring 1998, the checklist for which is documented here.

INDEX

Page references in italics indicate illustrations.

COLOPHON

The titling typeface, Delphian, was designed in 1928 by R. Hunter Middleton, a

contemporary Chicago type designer for the Ludlow Corporation. The text typeface is

Adobe Garamond. It is based on the work of Claude Garamond, 1480–1561. Garamond's

first specimens were printed in Paris about 1651.

The book was typeset by Paul Hotvedt at Blue Heron Typesetters, Inc. in Lawrence, KS.

The paper is 135 gsm Garda Matte and printed by Amilcare Pizzi S.p.A. Arti Grafiche in

Milan, Italy.